The Trial of Susan B.

The Trial of Susan B. Anthony

An Illegal Vote, a Courtroom Conviction and a Step Toward Women's Suffrage

MARTIN NAPARSTECK

McFarland & Company, Inc., Publishers
Jefferson, North Carolina

Library of Congress Cataloguing-in-Publication Data

Naparsteck, M. J. (Martin John), 1944–
 The trial of Susan B. Anthony : an illegal vote, a
courtroom conviction and a step toward women's
suffrage / Martin Naparsteck.
 p. cm.
 Includes bibliographical references and index.

 ISBN 978-0-7864-7885-9 (softcover : acid free paper) ∞
 ISBN 978-1-4766-1757-2 (ebook)

 1. Anthony, Susan B. (Susan Brownell), 1820–1906—Trials,
litigation, etc. 2. Trials (Political crimes and offenses)—
New York (State)—Canandaigua. 3. Election law—United
States—Criminal provisions. 4. Women—Suffrage—
United States. I. Title.
KF223.A58N37 2014
364.1'324—dc23 2014037950

British Library Cataloguing Data Are Available

On the cover: Susan B. Anthony photograph (by Mathew B. Brady,
ca. 1870 Library of Congress); Ontario County Courthouse in
Canandaigua, New York (Martin Naparsteck)

Printed in the United States of America

McFarland & Company, Inc., Publishers
 Box 611, Jefferson, North Carolina 28640
 www.mcfarlandpub.com

Again for
Taft, America, Molly
and for
the millions of women and men who fought for the right of women
to vote.

Table of Contents

Acknowledgments ix

Preface 1

Introduction 5

1. The Motivation 9

2. Planning the Crime 31

3. The Crime 51

4. The Speech 86

5. The Trial 107

6. The Trial of the Inspectors 147

7. The Wages of Crime 182

Appendices

 Appendix A: Indictment in the Case of
 United States vs. Susan B. Anthony 203

 Appendix B: Supreme Court Ruling in Minor Case 206

Chapter Notes 215

Bibliography 223

Index 229

Acknowledgments

Thank you to Marcilyn Morrisey, Commissioner of Jurors in Ontario County, New York, for an enlightening tour of the Ontario County Courthouse, where Susan B. Anthony was tried.

To Ruth Rosenberg-Naparsteck, former historian for the city of Rochester, for useful information and leads, and for use of photographs from her private collection.

To Sara Kersting and Michelle Cardulla for encouragement and useful comments.

To the helpful staff in the Local History Division of the Rochester Public Library, and librarians in the New York towns of Greece, Irondequoit, Webster, and Canandaigua.

To Steve Petteway of the Office of the Curator of the Supreme Court of the United States, for providing the photograph of Associate Justice Ward Hunt.

And for many others too numerous to enumerate.

The right of citizens of the United States to vote shall not be denied or abridged by the United States or by any State on account of sex.

Congress shall have power to enforce this article by appropriate legislation.

<div align="right">

19th Amendment
Constitution of the United States of America

</div>

Preface

Susan B. Anthony had much in common with George Washington. Both were more admirable than amiable. Much of what has been written about each has been hagiographic. They are often seen as humorless and harsh, and the available historical evidence suggests that is pretty much accurate. These two leaders were skilled at keeping a following alive but possessed little talent for strategy or tactics. Both had high opinions of themselves and often low opinions of others.

Yet, just as it is difficult to see how the Americans could have defeated the British in the Revolution if someone other than Washington had led their army, even a more talented general, and how the new republic could have survived its earliest years if someone else had been its first president, it's just as difficult to imagine that the women's suffragist movement would have been successful if any other woman had assumed the figurehead position accorded to Anthony. She was, while alive and still today, the towering figure of the long, often bitter fight to win American women the right to vote.

And she had one more attribute she shared with Washington. She triumphed in defeat. Just as Washington lost most of the major battles he fought against the British, so too did Anthony lose in her major efforts. Her genius was visible only in the light of the final victory. She kept the army of suffragists together, marching forward, through defeat after defeat, until—after she died and could not benefit from it—victory finally arrived in the form of the 19th Amendment to the Constitution of the United States, often called, appropriately, the Susan B. Anthony amendment.

Washington, from the British point of view, committed the crime of treason. Anthony, from the point of view of a federal district attorney, committed the crime of voting. That is the subject of this book. That crime.

She did not set out to commit a crime, but as circumstances unfolded, a crime of opportunity presented itself and she did not let it pass.

1

Her plan was simple. She would go the polling place, say she wanted to register to vote, and would be told she could not because New York state law allowed only men to vote. At the time no state permitted women to vote. And then she would sue. She would claim that the 14th Amendment to the Constitution gave all citizens, including women, the right to vote. It was an idea given to her by a lawyer in St. Louis, Francis Minor. Francis Minor's wife, Virginia, would do the same thing. Try to register, be refused, sue. For Virginia Minor, that's how it worked out, so she did not commit a crime.

Anthony, however, played her role too well, and the three male inspectors of election in the First District of the Eighth Ward in Rochester, New York—confused, given contradictory advice, young, inexperienced in their roles, and probably overwhelmed by the surprise presence of the most famous woman in the city, indeed, one of the most famous women in the country—said, well, maybe, all right, we think perhaps you can register.

That was on a Friday. The next Tuesday, which was the first Tuesday after the first Monday of November 1872, she showed up at the same place, and having been duly registered, cast a ballot. She voted a straight Republican ticket, including voting for the re-election of Ulysses S. Grant for president. She voted for Republicans because at their national convention they adopted a platform plank that said careful consideration should be given to things women want. Presumably that included the vote, but the plank didn't say that. That was all, careful consideration, nothing more. Elizabeth Cady Stanton, Anthony's closest friend, called it more a splinter than a plank. But Anthony was far less concerned about whom she voted for than the act of voting.

That was a violation of New York state law, but the state did not charge her with a crime. The local federal district attorney, Richard Crowley, charged her under a federal law with violating the state law. That is, according to the federal law, anyone who was not allowed under a state law to vote but who did vote in a federal election had committed a federal crime.

Anthony was not charged with voting for anyone for state office, although she did, because that was not a federal crime. And, oddly, she was not charged with voting for the president. She was charged with voting for two candidates for the U.S. House of Representatives, one running for the seat from Rochester, one for a statewide seat (because the state legislature had not yet redistricted the state after the 1870 census gave New York an additional seat in Congress).

She was arrested, she was tried, she was found guilty. Her trial attracted a great deal of attention. Newspapers around the world reported on it. Even today it is the one detail of Susan B. Anthony's life that is best known about her. Probably the trial would have been covered extensively regardless of who

the judge was. But the judge did something that made Anthony a martyr, something no other judge is known to have done before or since in an American courtroom.

The judge was Ward Hunt, who had just been appointed by Grant to be an associate justice of the U.S. Supreme Court. And the Senate had already confirmed his appointment. At the time, Supreme Court justices rode circuits and sat as judges in trials. Hunt's first act as a Supreme Court justice was to sit as judge in the Anthony trial. And when all the testimony was in, Hunt told the jury—12 men, true and good—to find her guilty. A directed verdict. A clear violation of the 6th Amendment's guarantee of a trial by jury. Never before, never since has that happened in a U.S. criminal court. It's permitted in civil cases, in very limited circumstances, but never in criminal cases.

Newspapers that had scolded Anthony for voting and called for punishment now scolded Hunt. Outrageous. What about the Constitution? The case was over, and if not for Hunt's action, may have been forgotten. Thanks to Hunt, Anthony lost in the courtroom. Thanks to Hunt, Anthony won in the court of public opinion.

She was fined $100. She told Hunt she would never pay. Never. And she never did. Hunt knew better than to imprison her until she paid.

Associate Justice of the Supreme Court Ward Hunt is today all but forgotten. Pretty much he's mentioned only when someone is writing about Anthony.

And Susan B. Anthony? She committed a crime. Got herself arrested. Was convicted. And, with all her flaws, like George Washington, she was one of the giants of her time.

Introduction

Often in writing about a trial of historical importance, it's a mistake to rely too heavily upon the official record. Courtroom transcripts are incomplete. They leave out sidebar comments, facial expressions, tones of voice, so much of what is human, so much of what tells us deeper truths the legal record omits. But in the case of the trial of Susan B. Anthony, the transcripts make exciting reading.

Anthony wanted people to read them. After the trial, she paid to have thousands of copies of the transcripts printed and distributed.

This book uses the transcripts almost in their entirety, not as an appendix or a mere insert, but as a screenwriter might, eliminating only highly legalistic references which would have no meaning for most readers and whose omission in no way distorts the story being told. Similarly, thorough newspaper accounts of preliminary legal hearings provide details similar to those that would be found in transcripts. And Anthony devoted a good deal of space to her legal case in a book she co-wrote, *The History of Woman Suffrage*, which is also extensively quoted here. As is the first ever book-length biography of Anthony, written by her friend Ida Husted Harper, with so much cooperation from Anthony that it comes close to being an autobiography.

I visited her home in Rochester, New York, where I happen to reside, and the courthouse in nearby Canandaigua where the trial was held, and stood on the site of the building, which no longer stands, where she registered and voted. And stood at her graveside, and that of her friend and adversary Frederick Douglass. As much as possible, I've tried to incorporate a feeling for place in the narrative, just as she would have sensed the places that surrounded her as she acted out her drama.

The result is intended to be an account of not just the trial, but of the crime. Of how and why she planned it, how she, almost accidently, carried it out. How she reacted to the deputy marshal who arrested her, to the various

judges she encountered, to the district attorney and assistant district attorney who prosecuted her, to her friends, to everyone who touched upon the crime and its results.

Today Susan B. Anthony is more icon than human being. I've tried to correct that. While she lived she was not always likable. Her dear friend Elizabeth Cady Stanton was remarkably tolerant of Anthony's excesses in their friendship. Anthony ordered Stanton around mercilessly, and was often cruel in her comments to her. But Stanton loved Anthony. And admired her.

It's hard not to feel that admiration. It's hard, conversely, to love Susan B. Anthony the human being. There was so much in the personality of this woman—harsh, demanding, sometimes nasty—that even liking her requires a saint-like capacity to overlook flaws.

This book is divided into seven chapters, representing the seven stages of the crime.

First, the motivation. Susan B. Anthony in 1869 attended a meeting in New York City where the proposed 15th Amendment to the U.S. Constitution was debated by an audience of hundreds of men and women, white and black, who had constituted the leadership of both the pre–Civil War abolitionist movement and the women's rights movement. The 13th Amendment outlawed slavery. The 14th was designed to guarantee equal rights for former slaves. And because the 14th seemed destined to not always achieve its goal, the 15th would prevent any state from denying blacks the right to vote. Anthony and Stanton and other women's rights leaders wanted it to also guarantee the right of women to vote. Their opponents said no, that will make it more difficult to be accepted by the states and actually become part of the Constitution. They won; Anthony and her allies lost, and the 15th Amendment makes no mention of sex. That motivated Anthony to seek some other method of winning female suffrage.

Second, planning the crime. Anthony considered various alternative strategies for winning the right of women to vote. State by state? A 16th amendment? She settled upon a plan suggested by a St. Louis attorney, Francis Minor, who believed the 14th Amendment already granted women the right to vote: Attempt to register, be denied, sue, and appeal all the way up to the U.S. Supreme Court, which would, he believed, agree with him. That's what his wife, Virginia, would do. That's what Anthony also planned to do.

Third, committing the crime. Even the most careful planning may go awry. Anthony went to register to vote and much to her surprise was allowed to register. Four days later, also to her surprise, she was allowed to vote. Thus, she didn't actually plan to commit a crime, but the opportunity to commit

one presented itself and she didn't let it pass by. And she was arrested and charged.

Fourth, preparing for the trial. She spoke to potential jurors in dozens of communities in Monroe County, where the trial was scheduled to be held, urging them to disregard the law under which she was charged and recognize that she had a right to vote. When an irate federal district attorney was granted a change of venue because of her pre-trial activities, and the trial was moved to Canandaigua in neighboring Ontario County, Anthony gave dozens of speeches there. So did her friend Matilda Joslyn Gage.

Fifth, the trial. It was widely anticipated, widely covered, and, at points, explosive. The judge, Ward Hunt, a U.S. Supreme Court associate justice riding circuit, and Anthony clashed. And when the judge, near the end, asked Anthony if she had anything to say, she indeed did. She was, in fact, Churchillian. It was her finest hour.

Sixth, the trial of the inspectors. The three young men who allowed Anthony to register and vote were also brought to trial, and while their trial was anti-climatic, it said a great deal about overreach by the federal district attorney and the judicial arrogance by the judge.

Seventh, the wages of crime. Although found guilty, Anthony clearly won. She became and remained for the rest of her life the symbol of the women martyred on the altar of a woman's right to vote.

One final point. This is not a biography of Susan B. Anthony. While, of necessity, much about her life that preceded and followed her illegal vote are included, most of what shaped her life is omitted. This is a biography of a crime: what caused the crime to be conceived, how it grew, what the consequences were for the perpetrator, how the world viewed the crime. Crimes have lives of their own. This is the story of the life of one crime.

1

The Motivation

There were giants in the room.

And boredom.

And great tension.

The room was the auditorium in Steinway Hall, on 14th Street in Manhattan, two years old and the premiere meeting space in the nation's largest city. It would serve as the home of the New York Philharmonic until 1891, when Carnegie Hall opened. And it held 2,000 people. On that Wednesday in May 1869, there were enough people present to fill every seat. But many people walked up and down the aisles or lingered at the sides of the stage.[1]

Elizabeth Cady Stanton was in the room. And Lucy Stone. Leaders of the women's suffrage movement. And the Reverend Octavius Brooks Frothingham and Stephen Symonds Foster, leaders of the abolitionist movement. This was four years after the end of the Civil War and three and a half years after adoption of the 13th Amendment to the Constitution banning slavery. The leaders of the women's suffrage movement had been supporters of the abolitionist movement, and the leading abolitionists had spoken in favor of granting women the right to vote. And now, the two movements had merged in the American Equal Rights Association, and they were holding their third annual national meeting. The giants of their movements, the giants of their day, were in the room.[2] Frederick Douglass, the most famous black man in America, was there. And Susan B. Anthony, among the most famous women in the country.

Once Douglass and Anthony had been friends. Douglass had dined at the Rochester home of Anthony's father. Douglass spoke up at the famous Seneca Falls convention in 1848, often cited as the birthplace of the women's rights movement. Anthony had been, in pre–Civil War days, a paid organizer for the New York abolitionist movement.

And now these two giants knew they would clash.

The meeting was called to order by Lucy Stone, and the Rev. Mrs. Phebe Hannaford of Massachusetts led the crowd in prayer. Stone read routine reports. She told the audience about petitions presented to Congress and to state legislatures, and said that now, in 1869, more than ever elected representatives, all of them men, showed more respect for the cause of woman's suffrage than they ever had previously. In the past, she said, their petitions were met with laughter, but now they were referred to various committees. None of this was news to those assembled in Steinway Hall. But all meetings include the mundane, the familiar, the necessary repetition of the known.

In Western states, in particular, Stone said, the idea that women should vote was being seriously discussed, and newspapers all over the country wrote about the concept. She asked that the report be accepted, and by a voice vote, without disagreement, it was.

Then the Reverend Frothingham took the podium. Enough people in the audience suspected he might touch on the subject of contention that the atmosphere in the auditorium approached quiet and attention. Frothingham had been a Unitarian minister who later broke with the church and started his own non-sectarian church because he believed Unitarians were not sufficiently anti-slavery.[3]

He spoke as he usually did in a soft voice that carried surprisingly well in a crowded hall:

> I am not here this morning thinking that I can add anything to the strength of the cause, but thinking that perhaps I may gain something from the generous, sweet atmosphere that I am sure will prevail. This is a meeting, if I understand it, of the former Woman's Rights Association, and the subjects which come before us properly are the subjects which concern woman in all her social, civil, and domestic life. But the one question which is of vital moment and of sole prominence is that of suffrage. All other questions have been virtually decided in favor of woman. She has the entrée to all the fields of labor. She is now the teacher, preacher, artist. She has a place in the scientific world—in the literary world. She is a journalist, a maker of books, a public reader; in fact, there is no position which woman, as woman, is not entitled to hold. But there is one position that woman, as woman, does not occupy, and that is the position of a voter. One field alone she does not possess, and that is the political field; one work she is not permitted, and that is the work of making laws. This question goes down to the bottom—it touches the vital matter of woman's relation to the State.

Frothingham summarized well the reason hundreds of women in the audience were attending the meeting. He continued, "Is there anything in the constitution of the female mind to disqualify her for the exercise of the franchise? As long as there are fifty, thirty, ten, or even one woman who is

capable of exercising this trust or holding this responsibility it demonstrates that sex, as a sex, does not disfranchise, and the whole question is granted." The applause that erupted in the room demonstrated that he was being listened to. "Here our laws are made by irresponsible people—people who demoralize and debauch society; people who make their living in a large measure by upholding the institutions that are inherently, forever, and always corrupt." More applause. He was touching on the often unspoken belief that if women were granted the vote they would in some way make politics less corrupt.

> Laws that are made by the people who own dram shops, who keep gambling-saloons, who minister to the depraved passions and vices of either sex, laws made by the idler, the dissipated, by the demoralized—are they laws? It is true that this government is founded upon caste. Slavery is abolished, but the aristocracy of sex is not. One reason that the suffrage is not conceded to woman is that those who refuse to do so do not appreciate it themselves [again, applause]. As long as the power of suffrage means the power to steal, to tread down the weak, and get the rich offices into their own hands, those who have the key of the coffers will wish to keep it in their own pockets.

The closing applause was the loudest he had received.

Then there was some more mundane business. Committee reports. Anyone believing that Frothingham would touch on what made the room tense, what infused the auditorium with a sense of a coming explosion, was disappointed. But then the committee reports were completed and Stephen S. Foster stood to speak.

Foster was a fiery speaker whose voice and demeanor demanded attention.[4] He had delighted for decades preceding the Civil War in denouncing any church or clergyman who was not sufficiently opposed to slavery. The 13th Amendment banning slavery and his marriage to Abbey Kelley made him as determined to fight for women's rights. He fought for temperance and against debtors' prison, and was involved in a dozen causes.

Foster at first spoke vaguely, saying that someone who headed an organization and who had strong disagreements with members of that organization created disharmony and should step down from the leadership position. He said he had once resigned from a position in the Anti-Slavery Society because he disagreed with others in the organization. That had to do with nominations for other leadership positions, and the same, he added, was happening now. Accordingly—and by now everyone in the hall was listening to him—the presiding officer of this meeting should resign for the same reason because she held positions that differed from many in the organization.

The presiding officer, Elizabeth Cady Stanton, with a mixture of forced calmness and irritation, said, "I would like you to say in what respect."

"I will with pleasure," Foster replied, "for, ladies and gentlemen, I admire our talented president with all my heart, and love the woman." He paused to allow laughter from the audience to subside. "But I believe she has publicly repudiated the principles of the society."

"I would like Mr. Foster to state in what way." Stanton was clearly having difficulty hiding her impatience. Foster was prepared.

> What are these principles? The equality of men—universal suffrage. These ladies stand at the head of a paper which has adopted as its motto Educated Suffrage. I put myself on this platform as an enemy of educated suffrage, as an enemy of white suffrage, as an enemy of man suffrage, as an enemy of every kind of suffrage except universal suffrage. *The Revolution* lately had an article headed "That Infamous Fifteenth Amendment." It is true it was not written by our president, yet it comes from a person whom she has over and over again publicly indorsed. I am not willing to take George Francis Train on this platform with his ridicule of the Negro and opposition to his enfranchisement.

The Reconstruction Amendments

The 15th Amendment. *The Revolution*. George Francis Train. These caused the tension, and until Foster mentioned all three, it was merely a matter of waiting until someone did. These were three sparks waiting to ignite the flammable distrust so many in the auditorium held for so many others in the same place.

The 15th Amendment to the U.S. constitution was the third of three Reconstruction changes in that document. The North had won the Civil War and the three amendments cemented that victory. They reconstructed the fabric of American, especially Southern, society.

The 13th Amendment banned slavery. It was passed by the U.S. Senate on April 8, 1864, and by the House of Representatives on January 1, 1865, while the Civil War was still being fought. It was ratified on December 6, 1865, when Georgia, led by a Reconstruction government, became the 27th of the then 36 states to approve it. (Three-fourths of all states must ratify an amendment before it becomes part of the Constitution.)

The 14th Amendment had four purposes. Its first section says citizens of the United States have "privileges" and "immunities" that states cannot take away from them. That wording and exactly what it means would be much debated in the decade following its ratification and would play a major role in

the life of Susan B. Anthony and in the struggle to win the vote for women. The same section also refers to "due process of law" and "equal protection of the laws," and those two phrases would lead to more litigation than any other parts of the Constitution in the century and a half following its adoption. Extraordinarily important 20th Century cases, like *Brown v. Topeka Board of Education, Roe v. Wade,* and *Bush v. Gore* revolved around how the high court interpreted those phrases. The purpose of the first section, when viewed in its historical context, was to overturn the 1857 Supreme Court ruling in the infamous Dred Scott case, in which the court ruled that persons of African descent could not be citizens.

Section Two says that if any state denies a group of citizens the right to vote, its representation in the House of Representatives will be reduced. This was designed to prevent Southern states from excluding blacks, former slaves, from voting. Importantly, the section refers to "male inhabitants of such State," the first time the word "male" appears in the Constitution.

Section Three says that any person who rebelled against the United States and who held a political office in the Confederacy could not hold any elective or high appointed office unless Congress specifically said he could. The intent clearly was to forbid people who were seen as responsible for the Civil War from playing any role in the reunited country.

Section Four said the United States could not assume any debts incurred by any Confederate state.

The debate over the 14th Amendment was protracted and bitter, and the proposed amendment underwent dozens of revisions and rewordings before Congress ratified it on June 16, 1866. On July 9, 1868, the amendment was ratified by the Reconstruction government of South Carolina, bringing to 28, or three-fourths of the 37 states, the number that had approved it.

Much of the debate over the amendment, and much of the bitterness, concerned whether it should include a clause guaranteeing the right of former slaves to vote. As passed, it did not, and the debate on suffrage for former slaves did not abate. The debate continued, and in fact wrenched the women's rights movement into the boiling cauldron.

The 15th Amendment

And that cauldron was called the 15th Amendment.

Once a compromise was reached in the Congress about the wording of the 15th Amendment, it moved quickly through both houses and was sent to the states for ratification. The wording is simple: "The right of citizens of the

United States to vote shall not be denied or abridged by the United States or by any State on account of race, color, or previous condition of servitude."

There is no mention of a poll tax or other measures that might be used to circumvent the intent of the law. And there was an understanding that the growing population of Chinese in the far West would not be included, the argument being that Chinese is not a race. The idea was that former slaves would be allowed to vote and that would help the Republicans in Congress, since whites in the South were expected to vote overwhelmingly Democratic. Lincoln and Grant, after all, were Republicans. The House passed the amendment on February 25, 1869, and the Senate did the same the next day.[5]

Leaders of the women's suffrage movement became enraged. Why couldn't the amendment also contain the word "sex," they wanted to know. Weren't women as much citizens as blacks? And Susan B. Anthony, always an ardent abolitionist, always a supporter of equal rights for blacks, noted that once the amendment passed the most ignorant, most ill-educated black man would be able to vote and the most educated, most informed woman would not. That knowledge led her at times to call for the educated suffrage that Foster denounced, an argument that the right to vote should be based on the level of one's education. Anthony and Stanton and many other leaders of the women's suffragist movement were incensed.

But not all of them. As the Steinway Hall meeting would show, some women were quite willing to give blacks the vote now and give it to women later. A common argument was that the reality of national politics would not permit two major changes to the country at the same time. The vote for blacks *or* women was politically possible, but not for blacks *and* women.

Nevada ratified the 15th Amendment on March 1, 1869, the first of the 28 states needed to reach the three-quarters mark. That was only two and a half months before the American Equal Rights Association held its third annual meeting in New York, and Anthony, Stanton, and others still hoped that the amendment could be defeated and replaced with one that included sex, or, as an alternative, that a 16th amendment granting women the vote could be passed either concurrently or immediately after the 15th. But the politics of the time dictated otherwise. Republicans controlled both houses of Congress, and the president, Ulysses S. Grant, was a Republican. They understood that without blacks voting in the South, Democrats would win most elections there. Congress would pass laws in April and December of 1869 requiring that Georgia, Mississippi, Texas, and Virginia ratify the amendment before they could be fully restored to the Union, and all four states complied. In February 1870, Georgia, Iowa, Nebraska, and Texas all ratified the amend-

ment, bringing the total to 29, one more than needed. That extra state may or may not have been necessary because New York, which ratified the amendment on April 14, 1869, rescinded its ratification nine months later, on January 5, 1870, largely because of the influence of Governor John Hoffman, a Democrat. The question of whether a state can rescind ratification of an amendment has still not been definitively answered, since no such case has caused an amendment to fail.

George Francis Train

Anthony, Stanton, and other women suffragist leaders were in the uncomfortable position of believing that if they supported the 15th Amendment guaranteeing blacks the vote, they would delay winning the vote for women by decades. Their situation was made more uncomfortable and more difficult by the finances of a newspaper they had established to fight for their cause, *The Revolution*. The paper never made money and would have folded early if not for George Francis Train.

Train was a rich man who generously supported women's rights, especially the right of women to vote, with his pocketbook. He was, unfortunately, also a racist.[6]

Train had made a fortune in transportation, organizing a horse-drawn tramway company in England, helping to organize the Union Pacific Railroad in the United States, and establishing a line of clipper ships to sail around the southern tip of South America, carrying passengers and freight between the two coasts of the United States. He was an avid world traveler who went around the Earth three times. Some people believe he was the model for Phileas Fogg, the protagonist in Jules Verne's *Around the World in Eighty Days*. He ran for president of the United States in 1872 as an independent candidate, claimed to have once been offered and rejected the presidency of Australia (an office that never existed), spent much of the American Civil War in England, thus avoiding service in the Union army, and making speeches denouncing the Confederacy, and spent the last years of his life sitting in a park in New York City handing out dimes to children and refusing to speak to anyone except animals and children. Along the way, in his late 30s and early 40s, he became an ardent supporter of women's rights.[7]

In 1867 Anthony and Stanton went to Kansas to campaign for passage of two pieces of legislation that would have allowed both women and blacks to vote. The Republican Party failed to support the measure designed to give the vote to women, and both Anthony and Stanton felt embittered. They

believed that since they had staunchly supported abolition, a cause at the heart of the formation of the Republican Party, they should have their cause supported in return. The St. Louis Suffragist Association sent a rich Democrat to campaign for both measures, much to the chagrin of Republicans in Kansas. But Anthony and Stanton were willing to accept help from wherever they could get it. That Democrat was George Francis Train. He was an entertaining and effective speaker, rich enough to pay all of his own travel expenses. When the two campaigns lost, Train still offered to help. He would, he said, fund a newspaper to promote the cause of women's rights. Anthony and Stanton were ecstatic. The paper would be called *The Revolution.* Its motto would be "Men, their rights, and nothing more; women, their rights, and nothing less." Anthony would be the publisher and Stanton an editor along with Parker Pillsbury, a longtime leader in both the abolitionist and women's rights movements. The first issue appeared on January 1, 1868, paid for by $600 given to them by Train.

Train recruited David M. Mellis, the financial editor for the *New York World,* to help. *The Revolution* would be a weekly, and Train and Mellis said they would fund it until it was successful enough to no longer need subsidization. As part of the deal, Train and Mellis would be given space in the back pages of the 16-page publication to write about politics and finances. Stanton wrote editorials urging women to be become more self-reliant, calling for more liberal divorce laws, and in general espousing women's causes. The news columns often reported sympathetically on women accused of crimes, especially if it involved a woman defending herself against an abusive husband.

But what Train said in his speeches and wrote in books and in *The Revolution* caused problems. "Woman first, and Negro last in my programme," he wrote at one point. In one speech in Kansas he recited a little poem he had written:

> Let your corrupt politicians dance their double clogged jig,
> As a bid for the suffrage of the poor Kansas Nig,
> For our women will vote while the base plot thickens,
> Before barbers, bootblacks, melons and chickens.

Barbers and bootblacks were occupations often stereotypically associated with blacks, and melons and chickens were often similarly associated with the diets of blacks. In another poem he wrote,

> Woman votes the black to save,
> The black he votes to make the woman slave,
> Hence, when blacks and "Rads" write to enslave the whites,
> 'Tis time the Democrats championed woman's rights.

He once said, "Keep your nose twenty years on a Negro and you will have hard work to smell a white man again." He also said Susan B. Anthony "commenced the campaign four-fifth negro and one-fifth woman; now she is four-fifths woman and one-fifth negro."[8]

His racism was open and openly offensive, but neither Anthony nor Stanton would denounce it. They wanted his help, wanted his money, and remained embittered towards the leaders of the abolitionist movement, a movement they had once worked hard for, because those leaders refused to support the fight for women's suffrage.

A Call for Resignations

Foster's barbed jibes wounded Anthony. She could tolerate him no longer. Her tolerance level was often low, but few had annoyed her as much as Foster in this hall. "That is false," Anthony called, interrupting Foster mid-speech.

Foster shot back, "I would be glad to believe Miss Anthony, but her statement is not reliable."

The shock of the sudden and sharp implication that she was a liar stunned Anthony uncharacteristically into a moment of silence, and before she could reply, Stanton came to her rescue. "When any man comes to this platform and says that a woman does not speak the truth," she said in her harshest tone, "he is out of order."[9]

Then Mary Livermore stood to ask a question. Like many women in the room she had devoted herself to the abolitionist movement until slavery was abolished and then shifted her energies to the women's rights movement. She was one of the best known female journalists in America. She pointedly asked, "Is it quite generous to bring George Francis Train on this platform when he has retired from *The Revolution* entirely?"[10] By the time of the Steinway Hall convention, Train was no longer providing financial assistance to or writing for *The Revolution.*

This was a view Foster had heard before and he was ready with his retort. "If *The Revolution,* which has so often indorsed George Francis Train, will repudiate him because of his course in respect to the Negro's rights, I have nothing further to say. But it does not repudiate him. He goes out; it does not cast him out." Foster's argument that it was not enough for Train to have disassociated himself from *The Revolution,* that Stanton and Anthony must also openly condemn him, must have struck many of those in the hall as unreasonably protracted, an attempt to make his criticism of the two best known leaders of the women's suffragist movement unending.

Anthony, as was so common with her, found it impossible to remain silent. She near-shouted, "Of course it does not."

Foster, despite less than a minute earlier promising he had nothing further to say, continued, building momentum, to reach his point, a common tactic in his delivery.

> My friend says yes to what I have said. I thought it was so. I only wanted to tell you why the Massachusetts society cannot coalesce with the party here, and why we want these women to retire and leave us to nominate officers who can receive the respect of both parties. The Massachusetts abolitionists cannot co-operate with this society as it is now organized. If you choose to put officers here that ridicule the Negro, and pronounce the Amendment infamous, why I must retire; I cannot work with you. You cannot have my support, and you must not use my name. I cannot shoulder the responsibility of electing officers who publicly repudiate the principles of the society.

Then Henry Blackwell rose to speak. The England-born Blackwell had long been an advocate of women's rights, especially arguing for reform of marriage laws.[11] Blackwell said:

> In regard to the criticisms on our officers, I will agree that many unwise things have been written in *The Revolution* by a gentleman who furnished part of the means by which that paper has been carried on. But that gentleman has withdrawn, and you, who know the real opinions of Miss Anthony and Mrs. Stanton on the question of Negro suffrage, do not believe that they mean to create antagonism between the Negro and the woman question. If they did disbelieve in Negro suffrage, it would be no reason for excluding them. We should no more exclude a person from our platform for disbelieving Negro suffrage than a person should be excluded from the anti-slavery platform for disbelieving woman suffrage. But I know that Miss Anthony and Mrs. Stanton believe in the right of the Negro to vote. We are united on that point. There is no question of principle between us.

The tension was momentarily eased when a vote was taken to accept a report from the committee on organization. It passed easily on a voice vote.

Frederick Douglass Speaks

Then Frederick Douglass rose to speak. The most famous black man in America. A man who once insisted that women as well as black men were entitled to rights their country had denied them. But, everyone in the auditorium knew, his views had been modified by what he saw as the urgency of passing the 15th Amendment.[12] Douglass, in his deep voice that easily filled the auditorium, said,

> I came here more as a listener than to speak, and I have listened with a great deal of pleasure to the eloquent address of the Rev. Mr. Frothingham and the splen-

did address of the president. There is no name greater than that of Elizabeth Cady Stanton in the matter of woman's rights and equal rights, but my sentiments are tinged a little against *The Revolution.* There was in the address to which I allude the employment of certain names, such as "Sambo," and the gardener, and the bootblack, and the daughters of Jefferson and Washington, and all the rest that I cannot coincide with. I have asked what difference there is between the daughters of Jefferson and Washington and other daughters.

Some members of the audience laughed at this remark.[13] Douglass continued,

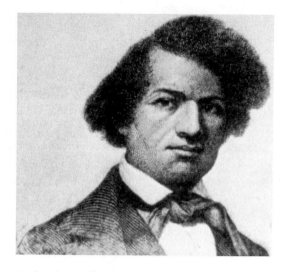

Frederick Douglass. Susan B. Anthony and Douglass, both long-time residents of Rochester, New York, were friends for decades, but the debate over women's rights versus black rights created bitterness between them. Their friendship continued, but after 1869 it was strained. This photograph appeared in the first edition of *Narrative of the Life of Frederick Douglass, An American Slave, Written by Himself.*

I must say that I do not see how anyone can pretend that there is the same urgency in giving the ballot to woman as to the Negro. With us, the matter is a question of life and death, at least, in fifteen States of the Union.[14] When women, because they are women, are hunted down through the cities of New York and New Orleans, when they are dragged from their houses and hung upon lampposts, when their children are torn from their arms and their brains dashed out upon the pavement, when they are objects of insult and outrage at every turn, when they are in danger of having their homes burnt down over their heads, when their children are not allowed to enter schools, then they will have an urgency to obtain the ballot equal to our own.

At this point many people, but not everyone, in the audience broke into applause. Those who applauded favored the 15th Amendment. Those who did not, did not applaud. Most men applauded; most women did not.

Then a voice from the audience. In the ambient noise of the auditorium it couldn't be identified as either male or female. "Is that not all true about black women?"

Douglass had often heard the argument implied by the question and was so prepared with a reply that the question might have been planted. "Yes, yes, yes," he said, "it is true of the black woman, but not because she is a woman,

but because she is black." He paused to allow the small explosion of applause to subside. Then he invoked the name of one of the leaders of the women's rights movement. "Julia Ward Howe at the conclusion of her great speech delivered at the convention in Boston last year, said, 'I am willing that the Negro shall get the ballot before me.'" Again, applause. Then he continued, "Woman! Why, she has ten thousand modes of grappling with her difficulties. I believe that all the virtue of the world can take care of all the evil. I believe that all the intelligence can take care of all the ignorance." Once more there was applause. Douglass had learned long ago how to deliver an applause-inducing line. "I am in favor of woman's suffrage in order that we shall have all the virtue and vice confronted. Let me tell you that when there were few houses in which the black man could have put his head, this woolly head of mine found a refuge in the house of Mrs. Elizabeth Cady Stanton, and if I had been blacker than sixteen midnights, without a single star, it would have been the same."

Once again applause. Once again it came from those in support of the 15th Amendment.

Anthony's Response

Anthony, whose immense energy, her greatest strength, forbade her to practice patience, was no longer willing to remain silent. She made no effort to hide her lack of patience and little to hide her anger. "The old anti-slavery school," she said, "says women must stand back and wait until the Negroes shall be recognized. But we say, if you will not give the whole loaf of suffrage to the entire people, give it to the most intelligent first." She had to pause because of the applause from those opposed to the 15th Amendment's omission of women. When it began to subside, she continued, "If intelligence, justice, and morality are to have precedence in the government, let the question of woman be brought up first and that of the Negro last." Again there was applause. Anthony must have known that some of those who did not applaud heard racism in her remark, a belief that black men were not as intelligent as white women. Yet, she went on. "While I was canvassing the state with petitions and had them filled with names for our cause to the legislature, a man dared to say to me that the freedom of women was all a theory and not a practical thing." The scorn in her voice attracted the applause that followed. "When Mr. Douglass mentioned the black man first and the woman last, if he had noticed he would have seen that it was the men that clapped and not the women. There is not the woman born who desires to eat the bread of depend-

ence, no matter whether it be from the hand of father, husband, or brother; for anyone who does so eat her bread places herself in the power of the person from whom she takes it." Again there was applause, mostly from women. "Mr. Douglass talks about the wrongs of the Negro, but with all the outrages that he today suffers, he would not exchange his sex and take the place of Elizabeth Cady Stanton." This time there was laughter of agreement mixed with the applause.

The laughter each speaker attracted increased the willingness of each to move closer to sarcasm.

Douglass asked, "Will you allow me a question?"

Anthony replied, good naturedly, "Yes, anything for a fight today."[15]

Douglass said, "I want to know if granting you the right of suffrage will change the nature of our sexes?" The auditorium quickly filled with laughter. Douglass had made a scorching point. He had long argued that assuring that blacks could vote would change their lives more than giving women the vote would change theirs.

Anthony had heard the argument before and rejected it before. And now. "It will change the pecuniary position of woman," she said. "It will place her where she can earn her own bread." The applause was as loud as the laughter that had approved of Douglass's remark. But from different members of the audience. As it subsided, Anthony added, "She will not then be driven to such employments only as man chooses for her."

Voices of Other Women

Then Sarah Norton rose to speak. A close friend of Anthony's, the two campaigned to have Cornell University and other institutions admit women. Their most successful effort was in getting Ezra Cornell, founder of the university that carries his name, to agree with them, and the year following the Steinway Hall meeting, Cornell University's trustees, because of the founder's influence, became one of the first colleges or universities in the country to admit women. Norton knew her pending success in that effort was known among this crowd when she offered a view intended to soften the harshness that had permeated the hall. Norton said, "Mr. Douglass's remarks leave me to defend the Government from the inferred inability to grapple with the two questions at once. It legislates upon many questions at one and the same time, and it has the power to decide the woman question and the Negro question at one and the same time."[16] Applause mostly from women greeted her remarks.

Then Lucy Stone spoke. Fifty years old, for a quarter of a century Stone

had been one of the most influential leaders of the women's rights movement. When she spoke, the hall quieted.

> Mrs. Stanton will, of course, advocate the precedence for her sex, and Mr. Douglass will strive for the first position for his, and both are perhaps right. If it be true that the government derives its authority from the consent of the governed, we are safe in trusting that principle to the uttermost. If one has a right to say that you cannot read and therefore cannot vote, then it may be said that you are a woman and therefore cannot vote. We are lost if we turn away from the middle principle and argue for one class. I was once a teacher among fugitive slaves. There was one old man, and every tooth was gone, his hair was white, and his face was full of wrinkles, yet, day after day and hour after hour, he came up to the schoolhouse and tried with patience to learn to read, and by and by, when he had spelled out the first few verses of the first chapter of the Gospel of St. John, he said to me, "Now, I want to learn to write." I tried to make him satisfied with what he had acquired, but the old man said, "Mrs. Stone, somewhere in the wide world I have a son. I have not heard from him in twenty years. If I should hear from him, I want to write to him, so take hold of my hand and teach me." I did, but before he had proceeded in many lessons, the angels came and gathered him up and bore him to his Father. Let no man speak of an educated suffrage. The gentleman who addressed you claimed that the Negroes had the first right to the suffrage, and drew a picture which only his great word power can do. He again in Massachusetts, when it had cast a majority in favor of Grant and Negro suffrage, stood upon the platform and said that woman had better wait for the Negro; that is, that both could not be carried, and that the Negro had better be the one. But I freely forgave him because he felt as he spoke. But woman suffrage is more imperative than his own, and I want to remind the audience that when he says what the Ku Kluxes did all over the South, the Ku Kluxes here in the North in the shape of men take away the children from the mother, and separate them as completely as if done on the block of the auctioneer. Over in New Jersey they have a law which says that *any* father—he might be the most brutal man that ever existed—*any* father, it says, whether he be under age or not, may by his last will and testament dispose of the custody of his child, born or to be born, and that such disposition shall be good against all persons, and that the mother may not recover her child, and that law modified in form exists over every State in the Union except in Kansas. Woman has an ocean of wrongs too deep for any plummet, and the Negro, too, has an ocean of wrongs that cannot be fathomed. There are two great oceans. In the one is the black man, and in the other is the woman. But I thank God for that Fifteenth Amendment, and hope that it will be adopted in every State. I will be thankful in my soul if *any*body can get out of the terrible pit. But I believe that the safety of the government would be more promoted by the admission of woman as an element of restoration and harmony than the Negro. I believe that the influence of woman will save the country before every other power.

Again the hall erupted in applause, and again it came mostly from women. Stone continued, "I see the signs of the times pointing to this consummation, and I

believe that in some parts of the country women will vote for the President of these United States in eighteen seventy-two." Again there was great applause.

Anthony's Reconsideration

By now much of the tension of the meeting had subsided, but the damage had been done. Susan B. Anthony and Frederick Douglass had clashed. Openly and with bitterness. More bitterness on the part of Anthony than Douglass, for she felt betrayed. A man she once considered an ally had openly condemned her position, and she began to reconsider her hopes and plans for the future. It now seemed certain to her that the 15th Amendment would pass, that black men would have their vote protected by the Constitution, and that women, once again, would have to wait.

The afternoon session ended and when the evening session opened, the meeting was again dominated by the mundane. Henry Blackwell offered some resolutions and his sister-in-law Antoinette Brown Blackwell, the first woman in America to be ordained as a minster, spoke. Than Olive Logan spoke. Logan was an actress and sometime writer. Mostly she was, with the aid of her husband, a self-promoter, a talent that earned the scorn of Mark Twain.[17] Logan said that as an actress she made as much money as an actor and as a woman writer she was paid as much as a man writer, because, she made clear, she was as good as they were.

Then Phoebe Couzins spoke; she was a law student and later would become the first women to graduate from a law school. She attacked the proposed 15th Amendment, saying, "I feel deeply the humiliation and insult that is offered to the women of the United States in this amendment."

Anthony listened to the Blackwells and Olive Logan with disinterest and to Couzins with approval. But, as always, she was looking for an opportunity to speak. So when the next speaker, Gilbert Haven, a Methodist Episcopal minister who often insisted in his sermons that since everyone was equal in the eyes of God, they should be equal in the eyes of all humanity, she found an opening. He started his talk by saying, "Ladies and Gentlemen, as I believe that is the way to address you, or shall I merge you into one and call you fellow citizens...." Anthony interrupted. "Let me tell you how to say it," she said. "It is perfectly right for a gentleman to say "ladies and gentlemen," but a lady should say, 'gentlemen and ladies.'" She paused for the applause that followed. "You mention your friend's name before you do your own." Again there was applause. "I always feel like rebuking any woman who says, 'ladies and gentlemen.' It is a lack of good manners." This time laughter mixed with the applause.

It did not occur to Anthony that her little lecture on good manners was itself rude.

Haven politely accepted the scolding and then gave a short speech that included the argument that it is not merely that women are entitled to the vote but that society has an obligation to give them the vote. His point would no doubt have been more closely listened to if Anthony had not distracted the audience with her ill-timed lesson on manners.

Distractions

Henry Blackwell then presented a resolution: "*Resolved,* that in seeking to remove the legal disabilities which now oppress woman as wife and mother, the friends of woman suffrage are not seeking to undermine or destroy the sanctity of the marriage relation, but to ennoble marriage, making the obligations and responsibilities of the contract mutual and equal for husband and wife."

The resolution addressed a minor point being considered at the convention, the insincere and distracting argument that if women voted they would for some reason not be as good at being mothers and wives. It was an argument often mentioned but seldom taken seriously in any state or national legislature.

Mary Livermore, who earlier had chastised Stephen S. Foster for his unkind remarks about the leadership of the convention, now offered a revised resolution that she hoped would replace Blackwell's: "*Resolved,* that while we recognize the disabilities which the legal marriage imposes upon woman as wife and mother, and while we pledge ourselves to seek their removal by putting her on equal terms with man, we abhorrently repudiate Free Loveism as horrible and mischievous to society and disown any sympathy with it."

This too dealt with a distracting argument, that those who favored woman suffrage probably also favored free love, the right of a woman to have sex with whichever man and as many men as she wanted to.

Both resolutions annoyed Anthony. More and more she was coming to believe that whatever rights women were entitled to, they could be gained only if women had the political power that the vote would give them. If they could vote out of office any man who did not support their rights, the men would change their views.

The Rev. Phebe Hannaford, who had opened the convention with a prayer, and who was the first woman ordained minister in New England, rose to denounce the assumed connection between supporting woman suffrage and free love. "Let me carry back to my New England home," she said, "the

word that you as well as your honored president, whom we love, whose labor we appreciate, and whose name has also been dragged into this inference, scout all such suggestions as contrary to the law of God and humanity."

Lucy Stone rose to agree with Hannaford. "I feel it is a mortal shame," she said, "to give any foundation for the implication that we favor Free Loveism. I am ashamed that the question should be asked here. There should be nothing said about it at all. Do not let us, for the sake of our own self-respect, allow it to be hinted that we helped forge a shadow of a chain which comes in the name of Free Love. I am unwilling that it should be suggested that this great, sacred cause of ours means anything but what we have said it does." It was a comment that Anthony might have made had not Stone made it first. Stone continued, "Today we are fined, imprisoned, and hanged, without a jury trial by our peers. You shall not cheat us by getting us off to talk about something else. When we get the suffrage, then you may taunt us with anything you please, and we will then talk about it as long as you please."

Next Ernestine Rose stood to speak. She was perhaps most famous for being an atheist.[18] One of the lesser known but more influential leaders of the women's rights movement, her atheism made her controversial and, thus, a distraction. Anthony wanted the discussion to stay on the right, on the need as she saw it, for women to gain the vote. The convention was spending too much time on distractions, even if she agreed with some of the views expressed. Rose said, "I object to Mrs. Livermore's resolution, not on account of its principles, but on account of its pleading guilty. When a man comes to me and tries to convince me that he is not a thief, then I take care of my coppers." As Rose spoke, Anthony wondered if the meeting would ever return to what she saw as its main, its only, purpose.

Now Anthony, once again unable to restrain herself, spoke. "This howl," she said, "comes from those men who knew that when women got their rights they would be able to live honestly: no longer be compelled to sell themselves for bread, either in or out of marriage."[19]

Other speakers tried to deflect the conversation away from its distractions. Dr. L.S. Batchelder said she "represented ten thousand working women of New England, and they have instructed me as their representative to introduce a resolution looking to the amelioration of the condition of the working women."[20] While not directly about suffrage, her issue was not divisive and Anthony found no fault with it.

Then U.S. Senator Henry Wilson of Massachusetts rose to speak in favor of women's suffrage, returning the dialogue to the path Anthony wanted it to travel along.[21] "I do not know," he said, "that all the good in the world will be

accomplished when the women of the United States have the right to vote. But it is sure to come. Truth is truth, and will stand."

Ernestine Rose, like Susan B. Anthony, couldn't let much time pass without exercising her desire to speak, even if the point she wanted to make had little to do with the current discussion. She said the Rev. Gilbert Haven had said "the seeds of the Woman's Rights reform were sown in Massachusetts, but thirty-two years ago I went round in New York City with petitions to the Legislature to obtain for married women the right to hold property in their own names. I only got five names the first year, but I and others persevered for eleven years, and finally succeeded. Who was the first to call a National Convention of women—New York or Massachusetts?"[22] The rhetorical question drew great applause from New Yorkers in the audience. "I like to have justice done and honor given where it is due."

The rambling quality of the meeting continued as Sarah Norton said the convention should discuss "the relations between capital and labor," and Eleanor Kirk, a member of the New York Working Women's Association, rose to discuss just that.

Then a woman in the audience, Mary F. Davis, rose to say she was willing to wait to get the vote and to let the Negro have it first. "Every step in the great cause of human rights helps the next one forward," and, she added, "in eighteen forty-six Mrs. Stanton called the first convention at Seneca Falls," referring to the first women's rights convention.

Susan B. Anthony, annoyed by a woman saying it was all right for the Negro to get the vote first, interrupted. "And Lucretia Mott," she said.

Davis, not fully understanding she was being scolded for saying the vote for women could be delayed, said, "Yes, and Lucretia Mott; and I love to speak of them in association. Mrs. Rose has alluded to the primary steps she took, and there were Susan B. Anthony, Lucy Stone, Antoinette Brown Blackwell, and Paulina Wright Davis, and a great galaxy who paved the way; and we stand here to proclaim the immortal principle of woman's freedom." The tribute drew enthusiastic applause.

Then Paulina W. Davis, one of the earliest leaders of the 19th Century American women's rights movement, said blacks should not get the vote before women, because if that happened

woman would have a race of tyrants raised above her in the South, and the black women of that country would also receive worse treatment than if the Amendment was not passed. Take any class that have been slaves, and you will find that they are the worst when free, and become the hardest masters. The colored

women of the South say they do not want to get married to the Negro, as their husbands can take their children away from them, and also appropriate their earnings. The black women are more intelligent than the men, because they have learned something from their mistresses.[23]

Now Frederick Douglass, like Susan B. Anthony earlier, felt compelled to speak. Neither could remain silent very long in a public debate. He said "all disinterested spectators would concede that this equal rights meeting has been preeminently a woman's rights meeting."[24] He waited for the applause to lessen, then continued. "You have just heard an argument with which I cannot agree, that the suffrage to the black men should be postponed to that of the women. I do not believe the story that the slaves who are enfranchised become the worst of tyrants."

Someone in the audience shouted, "Neither do I," and was greeted with a scattering of approving applause. "I know how this theory came about," Douglass continued. "When a slave was made a driver, he made himself more officious than the white driver so that his master might not suspect that he was favoring those under him. But we do not intend to have any master over us." Again there was applause.

But that applause was matched by the applause following Stanton's interruption of Douglass. "Not another man should be enfranchised," she said, "until enough women are admitted to the polls to outweigh those already there. I do not believe in allowing ignorant Negroes and foreigners to make laws for me to obey."[25]

Then Frances Harper stood, and she attracted attention. She was a black woman, 44 years old, born to free parents, and a widely respected poet. What side would a black woman take in the debate on the 15th Amendment? Somewhat surprisingly, with remarks that did not at first reveal her position: "When it is a question of race," she said, "I let the lesser question of sex go. But the white women all go for sex, letting race occupy a minor position. I like the idea of working women, but I would like to know if it is broad enough to take colored women."[26]

Anthony said, "Yes, yes," and several other women echoed her remark.

Harper continued, "When I was at Boston there were sixty women who left work because one colored woman went to gain a livelihood in their midst." There was some applause at that remark, but it seemed strange, as if some in the audience were agreeing with white women refusing to work with a black woman. Probably they misunderstood what Harper said. "If the nation can only handle one question, I would not have the black women put a single straw in the way, if only the men of the race could obtain what they wanted." The

men in the audience and some of the women applauded loud and long. Harper had revealed her position; being black was more important to her than being a woman.

C.C. Burleigh tried to speak, but some members of the audience objected. He was an abolitionist without much connection to the women's rights movement. He did not complete his remarks, and few in the audience could hear what he said.

Anthony again spoke, saying she was against the 15th Amendment "because it is not equal rights. It puts two million more men in position of tyrants over two million women who have until now been the equals of the men at their side."

Anthony spoke up as if Burleigh had not attempted to speak, which did not deter him from trying a second time, and again too many members of the audience objected for him to be heard clearly.

Lucy Stone, kinder than Susan B. Anthony, appealed to the crowd to let him speak. She succeeded in getting enough silence so Burleigh tried once more to speak, but again noise and disruption ruled. Anthony, not to be outdone by Stone, now also appealed to the audience to let him be heard. Again he tried, but again his remarks were drowned out.

Mrs. Livermore scolded the audience in general for the bad behavior of the few. Then she praised the views expressed by Frederick Douglass. Next Henry Blackwell made a motion. He called for the "previous question." There wasn't at that point much certainty what the previous question was. The convention had jumped from topic to topic and too many members of the audience were disruptive.

Susan B. Anthony was livid with Blackwell. "I hope his, the first attempt at gagging discussion, will not be countenanced," she said.[27] Loud and long applause filled the auditorium. It came from those who agreed with Anthony that there should be no new amendment to the Constitution that did not grant the vote to women.

Anthony paused and then protested that Burleigh had been poorly treated. That brought some quiet to the audience. Enough quiet for Burleigh to kindly say he had completed saying what he had to say. No one in the audience, however, seemed to know what he had said.

Someone made a motion to adjourn and to delay any further action to the evening session. Someone else reminded the audience that the evening session would be held at Cooper Institute, not at Steinway Hall.

And the first session of the third annual meeting of the American Equal Rights Association came to an end, for a while. Its major accomplishment was

to leave a feeling of distrust and even dislike between two giants of their time, Frederick Douglass and Susan B. Anthony.

Evening Session

The evening session was far less tense, but at moments there was open disagreement. Ernestine Rose said, "I suggest that the name of this society be changed from Equal Rights Association to Woman's Suffrage Association."

Lucy Stone objected: "I must oppose this till the colored man gained the right to vote. If we changed the name of the association for such a reason as it was evident it was proposed, they would lose the confidence of the public. I hope you will not do it."[28]

A man in the audience called out, "I hope you will do it. I move that the name of the association be changed to the Universal Franchise Association."

Stanton, hoping to deflect a renewal of tension, sought to end the discussion. "The question is already settled by our constitution," she said, "which requires a month's notice previous to the annual meeting before any change of name can be made." And in case that didn't end divisive talk, she added, "We will now have a song."[29] The last remark brought enough laughter so the convention could go on to other matters. But that did not mean harmony.

Blackwell rose to say the loyalty oath required of former Confederate soldiers should be abolished, adding, "I am willing that the Negro should have the suffrage, but not under such conditions that he should rule the South." That brought loud and long hisses from the audience.

Stanton, annoyed that she could not keep order, said, "Gentlemen and ladies, I take this as quite an insult to me. It is as if you were invited to dine with me and you turned up your nose at everything that was set on the table."

Mary Livermore rose to address the men in the audience. She said, "It certainly requires a great amount of nerve to talk before you, for you have a frankness in expressing yourselves that I am afraid of you." Many in the audience laughed and applauded. "If you do not like the dish, you turn up your nose at it and say, 'Take it away, take it away.'" More laughter. "I was brought up in the West, and it is a good place to get rid of any superfluous modesty, but I am afraid of you." More applause. "It seems that you are more willing to be pleased than to hear what we have to say." Again, applause. "Throughout the day the men who have attended our convention have been turbulent." More applause. "I say it frankly that the behavior of the majority of men has not been respectful." Again, more applause.

The Next Day

The next day, Friday, May 14, 1869, some of the delegates to the Equal Rights Convention who had met on Thursday in Steinway Hall and at Cooper Union attended a meeting of about 200 people, mostly women, at the Brooklyn Academy of Music.[30] It began at 10 a.m. This was the inaugural meeting of the Brooklyn chapter of the American Equal Rights Association. Elizabeth Cady Stanton spoke. So did Lucy Stone. And Phebe Hannaford. And Gilbert Haven. And Olive Logan. Henry Ward Beecher was there, and he spoke. And Phoebe Couzins. And Frederick Douglass spoke.[31]

Neither the *History of Woman Suffrage* nor the *New York Daily Tribune* reported Susan B. Anthony making any comments at the meeting. Nor did the *Brooklyn Daily Eagle.* None of the three even reported that she was in the room. Since she almost always spoke up at meetings and since she was one of the best known women in the country, it seems likely she did not attend the Brooklyn meeting. There is nothing to indicate that she was sick or had another engagement. It thus seems likely that she chose not to attend because she was so upset about her exchange the day before with Frederick Douglass.

The previous day's meeting had stirred the wrath of Susan B. Anthony. It changed her.

2

Planning the Crime

Susan B. Anthony would not allow herself to feel embittered by what happened in New York for too long. The wound to her friendship with Frederick Douglass would, she knew, heal. But the damage done to the strategy of revising the proposed 15th Amendment to the Constitution was permanent. She left New York with the realization that leaders of the black rights movement were unwilling to expend their influence with Congress to assure that the proposed amendment protected the right of women as well as recently freed slaves to vote. She would need a new strategy.

A letter received by her newspaper, *The Revolution,* provided it. The letter was written by someone Anthony was only vaguely familiar with, Francis Minor, an attorney in St. Louis. But she was instantly and greatly impressed by it.

The letter, dated October 14, 1869, was essentially a report on a women's rights convention that had just been held in St. Louis.[1]

Dear Revolution:

I wish to say a few words about the action of the Woman's Suffrage Convention just held here. It is everywhere spoken of as a complete success, both in point of numbers and the orderly decorum with which its proceedings were conducted. But I desire to call special attention to the resolutions adopted. When I framed them, I looked beyond the action of this Convention. These resolutions place the cause of equal rights far in advance of any position heretofore taken. Now, for the first time, the views and purposes of our organization assume a fixed purpose and definite end. We no longer beat the air—no longer assume merely the attitude of petitioners. We claim a right, based upon citizenship. These resolutions will stand the test of legal criticism—and I write now to ask, if a case can not be made at your coming election. If this were done, in no other way could our cause be more widely, and at the same time definitely brought before the public. Every newspaper in the land would tell the story, every fireside would hear the news. The question would be thoroughly discussed by thousands, who now give it no thought—and by the time it reached the court of final resort, the popular verdict would be in accord with the judgment that is sure to be rendered. If these resolutions are right, let the

question be settled by individual determination. A case could not be made here for a year to come, but you could make one in New York at the coming election.

Francis Minor,
Respectfully.

The St. Louis Resolutions

Minor included copies of what he called "the St. Louis Resolutions" in his letter. The first one said,

Whereas, In the adjustment of the question of suffrage now before the people of this country for settlement, it is of the highest importance that the organic law of the land should be so framed and construed as to work injustice to none, but secure as far as possible perfect political equality among all classes of citizens; and

> Whereas, All persons born or naturalized in the United States, and subject to the jurisdiction thereof, are citizens of the United States, and of the State wherein they reside; be it
> *Resolved,* 1. That the immunities and privileges of American citizenship, however defined, are National in character and paramount to all State authority.
> 2. That while the Constitution of the United States leaves the qualification of electors to the several States, it nowhere gives them the right to deprive any citizen of the elective franchise which is possessed by any other citizen—to regulate, not including the right to prohibit the franchise.
> 3. That, as the Constitution of the United States expressly declares that no State shall make or enforce any laws that shall abridge the privileges or immunities of citizens of the United States, those provisions of the several State Constitutions that exclude women from the franchise on account of sex, are violative alike of the spirit and letter of the Federal Constitution.
> 4. That, as the subject of naturalization is expressly withheld from the States, and as the States clearly would have no right to deprive of the franchise naturalized citizens, among whom women are expressly included, still more clearly have they no right to deprive native-born women citizens of this right.
> 5. That justice and equity can only be attained by having the same laws for men and women alike.
> 6. That having full faith and confidence in the truth and justice of these principles, we will never cease to urge the claims of women to a participation in the affairs of government equal with men.

Minor then went on to cite a dozen sections of the Constitution that he said supported the intent of the resolutions, including the Preamble, the privileges and immunities clause in Article IV, and, most importantly, the 14th Amendment.

His point, while overly drawn out, was fairly simple. The Constitution

already gave women the right to vote and states couldn't take that away from them.

Virginia Minor's Speech

He then quoted extensively from a speech given at the same St. Louis convention by his wife, Virginia, who was president of the Missouri State Association of the National Woman Suffrage Association. In her opening address to the convention, Virginia Minor said,

> I believe that the Constitution of the United States gives me every right and privilege to which every other citizen is entitled; for while the Constitution gives the States the right to regulate suffrage, it nowhere gives them power to prevent it. The power to regulate is one thing, the power to prevent is an entirely different thing. Thus the State can say where, when, and what citizens may exercise the right of suffrage. If she can say that a woman, who is a citizen of the United States, shall not vote, then she can equally say that a Chinaman, who is not a citizen, shall vote and represent her in Congress. The foreign naturalized citizen claims his right to vote from and under the paramount authority of the Federal Government, and the State has no right to prevent him from voting, and thus place him in a lower degree or grade of citizenship than that of free citizens. This being the case, is it presumable that a foreign citizen is intended to be placed higher than one born on our soil? Under our Constitution and laws, woman is a naturalized citizen with her husband. There are men in this town today, to my certain knowledge, who have had this boon of citizenship thrust upon them, who scorned the name, and who freely claimed allegiance to a foreign power. Our government has existed for eighty years, yet this question of citizenship has never been settled.
>
> In 1856 the question came before the then Attorney-General, Mr. Cushing,[2] as to whether Indians were citizens of the United States, and as such, were entitled to the privilege of preempting our public lands. He gave it as his opinion that they were not, but domestic subjects, and therefore not entitled to the benefits of the act.
>
> In 1821 the question came before Attorney-General William Wirt,[3] as to whether free persons of color in the State of Virginia were citizens of the United States, and as such, entitled to command vessels engaged in foreign trade. He gave it as his opinion that they were not, that the Constitution by the term citizen, and by its description of citizen, meant only those who were entitled to all the privileges of free white persons, and negroes were not citizens.
>
> In 1843 the question came before Attorney-General Legree,[4] of South Carolina, as to whether free negroes of that State were citizens, and he gave it as his opinion that as the law of Congress intended only to exclude aliens, therefore that they as denizens could take advantage of the act.
>
> Mr. Marcy,[5] in 1856, decided that negroes were not citizens, but entitled to the protection of the government.
>
> In justice to our sex, I must ask you to bear in mind the fact that all these

wise Secretaries of State and Attorney-Generals, were men that made these singular decisions, not illogical, unreasoning women, totally incapable of understanding politics.

And lastly, in 1862, our late honored and lamented fellow-citizen, Attorney-General Bates,[6] decided that free negroes were citizens. Thus, you see, it took forty-one years to make this simple discovery.

I have cited all these examples to show you that all rights and privileges depend merely on the acknowledgment of our right as citizens, and wherever this question has arisen the government has universally conceded that we are citizens; and as such, I claim that if we are entitled to two or three privileges, we are entitled to all.

This question of woman's right to the ballot has never yet been raised in any quarter. It has yet to be tested whether a free, moral, intelligent woman, highly cultivated, every dollar of whose income and property are taxed equally with that of all men, shall be placed by our laws on a level with the savage.

I am often jeeringly asked, 'If the Constitution gives you this right, why don't you take it?' My reply is both a statement and a question. The State of Massachusetts allows negroes to vote. The Constitution of the United States says the citizens of each State shall be allowed all the privileges of the citizens in the several States. Now, I ask you, can a woman or negro vote in Missouri? You have placed us on the same level. Yet, by such question you hold us responsible for the unstatesmanlike piece of patchwork which you call the Constitution of Missouri!

Women of the State, let us no longer submit to occupy so degraded a position! Disguise it as you may, the disfranchised class is ever a degraded class. Let us lend all our energies to have the stigma removed from us. Failing before the Legislatures, we must then turn to the Supreme Court of our land and ask it to decide what are our rights as citizens, or, at least, not doing that, give us the privilege of the Indian, and exempt us from the burden of taxation to support so unjust a government.

"A New Departure"

There it was. The argument. Slow in reaching the point, but building a careful historical case to justify the conclusion. Take the case to the United States Supreme Court. And to do that there must be a case. A woman, or many women, must attempt to vote, and when denied, sue. Then appeal and appeal until the highest court in the land would decide.

Susan B. Anthony, in reading Francis Minor's letter and Virginia Minor's speech, was convinced. She now had a new strategy.

So impressed by the Minors' argument was Anthony that she not only had the letter published in *The Revolution,* the weekly newspaper she and Elizabeth Cady Stanton published, but she arranged to have 10,000 additional copies of that issue printed. The paper's circulation never exceeded 3,000 paid

subscribers, so this amounted to a quadrupling of the normal distribution. The paper always lost money and Anthony's decision to print and mail out the extra copies was a significant cost factor in its eventual demise. Anthony was interested in her cause, not in sound business practices.

The extra-distribution issue contained Francis Minor's letter, Virginia Minor's speech, and the Missouri resolutions. Every member of the U.S. Congress, both houses, was given a copy. Copies were distributed at the next convention of the National Woman Suffrage Association, held in Washington, D.C. And hundreds of copies were mailed around the country to people, men and women, considered friends of the women's suffrage movement. Anthony was determined that her plan to have the Minors' new strategy become the main strategy of the movement would be a success.

An invitation to hundreds of women around the country to attend the Washington convention contained a new phrase that would become associated with this new strategy: "The National Woman Suffrage Association will hold its annual convention at Lincoln Hall, Washington, D. C., January 10th, 11th and 12th, 1872. All those interested in woman's enfranchisement are invited there to consider the 'new departure'—women already citizens, and their rights as such, secured by the XIV. and XV. Amendments of the Federal Constitution."

The invitation was signed by Anthony, Lucretia Mott, Elizabeth Cady Stanton, Isabella Beecher Hooker, and Josephine S. Griffing, five of the key leaders of the women's rights movement. It's not known which of these women came up with the phrase *New Departure,* but since this was the first time it was known to have appeared in print and since it was in quotation marks, it seems likely that someone was consciously attempting to make that term well known within the movement. One likely possibility is that Stanton wrote the invitation, since Anthony and the other women routinely assumed Stanton was the best writer in the group and typically assigned writing projects to her, but that some other woman came up with the phrase. It's an awkward phrase and Stanton, by using quotation marks, if indeed she did write the invitation, might have been saying, Hey, it's not mine. Anthony, of course, was far from poetical in her own writings and is a prime candidate for originator of the clumsy concoction.

Creating a Test Case

Anthony spent much of the next three years planning her crime. She would create a test case. Test cases have had a long, and often honorable, his-

tory, in American jurisprudence, but all of the most notable cases follow hers by decades or a full century. A test case is one in which a plaintiff deliberately breaks a law with the intention of having the case go to court so it can be appealed to the state or national supreme court, which will then, if the plan works, rule the law unconstitutional.

PLESSY V. FERGUSON

Plessy v. Ferguson is a prime example.[7] In 1890 Louisiana enacted a law that required railroads within the state to have separate cars for blacks and whites. A group of whites and blacks who opposed the law persuaded Homer Plessy, a 30-year-old New Orleans resident who was seven-eighths white and one-eighth black, to test the law. Under state law, Plessy was legally "colored" and was therefore required to ride in the "colored" car. But he looked white. On June 7, 1892, Plessy purchased a train ticket in New Orleans for Covington, a distance, by train, of about 40 miles, and sat in the whites only car.

Officials of the East Louisiana Railroad, on which Plessy rode, were informed ahead of time of the plan formulated by the Comité des Citoyens, or Committee of Citizens. The railroad opposed the law for economic reasons. It meant it had to buy additional cars. The committee hired a private detective to confront Plessy on the train. The detective did, telling Plessy he must move to the colored car. Plessy, by prearrangement, refused, and the private detective, also by prearrangement, arrested him. The idea was to make certain Plessy was charged with violation of the Separate Car Act. They did not want him charged with a different offense, such as disturbing the peace. Such a charge would not test the law, and that was the whole purpose of the legal charade. The charade was needed because in the United States, unlike some other countries, laws cannot be tested for their constitutionality in a court unless there is an actual case.

As planned, Plessy was arrested, the train was stopped within the city of New Orleans, and Plessy was taken off. He was tried in a local court and, as expected, was found guilty. He was fined $25. The judge in the case was John Howard Ferguson. The judge ruled that the state had a right to require separate accommodations on trains based on race as long as the trains operated entirely within the state. Federal law prohibited racial segregation of passengers on trains that crossed state lines.

Also as expected, the Citizens Committee appealed to the state Supreme Court, where, again as expected, Ferguson's ruling was upheld. And, as expected, the case was finally appealed to where the plaintiff's attorneys intended it go all along, the United States Supreme Court. That court heard

arguments in the case on April 13, 1896. The key argument on behalf of Plessy was that separate accommodations meant he was denied the equal rights guaranteed by the 14th Amendment. The next month, on May 18, the high court handed down its decision.

The decision was 7 to 1. (Justice David Josiah Brewer did not participate because his daughter had recently died.) Associate Justice Henry Billings Brown wrote the majority opinion: "We consider the underlying fallacy of the plaintiff's argument to consist in the assumption that the enforced separation of the two races stamps the colored race with a badge of inferiority. If this be so, it is not by reason of anything found in the act, but solely because the colored race chooses to put that construction upon it."

John Marshall Harlan cast the only dissenting vote, writing that the Plessy case would become as infamous as the Dred Scott case, which ruled that the plaintiff, Scott, could not sue in federal court because blacks could not be citizens of the United States. The Dred Scott case is often considered the nadir of Supreme Court history. And the Plessy case is not far off.

Although never actually used in the case, the most famous phrase to come out of it is "separate but equal." That phrase is an addendum to Justice Brown's logic. The 14th Amendment's equal protection clause required, his logic dictated, equality, not racial integration. The fact that segregation assured inequality was clearly beyond his ability to comprehend.

Plessy's attorneys wanted to kill Jim Crow laws across the South. Instead they gave segregationists a doctrine upon which to build their bigotry that would last more than half a century.

The decision not only went against Plessy, it was devastating to the Civil Rights movement in America. It was clearly a case of Be Careful What You Wish For—in this case that the highest court in the land rule on the case—Because You Just Might Get It.

BROWN V. TOPEKA

A half century later, another citizens' group, a much larger one, the National Association for the Advancement of Colored People, would seek out other blacks to again test the constitutionality of legally required racial segregation.

The NAACP in 1951 recruited 13 black parents in Topeka, Kansas, and had them attempt to enroll their children in all-white public schools. When, as expected, they were turned away, the organization sued on behalf of them and their 20 children. The resulting case, *Brown v. Topeka*,[8] is referred to by

the name of one of those parents, Oliver L. Brown, a welder on the Santa Fe Railroad and a pastor who had been outspoken on race relations in Kansas.

Where the Supreme Court in the 1896 Plessy case had argued that racial segregation did not harm blacks, the high court in 1954 based its ruling on a growing mountain of scientific evidence that it did indeed do harm. Specifically, the court accepted the plaintiffs' argument that black children in racially segregated schools were made to feel intellectually inferior simply by having been placed in those schools. The court in its unanimous 1954 decision said, "Separate educational facilities are inherently unequal." And *Plessy* was overturned.

Despite the different outcomes, there were several important similarities in the two cases. Both involved a deliberate challenge to the existing laws; both involved lawyers recruiting plaintiffs rather than plaintiffs with a grievance seeking out lawyers; both based their central legal argument on the 14th Amendment's equal protection of the laws clause, and both had far reaching, long term social implications for the country. One underpinned legal racial segregation; one ripped away part of that underpinning.

There was one significant difference worth noting, however. *Plessy* was particular to Louisiana, although its implication was national. *Brown* was just one of five cases that the Supreme Court combined into one; the others involved similar cases from Delaware, South Carolina, Virginia, and Washington, D.C.

Both of these cases followed Susan B. Anthony's by decades, but the similarities and differences are notable. Like both Plessy and Brown, Anthony engaged in a deliberate act of defiance designed to get the case before the U.S. Supreme Court. Like both Plessy and Brown, Anthony would be represented for free by some high priced legal talent. All three cases placed the 14th Amendment's equal protection clause at the heart of its legal argument. All three attracted great national and international attention.

The differences are also notable. Plessy and Brown both achieved their goal of having their cases heard by the United States Supreme Court. Anthony did not. But, her strategy did work, because another woman, Virginia Minor, whose husband suggested the strategy to Anthony, also tried to register to vote. In Missouri. Unlike Anthony, she wasn't allowed to register, so she could not cast a vote. And she sued. And the Supreme Court would hear her case, not Anthony's.

SCOPES MONKEY TRIAL

Sometimes a test case is designed more to attract publicity to a cause than it is to test a law in court. The most famous example of this is the Scopes Monkey Trial in Tennessee in 1925.[9]

Tennessee had passed a law prohibiting the teaching of evolution of humans (but not necessarily of other life forms) in any school that received state funds. Teaching it in a private school was permitted. Scopes, who was a sometimes substitute science teacher in Dayton, a town of about 2,000 people[10] in the eastern part of the state, would later say he could not remember ever having taught Darwinian evolution in the Dayton school prior to being approached and asked to teach it to create a test case, but he wasn't certain. The request came from the American Civil Liberties Union. To help win publicity, the ACLU brought in Clarence Darrow, the most famous defense attorney in America. The state of Tennessee unwittingly cooperated with the ACLU's plan by agreeing to have William Jennings Bryan serve on the prosecution team. Bryan was a three-time unsuccessful Democratic Party nominee for president, losing twice to William McKinley and once to William Howard Taft. He had also been secretary of state in Woodrow Wilson's administration. He was among the best known politicians in America, and his presence in Dayton helped assure a worldwide audience.

Publicity was, indeed, the hallmark of the trial. It was the first trial ever carried nationwide on radio. Nearly every major newspaper in America and many from Europe and elsewhere sent reporters to cover it. America's best known columnist, H.L. Mencken, of the *Baltimore Sun,* which paid some of the defense team's expenses, covered it; it was Mencken who gave the trial its famous moniker, The Monkey Trial.

Scopes was found guilty of having taught a scientific doctrine that was prohibited by state law, namely Darwinian evolution as it applied to the biological descent of humans. He was fined $100 (which would be equivalent to about $1,500 in 2015 dollars). The defense appealed to the state Supreme Court, which overturned the conviction because the state law, known as the Butler Act, mandated a minimum fine of $100, and that's what the judge imposed, although state law at the time said a judge could not impose a fine of more than $50. If he thought a greater fine was appropriate he should have, under Tennessee law, had the jury determine the amount.

The Tennessee high court also took the unusual step of suggesting that district attorneys in the state not bring any more prosecutions under the Butler Act. And they didn't. The law, thus, went unenforced, and in 1967 the state legislature repealed it. It had remained on the books and had therefore remained an embarrassment to the state.

In 1968, the U.S. Supreme Court ruled that bans on the teaching of scientific theory that are based on religious beliefs were unconstitutional because they violate the First Amendment prohibition against the establishment of a religion.

Susan B. Anthony valued publicity. Her cause thrived on it. The Scopes trial may therefore be the one that Anthony, if she had known about the famous test cases, would have most identified with. She had always championed equal rights for and equal treatment of blacks and would certainly have sided with the plaintiffs in the Plessy and Brown cases. But she also always had a sense of intellectual superiority over the men who made the laws of the country and in the states and cities and towns, and while she was not scientifically oriented, there is no doubt she would have seen in Scopes a person, like her, who sided with reason against ignorance.

Lucy Stone

Meanwhile, the women's suffrage movement was suffering from ever recurring internal strife. For decades there had been disagreement about the general direction the movement should take, as was highlighted by the acrimonious debate in May 1969 between those, like Frederick Douglass, who felt any efforts and energies spent on women's rights should wait until black rights were secured, and those, like Anthony, who thought both sets of rights should be fought for together. That produced a never-closed split between the two factions.

And before the end of the year, another split developed, with one faction, led by Lucy Stone,[11] once a staunch ally of Anthony and Stanton, complaining about the nature of the leadership within the National Woman's Suffrage Association. Stone had publicly said less than a year earlier that so many blacks she met, especially in Kansas, expressed such open hostility to equal rights for women that she was certain the chances of women achieving the vote would be lessened once black men were permitted to vote. Black men, she felt, were even more inclined than white men to oppose women's suffrage. But later she came to believe Anthony and Stanton were wrong to insist that women should and could win the right to vote at the same time as blacks. In fact, in the bitter New York City meeting she sided with those who said it was "the Negro hour" and that women would have to wait.

Now, in late 1869, because of the bitterness engendered in New York, Stone formed her own women's rights organization, the American Woman Suffrage Association (AWSA), to rival Anthony's and Stanton's National Woman Suffrage Association (NWSA). Stone said the two organizations need not be rivals and they could work together towards the same end, suffrage for women. Stanton was angry, but Anthony used the opportunity to promote her new strategy, the "new departure." She surprisingly accepted Stone's *pro*

forma invitation to attend the first ever AWSA convention. It was held in Cleveland, Ohio, and when the hundreds of men and women in attendance[12] were told she was present and she was invited to sit on the front stage, she received a thunderous ovation. She urged those present to view the fact of two women's suffrage associations not as a sign of a split but rather as proof of the vitality of the movement.

Then she told the meeting about her new strategy and urged them not to waste time trying to convert members of highly reluctant state legislatures, but instead to seek to register to vote and when denied, to sue.

Whatever Stone's intention was, she had given Anthony an opportunity to preach to and convert a motivated, ambitious audience.

There is little evidence that having two seemingly competing organizations seeking the same goal did much damage. In San Francisco the local women's rights organization joined Anthony's NWSA, but the California organization decided not to join either one. But affiliation with one or the other or with neither did not stop any local or statewide chapter anywhere in the nation from holding meetings, distributing literature, or in other ways carrying out their day to day operations.

Anthony's Personality

The NWSA held its annual meeting in January 1870 in Washington, D.C., and there were more attendees on the second day than on the first, and still more on the third and final day. In February, the organization held a big birthday party for Anthony. She was 50 years old, in good health, a bit stout but in no way slowed down. Her friend Elizabeth Cady Stanton was more than stout, she was in fact obese. Stanton was well over 200 pounds although she was about four inches shorter than Anthony, who was at least 50 pounds lighter. Anthony often scolded Stanton because of her weight, chiding her when she ate too much, telling her she damaged not only her own health but her ability to be useful to the cause. Anthony was often very unkind to her friend. Many aspects of Susan B. Anthony's personality were unpleasant, not only by today's standards but by those of her contemporaries.

When Frederick Douglass' wife died and a year later, in 1884, he married his Washington, D.C., neighbor, Helen Pitts, a white woman, Stanton wrote a letter of congratulations that she wanted to publish in a newspaper, but Anthony persuaded her not to, saying the marriage of a black man to a white woman "has no place on our platform; your sympathy has run away with your judgment."[13] (Although acquiescing at the time, Stanton did later publicly

defend the marriage, saying, "If a good man from Maryland sees fit to marry a disenfranchised woman from New York, there should be no legal impediments to the union."[14] Douglass had been born a slave in Maryland and Pitts was born in New York.)

Anthony could be demanding and did not hesitate to scold those who did not adhere to her wishes. Once an aide, Clara Colby, did not mark up copies of newspapers in red pen, as Anthony had instructed, before distributing them to people who had contributed money to the suffrage cause. Anthony wrote a scolding letter about Colby to a third party, Harriet Taylor Upton, a leader of the Ohio suffrage movement. Anthony felt readers of the newspaper would thus not have their attention drawn to the two points she wanted marked. "She lost me my two special points—by doing it her own way."[15] Anthony did not like other women doing things their own way. She wanted everything done her way.

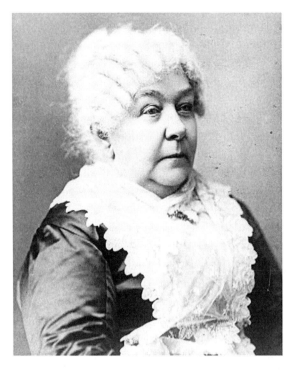

Elizabeth Cady Stanton. She endured a good deal of verbal abuse from Susan B. Anthony, despite their long-time friendship. Anthony criticized Stanton for eating too much, for not being devoted enough to the women's suffragist movement, and even for having too many children. This photograph is believed to have been taken a year or two before Stanton died in 1902 (Library of Congress).

Anthony v. Stanton

When Stanton indicated that she would not return to America from a family vacation in England to attend a meeting in Washington, Anthony scolded, nearly bullied, the malleable Stanton so severely in letters that Stanton caved in and returned, leaving her family to vacation without her. Anthony even bragged in her diary that she wrote "the most terrific letter to Mrs. Stanton."[16]

Stanton, late in her life, would write of the collaboration between her and

Anthony, "While she is slow and analytical in composition, I am rapid and synthetic. I am the better writer, she the better critic."[17] Although Stanton's comment was intended to describe projects they wrote together, it metaphorically reveals their personal relationship. At one point Stanton more consciously summed up how she viewed their relationship. When Anthony insisted that Stanton attend a meeting in Albany, New York. Stanton, acquiescing, wrote, "If Napoleon says cross the Alps, they are crossed."[18] When Stanton was old and blind and obese, Anthony wrote of her friend, "It is too cruel that such mental powers must be hampered with such a *clumsy body.*"[19]

The Cause v. Friendship

But nothing brought out Anthony's willingness to be unkind to even her closest friends more than a feeling that any of them might be less committed to the cause of women's rights than she was. When Lucy Stone said she was getting married, Anthony told her marriage was a "defection." She told both Stone and Antoinette Brown, who also announced a pending marriage, that fighting for women's rights was more important than getting married. And, in the epitome of her arrogance on the issue, she told Stone, Brown, and Stanton to stop having children. It interfered with their more important work.[20] She wrote to Brown, "Now, Nette, not another baby, is my peremptory command" and "I say stop now, once & for all. Your life work will be arduous enough with two."[21] And she wrote to Stanton, "Those of you who have the *talent* to do honor to poor—oh! how poor—womanhood, have all given yourselves over to *baby* making and left poor brainless *me* to do battle alone—it is a shame, such a body as *I might be spared to rock cradles,* but it is a crime for you & Lucy & Nette."[22]

Anthony often visited Seneca Falls, about 55 miles east of Rochester, to order Stanton to do some writing. Stanton had children, five boys and two girls by 1859, and Anthony would simply boss them around so Stanton could do the writing Anthony commanded. "Her advent was not a matter of rejoicing," Harriot, the youngest of the two daughters would recall years later, for it meant "mother was to retire as mentor and be entirely engrossed in writing a speech for Miss Anthony to deliver ... while she kept the children out of sight and out of mind." Anthony "ruled more by compulsion than by attraction," Harriot said.[23]

The nature of the relationship between the two women can be discerned from the salutations in the letters they wrote to each other. Anthony wrote to "Mrs. Stanton," while Stanton wrote to "Susan," suggesting that while each

frequently spoke of the other as "friend," Anthony was more formal, Stanton more genial.[24] The tone was always as if Anthony was hesitant to become too close to someone she saw as a valuable professional associate.

There seems also to have been a significant amount of jealousy constantly simmering in Anthony in her relationship with Stanton. When, in the early 1870s, Stanton decided to not attend so many women's suffrage conventions and other events, Anthony both scolded Stanton ("How you can excuse yourself is more than I can understand"[25]) and expressed relief, writing in a letter to her sister Mary, "whoever goes into a parlor or before an audience with that woman does it at the cost of a fearful overshadowing, a price which I have paid for the last ten years."[26] Anthony was the more famous, but Stanton was the better writer, the better speaker, the more amiable. Anthony's admiration of Stanton's talents, appreciation of her value to the cause, and her love for the woman could not drown out the envy.

The cause was always more important. Anthony, who once was a paid recruiter to enlist names in the abolitionist movement, would in 1895 ask her one time friend Frederick Douglass to not attend a women's suffrage meeting in Atlanta because white women there might be offended. Four years later she successfully opposed an effort to have the National American Woman Suffrage Association go on record as favoring an end to racial segregation on interstate trains.[27] Again, white women in the South might withdraw from the movement.

Anthony could be warm and friendly, and Stanton and others often had sumptuous praise for her. But there were so many times when Anthony could say something unkind, demand something she had no right to demand, insist on loyalty to the cause above friendship, that the irrefutable conclusion is that she was capable of unkindness and even nastiness. Nobility of purpose seemed to her to justify all social heavy-handedness. The same qualities that made her an admirable crusader also made her a difficult friend.

Perhaps nothing shows as clearly the aspects of Susan B. Anthony's personality that led her to commit the crime of voting as her relationship with Elizabeth Cady Stanton. Most biographies of Anthony devote considerable space to Stanton and most of Stanton considerable space to Anthony. Several dual biographies of the two women have been published. And a three and a half hour television documentary about their friendship was made in 1999.[28] Without exception these portrayals refer to these women as friends, but the relationship was clearly more complicated than that, and often more intense. They were like a married couple who had a lasting but strained bond. Or, since Stanton was married and Anthony single, like a couple engaged in an uneasy

affair that wavered between attraction and addiction, with Anthony being the domineering, demanding partner, and Stanton the talented but submissive mistress.

Anthony presented an imposing figure. In late 1855, because she applied for a life insurance policy, she took a medical exam, conducted by Dr. Edward M. Moore, who her first biographer, Ida Husted Harper, called "the leading surgeon of western New York," and he described a woman of commanding presence. According to his report, dated December 18, 1855, when Anthony was 35 years old, she was five feet, five inches tall, weighed 156 pounds, had a bust line of 38 inches, and a fair complexion. He described, without going into details, her "habits" as "healthy and active," added, "nervous affections, none; character of respiration, clear, resonant, murmur perfect; heart, normal in rhythm and valvular sound; pulse 66 per minute; disease, none." He concluded, "The life is a very good one."[29]

Stanton, by contrast, was short, barely over five feet, and started out plump when a young women, and steadily grew into morbid obesity. In her 80s, she reached 240 pounds and could not walk across a room without assistance from one of her grown children.

In public, as far as others could notice, they were in harmony, but in private they frequently clashed, and the clashes had a discernible pattern. Anthony made demands. Anthony bullied. And Stanton sometimes acquiesced, and sometimes, as is frequent among those who enable bullies, resisted, if only meekly. Part of the problem was that Anthony, after the 1869 meeting in New York, focused almost exclusively, evenly obsessively, on suffrage, while Stanton, far more intellectual, was attracted to ideas and subtleties. Anthony focused like a hovering eagle on a distant prey, while Stanton wanted to appreciate the panoramic view, the complications of society, politics, theology, and other disciplines. In 1865 Stanton told Anthony in a letter to stop acting like a bully. Five years later she wrote to their mutual friend, Martha Wright, that she was determined to not be bossed around so much by Anthony. And a year later she wrote that they had a fine friendship as long as Anthony accepted her as an equal, the implication being that Anthony did not always do that.[30]

One way in which Stanton stood up to Anthony was by not offering a penny towards the $10,000 debt accumulated by *The Revolution,* the weekly newspaper they started together. Anthony felt unfairly treated having to repay the debt for the defunct newspaper, because Stanton was the editor and also had a good deal more money than Anthony. But while Anthony strongly hinted that Stanton should help with the debt, she did not resort to the bullying rhetoric she used when she wanted Stanton to write something

or attend a convention. And if Anthony didn't bully, Stanton could stand up to her.[31]

But Stanton could not resist Anthony completely. In May 1872 at a New York City meeting of the National Woman Suffrage Association, Victoria Woodhull, a newcomer to women's rights leadership, hoped to persuade the attendees to support her newly formed Equal Rights Party. The party was created as a vehicle to allow Woodhull to run for president. Although women could not vote, nothing in the Constitution forbade them from holding federal office. The party nominated Woodhull for president and Frederick Douglass, who did not attend the party's convention, for vice president. Douglass refused to accept the nomination. Woodhull was the first woman to make a fortune on Wall Street, and she and her sister, Tennessee Claflin, were the first American women to start a newspaper, *Woodhull and Claflin's Weekly.*[32] Stanton found Woodhull interesting and amiable. Anthony did not.

When Woodhull rose to speak at the NWSA meeting, Anthony physically blocked her. She stood at the lectern and wouldn't let Woodhull stand behind it. When Woodhull still refused to leave, Anthony ordered a janitor to turn out the gas lights, effectively ending the meeting. Stanton was infuriated with Anthony, calling her "narrow, bigoted and headstrong," one of the few times she used such severe language about her friend. She had thought there was a tactical understanding that while Anthony disliked Woodhull, Woodhull would at least be allowed to speak. Anthony expected loyalty from Stanton, and when she didn't get it, she felt offended and wounded. In her diary she wrote about "the folly of Stanton." She let Stanton know with clarity that Stanton could not support Woodhull and be Anthony's friend. Stanton, once again giving in, decided to abandon her backing of Woodhull and told Anthony she was still her friend.[33]

Anthony often was aided in her criticism of Stanton by younger members of the movement. Harriet Taylor Upton, a leader of the Ohio women's suffrage effort, once claimed that "Mrs. Stanton's greatest delight was to spring some quite radical statement on the assemblage ... something that would 'set them on their ears' ... confounding poor Susan and causing setbacks to the Cause."[34] Upton was simply reflecting Anthony's prejudice, after 1869, that anything said about any subject other than gaining the vote for women was disruptive. Stanton's love of ideas drew her to other subjects. The younger women joining the women's rights movement in the 1870s and the following decades looked to Anthony for leadership, calling her Aunt Susan, and tolerated Stanton only when Anthony did. To them, this other woman was always "Mrs. Stanton."

Stanton's reaction to Anthony's heavy-handed relationship with her was

often to quietly, but not quite stoically, resist. While Anthony encouraged women from the around the nation to vote in the 1872 presidential election, Stanton never said she would or wouldn't. But when election day 1872 arrived, Stanton did not attempt to register or to vote. Stanton would eventually vote, eight years later. Stanton was in her Tenafly, New Jersey, home on November 2, 1880, and Anthony happened to be visiting. Neither Stanton's husband nor grown sons were home when a carriage arrived. It had flags, greenery, and other decorations, and was sent by the Republican Party to help Republican voters get to the polls. Stanton told the men with the carriage that she was the owner of the house and that she paid taxes on it, so she would "go down and do the voting." She climbed onto the wagon, and Anthony, whose mere presence urged Stanton to engage in this small act of defiance, also got in. At the polling place, Stanton later wrote, "The inspectors were thunderstruck when she filled out a ballot. One inspector grabbed the ballot box and placed his hand over the opening, making certain Stanton could not put anything into it. He said, "Oh, no, madam, men only are allowed to vote." He added, "I cannot accept your ballot." Stanton, undaunted, placed the ballot on top of his hand and said that she "had the same right to vote that any man present" had.[35] She voted only for Republican candidates, including, for president, Ohio Congressman James A. Garfield, who defeated Civil War hero Winfield S. Hancock. Stanton's vote was not counted, but it wouldn't have helped. Hancock carried New Jersey. Six months later, Garfield was assassinated by Charles J. Guiteau, who was angry because no one in the new president's cabinet would give him a federal job.

At times, Anthony attempted to talk Stanton into moving to Rochester, but Stanton always said no.[36] Stanton of course had a husband and children, but the verbal abuse she endured from Anthony was greater than she could tolerate more than a few days at a time.

Sometimes, however, they did spend longer periods together. In 1871 they traveled together to California on the recently completed transcontinental railroad. It was part lecture tour, part vacation. On the train, Anthony wrote in a letter to her sisters, "We have a drawing room all to our selves, and here we are just as cozy as lovers." Stanton, speaking of pioneering couples in covered wagons but clearly also referring to herself and Anthony, observed that they experienced "real bliss, if only the two are perfect equals, two loving people, neither assuming to control the other." Anthony said, "After all, life is about one and the same things, whether in a prairie schooner and sod cabins, or the fifth Avenue palace. Love for and faith in each other." She added, "It is not the outside things which make life, but the inner, the spirit of love."[37]

Anthony clearly viewed the love between her and Stanton as unconditional, but Stanton saw it as being conditioned upon a sense of equality, and the clear implication was that Anthony did not always accept her as an equal.

At least part of the cause of these differing views is evidenced in an incident in Yosemite Valley during their western trip. They visited the spectacular scenery of Central California 19 years before the area became Yosemite National Park. They went horseback riding. Or, rather, Anthony went horseback riding, while Stanton walked. Stanton said she had to walk because a guide had made a poor decision in which horse to select for her to ride. The horse was too tall and too wide, so her feet could not reach the stirrups. Anthony simply dismissed that, saying Stanton was just too fat.[38]

Anthony always assumed the role of the dominant partner in her relationship with Stanton and accordingly never hesitated to lecture her. When Stanton, after their return from California, expressed a desire to not attend the National Woman Suffrage Convention in Washington, D.C., Anthony objected in a letter, underlining key words for rhetorical emphasis: "Remember that you—E.C.S.—are President ... and that [it] is your immediate duty as such—to issue the call forthwith at once—without delay ... good, strong, singing bugle blast[s]—inviting every earnest worker & speaker to come."[39]

The Splinter

As political parties prepared for the 1872 election, the Republicans adopted a platform that said, in regard to the call for better treatment for women, "The Republican party is mindful of its obligations to the loyal women of America for their noble devotion to the cause of freedom; their admission to wider fields of usefulness is received with satisfaction; and the honest demands of any class of citizens for equal rights should be treated with respectful consideration."[40] Anthony, although she spoke of the "timidity" and "meagerness" of the plank, was pleased enough to promise to work for the reelection of Republican President Ulysses S. Grant. Stanton, a bit more insightful and far more witty, labeled the plank a "splinter."[41] Stanton wrote, "I do not feel jubilant over the situation; in fact I never was so blue in my life."[42]

These were very different women. Stanton was wittier, possessed broader intellectual views, and felt as much pride in her role as a wife and mother as she did in her role as a leader of the women's rights movement. Anthony never developed an ability to turn her anger into wit, only into sarcasm, never married, never had children, and after the acrimonious 1869 Steinway Hall meeting

focused her reform efforts narrowly. She did not think of herself as anybody other than a leader of the women's rights movement. If she could treat a close friend harshly, she could think with downright scorn about the laws of a state and country that would not permit her to participate in its alleged democracy. A citizen without the right to vote is not a true citizen, she believed. Unjust laws not only need to be disobeyed, they must be defied. And she would defy them. Her sense of social obligation would not permit any other action. Nor would her personality.

Other Women Who Voted

Numerous American women had attempted to vote before Susan B. Anthony cast a ballot. And many others would make the attempt when she did in 1872.

Mary Ann Shadd Cary accomplished several notable firsts—she was the first black female publisher of a newspaper in North America and the first woman publisher in Canada, and in 1883 at age 60 became the second black woman lawyer in the United States. Cary registered to vote when she lived in Washington, D.C., after the Civil War, but she was turned away when she showed up on election day.[43]

Isabella Baumfree escaped from slavery in New York in 1826 when human bondage was still legal in the state. She then sued her former owner to gain custody of her son. And won. No black woman had successfully sued a white man anywhere in the United States. In 1843 at age 46, she changed her name to Sojourner Truth and became, and remains, one of the legendary leaders of the anti-slavery movement. Her "Ain't I a Woman" speech at a women's rights meeting in Akron, Ohio, in 1851 also made her an admired icon of the suffrage movement. In 1872 she went to a polling place in Battle Creek, Michigan, and attempted to vote. She was turned away.[44]

Sarah and Angelina Grimke, sisters, led a group of 40 women to the ballot box in New Hyde Park, New York. In Vineland, New Jersey, 172 women set up their own polling place and cast ballots. Nanette Gardner actually voted, and her vote was counted, in Detroit in 1871 in an election for state office.[45]

In fact, hundreds of women had attempted to cast votes over the first century of the country's history, but nearly all were politely, and sometimes not so politely, turned away from the polling place. A few, like Gardner, had their votes counted.

Anthony was familiar with much of this history. She also knew that there was no known instance where a woman denied the right to vote took her case

to court. That, Anthony told herself, is what she would do. Her plan was to attempt to register in the 1872 presidential election, be turned away, and then sue and take her case to the U.S. Supreme Court, which, she was certain, would agree with her that the 14th Amendment of the federal constitution gave her, and all women, the right to vote.

3

The Crime

On Friday, November 1, 1872, Susan B. Anthony, while sitting in her Madison Street home, turned to page 4 of the *Rochester Democrat and Chronicle* and read an editorial commentary, one common to the majority of newspapers in democracies just prior to an election, urging everyone to register to vote. This one was unusual only in that it urged all Republicans to vote and did not mention Democrats or members of other parties or independents. But that's not what Anthony noticed.

The commentary began, "Every Republican voter should remember that he must have his name entered upon the ward register to day or to morrow, if he intends to vote on Tuesday next."[1] The election was scheduled for Tuesday, November 5, the first Tuesday after the first Monday, as specified by an 1845 U.S. law. "Many have neglected the important duty so far," the article continued. The newspaper, a morning daily, added, "The boards of registry will be in session from 8 o'clock this morning until 9 o'clock this evening, and during the same hours to-morrow." The article then listed the location of places to register in each of the 14 voting districts in the city. Two were listed for the Eighth Ward. The one for the First District in that ward was "West End news depot." The location, which also contained a barber shop, was about one-third of a mile from Anthony's home on Madison Street. Perhaps a 10 minute walk.

On page one of the same issue was a similar editorial that said, in part,

Now register! Today and tomorrow are the only remaining opportunities. If you were not permitted to vote, you would fight for the right, undergo all privations for it, face death for it. You have it now at the cost of five minutes' time to be spent in seeking your place of registration and having your name entered. And yet, on election day, less than a week hence, hundreds of you are likely to lose your votes because you have not thought it worth while to give the five minutes. Today and tomorrow are your only opportunities. Register now!

The page one comment was generalized and not limited to Republicans.

In the Harper biography of Anthony, a book with which the subject cooperated so thoroughly it can be considered an autobiography, the author writes of the page one editorial comment, "There was nothing to indicate that this appeal was made to men only, it said plainly that suffrage was a right for which one would fight and face death, and that it could be had at the cost of five minutes' time. She was a loyal American citizen, had just conducted a political campaign, was thoroughly conversant with the issues and vitally interested in the results of the election, and certainly competent to vote."[2] (The campaign was probably Anthony's unsuccessful effort to have voters in Kansas change state law to allow both women and blacks to vote.)

She contacted her three sisters, according to the biography, and together they walked to the voting place. Within parenthesis they refer to the polling place as being "(in a barber shop)," but it was actually a general store in which a barber's chair was present. It sold newspapers and some groceries and other items. When the women said they wanted to register to vote, the three inspectors of election hesitated, and Anthony had come prepared and read aloud the 14th Amendment to the U.S. Constitution, saying that it gave her and her sisters the right to vote. She also read the part of the New York State Constitution on voters taking an oath, which did not limit voting to one gender.

The once shy Anthony, by this point in her life, knew how to create a commanding presence. She could look stern and forceful and authoritative, and that appearance no doubt had an effect. The discussion went on for several minutes, always polite, but Anthony more in command of its tone than the men, and finally two of them—Beverly W. Jones and Edwin F. Marsh—agreed she could register. They were both Republicans. The third inspector, William B. Hall, a Democrat, objected. But only two needed to agree, and so the names of the four sisters were entered in the registry of voters for the First District of the Eighth Ward for the general election in Rochester, New York, in 1872.

Anthony was surprised but she could not have been more pleased. She contacted other women, friends she knew who agreed with her, and by the end of the day eleven more women registered to vote in the West End News Depot. Word spread throughout the city, and in all 14 city wards combined, by the end of the day, 50 Rochester women appeared at polling places and successfully registered to vote.

The two Republican papers in town, the *Express* and the *Democrat and Chronicle*, both reported the next day what had happened without comment.

The Democratic paper, the *Union and Advertiser* didn't hold back: "If the votes of these women were received the inspectors should be prosecuted to the full extent of the law."

Anthony would often claim that the editorial comment in the morning paper inspired her to register to vote that day because it did not specifically say women could not register. That of course is not accurate. She had intended for a long time, months at least, to vote in the November 1872 election. Her life for half of a century had prepared her for that act of rebellion.

The Harper biography of Anthony is not the only version of what happened that day. According to the first published version of what transpired, the one that appeared in the *Rochester Democrat and Chronicle* on Saturday morning,[3] Anthony recruited Mrs. Charles Hebard and Mrs. Hannah L. Mosier, and the three of them walked south on Madison to the intersection of West Avenue, turned left, and continued to the West End News Depot. (The polling place was at 89 West Avenue, which is now 431 West Main St.; the building in which Anthony voted no longer exists.) They asked to register to vote and were permitted to. Anthony then recruited other women to register, and Mrs. Amy Post and "Mrs. Dr. Dutton" showed up to register but weren't able to. According to the newspaper, "They were not given a direct refusal but the inspectors asked time till to-day [Saturday] to consider the subject."[4] The newspaper reported that at least 10 and maybe as many as 20 women intended to show up at polling places in the city's First, Third, and Eighth Wards with the intent of registering to vote.

The women had already talked to Rochester's best known attorney. As the newspaper noted: "Should they be met by a refusal, the question will be carried into the courts and Henry R. Selden or some other leading lawyer will be retained as counsel by the complainants, who have clubbed together to meet all expenses which may be necessary.... "These ladies claim the right to vote under the fourteenth amendment," the article said.

The audacity of Anthony's action preordained that it would be controversial. On the day of the election, four days after she and the other women registered, an unsigned commentary appeared in the *Democrat and Chronicle* under a three-deck headline:

ELECTION LAWS
Extracts from United States Laws
Relative to Voting

———

Willful Voting—False Personation—Voting
Illegally—Preventing Legal Voters from

Voting—Overacting and Hindering Voters
from Voting, &c., &c.[5]

The article beneath the headlines did not specifically accuse Anthony or the other women of violating any laws, but instead merely listed extracts from federal election laws, but the implication was clear: she and the other women had committed a crime. There was no mention this time of Anthony's already well-known defense of her actions, namely that any law forbidding women from voting was a violation of the 14th Amendment to the U.S. Constitution.

Two days later the newspaper published a letter to the editor[6] under the title "A Woman's Opinion of the Rights of her Sex." It was signed only "E.L.G."[7] The author praised the women who registered and offered an interesting detail about how they got to the polling place. "Carriages were offered them to convey them to and from the poll, but they politely refused, no doubt preferring to 'paddle their own canoe'; and moreover they were not so helpless but they could get there alone. (All due respect to the gallantry of the great men of the Eighth Ward, however.)"

E.L.G. also noted that "one lady registered her name in the fourth ward, and it was afterwards erased," but she did not provide the name of that woman. She added that "another registered in the Fourteenth Ward, her vote was challenged," and she wasn't permitted to vote. "Wards One, Three, Six, Seven and Ten refused to permit women to register at all."

The following day, a Friday, the same newspaper published another letter to the editor signed only "Fitro."[8] The letter said that the inspectors of elections in the wards that forbade women to register "did a much more gallant act" than did the inspectors in Anthony's ward. But the letter then went on to ask, speaking of Anthony and her female friends, "What shall I call them? Women, Persons or what?" Still later it noted, "because they were neither citizens nor persons, they were refused the right to vote." That is, the letter at points sounded clearly facetious, somewhat in the style of Petroleum V. Nasby,[9] who gained fame during the Civil War for writing articles purporting to support the Confederacy but whose logic was so obviously flawed that he made the Confederate cause sound silly. It's very possible, therefore, that "Fitro" was a woman actually writing in support of Susan B. Anthony.

The Perpetrators

On Tuesday, November 5, 1872, Susan B. Anthony walked south from her Madison Street home, turned east on West Avenue, in 10 minutes was at

the West End News Depot, and performed the most famous act of her life. She committed the crime of voting. A crime, at least, under United States law. Fourteen other Rochester women committed the same crime the same day in the same building.[10]

The perpetrators of the crime of voting were Anthony; Guelma Anthony McLean, Susan's older sister; Hannah Anthony Mosher, Susan's younger sister; Mary S. Anthony, Susan's younger sister;

Lottie B. Anthony, sister-in-law of Susan; Ellen S. Baker; Nancy M. Chapman; Hannah Chatfield; Rhoda DeGarmo, at 75 the oldest; Mary Culver; Mary L. Hebard (or Hibbard), wife of the editor of the *Express*; Susan M. Hough; Margaret Leyden; Mary Pulver; and Sarah Truesdale.

All resided in the First District of the Rochester's 8th Ward, on the west side of the Genesee River, a middle class district of comfortable homes a 10-minute trolley ride from the city's downtown shopping district.

About three dozen other women in other parts of Rochester had registered, but none were permitted to actually vote. Some did not show up at the polls on election day, and inspectors of election in the other polling places forbade those who did show up to cast ballots. Without the force of Susan B. Anthony's commanding presence, they could not overcome the legalistic, political and social forces conspiring to keep them from voting.

Mrs. L.C. Smith, Amy Post, Mary Fish, and Dr. Sarah Adamson Dolley are among the women known to have registered in other wards, and none could actually cast a ballot on election day.[11]

Straight Republican Ticket

Anthony voted a straight Republican ticket because of the party's platform plank that it would consider more legal rights for women, the plank that Stanton famously called a splinter.

Anthony voted for the reelection of U.S. Grant, the Republican, as president. He carried 31 states with 286 electoral votes, easily defeating his main opponent, Horace Greeley, the candidate of both the Liberal Republican and Democratic parties, who carried six states with 66 electoral votes. Grant won the popular vote by 3,598,235, or 55.6 percent, to Greeley's 2,834,761, or 43.8 percent. Other votes were scattered among a half dozen other candidates.

Anthony also voted for Lyman Tremain, a Republican, to fill an unusual at-large, or statewide, seat, defeating the Democratic incumbent, Samuel Sullivan Cox. Based on the results of the 1870 census, the New York state dele-

gation to the U.S. House of Representatives was increased by one member for the 1872 election, but the state assembly had not yet redrawn district lines, so the extra seat was assigned to the entire state. And for member of Congress from New York's 29th district, the one in which she resided, she voted for Freeman Clarke, a Republican.

And while she cast a secret ballot, Anthony did say she voted a straight Republican ticket, indicating she also voted for John Adams Dix for governor, John C. Robinson for lieutenant governor, Reuben W. Stroud for canal inspector, and Ezra Graves for inspector of state prisons, all statewide offices. All the candidates she voted for won and won easily. Republicans, in fact, won easily in most of the races all around the country.

Republicans, riding the coattails of Grant's popularity, won 24 of New York's congressional seats. Democrats won the other nine. Nationally, Republicans maintained their large majority in the House of Representatives, winning 203 seats to 89 for Democrats. Anthony and the 14 other Rochester women accused of voting illegally had no effect on the outcome of the election. If anyone wanted them punished it was clearly for the mere act of voting, not for changing the outcome of the election.

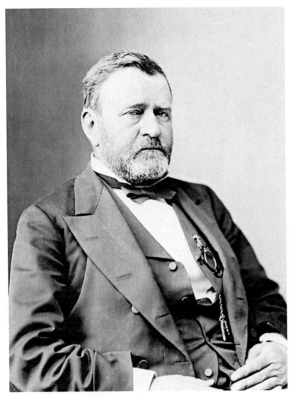

President Ulysses S. Grant. When Anthony voted in 1872, she cast a straight Republican ticket, headed by Grant, who was seeking a second term. She supported Republicans because they promised to consider more rights for women. This photograph was probably taken sometime during Grant's second term (Library of Congress).

"I Have Gone and Done It!!"

Anthony could not contain her excitement.

After voting she went home and wrote a letter to Stanton:

Rochester Nov. 5th 1872—

Dear Mrs Stanton

Well I have been & gone & done it!!—positively voted the Republican ticket—strait—this A.M. at 7 Oclock—& *swore my vote in at that*—was registered on Friday & 15 other women followed suit in this ward—then in Sunday others some 20 or thirty other women *tried* to *register*, but all save two were refused—all my three sisters voted—*Rhoda* De Garmo—too—Amy Post was rejected—& she will immediately ~~institute~~ bring action against the registrars—then another woman who was registered but vote refused will bring action for that—Similar to the Washington action—& Hon Henry R. Selden will be our Counsel—he has read up the law & all of our arguments & is satisfied that we are right & ditto the Old Judge Selden—his elder brother—So we are in for a fine agitation in Rochester on the question—I hope the morning's telegrams will tell of many women all over the country trying to vote—It is splendid that without any concert of action so many should have moved here so impromptu....

Haven't we *wedged* ourselves into the work pretty fairly & fully—& now that the *Repubs* have taken our votes—for it *is the Repub. members* of the Board—The Democratic paper is out *against us strong*—& that scared the Dem's on the registry board—How I wish you were here to *write* up the *funny things* said & done—Rhoda De Garmo told them she wouldn't swear nor affirm—but would tell them the truth—& they accepted that. When the Dems said my vote should not go in the box—one repub said to the other—What do you say Marsh?—I say put it in!—so do I, said Jones—and "We'll *fight* it out on this line if it takes all winter."—Mary Hallowell was just here—She & Mrs Willis *tried* to register but were refused—

Horace Greeley. Dissatisfied with Ulysses S. Grant's first term as president, Greeley left the party and joined the newly created Liberal Republican Party, and became the party's surprise candidate for president. Then the Democratic Party surprisingly also nominated him. Grant won by a landslide. Greeley had earlier angered Anthony by siding with those who thought women's rights had to wait until black rights were secured (Library of Congress).

A sculpture of a ballot box sits on a pedestal near where Susan B. Anthony voted in 1872. The sculpture, created by Pepsy Kettavong, commemorates Anthony's defiance of sexist laws that limited to men the right to vote (photograph by the author).

also Mrs Mann the Unitarian Minister's wife—& Mary Curtiss,—Catharine Stebbins sister—Not a jeer not a word—not a look—disrespectful has met a single woman—If only now *all the Woman* Suffrage *Women* would work to *this* end, of *enforcing the existing constitution*—supremacy of *national law* over state law—what strides we might make this very winter—But—I'm awful tired—for five days I have been on the constant run—but to splendid purpose—so all right—I hope you voted too—

<div align="center">

Affectionately—
Susan B. Anthony

</div>

Stanton had not attempted to vote.

A Promise

Anthony would later suggest that one of the reasons the women in the First District of the Eighth Ward were able to vote, while women in other polling places could not, was because she offered to pay the legal expenses of the inspectors of election if they were charged with a crime for allowing the

women to vote. She left the polling place, then read the law that said they, the inspectors, could be punished for allowing her and the other women to register and vote, and so returned to the polling place and told the inspectors of her willingness, even determination, to cover their legal expenses. Her biographer, Ida Harper, would write,

> Miss Anthony assured them that should they be prosecuted she herself would bear all the expenses of the suit. They had been advised not to register the women by Silas J. Wagner, Republican supervisor. All three of the inspectors and also a bystander declared under oath that Daniel J. Warner, the Democratic supervisor, had advised them to register the names of the women; but on election day this same man attempted to challenge their votes. This, however, already had been done by one Sylvester Lewis, who testified later that he acted for the Democratic central committee. The general belief that these ladies voted the Republican ticket may have influenced this action.[12]

The women who did vote were required to take an oath saying they truly believed they were entitled to vote. Thirteen of the women took the oath, and

Susan B. Anthony lived in this house most of her adult life. Today it is a museum at 17 Madison Street, Rochester, New York. When Anthony lived there the house number was 7 (photograph by the author).

one, Rhoda DeGarmo, a devout Quaker whose religion would not allow her to swear an oath under any circumstances, or even to "affirm" anything, instead said "I will tell the truth," and the inspectors accepted that.

Seven of the women, including Anthony, had shown up at the polling place at about 7 a.m. on election day, even before it opened, so that their appearance would not create a disturbance. Either this was an act of politeness, as Harper and Anthony would later suggest, or more likely a successful attempt not to give the authorities one more reason to bar them from voting.

An "Invitation"

But first there would be legal expenses for Anthony. William C. Storrs, the local United States commissioner, sent a message to Anthony and the other women who had voted telling them to come to his office. Anthony, without trying to hide her desire for sarcasm, replied that she had no desire to call on a man with whom she had no social acquaintance. In fact, none of the women went to his office based on that "invitation." Storrs then contacted the local U.S. marshal.

On Monday, November 18, 1872, two weeks after she voted, a United States deputy marshal named Elisha J. Keeney knocked on the front door of Anthony's Madison Street home. He was 63 years old, tall, wore kid gloves and a beaver hat, tried hard to be polite, and was clearly embarrassed with his task. Keeney may have been sympathetic to Anthony's claim of a right to vote. She invited him to sit in her parlor. He did and he told Anthony the weather was nice. The parlor had several rocking chairs, a fireplace, paintings of landscapes on the walls, an almost-wall-to-wall rug. Keeney stammered and hesitated, and took long seconds to explain to Anthony why he was there. He even blushed. Finally, he said, Mr. Storrs wanted to see her, and she said, "What for?" He hesitated again, his discomfort growing, and said it was his "unpleasant duty to arrest" her. "The commissioner wishes to arrest you," he added.

Anthony had no sympathy for Keeney. Always willing to tend towards the dramatic, she said, "Is this your usual method of serving a warrant?" Keeney reached into a coat pocket and extracted some papers. One of the pieces of paper said,

> Complaint has this day been made by [Sylvester Lewis] on oath before me, William C. Storrs, commissioner, charging that Susan B. Anthony, on or about the fifth day of November 1872, at the city of Rochester, N. Y., at an election held in the Eighth ward of the city of Rochester aforesaid, for a representative in the Congress of the United States, did then and there vote for a representative

in the Congress of the United States, without having a lawful right to vote and in violation of Section 19 of an act of Congress approved May 31, 1870, entitled "An act, to enforce the right of citizens of the United States to vote in the several States of this Union and for other purposes."[13]

It was an order from a United States commissioner, a sort of federal justice of the peace, ordering the federal marshal for upstate New York to arrest Anthony on the charge of having voted.

The marshal had assigned a deputy who clearly didn't want the job, probably to assure there were no unpleasant incidents during the arrest. Everyone involved in the arrest knew this was no ordinary apprehension. Everyone in the city, indeed the whole country, much of the world, would know about it. You don't arrest celebrities without being very careful.

Anthony looked at the papers, thought for a moment, and said she wanted to change clothes. Not every day you get arrested. Have to dress appropriately. Her sister Mary, who lived next door, came over, probably alerted by a servant, and said she wanted to go with Susan.

Keeney, ever willing to be condescending to women, said that was fine and they could go down to the commissioner's office whenever they were ready. He wanted to leave. Anthony would have none of his unease. She insisted he wait until she was ready and that he take her to court. She went upstairs, changed clothes, and made herself look proper for a public appearance, and went downstairs. She held out her wrists for Keeney to put handcuffs on her. He looked at her hands, evidently confused for a moment, and then said he did not think there was a need for handcuffs.

The three walked to the corner of Madison and West, crossed the street, and waited a few moments for a trolley, a horse-drawn streetcar. They got on and Keeney took out a small pocketbook and was about to pay the fare when Susan B. Anthony asked in a tone loud enough for everyone on the streetcar to hear if he always paid the fare for the criminals he arrested. Far more quietly than her, he said, yes, it was his duty to pay the fare of any criminal he arrested. He gave three nickels to the driver. Five cents each. Being called a criminal made Anthony feel good.

When they arrived at Storrs's office in the Arcade Building on Main Street, in the heart of Rochester's business district, Anthony and her sister had to wait. Storrs had summoned all of the women who had voted, and several hours passed before they all arrived. This time he had "summoned," not "invited," the women, and not appearing could result in contempt charges. But by the time they all arrived, one other person who was invited had not arrived, an assistant United States district attorney, whose job it would be to

question the women in Storrs's presence. The assistant D.A., John E. Pound, sent word that he would be unable to attend that day, and Storrs told the women to go home but to return the next morning. He made it clear that he was ordering them, not inviting them, to return the next day.

The building that housed Storrs's office no longer exists (although a building with the same name—the Arcade Building—exists on the same spot). Visitors entered from Main Street and walked down a short corridor that housed several shops, and they could take a staircase to the upper floors to visit various officers. The U.S. commissioner's office suffered from more than a little disrepute among many Rochesterians at the time. As Anthony pointed out years later, it was "in the same small dingy office where, in the days of slavery, fugitives escaping to Canada had been examined and remanded to bondage. This historic little room is a double disgrace to the American Republic, as within its walls the rights of color and of sex have been equally trampled upon." The office was so small that the 15 women defendants and the other persons crowded it to the point of making it uncomfortable.

After her first, brief and perfunctory, meeting with Storrs, Anthony sent a message to Henry R. Selden, Rochester's best known attorney, a former member of the New York Court of Appeals, the state's highest court, a man she knew to be sympathetic to her belief that the 14th Amendment gave women the right to vote. On November 27 he sent her a note:

> I suppose the commissioner will, as a matter of course, hold you for trial at the circuit court, *whatever your rights may be in the matter.* In my opinion, the idea that you can be charged with a *crime* on account of voting, or offering to vote, when you honestly believed yourself entitled to vote, is simply preposterous, whether your belief *were right or wrong.* However, the learned gentlemen engaged in this movement seem to suppose they can make a crime out of your honest deposit of your ballot, and *perhaps* they can find a respectable court or jury that will be of their opinion. If they do so I shall be greatly disappointed.

Selden thought about the case exactly as she did. He was, she believed, the perfect lawyer for her.

The Hearing

On the morning of Friday, November 29, 1872, Anthony and the 14 other women who voted on November 5 had a hearing before William C. Storrs, the United States commissioner for Rochester.[14] John E. Pound, the assistant United States district attorney for Rochester, represented the prosecution. Henry R. Selden, Anthony's principal legal advisor, attended the hearing for

only a few minutes before he left because he had other business to attend to, so John Van Voorhis, Jr., represented the women for much of the hearing. The hearing was held in the Arcade Building.

The first to testify was Edwin T. Marsh, one of the election inspectors who had, with reluctance, allowed Anthony and the other women to register and vote. He said he was 32 years old and had resided in the city for the last 27 years. He said his full-time job was as a letter carrier. He said that he and the other two inspectors on November 5, election day—W.B. Jones[15] and William B. Hall—were on duty when Anthony voted, that he knew who Anthony was when she voted, and that he did not know "what part of the ticket" she voted. This final point was important, because if she did not vote for anyone running for federal office, such as president or congressman, she would not have violated a federal law. She was being charged with the federal crime of violating a state law by voting for a candidate for federal office.

Pound asked, "Was Miss Anthony dressed as a woman and did she have on the apparel of a woman?"

Attorney Van Voorhis objected that the question was "irrelevant and impertinent." Selden at this point was not yet in the hearing room. Van Voorhis added that no one was denying that Anthony had voted. What Van Voorhis seemed to have missed is that Pound's question was probably aimed at the prosecution of Marsh, Jones, and Hall for allowing her to vote. It seemed designed to forestall any claim that the inspectors did not realize that Anthony and the other defendants were in fact female.

Storrs overruled Van Voorhis's objection, and Marsh had to answer. Marsh said, "Yes, her vote was challenged by Sylvester Lewis, a poll watcher for the Democratic Party. It was well known that Anthony and the other women intended to vote mostly, and perhaps entirely, for Republican candidates. After her vote was challenged, he required that the preliminary oath and general oath should be administered. It was administered by B.W. Jones. [The] United States supervisors of election were present."

When cross-examined by Van Voorhis, Marsh said, "Miss Anthony's name appeared properly registered. At the time she offered her vote other ladies who were registered did the same." He said, "Miss Anthony was questioned on the preliminary oath by inspectors" and he didn't "recollect what questions were put to Miss Anthony." He said he heard nothing said by the federal supervisors at the time of voting. "They said something at the time of registry."

The prosecutor, John E. Pound, objected to the answer, saying, "Registry had nothing to do with voting. The charge was for illegal voting, not illegal registering."

Van Voorhis said he "found that the supervisors were required to attend the registry and see that it was properly conducted. The registry was a preliminary to voting under the law."

By now, Selden, Anthony's lead attorney, was back in the courtroom. He read excerpts from the law, claiming they showed that Anthony "had a right to vote." Then he spoke what was to become a key point in his the defense argument. "It must be shown that Miss Anthony had voted knowing that she had no right." Selden "deemed this question important, to determine whether Miss Anthony knowingly committed the offense, if she did commit it." This, of course was normal lawyer talk. My client didn't commit the act she's accused of, and if she did, she had a right to.

Pound, the D.A., said, "No one could be excused from the consequences of a crime on the ground that he or she did not commit it knowingly."[16] Storrs, the commissioner, said the question would be allowed. Pound then asked, "What occurred at the registry when Miss Anthony registered?"

Marsh said, "Miss Anthony registered November first. I found the ladies there when I returned from breakfast. The other inspectors had settled the matter so far as they were concerned. They asked my opinion of it. I said I was satisfied to register them." He said he then met S.J. Wagner, one of two United States supervisors for the election in that voting district, and Wagner asked him, "Ed, did you register those women?" Daniel Warner, the other U.S. supervisor, said, "You will have to register them." Marsh then explained that Warner's comment came "after we decided to put down the names. There had evidently been some discussion before I arrived. They were just putting the oath to Miss Anthony."

Pound pushed the point. "Did you in registering Miss Anthony act in accordance with your best judgment in the matter?" Van Voorhis objected: "The court of appeals held that the officer might testify as to his intent." In New York state, the Court of Appeals is the highest court in the state (there are Supreme Courts, but they are regional and subservient to the Court of Appeals). At this point, however, the hearing was a federal matter, not a state one.

Pound replied, "The charge is against Miss Anthony, and it was her intention that we desire to ascertain. The officers are presumed to act upon their best motives."[17]

Storrs said the question was neither material nor admissible.

Marsh continued, saying he "did not hear much said by Miss Anthony when I came in. Can't say what she said," but that he did "find Miss Anthony's name on the registry checked by me."

Henry Selden

Henry Rogers Selden[18] had a distinguished career in New York politics, but his name would be omitted from most histories of the state if he had not agreed to represent Susan B. Anthony. He was born in Lyme, Connecticut, in 1805, and moved to Rochester when he was 20 to study law with his older brother, Samuel, and his brother's law partner, Addison Gardiner. He was admitted to the bar five years later and started a practice in Clarkson, a small town about 20 miles west of Rochester. He and his wife Laura Anne had five children, three boys and two girls. One of the sons, George, became, in 1895, the first person to receive a patent for an automobile.

Selden started his political life as a Democrat, but his abolitionist beliefs led him to help establish the New York Republican Party in 1856, and in 1860 he was a delegate to the national Republican convention in Chicago that nominated Abraham Lincoln for president and Maine Senator Hannibal Hamlin for vice president.

He was elected lieutenant governor of New York in 1856, and in 1862 was appointed associate justice on the New York Court of Appeals, the state's highest court. He was elected to an eight-year term on the court in 1863, but resigned in early 1865. He served in the State Assembly, representing Rochester, in 1866. After the Civil War, with the end of slavery, and the disappearance of the abolitionist movement, his driving force, he became dissatisfied with politics. By 1872, when Anthony voted, he held no political office and would never again seek one.

The Next Witness

Beverley Waugh Jones was called to testify. Responding to a series of routine opening questions, he said he knew who Susan B. Anthony was, that he was an inspector of elections in the Eighth Ward of Rochester during the last election, that he saw Anthony and other women accused of voting at the voting poll on the morning of the election. That Anthony voted for electors for president, and for candidates for Congress and the state assembly. Referring to the ballots the women filled out, Jones said, "I took the tickets and put them in the respective boxes." He added that Anthony "was challenged by Sylvester Lewis previously at the time of registry." Lewis was a Democratic Party poll watcher. His job technically was to see that everything went according to established legal procedure on election day. Of course, in reality, his job was to make it as easy as possible for Democrats to vote and if legally possible to

interfere with Republican voters. Because of Lewis's challenge of Anthony's right to vote during registration, on the Friday prior to election day, Jones said, "Her name was marked on the registry to be challenged. On offering her vote, I administered the preliminary and general oaths."

Van Voorhis then cross-examined Jones. The witness said in response to the defense questioning that he first saw Anthony on registration day, and that at that time William Hall, the third election inspector, among others, objected to her being allowed to register. Van Voorhis then said that Anthony did not deny who she was, and he added, "We admit that Miss Anthony is a woman."

Pound, the prosecutor, agreed to the stipulation. The point was to move beyond the obvious. Neither Anthony nor any of the other women were being accused of pretending they were men when they registered and voted.

Still, Pound now asked, "How was she dressed?" Van Voorhis objected, saying the question was both "immaterial and impertinent" and assumed that "Miss Anthony intended to commit some fraud." Storrs, however, said the question was admissible. So Jones answered: "She was dressed as a woman."

"What was her general appearance," Pound asked, "as a man or a woman?"

"Miss Anthony made her appearance and asked if this was the place to register to vote," Jones said, not directly addressing the question. "She was told that it was. She said she was a citizen of the United States and desired to be registered. I said I did not think we could register her name. She asked on what grounds. I told [her] the constitution of the state allowed only male citizens the right to suffrage. She asked if I was acquainted with the Fourteenth Amendment of the United States Constitution. I said I was. She said under that she had a right to vote. At this time Supervisor Warner says, 'Young man, how are you going to get around that? I think you will have to register their name.'" Warner was Daniel Warner, one of two U.S. supervisors of elections assigned to the polling place; the other was S.J. Wagner. Jones continued, "She asked if I have seen Ben Butler's reports." She referred to Benjamin Butler, a Republican congressman from Massachusetts, who had written a report saying women have a legal right to vote.[19] "I said no.... At this moment W.B. Hall, one of the inspectors, said he was in favor of registering, and I conceded and we placed the names on the book."

Pound then asked, somewhat ungrammatically, "Was you influenced by what Supervisor Warner said?" Van Voorhis objected. Storrs overruled him.

So Jones answered. "She had taken no oath and had not been challenged. She was challenged on the second day of November." He said the challenge was "noted on register. She took the preliminary oath at the time of voting and made answers. I turned to challenge and asked if satisfied. He said he wanted the whole thing put. I then took the general oath."[20] State law at the time

required that if someone was challenged in regard to casting a ballot, that person would take two separate oaths swearing he believed he had a right to vote.

"In what you did in this matter," Pound asked, "did you act in good faith and in accordance with your best judgment?"

Van Voorhis again objected, and this time his objection was sustained. The inspectors had been charged with the crime of allowing a woman to vote, and Van Voorhis would be representing them, Jones included, in their trial, and he did not want testimony introduced in the Anthony case that could be used against his other clients, although it's difficult to see how any likely answer to this particular question would be damaging to Jones and the two other inspectors of election. More likely, he was concerned with opening up a line of questioning that could damage his clients.

Pound continued. "Did you take counsel of any lawyer between the time of registry and that of voting?" Three days, Saturday to Monday, intervened between the two days referred to.

Jones said he "went to Henry R. Selden, but he advised me not to take his opinion because he was counsel to Miss Anthony." That Jones would go to Selden is not surprising because Selden was both the best known lawyer in Rochester and had been for a long time involved in electoral matters. "He stated his opinion," Jones continued, "that legally they were voters, there was no question about it." It was consistent with Selden's personality that he would first say not to listen to his opinion and then to give it. Jones went on, "I spoke once with Mr. Van Voorhis about it. Spoke to General Martindale before consulting with Mr. Selden." John H. Martindale had been a general in the Union Army in the Civil War. He became a lawyer and was active in Rochester-area politics as a Republican. Jones said he "did not state the case in full" when talking to Martindale, but simply "asked if he thought the women had a right to be registered. He said he thought we had a right to register them. He said that he did not think they had a right to vote. He did not look into the matter. I did not act on his advice. The names were registered before we took any advice." A point that Martindale made, namely that a distinction could legally be made between the right of election inspectors to allow the women to register and any right the women might have to vote, would be much discussed. Few legal minds of the day agreed with it.

The U.S. Commissioner

William C. Storrs, who was presiding over the hearing, was United States commissioner for the Northern District of New York. As commissioner he

had little authority. Storrs, the son and nephew of former members of the U.S. House of Representatives, held the office for 15 years, and if he had not presided at the first legal hearing in the Susan B. Anthony case, he would be lost to history. As U.S. commissioner his role was largely limited to issuing warrants to require people to appear before him, to supervise the questioning of those people by both a federal district attorney and lawyers for the accused, and setting bail to assure that accused persons appeared at future legal proceedings. A commissioner could not find an accused person guilty or not guilty; rather he could determine that there was or was not enough cause to have the person sent before a federal grand jury and that body would then determine if the person should be put on trial. Seldom did a commissioner find that there was not enough evidence to hold someone over for grand jury action. And based on Storrs' action in the Anthony hearing, in which he almost always overruled objections by defense attorneys and almost always sustained objections by the district attorney, there seemed virtually no chance from the opening of the hearing that Anthony's case would not be sent to the grand jury.

Three More Witnesses

Next, James A. Gilman was sworn in, and he testified that he was a clerk in the Eighth Ward on election day, and that he recorded names that an "inspector called out." He said, "I took the name and residence in the list and checked the ticket." He said he knew Anthony "by sight," which, of course, many people in Rochester did. She was the most famous woman in the city. Gilman said he "found her name in the list as having voted. She voted as 'Miss S.B. Anthony, Seven Madison Street.'" He added that "she voted the electoral, state, Congress and assembly" tickets.

Then Sylvester Lewis was sworn in. He was the Democratic Party poll watcher who had challenged Anthony's right to register. In response to routine opening questions, he said that he lived in Rochester, was "a salt manufacturer," and was present in the Eighth Ward polling station on November 5. He said that prior to that, on the days of registration he "had to take poll list and challenge all illegal voters. As the registry was proceeding I caused the word 'challenged' to be written opposite the name of Susan B. Anthony and other women. Saw Miss Anthony vote on the fifth of November. She handed up four ballots." He added, in response to a question from the defense counsel,[21] "Don't know that I have taken much interest in this matter of women voting." He was trying to indicate that his objection was strictly based on Anthony

not being eligible to vote and not on any personal opinion about whether women should or should not be allowed to vote.

Van Voorhis then asked, "Did you go to Mrs. Leyden and advise her to go and register?" Mrs. Leyden was Margaret Leyden, one of the women, along with Anthony, who was charged with voting illegally.

Pound objected, saying the matter was neither material nor within the range of matters covered in his questioning, and thus not subject to cross-examination.

Storrs overruled him, and Lewis answered. "I did not directly advise her to register," he said. "I took a ward canvas for the Democratic party. I took Susan B. Anthony's name on my list. I took all names when anybody desired to have a name down. I took names of all who claimed a right to vote and how they would vote when they would tell me." That, of course, was normal pre-election procedure for party workers; ask potential voters if they intended to vote and how they intended to vote; if they answered both questions, and the worker knew they would vote for the party he worked for, he would remind them to vote on election day and perhaps offer transportation to the polling place. Lewis continued, "I did not give Mrs. Leyden any advice about voting. I do not think that I gave her any advice to register in so many words. I have written articles for newspapers on women voting in answer to some that had appeared. Have written two."

Then Pound asked about any conversation Lewis might have had with Mrs. Leyden, and Lewis said he "did have a talk with Mrs. Leyden on voting at her residence. It was in the latter part of October."

"State the substance," Pound instructed. Van Voorhis objected that the point was "incompetent." Storrs, perhaps surprised by the objection, or simply wanting to take some time to consider it, indicated he would rule on it later. Pound, taking the hint, rested, and Storrs recessed the hearing at 2 p.m.

A half hour later, the preliminary hearing resumed. Van Voorhis called B.W. Jones, one of the inspectors who had testified in the morning session. Van Voorhis asked, "Do you recollect that Mr. Warner asked you if you knew the penalty of not registering these women?" Warner was Daniel Warner, one of the federal supervisors[22] of the election in the ward polling place. Jones said, "He did make that remark."

John Van Voorhis, Jr.

John Van Voorhis, Jr.,[23] had been an attorney for more than two decades, mostly in Rochester, and had a habit of representing the disenfranchised and

powerless. He represented Frederick Douglass and the Seneca Indian nation. He had opposed slavery and favored women's rights. While not quite as well known as Selden, anyone in Rochester who was looking for a lawyer in a case that seemed cause-related was likely to think of Van Voorhis. If it was the right cause. And women's suffrage was indeed the right cause for him.

He was born in 1826 and was 46 years old when he became the attorney representing the election inspectors in 1872 and assisted Selden in his defense of Anthony. He briefly taught school before studying law and opening a practice in Elmira, about 90 miles southeast of Rochester. He moved to the much larger Rochester in 1854 to practice law. Along the way he held a series of political offices. He was a member of the Elmira Board of Education and later was Elmira city attorney. Once in Rochester he managed to get himself appointed federal collector of internal revenue. In 1864 he was a delegate to the Republican National Convention in Baltimore that nominated Lincoln for reelection. (The Republicans used the name National Union Party in 1864.)

After the Anthony trial he would be elected twice to the U.S. House of Representatives, serving there from 1879 to 1883. He was elected again, for one more term, in 1893. In one of those small ironies that history loves to delight in, while in Congress he served on the House Committee on Territories with Richard Crowley, who would be the prosecuting district attorney when Anthony actually went to trial.

Anthony's diary suggests that she consulted at least as often with Van Voorhis as she did with Selden, although she seldom spelled his name correctly.

Susan B. Anthony Testifies

Then Van Voorhis called Susan B. Anthony. "Are you the defendant in this case?"[24]

"I am," she said. She spoke in a clear, even voice, wanting to make her sense of defiance clear. This was, indeed, her play, and now she was center stage, where she most enjoyed being.

"Did you take advice of counsel before registering?"

"I talked with a lawyer about it. Henry R. Selden."

"What did he advise you?" Van Voorhis asked.

"In the first place, he said the only way we could find out what the law was, was by offering our votes."

"Did you consult Judge Selden to learn what you could lawfully do?"

"I went to Judge Selden to sound him," she said, "find whether we would be able to employ him should we want counsel. I think his advice was sound. He did not speak positively. He was like all other people. He had not studied the question. He left me with the impression that in his opinion there was very fair ground for what I intended to do." Using "I" at this point instead of "we" was a way Anthony could offer some slight protection to her co-defendants.

"Had you any doubt as to the legality of the step?" Van Voorhis asked. This question was at the heart of Van Voorhis's plan for the defense of Anthony.

"Not a doubt," she answered.

Pound then rose and asked, "Would you not have made the same effort to vote had you not consulted any lawyer?" He was trying to remove the veneer defense that by following a lawyer's advice she could not have done something wrong.

Anthony was not afraid of any trap. "I should," she said. "After registering I consulted no one, lawyer, man, or minister." She added that she "was not influenced in my action by Judge Selden's advice at all," and that she "went into this matter deliberately to test the question." She added that she had "been determined to vote for a number of years whenever I should be at home thirty days previous to an election." Anthony wanted the world to understand that she had the courage to act on behalf of women's right to vote whether any lawyer stood by her or not. She would not be denied her right to be seen as a woman of courage.

Sylvester Recalled

Van Voorhis then recalled Sylvester Lewis, the Democratic poll watcher. Van Voorhis asked him if he said to anyone "that if these ladies voted you would get as many Greeley women to vote?" Greeley, of course, was Horace Greeley, the Liberal Republican and Democratic nominee for president, who lost to Ulysses S. Grant. The idea of the alleged comment is that since Anthony and the other women were presumed to be voting for Grant, rounding up women to vote for Greeley would in effect cancel out their votes. Ironically, Greeley died on the day this question was asked, November 29, 1872. It seems unlikely that anyone in the courtroom knew about his death at the time of the hearing.

Lewis answered, "I said it would be a good joke if we should get twelve or fourteen Irish women to offset their votes." The assumption of his joke was that recent immigrants tended to vote for Democrats.

John E. Pound

John E. Pound[25] was a minor player in the Susan B. Anthony case. He was federal assistant district attorney for the Northern District of New York, which included Rochester. Pound's office, however, was in Lockport, about 60 miles west of Rochester. Richard Crowley, the district attorney and therefore Pound's boss, sent word to Pound to take care of the preliminary legal steps in the case. Preliminary steps were usually mundane, uninteresting, and seldom attracted much attention from the press or public. When the always politically ambitious Crowley told Pound to take care of the hearing, he undoubtedly thought few people would be interested in what happened. He would have expected a short, routine procedure concluding with the U.S. commissioner sending the case to a grand jury. If he had known how much attention the hearing itself would attract, he would have attended himself, rather than telling Pound to go.

Pound received word so late that he had to attend that he sent word to Commissioner Storrs telling him he couldn't make it the first day, which is why the hearing didn't start until the next day.

Pound was only 29 years old when the hearing was held. After graduating from Brown University in Providence, Rhode Island, he returned to his hometown of Lockport to establish a law practice. He held the position of assistant district attorney for eight years. Once the Anthony case moved beyond the hearing, however, and it was clear that everything about the case would attract national and even international attention, Crowley took over the case, even the most routine matters, and Pound was relegated to being a secondary player.

Recruiting Women Democrats

Van Voorhis then called Margaret Leyden to the witness stand, and she began her testimony by saying she lived in the Eighth Ward, had lived there for 15 years, and she knew Sylvester Lewis.

"Did he advise you to test the matter?" Van Voorhis asked.

Pound objected to the question, saying it was immaterial. Van Voorhis told the court that "Mr. Lewis took the poll list for the Democratic party, and when he found ladies whom he thought would vote his way, advised them to register." He added that Lewis "called at Mrs. Leyden's residence and said the question of her right to vote might as well be tested in the Eighth Ward as anywhere."

Storrs ruled for Pound, and Mrs. Leyden was not allowed to answer the question.

Then a Mr. Garragus[26] was called. He said he lived in the Eighth Ward of Rochester and that he had had "a conversation with Mr. Lewis just before [the] election in reference to women voting."

"What did he say?" Van Voorhis asked.

Pound objected, and Van Voorhis told the court he was "going to prove, namely, that Mr. Lewis had declared he was going to get twenty Greeley women to register late on Saturday evening as an offset to the votes of Miss Anthony and her associates."

Storrs would have none of it. "The evidence seems immaterial in this case," he said.

"Truth crushed to earth will rise again," said Van Voorhis.

Storrs was clearly annoyed. He snapped, "I decide honestly, as near right as I can, and there is no occasion for these tinted comments."

"You don't propose to gag us," Van Voorhis shot back.

"I can scarcely make a decision without hearing uncalled for remarks," Storrs said. "Counsel will proceed with his witnesses."

Why would Van Voorhis unnecessarily irritate Storrs? Perhaps he was playing to the public through the reporters in the courtroom. Perhaps he was frustrated by a hearing that clearly was not going his way. Or perhaps he sensed that he had not served the election inspectors well, three men who were his clients, although not in the proceeding now before him, and that might have flustered him. In any case, it's never a good strategy to annoy the court when you don't have to, and he had nothing to gain, for himself or for any of his clients by doing so this time.

Anthony Recalled

Pound then recalled Susan B. Anthony and asked her, "Did you consult other counsel besides Judge Selden?" Selden immediately objected, and Pound responded, "If the fact that Judge Selden had been consulted was admitted in evidence, there could be no objection to showing that other advice had been taken. However, if counsel for defense didn't wish it known that other counsel had been consulted," he would "not press the matter." And that ended Pound's cross-examination of Anthony. Pound seemed simply to be needling Selden, suggesting that his own client wasn't satisfied with his opinion alone.

The Legal Arguments

Selden then addressed the court with the central part of his argument. "Are these ladies to be held criminally when they imagined they had a

right to vote? The offense must be committed knowingly, according to the statues."

Pound responded with the standard argument against such a view: "It is their business to know the law. Ignorance of the law is no excuse. A man voted once, got drunk, and voted again, and he was held guilty, although he did not remember voting the second time."

Selden was prepared for the response. He said, "If there was any way to get this case before the Supreme Court of the United States I should not desire it to end here, as I now do. But there are too many contingencies against such a result. It could only happen by a disagreement of the circuit judges and by other contingencies besides. However, it don't seem to me there is any possibility of conviction. These ladies did not vote knowingly in contravention of the law."

Pound stressed his key point: "They ought to know the law and are clearly guilty."

Then Van Voorhis spoke: "Are you prepared to dismiss this defendant," he asked Storrs, "or do you wish to hear an argument in the case?"

Storrs said, "I am ready to hear all that may be offered on both sides." Neither Van Voorhis nor Selden wanted to hear that; they wanted Storrs to accept Selden's argument that the belief of Anthony and the other women that they had a right to vote absolved them from having committed a crime.

Van Voorhis said, "Then you must set a time for the hearing as we are not ready for an argument."

The brief exchange hinted at an important difference in the approaches of Selden and Van Voorhis. Selden doubted he could bring the case to the U.S. Supreme Court, which was Anthony's real goal, while Van Voorhis, as focused on the cause as much as on the particular case, was by his nature more optimistic that it could be done.

As the lawyers for both sides discussed a possible date for presenting arguments, Anthony said she "should be engaged in Central Ohio till December tenth."

Pound said sternly, "You are supposed to be in custody all this time." Anthony spoke with some sarcasm: "Oh, is that so. I wasn't aware of it." Anthony viewed Pound, more than two decades younger than her, with a disdain reserved for those who do not automatically respect their elders.

The attorneys and Storrs agreed to complete the arguments on December 18. There was a general agreement that only the Anthony case needed to be heard because a decision in that one would determine the outcome of the cases against the other women. Anthony was pleased with still being center stage.

Then the defendants, the attorneys, and everyone else in the crowded room left.

Hearing Resumes

On Wednesday, December 18, however, the case was postponed until December 23, the following Monday. The office of Commissioner Storrs, where the first session was held, was too small to accommodate everyone who was expected to attend the second session, and the extra time would allow him to make arrangements to hold it somewhere else. The *Democrat and Chronicle* article reporting the postponement said Anthony and the other women were charged with "knowingly violating" the law by voting.[27] Although probably inadvertent, that wording effectively sided with the defense, since the federal district attorney, Pound, argued repeatedly that it was not necessary for Anthony and the others to actually know the law, that as citizens they had an obligation to know it. Van Voorhis and Selden, the defense attorneys, repeatedly argued that the women could not be guilty unless they knew the law and knowingly violated it. Anthony's position was, of course, somewhat different. She argued that indeed she did know the state law forbidding women from voting but that that law was a violation of the national Constitution.

The hearing was resumed on Monday, Dec. 23, 1872, in the Common Council chambers of Rochester City Hall, which could hold more than twice as many spectators as Commissioner Storrs's office. The careless wording of the *Democrat and Chronicle* continued when the newspaper on Monday morning referred to the defendants as "the criminals."

Selden spoke first. As later summarized in the *Democrat and Chronicle,* he said, "Miss Anthony, as well as the other women accused in this case, were tax-payers, and had a right therefore to a voice in the selection of rulers. If they had not at least they believed they had, and consequently their action in voting was void of corrupt intention, the indispensible ingredient of all crime. There had as yet been no conclusive decision as to the question involved in this matter and there was ample room for a divergence of opinion in regard to it." He next argued, according to the newspaper's summation,

> that women were citizens within the scope of the Fourteenth Amendment to the Constitution, and as such entitled to vote, suffrage being one of the distinctive marks of citizenship. The restrictions as to suffrage on account of age, mental infirmity, etc., affect all classes, male and female alike, and had a different justification from that offered for the restrictions on account of sex. As to the test of citizenship drawn from ability for military service ... it would disfranchise old men. Besides, like Florence Nightingale, women were capable of serv-

ice in war fully as important as carrying a musket. The greatest nations in Christendom had been wisely ruled by women. It was scarcely consistent to talk of their being unfit to perform a subordinate duty of citizenship.

Pound's response was as predictable as Selden's. As summarized in the *Democrat and Chronicle*, he said, "Women had not been allowed to vote in any of the states at the time of the adoption of the Constitution. Suffrage was not a natural right but a civil right." He said he had studied the amendments to the Constitution and concluded "that female suffrage was not contemplated or provided for in them." Further, he said, Anthony had testified on the matter of women's suffrage before several committees of Congress and "knew that they had reported adversely to her claims. She must have, therefore, been aware that grave doubts existed as to her right." He then asked Storrs to set bail for Anthony.

Van Voorhis then stood and said several states did in fact allow women to vote on some matters at the time the U.S. Constitution was adopted.

The banter between the prosecutor and the two defense attorneys continued for a while, but then Storrs adjourned the hearing until Thursday at 2 p.m. Storrs's unexpected delay in his ruling merely postponed the inevitable.

Storrs's Decision

The hearing concluded Thursday at 2 p.m. not in the Common Council chambers in Rochester City Hall, but in Commissioner Storrs's office in the Arcade Building. The *Democrat and Chronicle* noted that the women charged with illegal voting "were pretty well represented and a number of their male relatives and friends were also at hand to lend them what aid and comfort they might stand in need of."[28] The atmosphere was friendly. "The office presented rather the appearance of a social gathering than the arraignment of criminals," the newspaper reported.

Storrs got to the point quickly. He said he would "hold each of the accused to bail in the sum of five hundred dollars."

Susan B. Anthony immediately said she would not pay the bail. The unnamed newspaper reporter speculated that "it is probable that some of her associates will follow her example." Anthony was defiant. For her, any opportunity for defiance was an opportunity to stand for her cause.

Storrs was as defiant. He said the session was adjourned until Monday, "when all the ladies accused would be present, and then, if bail is not put in" he "will commit them to Albany jail to await trail."

Elisha J. Keeney, the same deputy marshal who had arrested Anthony a

month earlier, was put in "a sort of informal charge of the prisoners but they remain in reality at liberty until Monday," the newspaper reported. The reporter speculated that there was no doubt that the defendants could raise the bail money.

But Anthony didn't care about her ability to raise the money to keep her out of jail and said she intended to "fight it out on this line if it takes all summer." She said, in fact, she wanted to go to jail.

The reporter said he doubted that Anthony intended to go to jail but that, rather, this was a way of bringing the case to the U.S. Supreme Court. He noted that "the whole affair was conducted in an easy good natured style and the transgressors, for such the law now considers them, seemed to have little of the terror of their evil deeds before their eyes." The reporter added,

> We looked more carefully at the ladies present than perhaps the rules of strict politeness would justify; the majority of them were elderly and matronly look-ing women, with thoughtful faces. The idea suggested itself that many of them were just the kind of persons one would like to see in charge of a sick room—considerate, patient and kindly.... They were all dressed plainly and in the style of garments adopted by their less strong minded sisters. They were distinctively American, there not being so far as we could judge a single foreigner among them. There was no indication in their appearance that any [were] very rich or fashionable ladies belonging to the sacred band. They seemed neither to belong to the poor nor the rich, but to the middle class which is often more intelligent and always more independent than either.

The reporter's judgments were so consistent with Anthony's views and intentions, it likely would not have been much different if she had written them herself.

Buffalo Session

She was next required to appear before Nathan K. Hall, a federal district judge who rode circuit in upstate New York, holding sessions in cities from Buffalo to Albany. On January 10, 1873, he was holding court in Buffalo, 70 miles west of Rochester. Anthony and Selden arrived in his courtroom at 10:30 a.m. and sat impatiently while a bankruptcy case was heard. Patience was not one of Anthony's virtues, and she sat and stewed. Finally, the bankruptcy case adjourned, Selden and Richard Crowley, the U.S. District Attorney for North-ern New York, approached the bench, and they and Hall conferred. And con-ferred. And conferred. As lawyers and judges are prone to do. Then Hall retired to his chambers for a while, then came out, and then said the case was adjourned until January 21. The problem was that Crowley had told Hall he

wasn't yet prepared to present the government's case. And, as if Crowley and Hall were determined to endlessly irritate the easily irritated Anthony, she learned that on January 21, Hall would be holding court in Albany. Two hundred and twenty-five miles east of Rochester.

Well, Anthony could play the irritation game, too.

She was technically under arrest. Most arrestees who had not paid bail would, in fact, be in jail. Deputy Marshal Keeney, however, was, for reasons that are unclear, not willing to actually take her into custody. He might have been following orders. Or suggestions from higher ups. Or, most likely, he was selected for the job because he possessed a combination of discretion and judgment that would not embarrass federal officials with heavy handedness or impulsiveness in a case that was attracting national, even international, attention. Millions of women in America and Europe and South America, all around the globe, found her actions admirable, regardless of what they thought of her personality. She, more than any woman in history, had come to symbolize equal treatment for the sexes.

The country had fought a war to end enslavement of blacks in America, and the European powers, as much as they may have wanted to weaken the growing military and economic might of an ever-expanding United States, could not enter the war to help split that nation in two because their citizens would not allow them to. And now that same country was in a struggle over what rights a woman should have, and especially over whether a woman should be allowed to vote, and too many women, and probably just as many men, sided with more rights for women. The tide of history was with Susan B. Anthony, and poor Elisha J. Keeney had the difficult, unenviable, probably impossible task of keeping Susan B. Anthony under arrest without actually taking her into custody, and without making Americans and the world believe the United States had less respect for the rights of women than it did for the rights of the recently freed slaves.

Elisha J. Keeney

Poor Elisha J. Keeney.[29] Mostly because of Susan B. Anthony's characterization of him, he has come down through history as an unlikable and not particularly competent police officer. Yet he clearly tried to be polite in what he considered the unpleasant task of arresting a woman because she voted. He gave her time to change clothes and offered to allow her to go to the U.S. commissioner's office on her own and refused her request, close to a demand, that he put handcuffs on her. Anthony wrote that he was a young man, but he was

63 when he arrested her, more than a decade older than she was at the time. He died May 11, 1874, a year and a half after arresting Anthony.

In 1849 he was a constable in the Rochester Police Department. He would later serve as the city's chief of police twice, once in 1856 and again in 1859, each time for a year, holding the office while the two different mayors who appointed him remained in their office. In 1861 he was a police officer.

On the same day he arrested Anthony, Keeney also arrested three men who were charged with using forged naturalization papers in order to register to vote in the city's Fifth Ward. The names of two of the men are known, Hugh Kelly and William Falconer, because Storrs ordered both held for further legal action.

Keeney was a man of modest success. His last will and testament left his home to his wife, Mary Ann, and divided the rest among his two living brothers and sister and children of two deceased brothers. He also left $2,000 to his wife's niece, who was living with him and his wife when he died, and a $1,000 life insurance policy, from Guardian Mutual Life Insurance Company, which he had taken out about two and a half years before he died.

A Symbolic Champion

The next day, January 11, Anthony walked from her home, south on Madison, turned left, and walked a third of a mile east on West Avenue, and arrived at the train station. Keeney, who knew of her plans, was there to meet her. He asked her where she was going. New York and Washington. He told her she could not go, that she was in his custody, and, more with body language and facial expressions than words, she said, just try and stop me. She boarded the train, and Keeney, who could have handcuffed her and taken her to jail, stood by and watched. Her defiance and his discretion prevented the United States from being embarrassed in the eyes of the world.

Besides, everyone knew she was not fleeing, that she fully intended to appear in Albany on January 21. It would be an opportunity for courtroom drama, and Susan B. Anthony never passed up an opportunity for drama.

She went to Washington, D.C., and spoke at Lincoln Hall before the National Woman's Rights Association, where she was treated with admiration, warmth, appreciation, and something close to worship. Now, for the first time in its history, the American women's rights movement had a symbolic champion. Nothing had ever energized the women of the movement as the arrest of Susan B. Anthony for the simple act of voting. The energy was evident in the speeches in her honor, including a very long one from her friend Elizabeth

Cady Stanton, in the auditorium and hallway conversations, which focused more on Anthony and her act than on anything else, and in the way so many women, and men, approached her, wished her well, asked her questions. Congratulated her. It's not often someone is congratulated for being arrested. Susan B. Anthony had achieved heroic status.

Nothing could have helped her more to achieve that status than her arrest, unless, perhaps, Deputy Marshal Keeney had indeed handcuffed her, either when he first met her in the parlor of her Madison Street home or weeks later at the train depot in Rochester. But Keeney was either too kind hearted or too smart to do that. Probably both.

The Albany Hearing

Anthony enjoyed, cherished, her new status and wanted more. An opportunity for more, she was certain, would soon present itself. In Albany.

She went back to Rochester and then to Albany for the January 21 court proceeding. The purpose of the hearing was to discuss a filing by Anthony's attorneys for a writ of habeas corpus, that is, a court order releasing Anthony from her arrest.[30] Her hope, and the plan of her attorneys, Selden and Van Voorhis, who were both in Albany with her, was that the sitting federal judge, Nathan K. Hall, would grant it or would agree to send it to the U.S. Supreme Court.

If either court granted it on the basis that the original arrest was not justified because Anthony had, in fact, a constitutional right to vote, the legal proceedings would have been over, and women in America would have won the right to vote. It is, of course, possible that either court could have granted it on some other legal ground, some technicality perhaps, but none were mentioned during the proceedings. Although some later commentators believed granting of the writ by a federal court would have resulted in women winning the right to vote, it seems extremely unlikely that any judge would have issued the writ on that grounds, simply because the momentousness of the issue clearly required a more direct review, a review that took into consideration the historical significance of what was unfolding. This was more than freeing one woman from her arrest. It was freeing all American women from the yoke of being forbidden a direct voice in who represented them in their government.

The hearing was held in a federal courtroom in the Albany City Hall. Anthony's case was presented by Selden. Van Voorhis was not present. He wouldn't show up at the building until the procedure had been completed. If he had been there earlier, things might have turned out differently.

Anthony sat and listened to Selden as he made her case, and she was pleased with the arguments he used. They were the same arguments she had used over and over. Anthony should be freed from her arrest, he said, for two reasons. First, by voting she had not committed a crime but had rather performed a civic duty, something she and other women, just like men, were entitled to do as citizens of the United States; something she in fact should be praised for, not arrested for, and the 14th Amendment to the Constitution said she had a right to vote. Every citizen, Selden said, had a right, indeed a duty, to use the ballot to help decide who makes the laws we all have to live by. Second, he said, even if she did not have any such right, she acted in good faith because she believed the 14th Amendment gave her that right. And since that meant her intention was not "corrupt," she was not committing a crime.

Hall listened, was not impressed, and issued his ruling. The writ was denied. And the $500 bail that had been set by Commissioner Storrs in Rochester was increased to $1,000.

She lost, but that didn't bother Anthony. She told the court she would not pay the $1,000 and that Hall should send her to jail. Anthony always enjoyed her defiance.

Selden did not want to see Anthony go to jail, and told her there are times when the client, like it or not, must follow the advice of her attorney. And he paid the bail with his own money. Anthony was now free to leave the courtroom. She did leave, and Selden stayed to take care of some paperwork.

As she exited the room, Anthony saw Van Voorhis, and she told him what had happened, how Selden had been so kindhearted as to pay her bail.

Van Voorhis was incredulous. He told her, "You have lost your chance to get your case before the Supreme Court by writ of habeas corpus." If she was not in jail, there was no legal need for the writ.

Anthony had consistently asked Selden and Van Voorhis to explain their legal maneuverings to her, but she usually allowed them to make the decisions, as long as the heart of the case reflected her own views. Suddenly, in talking to Van Voorhis, she realized she had made a mistake. She had misunderstood what had happened in the courtroom. As if she was swallowing vinegar, a sense of frustration filled her.

She turned and walked as fast as she could back into the courtroom. She wanted to confront Selden, demand to know why he had done what he had done. Oh, yes, it was intended as an act of kindness, even of gallantry, but it was one more example of why male gallantry was so damaging to females. She

had allowed her own ignorance of the technicalities of the law to distort her view of what had happened. She told him not to pay the bail, but he said he already had, and she told him to get it back, and he said that couldn't be done, the payment was made, the issue was moot.

"Did you not know," she demanded of this man she both admired and considered a friend, "that you had estopped me from carrying my case to the Supreme Court?" "Yes," he said softly, "but I could not see a lady I respected put in jail."

She could have quickly taken her case to the United States Supreme Court, because requests for writs denied in lower federal courts were given almost immediate review by the high court, on the theory that if a person is improperly held in jail, the quicker he or she is released the better justice is served. But Selden, his 19th Century sense of chivalry guiding him, had taken that away from her. Selden was guilty of not fully informing his client of the consequences of his action, and he clearly failed her in that regard. It was her decision to make, not his.

The next day, Anthony spoke before a state commission in Albany that was considering a revision of the New York Constitution. She spoke of the need to include revisions that would guarantee the rights of women. Selden and Van Voorhis were both in the audience, and when she was done, Selden told her, "If I had heard this address first I could have made a far better argument before Judge Hall." It was another act of chivalry by Selden, one of politeness, but this one did no harm.

Nathan K. Hall

Nathan Kelsey Hall was 61 years old when he ruled that Susan B. Anthony was to be held over for grand jury action.

Hall was born in Marcellus, a small town about 80 miles east of Rochester. As he approached adulthood he worked as a shoemaker and a farmer, but finally chose to study law in Buffalo, where he was befriended by Millard Fillmore, who would shape his political life. He served as Fillmore's law clerk and then became his law partner. He was elected to the state Assembly, then to the U.S. House of Representatives. His mentor, Fillmore, meanwhile, was elected vice president, and when President Zachary Taylor died after just 16 months in office, became the nation's chief executive.

Fillmore appointed Hall postmaster general, a position he held for two years, then named him a federal judge for the northern district of New York. He remained a federal judge for 24 years, until two years after

he presided in the Albany hearing in the Anthony case, until he died at age 62, three weeks before his birthday. An assumption made by many involved in the case was that Hall would be the presiding judge in any trial of Anthony.

The Grand Jury

On the same day Anthony appeared in court, Tuesday, January 21, 1873, Crowley, the federal district attorney, presented the grand jury convening in Albany City Hall his charges against Anthony. And the grand jury, consisting of 20 men, no women, returned a true bill against her, saying in effect that they agreed with the federal district attorney that the accused, Susan B. Anthony, probably did commit a crime and should be brought to trial.[31]

She was not charged with the crime of voting for governor, lieutenant governor, canal inspector, or prison inspector, because those were state officers and voting for them was not a violation of federal law, and no state official saw fit to charge her with such a crime. Nor was she, oddly, charged with the crime of voting for president.

Although the indictment did not specifically mention it, she was charged with violating what became known as the Enforcement Act of 1870, which was intended to protect black voters in the former states of the Confederacy. It forbade anyone from voting in a contest for Congress, either the House or Senate, who was not eligible to vote, from voting more than once for the same office in the same election, from impersonating another person in order to vote, and a long list other possible ways to commit voting fraud. State laws, which of course differed from state to state, would determine whether a person was legally eligible to vote. The idea was to prevent Southern whites from voting so frequently that they negated black votes.

Since Anthony lived in a state, New York, that like all other states, had legislation that did not permit a woman to vote, she had, by voting for someone for Congress, violated a federal law. Anthony's argument had been and would continue to be not that she did not commit the crime, but rather that the state legislation violated the 14th Amendment to the U.S. Constitution, and therefore she did not violate the federal Enforcement Act of 1870.

Crowley's indictment, the grand jury's true bill, contained two counts. One was for voting for members of Congress. The second was for voting for candidates for Congress.

Summation

Susan B. Anthony had gone to register on November 1, 1872, expecting to be turned away and planning to then sue, claiming she had a constitutional right to register because she had a constitutional right to vote. But she played her role too well, and to her surprise, she was allowed to register.

On November 5, 1872, she went to the polling place not certain if she would be allowed to vote, but she was.

When she was charged with the crime of voting and arrested, she hoped her case would go to the U.S. Supreme Court. One plan was that her lawyers would seek a writ of habeas corpus to have her released from a jail that, in reality, she was never put in. But her kind-hearted attorney, against her wishes, paid her bail, so then there wasn't even the make believe jail to free her from. She was indicted.

Now she would have to face an all-male jury. Her next plan was to persuade jurors ahead of time to find her not guilty. Not because she had not committed the act of voting, but because the Constitution said she had a right to vote. The always confident Anthony had no doubt she could convince 12 men, true and good, to nullify the state law under which the federal prosecutor had charged her.

In Her Own Time

History would be kind to Susan B. Anthony, would view her act of defiance, her act of voting, as an act of heroism, an act for which she should be and has been honored. However, too often an admirable act is not viewed with kindness or sympathy by contemporaries. And some of Anthony's contemporaries viewed her act with disrespect, even disdain. But it would be a mistake to think that was the norm. While no public opinion polls existed at the time, a sizeable volume of public comment supports the view that Anthony's contemporaries, men and women, common folk and intellectuals, Democrats and Republicans, considered her act both courageous and honorable. A sampling of editorial commentary should suffice to make the point.[32]

The *New York Commercial Advertiser* praised her indirectly by praising her attorney:

> When a jurist as eminent as Judge Henry R. Selden testifies that he told Miss Anthony before election that she had a right to vote, and this after a careful examination of the question, the whole subject assumes new importance.... How grateful to Judge Selden must all the suffragists be! He has struck the strongest and most promising blow in their behalf that has yet been given. Dred Scott was

the pivot on which the Constitution turned before the war. Miss Anthony seems likely to occupy a similar position now.

The New York Sun criticized the U.S. government for prosecuting her:

> The arrest of the fifteen women of Rochester, and the imprisonment of the renowned Miss Susan B. Anthony, for voting at the November election, afford a curious illustration of the extent to which the United States government is stretching its hand in these matters. If these women violated any law at all by voting, it was clearly a statute of the State of New York, and that State might safely be left to vindicate the majesty of its own laws. It is only by an over-strained stretch of the Fourteenth and Fifteenth Amendments that the national government can force its long finger into the Rochester case at all.

In Ohio, the *Toledo Blade* praised her leadership:

> Whatever may be said of Susan B. Anthony, there is no doubt but she has kept the public mind of the country agitated upon the woman's rights question as few others, male or female, could have done. She has displayed very superior judgment and has seldom been led into acts of even seeming impropriety. She has won the respect of all classes by her ability, her consistency and her spotless character, and she today stands far in advance of all her co-workers in the estimation of the people. The fact that she voted at Rochester at the presidential election has created no little commotion on the part of the press, but if women are to become voters, who but the one who has taken the lead in the advocacy of that right should be among the first to cast the vote?

Her hometown Rochester *Evening Express* offered outright admiration:

> We pause in the midst of our pressing duties to admire the zeal and courage which find in the course of these ladies a challenge to battle, while evils a thousandfold worse, such as bribery, etc., are permitted to pass unnoticed.... The ladies who voted in this city on the 5th of this month did so from the conviction that they had a constitutional right to the ballot. In that they may or may not have been mistaken, but they certainly can not be justly classed with the ordinary illegal voter and repeater. The latter always vote for a pecuniary consideration, knowingly and intentionally violating our laws to get gain. The former voted for a principle and to assert what, they esteem a right. The attempt by insinuation to class them among the ordinary illegal voters will react upon its movers.

Susan B. Anthony was admired as much for voting when she committed the act as she would be a century and more later.

4

The Speech

Expecting to lose in court if her case were tried strictly on the facts, Susan B. Anthony commenced a months-long attempt to convince any man who might be on a Monroe County jury to engage in jury nullification. That is, she told whoever would listen, if you end up on the jury in my case, and you believe I am guilty based on the facts, you should still find me not guilty because you should believe, as I do, that the law under which I am charged is a violation of the Constitution of the United States.

Jury nullification has a proud history in United States jurisprudence.[1] The tradition of jury nullification actually predates the country. In 1670 the colony of Massachusetts charged a group of Quakers with violating a law that said only the Church of England could hold religious meetings. A jury acquitted them. In 1735, Peter Zenger was arrested in New York for criticizing public officials in print. A jury acquitted him. Another colonial jury ignored a law that said all trade between the colonies had to pass through England so it could be taxed. Colonial juries valued freedom of religion, the press, and trade more than the government did and nullified the offending laws.

In the 20th and 21st centuries, jurors often nullified laws in drug cases when they thought punishments were too harsh for minor offenses. During the Vietnam War, draft dodgers and protestors were sometimes freed by jurors sympathetic with their anti-war views. But at no time in American history has jury nullification been more praised by later generations as in the pre–Civil War days when many jurors, upset with the Fugitive Slave Act of 1850, which required that Northerners cooperate with Southern slave catchers, routinely refused to convict anyone accused of helping a slave to escape.

Susan B. Anthony was familiar with juries nullifying the law in opposition to the Fugitive Slave Act, and she admired the jurors involved. She

knew about what became known as the Jerry Rescue on October 1, 1851, in which a mob broke into a building where a 40-year-old fugitive slave named William Henry, but who called himself Jerry, was being held while paperwork authorizing slave catchers to return him to Missouri was being processed. The mob freed him and he was eventually led to Canada. Twenty-six men in the mob were arrested and charged with various crimes, but juries refused to convict 25 of them. The Jerry Rescue occurred in Syracuse, just 90 miles east of Rochester.

She was also familiar with the Anthony Burns case in 1854 in Boston. Burns, who had escaped slavery in Virginia, was captured by slave catchers while walking down a street in Boston. President Franklin Pierce, determined to placate the South, sent in federal troops to escort Burns from jail to a ship that took him back to Virginia and slavery. An angry Boston mob, mostly white, attacked federal officials after the ship left, and a U.S. marshal was stabbed to death. Three men were charged with murder, and juries found one not guilty, while the trials of the other two resulted in hung juries, and the federal government eventually dropped the charges. Burns' freedom was later purchased by sympathetic whites in Boston, and he eventually moved to Canada.

Anthony's Quaker upbringing would not allow her to condone the violence in these and similar cases, but she admired jurors who judged as unfair and reprehensible a law she found repugnant, and she admired the jurors for their courage.

She was not alone in her defense of jury nullification. As early as 1794, in the case of *Georgia v. Brailsford*, John Jay, the first chief justice of the U.S. Supreme Court, said,

> It may not be amiss, here, gentlemen, to remind you of the good old rule that on questions of fact, it is the province of the jury, on questions of law, it is the province of the court to decide. But it must be observed that by the same law, which recognizes this reasonable distribution of jurisdiction, you have nevertheless a right to take upon yourselves to judge of both, and to determine the law as well as the fact in controversy. On this, and on every other occasion, however, we have no doubt, you will pay that respect, which is due to the opinion of the court, for, as on the one hand, it is presumed, that juries are the best judges of facts, it is, on the other hand, presumable, that the court are the best judges of the law. But still both objects are lawfully within your power of decision.

Jay's comment has been quoted for centuries as a defense of jury nullification. We cannot be certain Susan B. Anthony was familiar with the quote, but we can be certain she was familiar with the sentiment, and that she agreed with it. And she intended to exploit it.

So she brought her message to Brockport and Spencerport in western Monroe County, where Rochester is located. And to Webster in the eastern part of the county. And Pittsford, just south of Rochester. To Churchville and Hilton and Honeoye Falls. To 29 towns around the county. And when she learned her trial, because of her speeches, would be moved out of Monroe County to Canandaigua in neighboring Ontario County, she made the same speech there. In Victor and Farmington, and Canandaigua. And Geneva and Phelps. Twenty-nine locations in Monroe County, 21 in Ontario County.

Her speech varied a little from place to place, but most of it was the same wherever she spoke. She opened with "Friends and fellow-citizens," reminding her audience that she was a neighbor and, like them, an American citizen.[2] "I stand before you tonight, under indictment for the alleged crime of having voted at the last presidential election without having a lawful right to vote. It shall be my work this evening to prove to you that in thus voting I not only committed no crime, but, instead, simply exercised my *citizen's right,* guaranteed to me and all United States citizens by the national constitution, beyond the power of any state to deny."

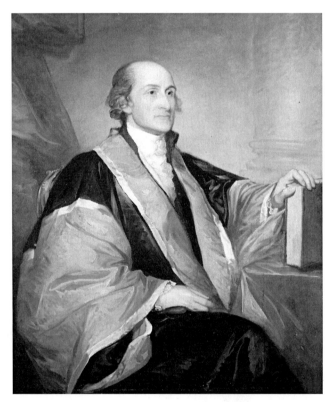

The first Chief Justice of the United States Supreme Court, John Jay, once spoke in favor of jury nullification, or the right of a jury to find an accused person not guilty because the jurors believe the law is unfair. Prior to her trial, Anthony urged potential jurors to do the same thing (painting by Gilbert Stuart, National Gallery of Art).

The opening paragraph of her standard speech thus succinctly captured her situation. Much of what followed, however, roamed among the pedantic, irrele-

vant, legalistic, and anger-strewn. Her standard second paragraph is an example:

> Our democratic-republican government is based on the idea of the natural right of every individual member thereof to a voice and a vote in making and executing the laws. We assert the province of government to be to secure the people in the enjoyment of their unalienable rights. We throw to the winds the old dogma that governments can give rights. Before governments were organized, no one denies that each individual possessed the right to protect his own life, liberty and property. And when a hundred or a million people enter into a free government they do not barter away their natural rights. They simply pledge themselves to protect each other in the enjoyment of them through prescribed judicial and legislative tribunals. They agree to abandon the methods of brute force in the adjustment of their differences and adopt those of civilization.

She quoted the Declaration of Independence, the Constitution, and the Articles of Confederation, speaking with sweeping statements, like a painter using an overly broad brush, about the authors of those documents, cited numerous legal cases, and overall sounded like a college professor lecturing freshmen in an introduction to American government class.

She said the Declaration of Independence "implied" the right of "the whole people to vote," making it clear that "the whole people" included women.

She quoted Luther Martin, a founding father who refused to support the Constitution because he felt it gave too much power to the national government, and James Madison, the principal author of the Constitution, as saying everyone should have an equal vote, suggesting, but not quite implying, that they advocated the right of women to vote. She thus came close to quoting both out of context, since neither ever called for giving the vote to females. She said, "Thus, at the very beginning, did the fathers see the necessity of the universal application of the great principle of equal rights to all—in order to produce the desired result—a harmonious union and a homogeneous people." By universal rights, however, Martin and Madison meant giving the vote to all adult men, not to all adults.

She quoted Thaddeus Stevens, the powerful Civil War senator from Pennsylvania, in the same manner. But when she got to B. Gratz Brown, who had been U.S. senator and governor of Missouri, and a losing candidate for vice president of the U.S., she was quoting someone who actually strongly argued for the right of women to vote. In 1866, speaking for the right of women in the District of Columbia to vote, he said, "I stand for universal suffrage, and as a matter of fundamental principle do not recognize the right of society to limit it on any ground of race or sex."

She even quoted the New York State Constitution, noting that it says, "We, the people of the State of New York, grateful to Almighty God for our freedom, in order to secure its blessings, do establish this Constitution." If the "people" establish the constitution, her argument went, the people, including women, must have the right to vote for who will govern them. The oddness, if not the irony, is that the laws of that same state said she couldn't vote, and thus when she did vote, according to the federal indictment against her, she committed a crime.

A stronger point was that the state constitution specifically enumerated who could be excluded from voting: "all persons who have been or may be convicted of bribery, larceny or any infamous crime." It did not list women among those who could be excluded. The New York Constitution also said no one could be excluded from voting because of residing in "any alms house, or other asylum, at public expense, nor being confined at any public prison." Even those in prison, if not yet convicted of a crime, could not be denied the right to vote.

She did note that the state constitution said, "Every male citizen of the age of twenty-one years" could vote. But, as she noted, even this did not specifically deny women the right to vote, because the document also said, "No member of this State shall be disfranchised, unless by the 'law of the land,' of the judgment of his peers."

Her reasoning became a little weaker after that when she claimed the phrase "the law of the land" meant the national, not the state, constitution. As for the word "peers," she said, if a woman is disenfranchised, only other disenfranchised women were her peers and therefore only they could be allowed to disenfranchise her. Her logic, at best, was parsing. At worst it was word manipulation. Throughout her decades of arguing for the right of women to vote, Anthony was strongest when making moral arguments, weakest when making legal ones. She did, however, make a notable connection between the moral and legal arguments when she told her audiences, "No barriers whatever stand today between women and the exercise of their right to vote save those of precedent and prejudice." That is, the moral right women had to vote was blocked only by legislation based on precedent and prejudice.

She quoted with approval Charles Sumner, leader of the Radical Republicans in the U.S. Senate. Sumner had said, "Qualifications cannot be in their nature permanent or insurmountable. Sex cannot be a qualification any more than size, race, color, or previous condition of servitude. A permanent or insurmountable qualification is equivalent to a deprivation of the suffrage. In other words, it is the tyranny of taxation without representation, against which our revolutionary mothers, as well as fathers, rebelled."

She attacked the grammatical logic of her opponents by saying, "But, it is urged, the use of the masculine pronouns *he, his and him,* in all the constitutions and laws, is proof that only men were meant to be included.... If you insist on this version of the letter of the law, we shall insist that you be consistent and accept the other horn of the dilemma, which would compel you to exempt women from taxation for the support of the government and from penalties for the violation of laws."

She noted that "the poor widow who keeps a boarding house, manufactures shirts, or sells apples and peanuts on the street corners of our cities is compelled to pay taxes from her scanty pittance." She had a solution to that clear case of taxation without representation. She called for civil disobedience. "I would that the women of this republic at once resolve never again to submit to taxation, until their right to vote be recognized."

An Hour-Long Talk

Her typical delivery of this talk took more than an hour, and it's hard today to imagine how an audience of farmers and tradesmen and housewives could sustain their attention to her often rambling oratory. But this was the 1870s, before television and radio and personal computers, before technology shortened our attention spans to minutes rather than hours. And the principal entertainments were live—theater, singers, orchestras, and, of course, speakers. And although all of the dozens of towns she spoke in were in Monroe and Ontario counties, most residents there had never seen her. And she was a celebrity. Among the most famous women in America. All that would encourage a longer attention span. These audiences had little difficulty in staying to the end, and in not just hearing but actually listening.

Women Who Refuse to Pay Taxes

Anthony delighted in telling the stories of women who had successfully rebelled against unfair taxation:

> Miss Sarah E. Wall of Worcester, Massachusetts, twenty years ago, took this position. For several years, the officers of the law distrained her property and sold it to meet the necessary amount. Still she persisted, and would not yield an iota though every foot of her lands should be struck off under the hammer. And now for several years the assessor has left her name off the tax list, and the collector passed her by without a call. Mrs. J.S. Weeden of Viroqua, Wisconsin, for the past six years, has refused to pay her taxes though the annual assessment is seventy-five dollars. Mrs. Ellen Van Valkenburg of Santa Cruz, California, who

sued the county clerk for refusing to register her name, declares she will never pay another dollar of tax until allowed to vote. And all over the country women property holders are waking up to the injustice of taxation without representation and ere long will refuse *en masse* to submit to the imposition.

Such civil disobedience excited Anthony and she hoped it would excite the audiences that came to hear her speak.

"There is no *she,* or *her,* or *hers,* in the tax laws," she noted. She added, "The same is true of all the criminal laws." She quoted, a bit inaccurately, the Fifth Amendment to the U.S. Constitution: "No person shall be compelled to be a witness against *himself.*" (The words "in any criminal case" were left out of her quote, but that does not change its meaning in the context she used it.)

Anthony pointedly told her audiences about a bit of linguistic manipulation in the legal case against her:

> The same with the law of May thirty-first, eighteen seventy, the nineteenth section of which I am charged with having violated. Not only are all the pronouns in it masculine, but everybody knows that that particular section was intended expressly to hinder the rebels from voting. It reads, "If any person shall knowingly vote without *his* having a lawful right," etcetera. Precisely so with all the papers served on me—the U.S. marshal's warrant, the bail-bond, the petition for habeas corpus, the bill of indictment—not one of them had a feminine pronoun printed in it, but, to make them applicable to me, the clerk of the court made a little carat at the left of "he" and placed an "s" over it, thus making *she* out of *he.* Then the letters "is" were scratched out, the little carat under and "er" over, to make *her* out of *his,* and I insist if government officials may thus manipulate the pronouns to tax, fine, imprison and hang women, women may take the same liberty with them to secure to themselves their right to a voice in the government.

This was her strongest argument, the unfairness of the law. This was what she wanted the men in her audiences to think about, and if they should become members of the jury in her trial, this is what would lead them to engage in jury nullification.

She went on and on, citing one example after another of laws discriminating against women, and while seeming ponderous at times, her argument accumulated the weight of repetition, undoubtedly convincing any fair minded member of her audiences of the extent to which America's legal systems put women at financial and political disadvantages. And then she cited the U.S. Constitution: "Whatever room there was for a doubt, under the old regime, the adoption of the Fourteenth Amendment settled that question forever in its first sentence: 'All persons born or naturalized in the United States and subject to the jurisdiction thereof, are citizens of the United States and of the state wherein they reside.'"

She added, "And the second settles the equal status of all persons—all

citizens: 'No state shall make or enforce any law which shall abridge the privileges or immunities of citizens; nor shall any state deprive any person of life, liberty or property, without due process of law, nor deny to any person within its jurisdiction the equal protection of the laws.'"

The intent of the 14th Amendment, of course, was to protect former slaves from discrimination in Southern states, but the wording is what counts, as many court cases have demonstrated. A law, the courts have ruled, means what its words say, not what they were intended to say.

She cited three dictionaries—Webster, Worcester, and Bouvier[3]—to prove her point that a citizen is someone "entitled to vote and hold office." She noted that even in the infamous Dred Scott decision, a ruling Anthony abhorred, Chief Justice Roger Taney had said, "The words 'people of the United States,' and 'citizens,' are synonymous terms, and mean the same thing. They both describe the political body, who, according to our republican institutions, form the sovereignty, and who hold the power and conduct the government, through their representatives. They are what we familiarly call the sovereign people, and every citizen is one of this people, and a constituent member of this sovereignty." His Dred Scott decision was based on the court's conclusion that African Americans were not "people." No court ruling had ever said women were not people, Anthony argued, and thus they could not constitutionally be denied the right to vote.

The 14th Amendment declared that blacks were people and thus entitled to the same rights as whites. And Anthony's argument was that the same amendment declared that women, although not specifically mentioned, had the same rights.

She did note Edward Bates, Lincoln's first attorney general, had said something different. According to Bates, "The constitution uses the word 'citizen' only to express the political quality, not equality mark, of the individual in his relation to the nation, to declare that he is a member of the body politic and bound to it by the reciprocal obligations of allegiance on the one side and protection on the other. The phrase, 'a citizen of the United States,' without addition or qualification, means neither more nor less than a member of the nation." Anthony rejected that logic, calling it "this base conclusion."

But Bates' base conclusion would later haunt Susan B. Anthony and the women's suffrage movement. It was an omen of legal setbacks to come.

Anthony went on, citing an argument against her position and refuting it, quoting a male supporter of her logic and praising him, repeating points, insisting on the rightness of her goal, and sometimes ascribing base motives to her opponents. The 15th Amendment, she argued, was not made part of

the Constitution to secure rights for blacks but rather to help Ulysses S. Grant get reelected. Blacks would, from gratitude, vote for him.

And, she said, only base outcomes could result if the 14th Amendment was not interpreted as she thought it should be. "It will not always be men combining to disfranchise all women," she argued, but "native born men combining to abridge the rights of all naturalized citizens ... it will not always be the rich and educated who may combine to cut off the poor and ignorant, but we may live to see the poor, hardworking, uncultivated day laborers, foreign and native born, learning the power of the ballot and their vast majority of numbers, combine and amend state constitutions so as to disfranchise the Vanderbilts and A.T. Stewarts, the Conklings and Fentons."[4] She compared women to slaves:

> By the law of Georgia, South Carolina, and all the states of the South, the Negro had no right to the custody and control of his person. He belonged to his master. If he was disobedient, the master had the right to use correction. If the Negro didn't like the correction, and attempted to run away, the master had a right to use coercion to bring him back. By the law of every state in this Union today, North as well as South, the married woman has no right to the custody and control of her person. The wife belongs to her husband; and if she refuses obedience to his will, he may use moderate correction, and if she doesn't like his moderate correction, and attempts to leave his "bed and board," the husband may use moderate coercion to bring her back.

Equating women with slaves may have been startling for some members of her audience, but not for most. The argument had been made repeatedly by Anthony and Elizabeth Cady Stanton, and others. It was a familiar and powerful argument.

She cited several examples of injustices to women that, she believed, would not exist if women had the political power that went with the right to vote. One example concerned false teeth.

> A good farmer's wife near Earlville, Illinois, who had all the rights she wanted, went to a dentist of the village and had a full set of false teeth, both upper and under. The dentist pronounced them an admirable fit, and the wife declared they gave her fits to wear them, that she could neither chew nor talk with them in her mouth. The dentist sued the husband. His counsel brought the wife as witness. The judge ruled her off the stand, saying "a married woman cannot be a witness in matters of joint interest between herself and her husband." Think of it, ye good wives, the false teeth in your mouths are joint interest with your husbands, about which you are legally incompetent to speak.

She gave another example, this one involving a sidewalk in New England.

> In Ashfield, Massachusetts, supposed to be the most advanced of any state in the union in all things humanitarian as well as intellectual, a married woman was

severely injured by a defective sidewalk. Her husband sued the corporation and recovered thirteen thousand dollars damages. And those thirteen thousand dollars belong to him *bona fide,* and whenever that unfortunate wife wishes a dollar of it to supply her needs she must ask her husband for it, and if the man be of a narrow, selfish, niggardly nature, she will have to hear him say, every time, "What have you done, my dear, with the twenty-five cents I gave you yesterday?"

The conclusion to draw, she felt, was clear. "The entire womanhood of the nation is in a condition of servitude as surely as were our revolutionary fathers when they rebelled against old King George. Women are taxed without representation, governed without their consent, tried, convicted and punished without a jury of their peers." What was needed, what was justified, she implied, was nothing less than a revolution.

As her talk progressed, and especially as it neared its conclusion, her words became deliberately more inflammatory. Minutes short of her concluding remarks she said, "To talk of freedom without the ballot is mockery, is slavery, to the women of this republic."

To assure there was no doubt about what she very specifically was calling for, she said, "Congress should pass a law to require the states to protect women in their equal political rights and ... the states should enact laws making it the duty of inspectors of elections to receive women's votes on precisely the same conditions they do those of men."

And then she arrived at the point she had been advancing to for an hour.

We no longer petition legislature or Congress to give us the right to vote. We appeal to the women everywhere to exercise their too long neglected citizen's right to vote. We appeal to the inspectors of election everywhere to receive the votes of all United States citizens as it is their duty to do. We appeal to United States commissioners and marshals to arrest the inspectors who reject the names and votes of United States citizens, as it is their duty to do, and leave those alone who, like our Eighth Ward inspectors, perform their duties faithfully and well.

She was asking for civil disobedience and for federal officers to support that disobedience.

And, more to the point, to potential jurors in her pending trial, which would be heard as required by law by an all male jury, she said, "We ask the juries to fail to return verdicts of guilty against honest, law-abiding, tax-paying United States citizens for offering their votes at our elections. Or against intelligent, worthy young men, inspectors of elections, for receiving and counting such citizens' votes."

She even called for the judge in the trial to support the disobedience. She

said, "We ask the judges to render true and unprejudiced opinions of the law and wherever there is room for a doubt to give its benefit on the side of liberty and equal rights to women, remembering that the true rule of interpretation under our national constitution, especially since its amendments, is that anything for human rights is constitutional, everything against human rights unconstitutional."

She closed with a rather uninspiring sentence:

"And it is on this line that we propose to fight our battle for the ballot, all peaceably, but nevertheless persistently through to complete triumph, when all United States citizens shall be recognized as equals before the law."

If she had created or borrowed a more memorable line, perhaps her speech would have resounded, if not throughout the country, at least throughout Monroe County, where the trial was scheduled to be held. She gave the speech 29 times in Monroe County. There was no "Remember the Alamo," no "We have not yet begun to fight," nothing memorable enough for her supporters to carry home to mealtime conversation or to reprint in letters to the newspaper. It was, in reality, a flat, uninspiring speech.

But it frightened federal officials enough for them to request a change of venue.

Waiting and Waiting and Waiting

The trial was scheduled for Tuesday, May 13, 1872. Susan B. Anthony and the other women charged with voting showed up at the federal courthouse in downtown Rochester.[5] The inspectors charged with allowing her to vote were also there. They waited as other defendants and their attorneys were called before Judge Nathan K. Hall. As so often happens in courthouses, they waited and waited, not being told what was happening. They were not called on Tuesday. On Wednesday, Anthony attended a meeting of the Women's Taxpayers Association of Monroe County. The meeting was held to express support for Anthony and her co-defendants. She was careful to let her attorneys know where she was so she could be quickly summoned if Judge Hall was ready to do something with their case. The meeting ended and she went to the home of her sister Guelma, who was sick, and sat with her for a while, again letting her attorneys know where she could be reached. But again, the court's day ended without Judge Hall saying he was ready to hear motions in the case of the women charged with illegally voting. Day after day after day after day Judge Hall did not call for the case. Then, on the tenth day, on Thursday, May 22, Anthony, the inspectors, the women co-defendants, and the attorneys were

called into Judge Hall's courtroom. Finally, it seemed, the trial would commence.

But it wasn't to be so.

John E. Pound, the federal assistant district attorney, holding what seemed like a ream of papers in his hand, called out the names, one by one, of the women who were defendants in the cases. Next, still holding the papers, he read aloud the formal charges against each of them. Then he asked each one if she was guilty or not guilty. Every woman defendant answered in a loud and clear voice, perhaps rehearsed, more likely simply reflecting determination, "Not guilty." One, Rhoda De Garno, added, "I have done only what I have a right to do."[6]

Because of the week and a half delay, and because the women defendants had lives to live, some of them were not present in the courtroom when their names were called. Pound wanted to know where they were, and Henry Selden, their attorney, rose and said some of them were teaching school. Some were "at this time engaged in teaching the men of the future in our public schools, but after school hours they will not be missing." The tone was clear, their case, which turned out to be an arraignment, not the actual trial as expected, shouldn't have been delayed for so long. They had lives to live and couldn't be expected to simply hang around until the federal D.A. got around to doing his job. And, like a knife that cuts twice with one stab, the irony was clear to everyone in the courtroom. If these women could be entrusted to teach children, they should be entrusted to cast votes.

Then Crowley stood. Pound's boss. The D.A. He made a surprising motion, one that reflected his annoyance with Anthony's public speechmaking and with Selden's taunt. He told Judge Hall he wanted a change of venue. He asked Judge Hall to move the trial to Canandaigua, about 30 miles to the southeast. He noted that Ward Hunt, recently appointed by President Grant to the United States Supreme Court, would preside at the next session of federal court held in that city. At the time U.S. Supreme Court justices in effect rode circuit, hearing cases in designated geographic areas. The area designated for Hunt included Western New York.

Having an already high profile case heard by a Supreme Court justice would add weight to Crowley's decision to prosecute the case. For a politically ambitious district attorney, the request made perfect sense, and it may have explained the ten day delay in bringing the case into Hall's courtroom. Crowley, sensitive to a potential insult to the sitting judge, however, mentioned the possibility that Hall might sit in the courtroom, perhaps as a co-judge, with Hunt. That was an unlikely possibility, without precedent. Judges often sat in groups

to hear appeals, but not during trials. Not in American courtrooms. Still, it was a sop to soothe Hall's sensibilities, and Crowley might appear again, in another case, before Hall. Crowley also asked the court to set bail to assure all the defendants showed up at trial.

Selden, predictably, objected to both the change in venue and to bail. He said that although the defendants had been indicted in Albany, they were entitled to be tried in their hometown, but he as much as gave away the point to Crowley by adding that if the trial had to be moved, moving it to Canandaigua was acceptable. On the point of bail he fought a little harder, citing a state law that said if a trial was delayed through no fault of the defendants, they were entitled to be released on their own recognizance. That is, on their own word that they would show up for trial and without bail or bond.

Judge Hall ruled quickly, saying the trial would indeed be moved to Canandaigua and held in June. He also said, almost as quickly, that the defendants would be released on their own recognizance, but illogically added that they would each have to put up $400 bail. Bail was inconsistent with a defendant being released on his or her own recognizance.

Anthony and the other women paid the bail, went home, and waited for the trial. But not quietly. The very next day Anthony arranged to have posters printed to be distributed in every town in Ontario County, including the largest, Canandaigua. She would deliver the same speech in the new home of her upcoming trial that she had delivered in Monroe County. But she now had only two months, so she needed help. And an old friend, Matilda Joslyn Gage, came to visit and made speeches in town after town in Ontario County. Together, Gage and Anthony urged the men of Ontario County, the men who constituted the juries in the trials in the county, to engage in jury nullification.

Matilda Joslyn Gage

Gage and Anthony were longtime but not lifelong friends.[7] Gage was born in Onondaga County, east of Anthony's Monroe County, and lived much of her life in the town of Fayetteville, now an eastern suburb of Syracuse. She wrote extensively about how women had been excluded from history. One book detailed how women helped create many inventions credited only to men. The phenomenon of a man receiving credit for scientific work done by a woman is, in fact, now often called the Matilda Effect because of her work. Another book gave credit for some of Ulysses S. Grant's Civil War campaign strategies, especially in Tennessee, to a woman, Anna Ella Carroll. Gage was

generally considered among the most radical leaders of the 19th Century women's rights movement, and when she published in 1893 a book, *Women, Church, and State,* that attacked Christian theology as oppressive to women, her influence among other women in the movement, many of whom were deeply religious, was greatly diminished. By the late 19th Century, Gage, Stanton, Lillie Devereaux Blake, and other leaders of the women's rights movement would find Anthony's exclusive focus on voting rights too narrow. That combination led to a friendly break between Anthony and Gage. There are several characters in the Wizard of Oz books written by Gage's son-in-law, L. Frank Baum, that some critics believe are based upon her personality.

But in the early 1870s, Gage and Anthony were still

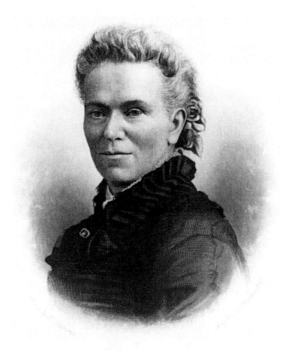

Matilda Joslyn Gage. Because Susan B. Anthony spoke prior to her trial in every town in Monroe County (where Rochester is located), the federal district attorney had the trial moved to nearby Ontario County. Anthony then spoke in as many towns as she could in that county. Her friend and fellow suffragist leader Matilda Joslyn Gage also spoke in dozens of towns in Ontario County, and like Anthony, urged potential jurors to engage in jury nullification. Gage appears as a character under several different names in various Wizard of Oz books written by her son-in-law, L. Frank Baum (engraving from *History of Woman Suffrage*).

close friends, and Anthony welcomed Gage's help. Gage was a good stand-in for Anthony as a speaker. They were both products of Western New York's Burned Over District that had produced leadership for the anti-slavery movement, the battle for women's rights, and several new religions, including the Mormon church. She presented a formidable appearance, and, like Anthony, spoke with an uninspiring delivery. Anthony, however, was more of a celebrity, and could draw and hold crowds. Gage had some fame, but not nearly as much as Anthony, and she tried to compensate for that by being even more provoca-

tive in what she had to say, although, even a quick reading of the speeches of both show them to be nearly identical in tone and points emphasized. They consulted on what Gage should say, and Gage accordingly would take an hour or so, like Anthony, to reach the concluding call for jury nullification.

She gave her speech in Canandaigua where the trial would be held, in Canadice to the west, Victor to the northwest, Geneva to the east, and in Naples, Phelps, and Seneca, in 17 towns and villages in all. Each of them were in Ontario County, because every juror in Anthony's trial would be from that county. And every one of them would be a man.

Gage's Speech

Gage opened with the title of her speech, which left no doubt about the point she was making: "The United States on Trial, Not Susan B. Anthony."[8]

Then, like Anthony, she lectured; at points she sounded like she was speaking to grade school students: "Governments derive their just powers from the consent of the governed. That is the axiom of our republic. From this axiom we understand that powers used by the government without the consent of the governed, are *not just* powers, but that on the contrary, they are *unjust* powers, *usurped* powers, *illegal* powers. In what way does the consent of the governed come? By and through the ballot alone."

She referenced writers, historians, politicians, often not adequately explaining to her audience who they were. "Macaulay calls government an experimental science," she said without explaining that Macaulay was Thomas Babbington Macaulay, a British historian and politician. It's possible but unlikely that most members of her audiences knew who he was. She said that "Bancroft ... placed the defense of liberty not in municipal corporations, but in persons." Bancroft was George Bancroft, an American historian and secretary of the Navy during the administration of President James Polk.

When she cited a woman, she wanted her audiences to have no doubt whom she referred to. "Mercy Otis Warren," she said, "sister of that James Otis whose fiery words did so much towards rousing the colonies, was herself no less in earnest, had no less influence than her brother. She was a member of the famous committee of correspondence, and was constantly consulted by Adams, Jefferson, Franklin, Hancock, Washington and all the foremost men of that day." Much of Gage's success as a leader of the women's rights movement was based on seeing that accomplished women received credit for doing work that was usually credited to men alone.

She particularly praised women who spoke up, as she and Anthony did.

She said, "A few weeks ago I attended a meeting of the tax-paying women of Rochester who met in the mayor's office in that city, and there, like their revolutionary mothers, formed a league against taxation without representation."

She read from a statement written by that group:

> To the Women of the City of Rochester and the County of Monroe: After twenty-five years of discussion, appeal and work, the women of Rochester assembled are prompted to advise and urge tax-paying women of the city and county that the time has come to act as our patriot mothers acted in seventeen seventy, in protest against unjust government, and the action appropriate and suited to the time, is strong and earnest protest against the violation of the republican principles which compels the payment of taxes by women while they are denied the ballot.

This was archetypal Gage and Anthony. Calling women to action, praising them for acting, demanding the ballot.

She quoted a Revolutionary War minister she did not name as saying, "One who is bound to obey the will of another is as really a slave, though he may have a good master, as if he had a bad one."[9]

In fact—and the irony was noticed by many leaders of the women's rights movement—Anthony, when arrested in Rochester, in the words of Gage, was "held there to examination in the same little room in which fugitive slaves were once examined." A little later in her speech, Gage made a point that history has largely forgotten but which was widely believed at the time by fans of Susan B. Anthony.

> Miss Anthony is today the representative of liberty, she is today battling for the rights of every man, woman and child in the country, she is not only upholding the right of every native-born citizen but of every naturalized citizen. Today is at stake in her person, the new-born hopes of foreign lands, the quickened instincts of liberty, so well nigh universal. All these are on trial with her; the destinies of America, the civilization of the world, are in the balance with her as she stands on her defense.

Today this sounds like rhetorical excess, but it illustrates a key difference between the speaking styles of Anthony and Gage. Both were flat speakers, but Gage, unlike Anthony, could embellish her talk with phrases that at least offered the potential of being remembered.

She noted that in England, France, and even czarist Russia women were permitted to vote in some local elections.

> In Russia about one-half of the property of the country is in the hands of women, and they vote upon its disposition and control. In France and Sweden,

women vote at municipal elections, and in England, every woman householder or rate-payer votes for city officers, for poor wardens and school commissioners, thus expressing her views as to the education of her children, which is a power not possessed by a single woman of this State of New York, whose boast has been that it leads the legislation of the world in regard to women.

As she approached the end of her speech, Gage displayed the rhetorical skills that were beyond Anthony's capabilities, and she applied a rhetorical logic designed to convince the men in the audience that they had a chance to make history, and a chance to make history trumped any narrow-minded commitment to the technical dictates of the law.

"The eyes of all nations are upon us," she told them.

Their hopes of liberty are directed towards us. The United States is now on trial by the light of its own underlying principle. Its assertion of human right to self-government lies a hundred years back of it. The chartered confirmation and renewal of this assertion has come up to our very day, and though all the world looked on and wondered to see us crush the rebellion of sixty-one, it is at this hour—at this soon coming trial of Miss Anthony at Canandaigua, before the Supreme Court of the Northern District of New York[10]—is at this trial that republican institutions will have their grand test, and as the decision is rendered for or against the political rights of citizenship, so will the people of the United States find themselves free or slaves, and so will the United States have tried itself, and paved its way for a speedy fall, or for a long and glorious continuance. Miss Anthony is today the representative of liberty. In all ages of the world, and during all times, there have been epochs in which some one person took upon their own shoulders the hopes and the sorrows of the world, and in their own person, through many struggles bore them onward. Suddenly or gradually, as the case might be, men found the rugged path made smooth and the way opened for the world's rapid advance. Such an epoch exists now, and such a person is Susan B. Anthony.

Susan B. Anthony herself was never capable of such flowing, potentially inspiring rhetoric. And Gage's call to the men in the audience offered far more likelihood that she could persuade them to ride what she saw as the tide of history and ignore any narrow instructions the trial judge might insist upon. Crowley must have realized he chose poorly when he arranged to have the trial shifted from Rochester to Canandaigua. He could never have anticipated the effectiveness of Gage's standard stump speech.

"To you, men of Ontario County, has come an important hour," she said in her concluding paragraph.

The fates have brought about that you, of all the men in this great land, have the responsibility of this trial. To you, freedom has come looking for fuller acknowledgment, for a wider area in which to work and grow. Your decision will not be

for Susan B. Anthony alone. It will be for yourselves and for your children's children to the latest generations. You are not asked to decide a question under favor, but according to the foundation principles of this republic. You will be called upon to decide a question according to our great charters of liberty—the Declaration of Independence and the Constitution of the United States. You are to decide, not only on a question of natural right, but of absolute law, of the supreme law of the land. You are not to decide according to prejudice, but according to the Constitution. If your decision is favorable to the defendant, you will sustain the Constitution. If adverse, if you are blinded by prejudice, you will not decide against women alone, but against the United States as well. No more momentous hour has arisen in the interest of freedom, for the underlying principles of the republic, its warp and woof alike, is the exact and permanent political equality of every citizen of the nation, whether that citizen is native born or naturalized, white or black, man or woman. And may God help you.

Gage's call for potential jurors to engage in nullification of the law that forbade women to vote was more ringing, more historically tuned, more emotionally convincing than Anthony's flat appeal. It would be heard by Crowley with dismay, and by Judge Hunt, Justice Hunt, with alarm.

Other Women Who Voted

History has remembered Susan B. Anthony better than it has remembered dozens of other women who attempted to vote or who actually voted in opposition to sexist laws that said they could not. But the historical record does exist. Dozens of women were in fact part of the same nationwide campaign to challenge the constitutionality of laws limiting the elective franchise to men.

Among them was Marilla M. Ricker,[11] a young widow who owned land in Dover, New Hampshire, and who in March 1870, the day before an election, applied with the town selectmen to register. They promised to write her name down as eligible to vote, but when she showed up to vote the next day, she was told she wasn't registered and couldn't cast a ballot. She had prepared a speech, expecting not to be allowed to register, but had left it with the selectmen the day before, so she never had a chance to deliver it. She considered suing the selectmen but was persuaded not to by friends. Perhaps because of those friends, her name is largely forgotten.

As noted earlier, Nanette B. Gardner registered on March 25, 1871, and actually voted in Detroit on April 3. She was not charged with a crime, so her case was never adjudicated by the courts, and she too has passed into the footnotes of history.

On April 20, 1871, 72 women, led by Sara Andrews Spencer and Sarah

E. Webster,[12] attempted to vote in the District of Columbia. A few days earlier the same 72 women tried to register. Both times they were turned away. The women did sue, and their case was heard by the Supreme Court of the District of Columbia, where the judges said they found the arguments interesting but unconvincing. The decision was appealed to the U.S. Supreme Court, which sustained the D.C. court's opinion without comment. If the U.S. Supreme Court had commented, the case might have attracted more attention from historians. Of course, no one in the case was anywhere close to possessing the fame of Susan. B. Anthony.

Ellen Rand Van Valkenburg[13] sued Registrar Albert Brown of Santa Cruz, California, in 1871 because he wouldn't allow her to register to vote. She lost, but she became the first woman to actually sue for the right to vote using the 14th Amendment as her constitutional argument.

On September 16, 1871, Carrie S. Burnham[14] of Philadelphia, an unmarried woman, registered successfully, but when she showed up to vote, her ballot was refused. She sued in a Pennsylvania court and lost. In the fall of 1871, Catharine V. Waite[15] sued for her right to vote in Illinois, and lost. About the same time, Sarah M.T. Huntington[16] was able to register in Norwalk, Connecticut, but was not allowed to vote.

And, most importantly, on October 15, 1872, Virginia Minor attempted to register in St. Louis. It was her husband, Francis Minor, whose letter to *The Revolution* convinced Susan B. Anthony that she should attempt to register, be turned away, sue, and take her case to the U.S. Supreme Court. Reese Happersett, the election registrar, told her she could not register, and Minor sued him. More than two years later her case, not Anthony's, reached the United States Supreme Court. In technical legal terms, *Minor v. Happersett* was more important than the *United States v. Susan B. Anthony,* but in terms of the emotional memories of the nation, it pales in comparison.

Anthony Collapses

Anthony also made speeches outside of Monroe and Ontario counties. Those speeches were designed to induce potential male jurors to disregard the law and likely instructions from the bench and to vote their conscience, and to persuade them that their conscience told them women have a right to vote. But she was also intent on convincing the nation, so she attended state suffrage conventions in Ohio and Illinois in early 1873, spoke in several cities in each of those states, and gained nationwide attention. The Associated Press picked up stories from local papers, so her arguments about the 14th Amendment

appeared in most papers around the country. Her first biographer, Ida Husted Harper, claimed it appeared in "every paper the country," but offers no proof.[17] It's unlikely that every small town weekly, many of which focused then, as they do today, entirely on local news, carried the story. But certainly dailies, perhaps all of them, did carry stories on her speeches and her 14th Amendment arguments.

But all that work, all that traveling, all the pressure from her pending trial, as much as she relished the battle, took its toll. On February 25, 1873, she spoke in Fort Wayne, Indiana, on a bitter cold night, and above where she stood while lecturing "was an open scuttle [or small hole], from which a stream of air poured down upon her head, and when half through her lecture she suddenly became unconscious."[18] The mixture of cold and warm air made her suddenly faint. She was taken to the home of her host, Mary Hamilton Williams, where she was cared for. When she regained consciousness, her first expressed concern was that the Associated Press not learn what happened because of the effect the news was likely to have on her frail, 79-year-old mother back in Rochester. Anthony in fact expressed concern the news might kill her mother. But her mother did eventually learn what happened and lived another seven years.

Anthony, as always, let nothing deter her. Three days following that incident, she spoke in Marion, Indiana. Her diary on that day says she was "going on the platform with fear and trembling."[19] Anthony often expressed hesitation about speaking in public, but she gave hundreds of speeches in her lifetime, and whatever fear and trembling she felt was never visible when she stood before an audience, large or small.

Anthony Votes Again

But voting felt too good, so she returned to Rochester in time to be present for the March 3 municipal election. And voted.[20] There were no federal offices on the ballot, so Crowley and Storrs took no legal interest in the matter, although they no doubt were surprised at the audacity of the woman. Under indictment for voting, and there she goes and votes again. Can you imagine? they must have wondered.

Mary Pulver and Mary S. Hebard[21] went with Anthony to the West Side News Depot to vote that day, but the other 12 women who had voted in November didn't show up. Nor did any of the several dozen who had registered prior to the November election. Harper, who always reflected Anthony's viewpoint in her biography, wrote, "All of the others who had voted in the fall were

thoroughly frightened, and their husbands and other male relatives were even more panic-stricken."[22] But Harper provides no proof that fear was the motivating factor in keeping the other women away from the polls that day. Or that their husbands or other male relatives played a role in their decision not to vote. There is always less interest in local elections than in national ones and lower turnouts.

No charges were brought against the three women who did vote. They had violated state law just as they had four months earlier, but no city or county or state officials saw fit to charge them. And federal officials, this time, had nothing to charge them with. So the world would await the outcome of Anthony's trial in Canandaigua to decide what to do with such women.

5

The Trial

The Ontario County courthouse intimidated many of the defendants tried there. But Susan B. Anthony, once she was beyond her teen years, would not allow herself to be cowered. Hadn't she debated publicly as an equal against the mighty Frederick Douglass, among the greatest orators of his day? Hadn't she stood against nasty comments from rude, even obnoxious, members of audiences, those who showed up not to listen but to deride? And, most of all, didn't she have an obligation to serve as a model for other women, those truly intimidated by the subservient roles society insisted they play?

Still, the courthouse was an impressive structure.[1] More impressive than almost any other building in Western New York. Its gold dome dominated the pretty lakeside village of Canandaigua. The four Ionic columns fronting the building provided an air of classicism widely admired in 19th Century America.

It was a Greek Revival building designed by Henry Searl, the best known architect in Rochester. Canandaigua, on the northern point of a Finger Lake that bore the same name, possessed an unusually wide main street, one that could accommodate a half dozen wagons moving side by side. The main shopping district extended from just north of the lake to the courthouse, and in good weather its sidewalks were crowded with the fashionably dressed and the working man and woman.

The courthouse was a 15-year-old building, a joint venture of Ontario County and the United States government. The federal government contributed $12,000 to the $57,400 cost and in exchange got about a quarter of the first floor to use as a post office and half of the second floor to use as a courtroom. The rest of the building was for use by the county, including a county courtroom on the south side of the second floor, across the corridor from the federal courtroom.

When Anthony entered the courthouse, it was from the front, on the

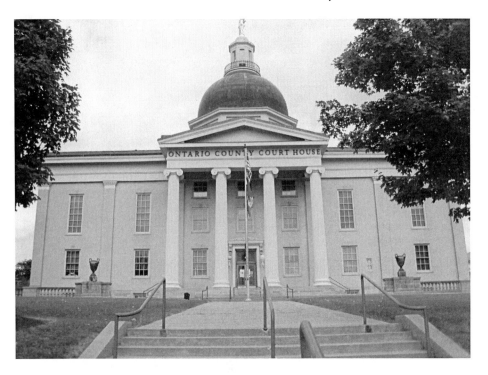

The Ontario County Courthouse in Canandaigua, New York, where Anthony's trial was held in 1873. At the time it was jointly owned by the county and federal government. Today it is still used for county trials. The courtroom where she was tried is on the second floor on the left side of the photograph. The courtroom was relocated a few feet to the north when the courthouse was expanded (photograph by the author).

Main Street side. She walked to the back of the first floor, climbed a grand wooden staircase to a landing, made a 180 degree turn to her left or right, and continued up a connected flight of steps to the second floor. On the second floor she turned right and in a few steps turned left and entered the federal courtroom from the rear. The courtroom was about 40 feet wide and more than 50 feet deep. The judge's bench was on the far end, so the judge's back would face Main Street. The jury box was to the left of the judge's bench, so members of the jury faced south. Defendants, attorneys, reporters, and spectators sat on benches that faced west.

It was the third courthouse in Canandaigua. The first trials in the town were held in 1792 in a tavern. That tavern later became the home of Judge Moses Atwater, who then rented the county space in it for use as a courtroom. In 1794, however, a courthouse, somewhat Georgian in design, was built for $1,500. In 1826 a larger courthouse was built. Both of these buildings possessed

a false stateliness. Each had a small, useless cupola on top, each had columns in front, and each was otherwise blocky and architecturally uninteresting. Canandaigua was not a town of pretentious people, but history had happened there. In 1794 President George Washington sent his personal representative, Timothy Pickering, to the town to negotiate and sign a peace treaty with the six nations of the Iroquois Confederacy. It was just the second treaty signed under the country's new constitution. Alexis de Tocqueville visited the town and wrote about it in *Democracy in America*. The townspeople, and all the residents of the county, wanted a building worthy of their short but honorable heritage.

Searl had designed a courthouse in Lyons,[2] 28 miles to the northeast of Canandaigua, and that may have served as a model for the somewhat larger building he designed in Canandaigua. It too has a dome and Ionic columns, and their general appearances are similar. Ontario County paid Searl $900 for his work.

Searl wanted the courthouse to face south, but town opinion was strong that it should face west, and the citizens won. Facing west meant it was more a part of Canandaigua's Main Street.

On top of the dome was placed a 12-foot-tall statue of Lady Justice, holding a sword in her right hand and the scales of justice in her left. Gas Lights illuminated the inside of the building. It was, by mid–19th Century standards, a modern building. And for a small town impressive. And in the late Spring of 1873 it would receive national attention because Susan B. Anthony was put on trial within its confines.

Anticipating Excitement

Like the meeting in Steinway Hall in New York City four years earlier, the trial of Susan B. Anthony in Canandaigua, about 310 miles northwest of New York City, was mostly mundane. Most of the excitement came from anticipation. This was one of the most widely anticipated trials in the nation in years and the courtroom was crowded. Among those in attendance was ex-president Millard Fillmore. The trial was short and the wait for excitement would be rewarded.

The weather for several days had been on and off rain, occasionally hard. The wooden statue of Lady Justice silently stood atop the courthouse.[3]

Richard Crowley, district attorney for the Northern District of New York, that is, most of New York State north of New York City, opened the trial, officially called *The United States of America vs. Susan B. Anthony*.[4] Ward Hunt

sat on the bench. Henry R. Selden, Anthony's attorney, sat behind a table alongside his client. With them was John Van Voorhis, acting as his assistant in this trial and who would represent the three registrars of election who allowed Anthony and other women to vote. Their trial was scheduled to begin immediately after Anthony's concluded. It was Tuesday, June 17, 1873, 2:30 p.m. A jury of 12 men sat to one side of the Judge Hunt.[5]

Crowley stood, looked at Judge Hunt, and said,

> May it please the court and gentlemen of the jury, on the fifth of November, eighteen seventy-two, there was held in this state, as well as in other states of the union, a general election for different officers, and among those, for candidates to represent several districts of this state in the Congress of the United States. The defendant, Miss Susan B. Anthony, at the time resided in the city of Rochester, in the country of Monroe, Northern District of New York, and upon the fifth day of November, eighteen seventy-two, she voted for a representative in the Congress of the United States, to represent the Twentieth Congressional District of the state, and also for a representative at large for the state of New York to represent the state in the Congress of the United States. At that time she was a woman. I suppose there will be no question about that. The question in this case, if there be a question of fact about it at all, will, in my judgment, be rather a question of law than one of fact. I suppose that there will be no question of fact, substantially, in the case when all of the evidence is out, and it will be for you to decide under the charge of his honor, the judge, whether or not the defendant committed the offense of voting for a representative in Congress upon that occasion. We think, on the part of the government, that there is no question about it either one way or the other, neither a question of fact, nor a question of law, and that whatever Miss Anthony's intentions may have been— whether they were good or otherwise—she did not have a right to vote upon that question, and if she did vote without having a lawful right to vote, then there is no question but that she is guilty of violating a law of the United States in that behalf enacted by the Congress of the United States. We don't claim in the case, gentlemen, that Miss Anthony is of that class of people who go about *repeating*. We don't claim that she went from place to place for the purpose of offering her vote. But we do claim that upon the fifth of November, eighteen seventy-two, she voted, and whether she believed that she had a right to vote or not, it being a question of law, that she is within the statute Congress in eighteen seventy passed the following statute.

Crowley then bored the jury and everyone else in the courtroom by reading the 19th Section of the Act of 1870, page 144, 16th statutes at large.

Then he continued. "It is not necessary for me, gentlemen, at this stage of the case, to state all the facts which will be proven on the part of the government. I shall leave that to be shown by the evidence and by the witnesses, and if any question of law shall arise his honor will undoubtedly give you instruction as he shall deem proper. Conceded, that on the

fifth day of November, eighteen seventy-two, Miss Susan B. Anthony was a woman."

Then Selden took his turn. He stood as Crowley sat and walked to the jury box. He turned first to Judge Hunt and then faced the jury as he said,

> If the court please, gentlemen of the jury, this is a case of no ordinary magnitude, although many might regard it as one of very little importance. The question whether my client here had done anything to justify her being consigned to a felon's prison or not is one that interests her very essentially, and that interests the people also essentially. I claim and shall endeavor to establish before you that when she offered to have her name registered as a voter, and when she offered her vote for member of Congress, she was as much entitled to vote as any man that voted at that election, according to the Constitution and laws of the government under which she lives. If I maintain that proportion, as a matter of course she has committed no offence and is entitled to be discharged at your hands. But, beyond that, whether she was a legal voter or not, whether she was entitled to vote or not, if she sincerely believed that she had a right to vote, and offered her ballot in good faith under that belief, whether right or wrong, by the laws of this country she is guilty of no crime. I apprehend that that proposition, when it is discussed, will be maintained with a clearness and force that shall leave no doubt upon the mind of the court or upon your minds as the gentlemen of the jury. If I maintain that proposition here, then the further question and the only question which, in my judgment, can come before you to be passed upon by you as a question of fact is whether or not she did vote in good faith believing that she had a right to vote. The public prosecutor assumes that however honestly she may have offered her vote, however sincerely she may have believed that she had a right to vote, if she was mistaken in that judgment, her offering her vote and its being received makes a criminal offence, a proposition to me most abhorrent, as I believe it will be equally abhorrent to your judgment. Before the registration, and before this election, Miss Anthony called upon me for advice upon the question whether, under the Fourteenth Amendment of the Constitution of the United States she had a right [to] vote. I had not examined the question. I told her I would examine it and give her my opinion upon the question of her legal right. She went away and came again after I had made the examination. I advised her that she was as lawful a voter as I am, or as any other man is, and advised her to go and offer her vote. I may have been mistaken in that, and if I was mistaken, I believe she acted in good faith. I believe she acted according to her right as the law and Constitution gave it to her. But whether she did or not, she acted in the most perfect good faith, and if she made a mistake, or if I made one, that is not a reason for committing her to a felon's cell.

Then the prosecution's case began. Crowley called Beverly W. Jones as a witness. Jones swore to tell the truth, and Crowley asked his first question . "Mr. Jones, where do you reside?" Jones said, "Eighth Ward, Rochester."

Crowley, pursuing the mundane that has always seemed to prosecutors

and defense attorneys alike necessary to lead up to some significant point, next asked, "Where were you living on the fifth of November, eighteen seventy-two?"

Jones, annoyed at being a witness in this case and angry at having, himself, been charged with a crime, one he would be tried for the next day, answered with as much flatness as he could muster, "Same place."

Crowley: "Do you know the defendant, Miss Susan B. Anthony?"

Jones: "Yes, sir."

"In what capacity were you acting upon that day, if any, in relation to election?" Crowley asked, already knowing the answer.

"Inspector of election."

"Into how many election districts is the Eighth Ward divided, if it contains more than one?"

"Two, sir," Jones said, trying to avoid having the "sir" filled with disdain.

"In what election district were you inspector of elections?"

"The First District."

"Who were inspectors with you?" Crowley asked. He knew the answer to all of these questions, and he knew the answers did not matter. Part of a prosecutor's standard strategy is to convince the jury that so much research has been done into the case that nothing could possibly have been overlooked or put into a misleading context. Thoroughness often substitutes for convincing.

Jones answered, "Edwin T. Marsh and William B. Hall."

"Had the board of inspectors been regularly organized?"

"Yes, sir," Jones said. Politeness might make the jury favorably disposed towards him, although he knew his trial would have a different jury.

Crowley continued, "Upon the fifth day of November did the defendant, Susan B. Anthony, vote in the First Election District of the Eighth Ward of the city of Rochester?" Of course, the defense had already conceded this point in its opening statement.

"Yes, sir."

"Did you see her vote?"

"Yes, sir."

"Will you state to the jury what tickets she voted, whether state, assembly, Congress and electoral?"

Selden objected by saying the question called for the witness to draw a conclusion.

Crowley, long practiced in responding to similar objections, restated his question. "State what tickets she voted," he said, "if you know, Mr. Jones?"

Jones was not quite certain what to say, but he offered a reply. "If I recollect right she voted the electoral ticket, congressional ticket, state ticket, and assembly ticket."

"Was there an election for member of Congress for that district and for representative at large in Congress for the state of New York, held on the fifth of November, in the city of Rochester?"

"I think there was; yes, sir," Jones said.

"In what congressional district was the city of Rochester at the time?"

"The Twenty-ninth."

"Did you receive the tickets from Miss Anthony?"

"Yes, sir."

"What did you do with them when you received them?" Crowley asked.

"Put them in the separate boxes where they belonged."

"State to the jury whether you had separate boxes for the several tickets voted in that election district." Of course, Jones's previous answer made clear that there were separate boxes.

"Yes, sir, we had," Jones said. Like most witnesses in most trials, he was unwilling to deviate from the mundane tone created by the questions.

"Was Miss Anthony challenged upon that occasion?"

"Yes, sir," Jones started, but quickly altered his answer. "No, not on that day she wasn't."

"She was not challenged on the day she voted," Crowley said, more stating a fact than asking a question.

"No, sir."

Crowley sat down and Selden stood, approached the witness, and began his cross-examination.

"Prior to the election," he asked, "was there a registry of voters in that district made?"

Jones, feeling friendlier towards Selden than he had towards Crowley, moderated his voice. "Yes, sir."

"Was you one of the officers engaged in making that registry?" Selden asked, a bit careless with his syntax.

"Yes, sir," Jones said.

"When the registry was being made did Miss Anthony appear before the board of registry and claim to be registered as a voter?"

"She did."

"Was there any objection made, or any doubt raised as to her right to vote?"

"There was," Jones replied.

"On what ground?" Selden asked. Like Crowley, he already knew the answers to the questions he asked.

"On the ground that the constitution of the state of New York did not allow women to vote."

"What was the defect in her right to vote as a citizen?"

"She was not a male citizen."

"That she was a woman?" Selden asked rhetorically, wanting to emphasize the point for the jury.

"Yes, sir."

"Did the board consider that and decide that she was entitled to register?"

Crowley quickly objected and Hunt as quickly overruled the objection.

Selden reworded the question to make his point even clearer to the jury. "Did the board consider the question of her right to registry," he asked, "and decide that she was entitled to registry as a voter?"

"Yes, sir."

"And she was registered accordingly?"

Jones repeated his most frequent answer. "Yes, sir."

"When she offered her vote, was the same objection brought up in the board of inspectors, or question made of her right to vote as a woman?"

"She was challenged previous to election day."

"It was canvassed previous to election day between them?" Selden was using the language of voting officials. To canvass in this circumstance was to ask each official for his opinion.

"Yes, sir; she was challenged on the second day of registering names."

"At the time of the registry, when her name was registered, was the supervisor of election present at the board?" By supervisor of election he meant a federal official. Jones was a local official working for the state.

"He was."

"Was he consulted upon the question of whether she was entitled to registry, or did he express an opinion on the subject to the inspectors?"

Crowley jumped up and spoke before Jones could answer. "I submit that it is of no consequence whether he did or not."

Selden as quickly replied, "He was the government supervisor under this set of Congress."

Crowley quickly countered: "The board of inspectors under the state law constitute the board of registry, and they are the only persons to pass upon that question."

Hunt, seeing no point to the argument between the attorneys, intervened and told the witness, "You may take it."

So Jones replied to Selden's question. "Yes, sir; there was a United States supervisor of elections, two of them."

Selden, sensing he was about to make a significant point for the jury, continued. "Did they advise the registry, or did they not?"

Jones said, "One of them did."

"And on that advice the registry was made with the judgment of the inspectors." Selden spoke with an air of certainty. If the local officials made their decision to allow a woman to register to vote only after consulting with a federal official, the jury no doubt would consider that significant.

Jones, sensing the point being made would be helpful when his trial commenced, answered with confidence. "It had a great deal of weight with the inspectors, I have no doubt."

Crowley's Turn

Then it was Crowley's turn to reexamine Jones. "Was Miss Anthony challenged before the board of registry?" he asked.

Jones said, "Not at the time she offered her name."

"Was she challenged at any time?"

"Yes, sir, the second day of the meeting of the board."

"Was the preliminary and the general oath administered?"

"Yes, sir," Jones said once again.

"Won't you state what Miss Anthony said, if she said anything, when she came there and offered her name for registration?"

Jones said, "She stated that she did not claim any rights under the constitution of the state of New York. She claimed her right under the Constitution of the United States."

"Did she name any particular amendment?"

"Yes, sir," Jones said. "She cited the Fourteenth Amendment."

"Under that she claimed her right to vote?" Crowley asked.

"Yes, sir."

"Did the other federal supervisor who was present state it as his opinion that she was entitled to vote under that amendment, or did he protest, claiming that she did not have the right to vote?"

Jones framed his answer with care. "One of them said that there was no way for the inspectors to get around placing the name upon the register. The other one, when she came in, left the room."

"Did this one who said that there was no way to get around placing the name upon the register state that she had her right to register but did not have the right to vote?"

"I didn't hear him make any such statement," Jones replied.

"You didn't hear any such statement as that?" Crowley wanted the jury to hear the answer a second time.

"No, sir." This was the first time Jones said No, sir, rather his oft repeated Yes, sir.

"Was there a poll list kept of the voters of the First Election District of the Eighteenth Ward on the day of election?"

"Yes, sir."

Crowley went to his table, picked up two books, and handed them to Jones. He said, "State whether that is the poll list of voters kept upon the day of election in the First Election District of the Eighth Ward of the city of Rochester."

Jones nodded. "This is the poll list, and also the register."

"Turn to the name of Susan B. Anthony, if it is upon that poll list."

Jones flipped some pages. After a few moments he said, "I have it."

"What number is it?"

"Number twenty-two."

"From that poll list," Crowley said, "what tickets does it purport to show that she voted upon that occasion?"

Jones looked carefully at the page the book was opened to. "Electoral, state, Congress and assembly."

Crowley, feeling good, said, "The United States rests."

Richard Crowley

Richard Crowley[6] was 36 years old when he prosecuted Susan B. Anthony. He had always been politically ambitious. Admitted to the practice of law in 1860, he served as city attorney for Lockport, 60 miles west of Rochester, in 1865 and 1866. It was the type of entry level position common to aspiring office holders. He served in the state Senate from 1866 to 1870. He was a loyal Republican, and President Grant appointed him federal district attorney for the Northern District of New York on March 23, 1871, and reappointed him in 1875; he served in that capacity until 1879, when he left after being elected to the U.S. House of Representatives, where he served two terms. He ran for Congress again in 1888 but lost.

The publicity he gained for prosecuting Anthony may have made his

name better known and may have therefore helped him get elected to Congress. But today, if anyone remembers his name at all, it does not help his reputation. Anthony is a national icon and Crowley is the man who tried to put her in jail.

The Defense Case

Next it was time for the defense to present its case. Henry R. Selden stood, faced Judge Hunt, and said, "For the second time in my life, in my professional practice, I am under the necessity of offering myself as a witness for my client." He was sworn in, promised to tell the truth, and commenced to speak, without asking himself any questions.

> Before the last election, Miss Anthony called upon me for advice, upon the question whether she was or was not a legal voter. I examined the question and gave her my opinion unhesitatingly that the laws and Constitution of the United States authorized her to vote, as well as they authorized any man to vote, and I advised her to have her name placed upon the registry and to vote at the election, if the inspectors should receive her vote. I gave the advice in good faith, believing it to be accurate, and I believe it to be accurate still.

Crowley, believing Selden had not made any useful point for his side, declined to cross-examine him.

Selden, not surprised that Crowley did not cross-examine him, moved to the next step of his defense. He looked at Judge Hunt and said, "I propose to call Miss Anthony as to the fact of her voting on the question of the intention or belief under which she voted."

Crowley stood quickly and said, "She is not competent as a witness in her own behalf." Judge Hunt nodded and agreed with the objection. Susan B. Anthony would not be allowed to testify in her own behalf.

Selden said, "Defendant rests."

Was Anthony "Competent?"

The trial transcript, the *History of Woman Suffrage,* and the Ida Husted Harper biography of Susan B. Anthony all fail to discuss the issue of Anthony's "competence" to testify at her own trial, as if it is a minor point. Later generations of scholars would see an anti-feminist bias in the issue, arguing that courts at the time viewed women as mentally deficient and unable to understand the issues they would be questioned about, or viewed both Crowley and Hunt as anti-woman, something Selden was complicit in because he failed to

object to Crowley's objection and also failed to use the ruling as a basis for an appeal. The problem with these later interpretations is that they omit the trial's context. Women in fact often testified in trials in New York and other states in the mid and late 19th Century. And the fact that the issue was so quickly disposed of in the Anthony trial suggests strongly that Selden expected the ruling.

The word "competent," then and to a lesser extent now, in a trial can be used to refer to something other the mental capacity of a witness. It was used as a synonym for relevant. When Selden said he wanted Anthony to testify "as to the fact of her voting on the question of the intention or belief under which she voted," Crowley was saying it didn't matter what she believed, that simply committing the act of voting was a violation of the law, intent was irrelevant, and Hunt was agreeing with Crowley. The issue was not one of Anthony's mental competence but rather of the relevance of what she was being called to testify about.

Pound Testifies

Crowley, feeling very self-assured, called John E. Pound as a witness. After he was sworn in, Crowley asked, "During the months of November and December, eighteen seventy-two, and January, eighteen seventy-three, were you assistant United States district attorney for the Northern District of New York?"

"Yes, sir," Pound answered in a strong, confident voice.

"Do you know the defendant, Susan B. Anthony?"

"Yes, sir." Pound sounded overly official in his confidence.

"Did you attend an examination before William C. Storrs, a United States commissioner, in the city of Rochester, when her case was examined?"

"I did," Pound said with the same self-assurance.

"Was she called as a witness in her own behalf upon that examination?"

"She was."

"Was she sworn?"

"She was."

"Did she give evidence?"

"She did."

"Did you keep minutes of evidence on that occasion?"

"I did."

Crowley handed Pound a piece of paper. "Please look at the paper now shown you and see if it contains the minutes you kept upon that occasion."

"It does."

"Turn to the evidence of Susan B. Anthony?"

"I have it."

"Did she, upon that occasion, state that she consulted or talked with Judge Henry R. Selden of Rochester in relation to her right to vote?"

Selden was surprised. He had not anticipated the document would be produced as evidence in the trial. He stood and said, "I object to that upon the ground that it is incompetent, that if they refuse to allow her to be sworn here, they should be excluded from producing any evidence that she gave elsewhere, especially when they want to give the version which the United States officer took of her evidence." Selden of course was well aware that any evidence collected in a preliminary examination can be offered as evidence in the trial. He realized now that he had erred in not objecting to the court disallowing his client to testify earlier.

Judge Hunt did not ponder over Selden's objection. He immediately said, "Go on."

Crowley, pleased with himself, looked at Pound. "State whether she stated on that examination, under oath, that she had talked or consulted with Judge Henry R. Selden in relation to her right to vote."

"She did."

"State whether she was asked, upon that examination, if the advice given her by Judge Henry R. Selden would or did make any difference in her action in voting, or in substance that."

Pound looked at the paper. "She stated on the cross-examination, 'I should have made the same endeavor to vote that I did had I not consulted Judge Selden. I didn't consult any one before I registered. I was not influenced by his advice in the matter at all, have been resolved to vote, the first time I was at home thirty days, for a number of years.'"

To most in the courtroom this seemed like an extraordinarily minor point. John Van Voorhis, who would represent the three registrars of election in the trial following this one, and who was now acting as Selden's assistant for the Anthony trial, whispered to Selden and then stood to question Pound. "Mr. Pound," he asked, "was she asked there if she had any doubt about her right to vote, and did she answer 'Not a particle?'"

Pound answered, "She stated, 'Had no doubt as to my right to vote,' on the direct examination."

"There was a stenographic reporter there, was there not?" Van Voorhis asked.[7]

"A reporter was there taking notes."

"Was not this question put to her, 'Did you have any doubt yourself of your right to vote?' and did she not answer 'Not a particle?'"

Hunt intervened, saying "Well, she says so, that she had no doubt of her right to vote." He was repeating testimony already given only a few minutes earlier. Meanwhile, Anthony was whispering to Selden.

Selden nodded to Anthony, then stood and said to Judge Hunt, "I beg leave to state, in regard to my own testimony, Miss Anthony informs me that I was mistaken in the fact that my advice was before her registry. It was my recollection that it was on her way to the registry, but she states to me now that she was registered and came immediately to my office. In that respect I was under a mistake."

Crowley and Selden then both told Hunt they had no more evidence to offer.

One of the most anticipated trials in the country's history had included not one line of explosive or even particularly interesting evidence, and the one event that may have interested the entire country had been blocked by the judge when he refused to allow Anthony to testify in her own behalf.

Selden's Closing Statement

Next Henry Selden presented his closing statement. He addressed the judge, not the jury, making legalistic arguments. His presentation droned on and on and on, consuming three hours, more time than it took for both sides combined to make opening statements and question witnesses.

"The defendant is indicted under the Nineteenth Section of the Act of Congress of May thirty-first, eighteen seventy," he began. He quoted from the law: "If at any election for representative or delegate in the Congress of the United States, any person shall knowingly ... vote without having a lawful right to vote ... every such person shall be deemed guilty of a crime ... and on conviction thereof shall be punished by a fine not exceeding five hundred dollars, or by imprisonment for a term not exceeding three years, or by both."

Then, with a sense of drama in his tone, he added,

> The only alleged ground of illegality of the defendant's vote is that she is a woman. If the same act had been done by her brothers under the same circumstances, the act would have been not only innocent, but honorable and laudable, but having been done by a woman it is said to be a crime. The crime therefore consists not in the act done, but in the simple fact that the person doing it was a woman and not a man. I believe this is the first instance in which a woman has been arraigned in a criminal court merely on account of her sex.

Unable to resist the temptation, Selden then offered a mild bit of sarcasm for Crowley. "If the advocates of female suffrage had been allowed to choose the point of attack to be made upon their position," he said, "they could not have chosen it more favorably for themselves; and I am disposed to thank those who have been instrumental in this proceeding for presenting it in the form of a criminal prosecution."

Much of what Selden would argue in the early part of his summation reflected the ideas that Anthony had espoused. "Women have the same interest that men have in the establishment and maintenance of good government," he said. "They are to the same extent as men bound to obey the laws; they suffer to the same extent by bad laws, and profit to the same extent by good laws, and upon principles of equal justice, as it would seem, should be allowed equally with men, to express their preference in the choice of lawmakers and rulers."

Then he hit at the heart of his argument, the argument Anthony wanted him to make. He told Hunt:

> I am aware, however, that we are here to be governed by the Constitution and laws as they are, and that if the defendant has been guilty of violating the law, she must submit to the penalty, however unjust or absurd the law may be. But courts are not required to so interpret laws or constitutions as to produce either absurdity or injustice, so long as they are open to a more reasonable interpretation. This must be my excuse for what I design to say in regard to the propriety of female suffrage, because with that propriety established there is very little difficulty in finding sufficient warrant in the constitution for its exercise.

He was telling Hunt that if you believe women should be allowed to vote, you are allowed to interpret the Constitution so it says that. The United States Constitution, he was arguing, can be read in the same way so many people read the Bible or the Koran or any holy book; it can be read to say what you want it to say. Selden continued:

> This case, in its legal aspects, presents three questions, which I purpose to discuss. One, was the defendant legally entitled to vote at the election in question. Two, if she was not entitled to vote, but believed that she was, and voted in good faith in that belief, did such voting constitute a crime under the statute before referred to? Three, did the defendant vote in good faith in that belief? If the first question be decided in accordance with my views, the other questions become immaterial. If the second be decided adversely to my views, the first and third become immaterial. The two first are questions of law to be decided by the court, the other is a question for the jury.

Judge Hunt interrupted him, saying, "The argument should be confined to the legal questions, and the argument on the other question suspended,

until my opinion on those questions are known."[8] Selden nodded agreement. Then he went on with his summation.

> My first position is that the defendant had the same right to vote as any other citizen who voted at that election. Before proceeding to the discussion of the purely legal question, I desire, as already intimated, to pay some attention to the propriety and justice of the rule which I claim to have been established by the Constitution.
>
> Miss Anthony, and those united with her in demanding the right of suffrage, claim, and with a strong appearance of justice, that upon the principles upon which our government is founded, and which lie at the basis of all just government, every citizen has a right to take part, upon equal terms with every other citizen, in the formation and administration of government.

Many in the courtroom had difficulty concentrating on Selden's arguments. They rambled, often became overly legalistic, and, mostly, went on and on and on.

"In the most celebrated document which has been put forth on this side of the Atlantic," he said, "our ancestors declared that 'governments derive their just powers from the consent of the governed.'" He didn't name the document but assumed everyone in the courtroom would know he was quoting the Declaration of Independence. Then he quoted William Blackstone, John Locke, William Godwin, and Abraham Lincoln. He cited cases. He said women must obey laws but they had no say in making them. Could not serve on juries. Could not be judges. He talked about Chinese girls having their feet bound to make them smaller, Hindu women being burned on the funeral pyres of their deceased husbands, Jewish women being divorced at the whim of their husbands, Persian women being required to wear veils when in public. None of this would happen, he said, if women had a say in making laws.

And he cited specific legal cases. First he cited *Chisholm v. Georgia*, a 1793 case in which Alexander Chisholm sued the state of Georgia for payment for goods he supplied to it during the Revolution. Georgia refused to appear in court, saying it was a sovereign state and could not be sued without its consent. The Supreme Court disagreed and said it could be sued. Exactly what this had to do with a woman voting 80 years later must have confused the 12 men on the jury.

He then restated his key point. "I respectfully insist, first, that upon the principles upon which our government is based, the privilege of the elective franchise cannot justly be denied to women. Second, that women need it for their protection. Third, that the welfare of both sexes will be promoted by granting it to them." He was offering arguments for why women should be allowed to vote, not arguments for why Susan B. Anthony's act of voting was legal.

He next quoted large portions of the Constitution and offered his conclusion that the 14th Amendment guaranteed women the right to vote. And then quoted Bouvier's Law Dictionary, long a standard reference in American jurisprudence, on the definition of the word *citizen:* "One who under the Constitution and laws of the United States, has a right to vote for representatives in Congress, and other public officers, and who is qualified to fill offices in the gift of the people."[9] And other dictionaries. And Richard Grant White.[10]

By now Selden had taken up more than an hour and a half, and members of the jury, Judge Hunt, and others in the courtroom must have had difficulty concentrating.

He now cited Supreme Court Justice Bushrod Washington who, in 1823, while riding circuit, said in the case of *Corfield v. Coryell* that the "privileges and immunities" of a citizen included "the elective franchise."[11] Selden then named other jurists who referred to Bushrod Washington's opinion in cases they tried. And he cited other Supreme Court justices.

Sometimes students are convinced that the longer they make their papers, the higher their grades will be. Selden's recitation of quote after quote, citation after citation, example after example, took on that same logic.

As he had done previously in his presentation, he felt obliged to interrupt his endless list to reiterate his point: "Beyond question, therefore," he said more than halfway through his presentation, "the first section of the Fourteenth Amendment, by placing the citizenship of women upon a par with that of men, and declaring that the 'privileges and immunities' of the citizen shall not be abridged, has secured to women, equally with men, the right of suffrage, unless that conclusion is overthrown by some other provision of the Constitution."

After another half hour, Selden again returned to his conclusion. "I humbly submit to your honor," he began, clearly indicating he was addressing the judge, not the jury, "therefore, that on the constitutional grounds to which I have referred, Miss Anthony had a lawful right to vote, that her vote was properly received and counted, that the first section of the Fourteenth Amendment secured to her that right and did not need the aid of any further legislation. But conceding that I may be in error in supposing that Miss Anthony had a right to vote, she has been guilty of no crime if she voted in good faith believing that she had such right." That is, what his client did was not against the law, and even if it was, as long as she believed it wasn't, she's not guilty. A few minutes later he added, "An innocent mistake is not a crime, and no amount of judicial decisions can make it such."

Then he went on to cite some more cases, quote from some more law books, always addressing the judge, not the jury, as if expecting the gentleman in the robe, not the twelve in the jury box, to decide the case.

Selden was well aware of the famous saying that "ignorance of the law is no excuse," and now addressed that issue:

> The state of the mind constitutes the essence of the offence, and if the state of the mind which the law condemns does not exist, in connection with the act, there is no offence. It is immaterial whether its non-existence be owing to ignorance of law or ignorance of fact, in either case the fact which the law condemns, the criminal intent, is wanting. It is not, therefore, in an "indirect way" that ignorance of the law in such cases constitutes a defense, but in the most direct way possible. It is not a fact which jurors "may take into consideration," or not, at their pleasure, but which they must take into consideration, because, in case the ignorance exists, no matter from what cause, the offence which the statute describes is not committed. In such case, ignorance of the law is not interposed as a shield to one committing a criminal act, but merely to show, as it does show, that no criminal act has been committed.

Evidently not satisfied with his extensive quotations and citations, Selden also decided to show off his Latin. He quoted English jurist Sir Mathew Hale[12] as saying, "As it is *cepit and asportavit,* so it must be *felonice, or animo furandi,* otherwise it is not felony, for it is the mind that makes the taking of another's goods to be a felony, or a bare trespass only." He then cited a dozen more cases.

Then he offered his own earlier advice to Anthony as part of her defense by saying, "Miss Anthony believed, and was advised that she had a right to vote. She may also have been advised, as was clearly the fact, that the question as to her right could not be brought before the courts for trial without her voting or offering to vote." That is, because he as her attorney advised her she had a right to vote, she was not guilty of voting illegally.

Finally, after three hours, he told Hunt, "Thanking your honor for the great patience with which you have listened to my too extended remarks, I submit the legal questions which the case involves for your honor's consideration."

Great patience indeed. Hunt, who throughout the Susan B. Anthony trial would usually speak at most for a few minutes, could not have had any reaction beyond annoyance with Selden's consumption of time. In addition, Selden was conceding a point he would later dispute, that the trial was primarily about legal questions to be decided by the judge, not matters of fact to be decided by the jury. It was a fatal error.

Hunt Addresses the Jury

Now it was Judge Ward Hunt's turn. Unlike Selden, he spoke to the jury. He took about 10 minutes to speak to the twelve men empanelled to find a verdict of guilty or not guilty. And he read from a piece of paper. He spoke almost immediately after Selden completed his oration, so he must have written the document before Selden even began, either between the end of the brief testimony and the beginning of Selden's long recitation, or perhaps even before the testimony. Hunt said,

Gentlemen of the jury, I have given this case such consideration as I have been able to, and, that there might be no misapprehension about my views, I have made a brief statement in writing. The defendant is indicted under the act of Congress of eighteen seventy for having voted for representatives of Congress in November, eighteen seventy-two. Among other things, that act makes it an offense for any person knowingly to vote for such representatives without having a right to vote. It is charged that the defendant thus voted, she not having a right to vote because she is a woman. The defendant insists that she has a right to vote. That the provision of the constitution of this state limiting the right to vote to persons of the male sex is in violation of the Fourteenth Amendment of the Constitution of the United States and is void. The Thirteenth, Fourteenth, and Fifteenth Amendments were designed mainly for the protection of the newly emancipated Negroes, but full effect must nevertheless be given to the language employed. The Thirteenth Amendment provided that neither slavery nor involuntary servitude should longer exist in the United States. If honestly received and fairly applied, this provision would have been enough to guard the rights of the colored race. In some states it was attempted to be evaded by enactments cruel and oppressive in their nature, as that colored persons were forbidden to appear in the towns except in a menial capacity, that they should reside on and cultivate the soil without being allowed to own it, that they were not permitted to give testimony in cases where a white man was a party. They were excluded from performing particular kinds of business, profitable and reputable, and they were denied the right of suffrage. To meet the difficulties arising from this state of things, the Fourteenth and Fifteenth Amendments were enacted.

The Fourteenth Amendment created and defined citizenship of the United States. It had long been contended, and had been held by many learned authorities, and had never been judicially decided to the contrary, that there was no such thing as a citizen of the United States, except as that condition arose from citizenship of some state. No mode existed, it was said, of obtaining a citizenship of the United States except by first becoming a citizen of some state. This question is now at rest. The Fourteenth Amendment defines and declares who should be citizens of the United States, to wit, "All persons born or naturalized in the United States and subject to the jurisdiction thereof." The latter qualification was intended to exclude the children of foreign representatives and the like. With this qualification every person born in the United States or naturalized is declared to be a citizen of the United States, and of the state wherein

he resides. After creating and defining citizenship of the United States, the amendment provides that no state shall make or enforce any law which shall abridge the privileges or immunities of a citizen of the United States. This clause is intended to be a protection, not to all our rights, but to our rights as citizens of the United States only; that is, the rights existing or belonging to that condition or capacity. The words "or citizen of a state," used in the previous paragraph are carefully omitted here. In article four, paragraph two, of the Constitution of the United States it had been already provided in this language, viz: "the citizens of each State shall be entitled to all the privileges and immunities of the citizens in the several States." The rights of citizens of the states and of citizens of the United States are each guarded by these different provisions. That these rights were separate and distinct was held in the Slaughter House Cases[13] recently decided by the United States Supreme Court at Washington. The rights of citizens of the state, as such, are not under consideration in the Fourteenth Amendment. They stand as they did before the adoption of the Fourteenth Amendment and are fully guaranteed by other provisions. The rights of citizens of the states have been the subject of judicial decision on more than one occasion.

Hunt then mentioned three cases without explaining any of their details.[14] Then he continued reading his written statement. "These are the fundamental privileges and immunities belonging of right to the citizens of all free governments, such as the right to life and liberty; the right to acquire and possess property, to transact business, to pursue happiness in his own manner, subject to such restraint as[15] the government may adjudge to be necessary for the general good."

Then he cited the case of "*Cromwell agt. Nevada*, 6 Wallace, 36," in which, he said,

is found a statement of some of the rights of a citizen of the United States, viz: "To come to the seat of the government to assert any claim he may have upon the government, to transact any business he may have with it; to seek its protection; to share its offices; to engage in administering its functions. He has the right of free access to its seaports through which all operations of foreign commerce are conducted, to the sub-treasuries, land offices, and courts of justice in the several states." Another privilege of a citizen of the United States, says Miller, Justice,[16] in the Slaughter House cases, is to demand the care and protection of the federal government over his life, liberty and property when on the high seas or within the jurisdiction of a foreign government. The right to assemble and petition for a redress of grievances, the privilege of the writ of habeas corpus, he says, are rights of the citizen guaranteed by the federal Constitution. The right of voting, or the privilege of voting, is a right or privilege arising under the constitution of the state, and not of the United States. The qualifications are different in the different states. Citizenship, age, sex, residence are variously required in the different states, or may be so.

Then he said something that was a clear indication of his reasoning on the question of who has a right to vote: "If the right belongs to any particular

person, it is because such person is entitled to it by the laws of the state where he offers to exercise it, and not because of citizenship of the United States."

That statement was the death knell for Anthony's case, for Selden's arguments. Hunt continued,

> If the state of New York should provide that no person should vote until he had reached the age of thirty-one years, or after he had reached the age of fifty, or that no person having gray hair, or who had not the use of all his limbs, should be entitled to vote, I do not see how it could be held to be a violation of any right derived or held under the Constitution of the United States. We might say that such regulations were unjust, tyrannical, unfit for the regulation of an intelligent state, but if rights of a citizen are thereby violated, they are of that fundamental class derived from his position as a citizen of the state, and not those limited rights belonging to him as a citizen of the United States, and such was the decision in *Corfield v. Coryell.*[17] The United States rights appertaining to this subject are those first under article one, paragraph two, of the United States Constitution, which provides that electors of representatives in Congress shall have the qualifications requisite for electors of the most numerous branch of the state legislature, and second, under the Fifteenth Amendment, which provides that the right of a citizen of the United States to vote shall not be denied or abridged by the United States, or by any state, on account of race, color, or previous condition of servitude. If the legislature of the State of New York should require a higher qualification in a voter for a representative in Congress than is required for a voter for a member of Assembly, this would, I conceive, be a violation of a right belonging to one as a citizen of the United States. That right is in relation to a federal subject or interest, and is guaranteed by the federal Constitution. The inability of a state to abridge the right of voting on account of race, color, or previous condition of servitude arises from a federal guaranty. Its violation would be the denial of a federal right, that is, a right belonging to the claimant as a citizen of the United States. This right, however, exists by virtue of the Fifteenth Amendment.

Then Hunt addressed what Anthony wanted the 15th Amendment to say but clearly did not.

> If the Fifteenth Amendment had contained the word "sex," the argument of the defendant would have been potent. She would have said an attempt by a state to deny the right to vote because one is of a particular sex is expressly prohibited by that amendment. The amendment, however, does not contain that word. It is limited to race, color, or previous condition of servitude. The legislature of the State of New York has seen fit to say that the franchise of voting shall be limited to the male sex. In saying this, there is, in my judgment, no violation of the letter or of the spirit of the Fourteenth or of the Fifteenth Amendment. This view is assumed in the second section of the Fourteenth Amendment, which enacts that if the right to vote for federal officers is denied by any state to any of the male inhabitants of such state, except for crime, the basis of representation of such state shall be reduced in proportion specified. Not only does this section assume

that the right of male inhabitants to vote was the especial object of its protection, but it assumes and admits the right of a state, notwithstanding the existence of that clause under which the defendant claims to the contrary, to deny to classes or portions of the male inhabitants the right to vote which is allowed to other male inhabitants. The regulation of the suffrage is thereby conceded to the states as a state's right.

The case of Myra Bradwell,[18] decided at a recent term of the Supreme Court of the United States, sustains both the positions above put forth, viz: first, that the rights referred to in the Fourteenth Amendment are those belonging to a person as a citizen of the United States and not character of a state, and second, that a right of the character here involved is not one connected with citizenship of the United States. Mrs. Bradwell made application to be admitted to practice as an attorney and counselor at law in the courts of Illinois. Her application was denied, and upon appeal to the Supreme Court of the United States, it was there held that to give jurisdiction under the Fourteenth Amendment, the claim must be of a right pertaining to citizenship of the United States, and that the claim made by her did not come within that class of cases. Mr. Justice Bradley[19] and Mr. Justice Field[20] held that a woman was not entitled to a license to practice law. It does not appear that the other judges passed upon that question.[21]

Hunt then delivered a key line in his instructions to the jury. He said,

The Fourteenth Amendment gives no right to a woman to vote, and the voting by Miss Anthony was in violation of the law. If she believed she had a right to vote and voted in reliance upon that belief, does that relieve her from the penalty? It is argued that the knowledge referred to in the act relates to her knowledge of the illegality of the act, and not to the act of voting, for it is said that she must know that she voted. Two principles apply here: first, ignorance of the law excuses no one; second, every person in presumed to understand and to intend the necessary effects of his own acts. Miss Anthony knew that she was a woman and that the constitution of this state prohibits her from voting. She intended to violate that provision, intended to test it, perhaps, but certainly intended to violate it. The necessary effect of her act was to violate it, and this she is presumed to have intended. There was no ignorance of any fact, but all the facts being known, she undertook to settle a principle in her own person. She takes the risk, and she cannot escape the consequences. It is said, and authorities are cited to sustain the position, that there can be no crime unless there is a culpable intent; to render one criminally responsible a vicious will must be present. A commits a trespass on the land of B, and B, thinking and believing that he has a right to shoot an intruder on his premises, kills A on the spot. Does B's misapprehension of his rights justify his act? Would a judge be justified in charging the jury that if satisfied that B supposed he had a right to shoot A he was justified, and they should find a verdict of not guilty? No judge would make such a charge. To constitute a crime, it is true, that there must be a criminal intent, but it is equally true that knowledge of the facts of the case is always held to supply this intent. An intentional killing bears with it evidence of malice in law. Whoever, without

justifiable cause, intentionally kills his neighbor is guilty of a crime. The principle is the same in the case before us, and in all criminal cases. The precise question now before me has been several times decided, viz.: that one illegally voting was bound and was assumed to know the law, and that a belief that he had a right to vote gave no defense, if there was no mistake of fact.

Hunt then cited four cases to support his position.[22]

The Surprise Ruling

Next he gave the jury the heart of his ruling, one that surprised everyone in the courtroom, especially Anthony, Selden, and Van Voorhis. He said, "No system of criminal jurisprudence can be sustained upon any other principle. Assuming that Miss Anthony believed she had a right to vote, that fact constitutes no defense if in truth she had not the right. She voluntarily gave a vote which was illegal and thus is subject to the penalty of the law. Upon this evidence I suppose there is no question for the jury and that the jury should be directed to find a verdict of guilty."

Directing the jury to find a verdict in a criminal case?

Hunt had, in clear violation of the Sixth Amendment to the United States Constitution, which guarantees an accused person a trial by jury, instructed the jury to find a verdict. A verdict of guilty.

The Sixth Amendment says, "In all criminal prosecutions, the accused shall enjoy the right to a speedy and public trial, by an impartial jury of the State and district wherein the crime shall have been committed, which district shall have been previously ascertained by law, and to be informed of the nature and cause of the accusation, to be confronted with the witnesses against him, to have compulsory process for obtaining witnesses in his favor, and to have the assistance of counsel for his defense."

By an impartial jury.

Selden at first didn't clearly understand the significance of what Judge Hunt had said, and, rather than respond to the obvious usurpation of constitutional authority, he rephrased his basic legal argument. "I submit," he told Hunt, "that on the view which your honor has taken that the right to vote and the regulation of it is solely a state matter, that this whole law is out of the jurisdiction of the United States courts and of Congress. The whole law upon that basis, as I understand it, is not within the constitutional power of the general government, but is one which applies to the states." He had argued for

hours that the national constitution gave his client a right to vote, but now he was arguing that the national government had no say in whether she could vote, that that was a matter entirely up to the states.

Then, as if Hunt had said nothing to the jury, Selden said,

> I suppose that it is for the jury to determine whether the defendant is guilty of a crime or not. And I therefore ask your honor to submit to the jury these propositions: First, if the defendant, at the time of voting, believed that she had a right to vote and voted in good faith in that belief, she is not guilty of the offense charged. Second, in determining the question whether she did or did not believe that she had a right to vote, the jury may take into consideration, as bearing upon that question, the advice which she received from the counsel to whom she applied. Third, that they may also take into consideration, as bearing upon the same question, the fact that the inspectors considered the question and came to the conclusion that she had a right to vote. Fourth, that the jury have a right to find a general verdict of guilty or not guilty as they shall believe that she has or has not committed the offense described in the statute.

Selden clearly had not been listening carefully to Hunt. He continued to speak as if Hunt had not instructed the jury on what verdict to reach.

> A professional friend[23] sitting by has made this suggestion which I take leave to avail myself of as bearing upon this question: "The court has listened for many hours to an argument in order to decide whether the defendant has a right to vote. The arguments show the same question has engaged the best minds of the country as an open question. Can it be possible that the defendant is to be convicted for acting upon such advice as she could obtain while the question is an open and undecided one?"

Judge Hunt was losing patience with Selden's failure to understand what had just happened in the courtroom. He said, "You have made a much better argument than that, sir."

Selden ignored the scolding, and continued to speak. "As long as it is an open question I submit that she has not been guilty of an offense. At all events it is for the jury." Now, finally, Selden was expressing some small awareness of the import of what Hunt had said only minutes earlier.

Hunt had had enough. He dismissively told Selden, "I cannot charge these propositions, of course." Then he turned to face the jury.

> The question, gentlemen of the jury, in the form it finally takes, is wholly a question or questions of law, and I have decided as a question of law, in the first place, that under the Fourteenth Amendment, which Miss Anthony claims protects her, she was not protected in a right to vote. And I have decided also that her belief and the advice which she took does not protect her in the act which she committed. If I am right in this, the result must be a verdict on your part of guilty, and I therefore direct that you find a verdict of guilty.

Finally Selden fully understood what was happening. He protested angrily. "That is a direction no court has power to make in a criminal case."

Hunt ignored Selden. "Take the verdict, Mr. Clerk."

The court clerk faced the jury and said, "Gentlemen of the jury, hearken to your verdict as the court has recorded it. You say you find the defendant guilty of the offense whereof she stands indicted, and so say you all."

Selden, now more angry than confused, said, "I don't know whether an exception is available, but I certainly must except to the refusal of the court to submit those propositions, and especially to the direction of the court that the jury should find a verdict of guilty. I claim that it is a power that is not given to any court in a criminal case." He added, in frustration, "Will the clerk poll the jury?"

Judge Hunt, straining to control his patience, responded, "No. Gentlemen of the jury, you are discharged."[24]

All 12 men on the jury then stood and filed out of the jury box and out of the courtroom. From the start of the trial to this point, not one of them spoke a word while sitting in the jury box.

The trial was over.

Ward Hunt

Selden may have made tactical errors in his defense of Anthony. Crowley may have betrayed political ambition in his prosecution. Anthony herself had a personality that at times was less than admirable. But no one, no one, associated with the case has been treated less kindly by history than Ward Hunt.[25]

The list of Hunt's offences during the trial is lengthy, according to his critics. (1) He wrote his opinion before all the testimony had been given (perhaps before the testimony began), indicating he approached the trial with a belief the accused was guilty. (2) He would not permit Anthony to testify in her own defense. (3) He then, inconsistently, allowed testimony she had given during a preliminary hearing to be introduced. (4) He instructed the jury to return a guilty verdict, in clear violation of the U.S. Constitution's guarantee of a jury trial for anyone accused of a crime. (5) He would not allow the jury members to be polled to see if, in fact, each one of the 12 men on it agreed with his instructions.

Even for those then and today who believe Anthony was indeed guilty of breaking the law, Hunt's performance at her trial was, to be kind, nonjudicious. More accurately, if harsher, it was shameful.

Most of Hunt's life and career before and after the trial would not have

suggested he was capable of such a performance. He was generally successful and as far as the historical record can detect honorable at most of what he did.

At Union College in Schenectady, New York, he was a member of the newly formed Kappa Alpha Society, now the oldest Greek fraternity in the country. At Union he became friends with Horatio Seymour, who later became governor of New York and the 1868 Democratic Party candidate for president (he lost to Ulysses S. Grant). Hunt served terms as mayor of his hometown, Utica, New York, and in the state assembly. A bit ironically, along with Henry Selden, he was a founder of the New York Republican Party in 1855. Also, like Selden, he served on the New York Court of Appeals, the state's highest court.

Along the way, Hunt became a friend of Roscoe Conkling, the most powerful politician in the state. In 1872, President Grant considered offering to nominate Conkling to a seat on the Supreme Court, but before he could make the offer, Conkling asked him to nominate Hunt, and Grant agreed. Hunt was confirmed by the Senate in January 1873. (Later in 1873, Grant did tell Conkling he was going to nominate him to the high court, but Conkling, then a U.S. senator, turned him down. He had more power, and more influence with the president, in the Senate and as a political boss.)

Hunt almost always voted with the majority on the Supreme Court, but one notable exception was *United States v. Reese,* which, like the Anthony case, involved the right to vote. It was decided on March 27, 1876, less than three years after Anthony's trial. Two white Kentucky officials refused to accept a ballot from a black voter, William Garner,

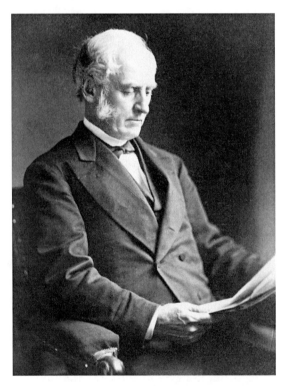

Ward Hunt, an associate justice of the United States Supreme Court, was judge in Anthony's trial. He was riding circuit at the time, something Supreme Court justices no longer do. Anthony called him "small-brained" (United States Supreme Court).

who had not paid a poll tax, and were prosecuted under the Enforcement Act of 1870, the same law used to charge Anthony. The court ruled, seven to two, that the 15th Amendment did not actually grant suffrage to blacks but rather merely prohibited the exclusion of blacks because of their race. The ruling in effect permitted states to enact poll taxes, literacy tests, and other laws clearly designed to prevent blacks from voting. The 15th Amendment was gutted. Hunt was one of the two justices who dissented.

But Hunt's time on the court is best remembered not for any vote he cast but rather for not leaving the court. He had a massive stroke in 1878 and was left partly paralyzed. His condition prevented him from sitting in on court sessions or from writing opinions. But he said he couldn't afford to retire. He was 66 years old and had been on the court five years. At the time, to receive a full pension he would need to be 70 years old and have 10 years of service. He was pressured by members of Congress, some newspapers, and perhaps privately by other members of the court, but he wouldn't leave. He was incapable of serving on the court, but he wanted his pension. In 1882 Congress passed a law that would give him a full pension if he retired within 30 days, and he agreed. He died four years later.

A Question of Great Magnitude

Anthony, Selden, Van Voorhis, and most of the spectators in the courtroom were stunned. Anthony's plan to have the jury nullify the law wasn't even given a chance. The dozens of speeches she had made were wasted effort. Selden had failed his client. He had not anticipated a directed verdict, an action clearly not permitted by the 6th Amendment to the Constitution. Nothing was left but a meaningless motion.

The next morning, Selden made that motion, a motion for a new trial. He stood in front of Hunt and said, "May it please the court, the trial of this case commenced with a question of very great magnitude, whether by the Constitution of the United States the right of suffrage was secured to female equally with male citizens. It is likely to close with a question of much greater magnitude, whether the right of trial by jury is absolutely secured by the federal constitution to persons charged with crime before the federal courts." He was bolder now than he had been the previous day. Now he was indisputably accusing Judge Ward Hunt of violating the Constitution. He continued.

> I assume, without attempting to produce any authority on the subject, that this court has power to grant to the defendant a new trial in case it should appear that in the haste and in the lack of opportunity for examination which necessar-

ily attend a jury trial, any material error should have been committed prejudicial to the defendant, as otherwise no means whatever are provided by the law for the correction of such errors. The defendant was indicted, under the nineteenth section of the act of Congress of May thirty-first, eighteen seventy, entitled "An act to enforce the right of citizens of the United States to vote in the several states of this Union, and for other purposes" and was charged with having knowingly voted, without having a lawful right to vote, at the congressional election in the Eighth Ward of the city of Rochester, in November last, the only ground of illegality being that the defendant was a woman. The provisions of the act of Congress, so far as they bear upon the present case, are as follows: "Section nineteen. If at any election for representative or delegate in the Congress of the United States, any person shall knowingly personate and vote, or attempt to vote, in the name of any other person, whether living, dead or fictitious or vote more than once at the same election for any candidate for the same office, or vote at a place where he may not be lawfully entitled to vote, or vote without having a lawful right to vote, every such person shall be deemed guilty of a crime, and shall for such crime be liable to prosecution in any court of the United States, of competent jurisdiction, and, on conviction thereof, shall be punished by a fine not exceeding five hundred dollars or by imprisonment for a term not exceeding three years, or both, in the discretion of the court, and shall pay the costs of prosecution."

Selden was re-walking heavily trod ground. There was nothing new in his argument. And he wasn't directly addressing the strongest point available to him, namely that Hunt had violated the 6th Amendment to the Constitution by ordering a directed verdict and denying Anthony her right to a trial by jury. As with his closing argument, after all the testimony had been presented, he talked on and on, straining the ability of anyone in the courtroom to concentrate on what he said.

> It appeared on the trial that before voting the defendant called upon a respectable lawyer and asked his opinion whether she had a right to vote, and he advised her that she had such right, and the lawyer was examined as a witness in her behalf, and testified that he gave her such advice, and that he gave it in good faith, believing that she had such right.

It also appeared that when she offered to vote, the question whether as a woman she had a right to vote was raised by the inspectors and considered by them in her presence, and they decided that she had a right to vote, and received her vote accordingly.

All this had been said only hours earlier, and the repetition added to the weakness of his presentation. To its ability to wear down his audience. He continued:

> It was also shown on the part of the government that on the examination of the defendant before the commissioner, on whose warrant she was arrested, she

stated that she should have voted, if allowed to vote, without reference to the advice she had received from the attorney whose opinion she had asked; that she was not influenced to vote by that opinion, that she had before determined to offer her vote and had no doubt about her right to vote. At the close of the testimony the defendant's counsel proceeded to address the jury and stated that he desired to present for consideration three propositions, two of law and one of fact. First, that the defendant had a lawful right to vote. Second, that whether she had a lawful right to vote or not, if she honestly believed that she had that right and voted in good faith in that belief, she was guilty of no crime. Third, that when she gave her vote she gave it in good faith, believing that it was her right to do so.

Like many persons overly impressed by the sound of their own voices, Selden could not allow himself to abbreviate his arguments. He went on and on. And on.

That the two first propositions presented questions for the court to decide, and the last for the jury. When the counsel had proceeded thus far, the court suggested that the counsel had better discuss in the first place the questions of law, which the counsel proceeded to do.[26] And having discussed the two legal questions at length, asked leave then to say a few words to the jury on the question of fact. The court then said to the counsel that he thought that had better be left until the views of the court upon the legal questions should be made known.

No one mentioned it at the time, but Judge Hunt's refusal to allow Selden to directly address the jury on this point might have been a good indication that he had already decided he would order a directed verdict. From Hunt's viewpoint, the jury was already irrelevant. Selden continued,

The district attorney thereupon addressed the court at length upon the legal questions, and at the close of his argument the court delivered an opinion adverse to the positions of the defendant's counsel upon both of the legal questions presented, holding that the defendant was not entitled to vote and that if she voted in good faith in the belief in fact that she had a right to vote, it would constitute no defense, the grounds of the decision on the last point that she was bound to know that by law she was not a legal voter, and that even if she voted in good faith in the contrary belief, it constituted no defense to the crime with which she was charged. The decision of the Court upon these questions was read from a written document.

Emphasizing that Hunt spoke from a written document was the second important point Selden made in this second lengthy address to the judge. It emphasized what would later become a common belief among historians, that Hunt had written his decision before all the testimony and arguments were presented, perhaps before the trial even commenced. The first important point, of course, was to accuse Hunt of violating the 6th Amendment.

Like a man addicted to hearing himself speak, Selden continued, repeat-

ing what had transpired in a past so recent that everyone in the courtroom who was paying attention could recall it without difficulty. "At the close of the reading," he droned on, "the court said that the decision of these questions disposed of the case and left no question of fact for the jury and that he should therefore direct the jury to find a verdict of guilty and proceeded to say to the jury that the decision of the court had disposed of all there was in the case, and that he directed them to find a verdict of guilty, and he instructed the clerk to enter a verdict of guilty."

At least now Selden was addressing what had become the paramount legal issue in the case, Hunt's directed verdict.

> At this point before any entry had been made by the clerk, the defendant's counsel asked the court to submit the case to the jury, and to give to the jury the following several instructions: first, that if the defendant, at the time of voting, believed that she had a right to vote and voted in good faith in that belief, she is not guilty of the offence charged. Second, in determining the question whether she did or did not believe that she had a right to vote, the jury may take into consideration, as bearing upon that question, the advice which she received from the counsel to whom she applied.
>
> Third, that they may also take into consideration as bearing upon the same question the fact that the inspectors considered the question and came to the conclusion that she had a right to vote. Fourth, that the jury have a right to find a general verdict of guilty or not guilty, as they shall believe that she has or has not been guilty of the offense described in the statute. The court declined to submit the case to the jury upon any question whatever and directed them to render a verdict of guilty against the defendant. The defendant's counsel excepted to the decision of the court upon the legal questions to its refusal to submit the case to the jury, to its refusal to give the instructions asked; and to its direction to the jury to find a verdict of guilty against the defendant, the counsel insisting that it was a direction which no court had a right to give in a criminal case.

Selden, of course, could have made just that point, that the court had no authority to direct a verdict in a criminal case, that the 6th Amendment prohibited it, in a sentence or two, but he chose to speak and speak and speak. There was nothing to be gained by talking relentlessly, and more than time to lose. He was losing the patience of the judge, and of spectators in the courtroom. Susan B. Anthony was always waging a battle for public opinion more than for a victory in Hunt's courtroom, and in such battles long-windedness is a gift to the enemy. Selden continued,

> The Court then instructed the clerk to take the verdict, and the clerk said, "Gentlemen of the jury, hearken to the verdict as the court hath recorded it. You say you find the defendant guilty of the offense charged. So say you all." No

response whatever was made by the jury, either by word or sign. They had not consulted together in their seats or otherwise. Neither of them had spoken a word. Nor had they been asked whether they had or had not agreed upon a verdict. The defendant's counsel then asked that the clerk be requested to poll the jury. The court said, "That cannot be allowed. Gentlemen of the jury, you are discharged," and the jurors left the box. No juror spoke a word during the trial, from the time they were impaneled to the time of their discharge.

"Abolishes Trial by Jury"

Selden was exasperated, and exasperating. But once again he finally returned to the one point he could usefully make.

Now I respectfully submit that in these proceedings the defendant has been substantially denied her constitutional right of trial by jury. The jurors composing the panel have been merely silent spectators of the conviction of the defendant by the court. They have had no more share in her trial and conviction than any other twelve members of the jury summoned to attend this court, or any twelve spectators who have sat by during the trial. If such course is allowable in this case, it must be equally allowable in all criminal cases, whether the charge be for treason, murder or any minor grade of offence which can come under the jurisdiction of a United States court, and as I understand it, if correct, substantially abolishes the right of trial by jury. It certainly does so in all those cases, where the judge shall be of the opinion that the facts which he may regard as clearly proved, lead necessarily to the guilt of the defendant. Of course by refusing to submit any question to the jury, the judge refuses to allow counsel to address the jury in the defendant's behalf. The constitutional provisions which I insist are violated by this proceeding are the following:

Constitution of the United States, article three, section two. "The trial of all crimes, except in cases of impeachment, shall be by jury." Amendments to Constitution, article six. "In all criminal prosecutions, the accused shall enjoy the right to a speedy and public trial, by an impartial jury of the state and district wherein the crime shall have been committed, which district shall have been previously ascertained by law; and to be informed of the nature and cause of the accusation; to be confronted with the witnesses against him; to have compulsory process for obtaining witnesses in his favor, and to have the assistance of counsel for his defense." In accordance with these provisions, I insist that in every criminal case, where the party has pleaded not guilty, whether upon the trial the guilt of such party appears to the judge to be clear or not, the response to the question, guilty or not guilty, must come from the jury, must be their voluntary act, and cannot be imposed upon them by the court. No opportunity has been given me to consult precedents on this subject, but a friend[27] has referred me to an authority strongly supporting my position, from which I will quote, though I deem a reference to precedents unnecessary to sustain the plain declarations of the Constitution: I refer to the case of the *State vs. Shule*.[28] ... Before

stating that case I quote from the text....[29] "The verdict is to be the result of the deliberation of the jury upon all the evidence in the case. The court has no right to anticipate the verdict by an expression of opinion calculated so to influence the jury as to take from them their independence of action." In the *State versus Shule*, two defendants were indicated for an affray. "The jury remaining out a considerable time; at the request of the prosecuting attorney they were sent for by the court. The court then charged them that although Jones (the other defendant) had first commenced a battery upon Shule, yet, if it—the jury— believed the evidence, the defendant, Shule, was also guilty. Thereupon, one of the jurors remarked that they had agreed to convict Jones, but were about to acquit Shule. The court then charged the jury again and told them that they could retire if they thought proper to do so. The jury consulted together a few minutes in the courtroom. The prosecuting attorney directed the clerk to enter a verdict of guilty as to both defendants. When the clerk had entered the verdict, the jury were asked to attend to it, as it was about to be read by the clerk. The clerk then read the verdict in the hearing of the jury. The jury, upon being requested if any of them disagreed to the verdict to make it known by a nod, seemed to express their unanimous assent, and no juror expressed his dissent." In reviewing the case, the court said, "The error complained of is that before the jury had announced their verdict, and in fact after they had intimated an intention to acquit the defendant, Shule, the court allowed the clerk to be directed to enter a verdict finding him guilty, and after the verdict was so entered, allowed the jury to be asked if any of them disagreed to the verdict which had been recorded by the clerk. No juror expressed his dissent, but by a nod which appeared to be made by each juror, expressed their unanimous assent. The innovation is that instead of permitting the jury to give their verdict, the court allows a verdict to be entered for them, such as it is to be presumed the court thinks they ought to render, and then they are asked if any of them disagree to it, thus making a verdict for them, unless they are bold enough to stand out against a plain intimation of the opinion of the court." A *venire de novo*[30] was ordered. The principal difference in this case and the one under consideration is that in the latter the court directed the clerk to enter the verdict and in the former he was allowed to do so, and in the latter the court denied liberty to the jurors to dissent from the verdict, and in the former the court allowed such dissent.

Now, finally, Selden was concentrating on his strongest point, Judge Hunt's directed verdict denying Anthony a trial by jury. Selden continued,

With what jealous care the right of trial by jury in criminal cases has been guarded by every English speaking people from the days of King John, indeed from the days of King Alfred, is known to every lawyer and to every intelligent layman, and it does not seem to me that such a limitation of that right as is presented by the proceedings in this case can be reconciled either with constitutional provisions, with the practice of courts, with public sentiment on the subject, or with safety in the administration of justice. How the question would be regarded by the highest court of this state may fairly be gathered from its

decision in the case of Cancemi,[31] where, on a trial for murder, one juror, sometime after the trial commenced, being necessarily withdrawn, a stipulation was entered into, signed by the district attorney and by the defendant and his counsel, to the effect that the trial should proceed before the remaining eleven jurors and that their verdict should have the same effect as the verdict of a full panel would have. A verdict of guilty having been rendered by the eleven jurors was set aside and a new trial ordered by the Court of Appeals, on the ground that the defendant could not, even by his own consent, be lawfully tried by a less number of jurors than twelve. It would seem to follow that he could not waive the entire panel, and effectually consent to be tried by the court alone, and still less could the court, against his protest, assume the duties of the jury, and effectually pronounce the verdict of guilty or not guilty in their stead. It will doubtless be insisted that there was no disputed question of fact upon which the jury were required to pass. In regard to that, I insist that however clear and conclusive the proof of the facts might appear to be, the response to the question, guilty or not guilty, must under the Constitution come from the jury and could not be supplied by the judgment of the court, unless, indeed, the jury should see fit to render a special verdict, which they always may but can never be required to do. It was the province of the court to instruct the jury as to the law, and to point out to them how clearly the law, on its view of the established facts, made out the offence, but it has no authority to instruct them positively on any question of fact, or to order them to find any particular verdict. That must be their spontaneous work. But there was a question of fact, which constituted the very essence of the offence, and one on which the jury were not only entitled to exercise, but were in duty bound to exercise, their independent judgment. That question of fact was, whether the defendant, at the time when she voted, knew that she had not a right to vote. The statute makes this knowledge the very gist of the offence, without the existence of which, in the mind of the voter, at the time of voting, there is no crime. There is none by the statute and none in morals. The existence of this knowledge, in the mind of the voter, at the time of voting, is under the statute necessarily a fact and nothing but a fact, and one which the jury was bound to find as a fact, before they could, without violating the statute, find the defendant guilty.

Once again, however, Selden repeated himself. Repeated point after point he had already made, no doubt losing the ability of those in the courtroom to concentrate on his logic. He droned on:

The ruling which took that question away from the jury, on the ground that it was a question of law and not of fact, and which declared that as a question of law the knowledge existed, was, I respectfully submit, a most palpable error, both in law and justice. It was an error in law because its effect was to deny any force whatever to the most important word which the statute uses in defining the offense, the word "knowingly." It was also unjust, because it makes the law declare a known falsehood as a truth, and then by force of that judicial falsehood condemns the defendant to such punishment as she could only lawfully be subject to if the falsehood were a truth.

Such juggling of words must have sounded either sophomoric or incomprehensible to many in the courtroom. "I admit that it is an established legal maxim," he continued,

> that every person—judicial officers excepted—is bound and must be presumed to know the law. The soundness of this maxim, in all the cases to which it can properly be applied, I have no desire to question but it has no applicability whatever to this case. It applies in every case where a party does an act which the law pronounces criminal, whether the party knows or does not know that the law has made the act a crime. That maxim would have applied to this case if the defendant had voted, knowing that she had no legal right to vote, without knowing that the law had made the act of knowingly voting without a right a crime. In that case she would have done the act which the law made a crime and could not have shielded herself from the penalty by pleading ignorance of the law. But in the present case the defendant has not done the act which the law pronounces a crime. The law has not made the act of voting without a lawful right to vote a crime where it is done by mistake, and in the belief by the party voting that he has the lawful right to vote. The crime consists in voting "knowingly," without lawful right. Unless the knowledge exists in fact, the very gist of the offence is wanting. To hold that the law presumes conclusively that such knowledge exists in all cases where the legal right is wanting, and to reject all evidence to the contrary, or to deny to such evidence any effect, as has been done on this trial, is to strike the word "knowingly" out of the statue, and to condemn the defendant on the legal fiction that she was acting in bad faith, it being all the while conceded that she was acting in good faith. I admit that there are precedents to sustain such ruling, but they cannot be reconciled with the fundamental principles of criminal law, nor with the most ordinary rules of justice. Such a ruling cannot but shock the moral sense of all right-minded, unprejudiced men.

Selden was now coming dangerously close to insulting the judge. He probably had no fear for being held in contempt, since he did not engage in *ad hominem* attacks, but he clearly wasn't winning the good will of the judge. Selden went on:

> No doubt the assumption by the defendant of a belief of her right to vote might be made use of by her as a mere cover to secure the privilege of giving a known illegal vote and of course that false assumption would constitute no defense to the charge of illegal voting. If the defendant had dressed herself in male attire and had voted as John Anthony, instead of Susan, she would not be able to protect herself against a charge of voting with a knowledge that she had no right to vote by asserting her belief that she had a right to vote as a woman. The artifice would no doubt effectually overthrow the assertion of good faith. No such question, however, is made here. The decision of which I complain concedes that the defendant voted in good faith, in the most implicit belief that she had a right to vote, and condemns her on the strength of the legal fiction, conceded to be in fact a mere fiction, that she knew the contrary.

But if the facts admitted of a doubt of the defendant's good faith, that was a question for the jury, and it was clear error for the court to assume the decision of it. Again, the denial of the right to poll the jury was most clearly an error. Under the provisions of the Constitution which have been cited, the defendant could only be convicted on the verdict of a jury. The case of *Cancemi* shows that such jury must consist of twelve men, and it will not be claimed that anything less than the unanimous voice of the jury can be received as their verdict. How then could the defendant be lawfully deprived of the right to ask every juror if the verdict had his assent? I believe this a right which was never before denied to a party against whom a verdict was rendered in any case, either civil or criminal. The following cases show, and many others might be cited to the same effect, that the right to poll the jury is an absolute right in all cases, civil and criminal."[32]

By criticizing the court for not allowing him to poll the jury, Selden was stressing a legally useless point, since the important issue was clearly that Judge Hunt had instructed the jury to deliver a guilty verdict. He may have delivered the criticism at the request or suggestion of Susan B. Anthony, who no doubt saw that emphasizing the point was another victorious skirmish in her battle for public opinion. Then Selden returned to his argument:

The ground on which the right of the defendant to vote has been denied is, as I understand the decision of the court, "that the rights of the citizens of the state as such were not under consideration in the Fourteenth Amendment; that they stand as they did before that amendment. The right of voting or the privilege of voting is a right or privilege arising under the constitution of the state, and not of the United States. If the right belongs to any particular person, it is because such person is entitled to it as a citizen of the state where he offers to exercise it, and not because of citizenship of the United States.... The regulation of the suffrage is conceded to the states as a state right."[33] If this position be correct, which I am not now disposed to question, I respectfully insist that the Congress of the United States had no power to pass the act in question, that by doing so it has attempted to usurp the rights of the states, and that all proceedings under the act are void.

Finally Selden reached the point he should have made at the beginning of his address to the court, a listing of reasons why his client was entitled to a new trial.

I claim therefore that the defendant is entitled to a new trial.

First, because she has been denied her right of trial by jury.

Second, because she has been denied the right to ask the jury severally whether they assented to the verdict which the court had recorded for them.

Third, because the court erroneously held that the defendant had not a lawful right to vote.

Fourth, because the court erroneously held that if the defendant, when she voted, did so in good faith, believing that she had a right to vote, that fact constituted no defense.

Fifth, because the court erroneously held that the question, whether the defendant at the time of voting knew that she had not a right to vote, was a question of law to be decided by the court, and not a question of fact to be decided by the jury.

Sixth, because the court erred in holding that it was a presumption of law that the defendant knew that she was not a legal voter, although in fact she had not that knowledge.

Seventh, because Congress had no constitutional right to pass the act under which the defendant was indicted, and the act and all proceedings under it are void.

Selden next addressed an important technicality, namely that appeals were not permitted to a higher court if the court of original jurisdiction was a court in which a U.S. Supreme Court justice was serving as a circuit-riding judge.

Sir, so far as my information in regard to legal proceedings extends, this is the only court in any country where trial by jury exists in which the decisions that are made in the haste and sometimes confusion of such trials are not subject to review before any other tribunal. I believe that to the decisions of this court, in criminal cases, no review is allowed, except in the same court in the informal way in which I now ask your honor to review the decisions made on this trial. This is therefore the court of last resort, and I hope your honor will give to these, as they appear to me, grave questions, such careful and deliberate consideration as is due to them from such final tribunal. If a new trial shall be denied to the defendant, it will be no consolation to her to be dismissed with a sight penalty, leaving the stigma resting upon her name, of conviction for an offence of which she claims to be, and I believe is, as innocent as the purest of the millions of male voters who voted at the same election are innocent of crime in so voting. If she is in fact guilty of the crime with which she stands charged, and of which she has been convicted by the court, she deserves the utmost penalty which the court under the law has power to impose. If she is not guilty she should be acquitted, and not declared upon the records of this high court guilty of a crime she never committed.

Selden took nearly an hour to make his request for a new trial. Crowley, the federal district attorney, spoke briefly in opposition to Selden's request. Hunt, quiet throughout both presentations, denied the request.

Anthony's Finest Moment

Since no appeal was possible to another court, the only remaining part of the trial was for Hunt to sentence Anthony. Hunt told Anthony to stand, and when she did, asked, "Has the prisoner anything to say why sentence shall not be pronounced?"

Anthony always had something to say. This time, she lashed out, her tongue a cutting whip.

> Yes, your honor, I have many things to say, for in your ordered verdict of guilty you have trampled underfoot every vital principle of our government. My natural rights, my civil rights, my political rights, my judicial rights are all alike ignored. Robbed of the fundamental privilege of citizenship, I am degraded from the status of a citizen to that of a subject, and not only myself individually, but all of my sex are, by your honor's verdict, doomed to political subjection under this so-called form of government.

Judge Hunt quickly lost his patience. He had allowed Selden to consume far too much of his time; he wouldn't be as lenient with Anthony. "The court," he said harshly, "cannot listen to a rehearsal of arguments the prisoner's counsel has already consumed three hours in presenting."

But Anthony was far more experienced at exchanging banter with a hostile audience member than was Hunt. "May it please your honor," she shot back, "I am not arguing the question, but simply stating the reasons why sentence cannot, in justice, be pronounced against me. Your denial of my citizen's right to vote is the denial of my right of consent as one of the governed, the denial of my right of representation as one of the taxed, the denial of my right to a trial by a jury of my peers as an offender against law, therefore, the denial of my sacred rights to life, liberty, property and...."

"The court cannot allow the prisoner to go on," Hunt said with exasperation and annoyance. This was why he had not allowed her to testify. She was turning his courtroom into a theater, her spot on the stage into a lectern.

"But your honor will not deny me this one and only poor privilege of protest against this high-handed outrage upon my citizen's rights," she said calmly, as if she was as prepared for his attempt to cut her off as she would have been from a predictable jibe from a rude audience member. "May it please the court to remember that since the day of my arrest last November this is the first time that either myself or any person of my disfranchised class has been allowed a word of defense before judge or jury."

Judge Hunt felt defeated. "The prisoner must sit down. The court cannot allow it."

Anthony did not sit. She said calmly but insistently,

> All of my prosecutors, from the Eighth Ward corner grocery politician who entered the compliant, to the United States marshal, commissioner, district attorney, district judge, your honor on the bench, not one is my peer, but each and all are my political sovereigns, and had your honor submitted my case to the jury, as was clearly your duty, even then I should have had just cause of protest,

for not one of those men was my peer, but, native or foreign born, white or black, rich or poor, educated or ignorant, awake or asleep, sober or drunk, each and every man of them was my political superior, hence, in no sense my peer. Even, under such circumstances, a commoner of England tried before a jury of lords would have far less cause to complain than should I, a woman, tried before a jury of men. Even my counsel, the Honorable Henry R. Selden, who has argued my cause so ably, so earnestly, so unanswerably before your honor, is my political sovereign. Precisely as no disfranchised person is entitled to sit upon a jury, and no woman is entitled to the franchise, so, none but a regularly admitted lawyer is allowed to practice in the courts, and no woman can gain admission to the bar, hence, jury, judge, counsel, must all be of the superior class.

Hunt was struggling to not lose his temper. This was not theater. This was an arena, and the longer the contest lasted, the more likely he was to emerge the loser. "The Court must insist the prisoner has been tried according to the established forms of law." He clearly made a mistake. Now he was engaging Anthony in a conversation. She had scored a point.

"Yes, your honor," she said, pleased with herself,

but by forms of law all made by men, interpreted by men, administered by men, in favor of men, and against women, and hence, your honor's ordered verdict of guilty against a United States citizen for the exercise of "that citizen's right to vote" simply because that citizen was a woman and not a man. But, yesterday, the same man-made forms of law, declared it a crime punishable with a one thousand dollar fine and six months imprisonment, for you, or me, or both of us, to give a cup of cold water, a crust of bread, or a night's shelter to a panting fugitive as he was tracking his way to Canada.

This clear reference to the fugitive slave law which both Hunt and Anthony could agree was evil was designed to enter the judge's conscience like an ice pick. "And every man or woman in whose veins coursed a drop of human sympathy violated that wicked law, reckless of consequences, and was justified in so doing."

Anthony was suggesting that if Hunt enforced any law that prevented her from voting, he was no better than someone who obeyed the fugitive slave law. "As then, the slaves who got their freedom must take it over, or under, or through the unjust forms of law. Precisely so now must women, to get their right to a voice in this government, take it, and I have taken mine, and mean to take it at every possible opportunity." Now she was not arguing, as Selden had, that she did not violate the law, but rather that she had a moral right, even a moral obligation, to violate it. And would continue to violate it.

Hunt, stung, was unable to summon a rejoinder, so he simply sought to silence Anthony. "The court orders the prisoner to sit down. It will not allow another word."

Anthony now knew she had won the skirmish, another small victory in the larger combat. Her finest moment in a lifetime of struggle.

"When I was brought before your honor for trial," she said triumphantly, "I hoped for a broad and liberal interpretation of the Constitution and its recent amendments that should declare all United States citizens under its protecting aegis. That should declare equality of rights the national guarantee to all persons born or naturalized in the United States. But failing to get this justice, failing even to get a trial by a jury not of my peers, I ask not leniency at your hands but rather the full rigors of the law." She was telling Hunt she wanted to be a martyr.

"The court must insist...," Hunt started to say, but suddenly Anthony sat down.

Hunt would have none of that. Another act of theatrics by Anthony, he was convinced. "The prisoner will stand up."

So Anthony stood. Even without any additional body language, it was as if she had shrugged her shoulders. She was not willing to display any respect for this judge.

Hunt paused, considered altering what he had planned to say, but decided against it, just as an officer decides not to berate an enlisted man who salutes but not quite properly. "The sentence of the court," he said with more exasperation and less finality than he intended, "is that you pay a fine of one hundred dollars and the costs of the prosecution."

Anthony was not done. She had long planned to greet her sentence with open defiance, and now her opportunity had been presented. She said, calmly but with rehearsed strength,

> May it please your honor, I shall never pay a dollar of your unjust penalty. All the stock in trade I possess is a ten thousand dollar debt incurred by publishing my paper, *The Revolution,* four years ago, the sole object of which was to educate all women to do precisely as I have done, rebel against your man-made, unjust, unconstitutional forms of law that tax, fine, imprison and hang women, while they deny them the right of representation in the government, and I shall work on with might and main to pay every dollar of that honest debt, but not a penny shall go to this unjust claim. And I shall earnestly and persistently continue to urge all women to the practical recognition of the old revolutionary maxim, that "Resistance to tyranny is obedience to God."

She wanted to go to jail, but Hunt would not send her there. "Madam," he said, "the court will not order you committed until the fine is paid." He would not send her to jail, he would not permit her to become a martyr, he would not hand her one more small victory. He was exasperated, he was defeated, he rose and left the courtroom.

Susan B. Anthony, convicted and fined, was triumphant.

The Legend of Lady Justice

There's a legend often told in Canandaigua, where the trial took place. According to that legend, hours after Hunt delivered his verdict, the statue of Lady Justice atop the courthouse was blown to the ground by a strong wind. Another version of the story says it was knocked to the ground by lightning. Still another version says only the right arm, the one holding a sword (the other held the scales of justice) was knocked to the ground, either by lightning or a strong wind.[34]

There are no contemporary news reports of damage done to the statue on the day of the trial. And Susan B. Anthony, who of course would have loved such a story to be true, never mentioned it. So maybe it never happened. But for decades there were folks in Canandaigua who told the story. Some still tell it today.

6

The Trial of the Inspectors

On Thursday, January 21, 1873, in United States District Court for the Northern District of New York, in Albany, the state capital, a federal grand jury of 20 men agreed with U.S. Attorney Richard Crowley that three men—Beverley W. Jones, Edwin T. Marsh, and William B. Hall,—allowed Susan B. Anthony and 13 other women to register to vote in October 1872, and on November 5, 1872, allowed Susan B. Anthony and 12 other women to actually vote. Crowley had decided to bring an actual case against only one of the women, the most prominent, Susan B. Anthony, but for reasons that still seem unclear he also decided to bring Jones, Marsh, and Hall to trial. They had been inspectors of election for the First Election District in the Eighth Ward in the city of Rochester, the district in which Anthony and the others registered and voted. Jones and Marsh pled not guilty, while Hall did not enter a plea, which for legal purposes is the same as pleading not guilty. Hall, in fact, was not in the courtroom at the time of his trial.

Why did Crowley proceed with a case against the inspectors when he in effect dropped the cases against a dozen women who had registered and voted? To intimidate other inspectors of election in the future so they would not also allow women to register and vote? That seems unlikely since everyone understood that the real target of any indictment was Anthony, which is why the other women were not brought to trial. To win an easy victory in the event Susan B. Anthony were to be found not guilty? That seems even more unlikely since a courtroom victory for Anthony would no doubt have been based on an interpretation of the U.S. Constitution that allowed women to vote, thus automatically invalidating any charges against the inspectors. Merely to get additional publicity to further his political ambitions? Again, unlikely, because no trial could gain him more publicity than the one against Susan B. Anthony.

The one remaining possibility is that mean-spiritedness guided Crowley's judgment. Something about either the inspectors themselves or their action

so annoyed him that he would not allow them to escape punishment for what today seems like an incidental crime, an act committed with no possibility of personal gain, without any motive other than trying to figure out exactly what their jobs as inspectors called on them to do and not do. Looking back today, they seem clearly to have been guilty of nothing more than not understanding their roles as inspectors of election. They did not share Susan B. Anthony's desire to test the constitutionality of a statue by deliberately violating it. They were simply trying to do their jobs, and if they did not do it particularly well maybe they should have been given better training, or fired, but certainly not prosecuted. But prosecuting attorneys have been known to bring mean-spirited charges for lesser reasons.

Does a U.S. Court Have Jurisdiction?

The trial of Susan B. Anthony concluded on the morning of Wednesday, June 18, 1873, in the federal courthouse in Canandaigua. The trial of the three inspectors of election began in the same courtroom, before the same judge, that afternoon. Crowley was again the prosecuting attorney. John Van Voorhis, who assisted Selden in the defense of Anthony, represented the three accused men.

The trial opened with a reading of the indictment, and then moved into a challenge of the indictment by Van Voorhis. He told Judge Hunt, "I wish to raise some questions upon the indictment in this case. This indictment, I claim, is bad for two reasons, and should be quashed. First, the act of Congress under which it is framed is invalid so far as it relates to this offence because [it is] not authorized by the Constitution of the United States. Second, there is no sufficient statement of any offence in the indictment." Then he expanded on his two points.

> First, Congress has no power to pass laws for the punishment of inspectors of elections, elected or appointed, under the laws of the state of New York, for receiving illegal votes, or registering as voters persons who have no right to be registered. No law of Congress defines the qualifications of voters in the several states. These are found only in the state constitutions and statutes. The offenses charged in the indictment are that the defendants being state officers have violated the laws of the state. If it be so, they may be tried and punished in accordance with the state laws. No proposition can be clearer. If the United States can also punish them for the same offense, it follows that they may be twice indicted, tried, convicted and punished for one offense. A plea in a state court of a conviction and sentence in a United States court would constitute no bar or defense,[1] and the defendants might be punished twice for the same offense. This cannot be, and if the act in question be valid, the state of New York is ousted of

jurisdiction. And where does Congress derive the power to pass laws to punish offenders against the laws of a state? This case must be tried under the laws of the United States. Against those laws, no offense is charged to have been committed. Such power, if it exist, must be somewhere expressly granted, or it must be necessary in order to execute some power that is expressly granted.

Van Voorhis had made a strong point, citing, in effect, the Constitution's prohibition against double jeopardy. The Fifth Amendment to the U.S. Constitution clearly says, "nor shall any person be subject for the same offence to be twice put in jeopardy of life or limb." But Van Voorhis suffered from the same fault as Selden. He was addicted to the sound of his own voice.

So he went on. "The act of Congress in question became a law on May thirty-first, eighteen seventy. It is entitled, 'An Act to Enforce the Right of Citizens of the United States to Vote in the Several States, and for Other Purposes.' The indictment is found under the nineteenth section of the act as it passed originally, and the twentieth section as amended by the act of February twentieth, eighteen seventy-one." The tediousness of the title not satisfying him, Van Voorhis read long excerpts from the act. Then he finally arrived at his point:

> No law of Congress describes the qualifications of voters in this state, or in any state. Congress has provided no registry law. Therefore, what constitutes the offenses charged in this indictment must be looked for in the laws of the state. By no act of Congress can it be determined in what case a person votes *"without having a right to vote."* By no act of Congress can it be determined when an inspector of election has received the vote of *"any person not entitled to vote"* or has registered *"as a voter, any person not entitled to be registered."* These are the offenses alleged in this indictment. They are penal offenses by the statutes of New York. The jurisdiction of the state courts over them is complete and cannot be questioned.

Van Voorhis could have said no federal law on the subject exists and therefore none could have been violated. But like Selden, he often lost his point in his avalanche of words.

The avalanche continued to move downhill. He spoke about how laws on voting differed from state to state. He discussed the 13th, 14th, and 15th Amendments to the U.S. Constitution. He noted that eligibility to be an elector in the electoral college was determined by each state.

Then he addressed what had happened the day before in the same courtroom. "I assume that your honor will hold," he said, "as you did yesterday in Miss Anthony's case that these amendments do not confer the right to vote upon citizens of the United States and therefore not upon women. That decision is the law of this case. It follows necessarily from that decision that these

amendments have nothing to do with the right of voting except so far as that right 'is denied or abridged by the United States, or by any State, on account of race, color, or previous condition of servitude.'" He then quoted, again, from the 13th, 14th, and 15th Amendments. And, he said, none of these amendments gives Congress the power to pass laws punishing inspectors of elections for any infraction on their part. Finally, he got around to his conclusion: "Congress cannot make laws to regulate the duties of inspectors, and it cannot inflict a penalty."

Next he went on to another objection he had to the indictment of the three inspectors of elections. "Second, no offense is stated in the indictment. The first count in the indictment is for knowingly and willfully registering as a voter, Susan B. Anthony.... The indictment contains no averment that the defendants were 'officers of registration' and charged with the duty of making a correct registry of voters. It simply alleges that they were inspectors of elections. What that means, the indictment does not inform us." Van Voorhis was using a technicality to defend his clients, making his argument obviously weak.

He continued in the same vein for several minutes. "Two, the second count is for the same offense, and obnoxious to the same objection. The only variation being that the first count charges the illegal registry of one woman, and the second, fourteen. Three, the third count ..." and so he continued arguing before a judge ill-disposed to consider technicalities.

Dismissing the technicalities without comment, Judge Hunt bade the case proceed.

City Clerk Testifies

Crowley called his first witness, William F. Morrison, the city clerk of Rochester. Morrison was holding two books when he took the stand.

Crowley asked, "Where did you live, in November, eighteen seventy-two?"

"City of Rochester," Morrison said.

"Where do you live now?"

"Same place."

"Did you occupy any official position in the month of November, eighteen seventy-two?" Crowley asked.

"I did."

"And do you now?"

"Yes, sir," Morrison answered.

"What is it?"

"City clerk."

"Have you any registration lists and poll lists of the first election district, Eighth Ward, city of Rochester, in your possession?"

"I have."

"Will you produce them?"

Morrison held up the two books he was carrying.

Crowley asked, "Do you know the defendants, Beverley W. Jones, Edwin T. Marsh, and William. B. Hall, or any of them?"

"I know them all."

"Do you know their handwriting?"

"I cannot say that I do."

"What are those books you hold in your hand?"

"The register of the board of registry and the poll list kept on election day."

"In what district?" Crowley asked.

"First Election District of the Eighth Ward."

"By whom were those books left in your office, if by anyone?"

"To the best of my knowledge," Morrison said, "they were left by Beverley W. Jones, chairman of the board of inspectors."

"By whom do they purport to be signed?"

"Beverley W. Jones, William B. Hall, and Edwin T. Marsh."

"Is there a certificate attached to them purporting to show what they are?"

"There is a certificate attached to the register," Morrison said, "but not to the poll list."

Crowley said, "Please read the certificate attached to the registration list."

Morrison read, "We, the undersigned, composing the Board of Registry for the First District, Eighth Ward, city of Rochester, do certify that the foregoing is a correct list of the voters in said district so far as the same is known to us." He added, "dated November second, eighteen seventy-two."

"In what congressional district was the First Election District of the Eighth Ward, in November, eighteen seventy-two?"

"Twenty-ninth."

"Was there an election for members of Congress for that district and for members of Congress at large for the state held in that ward and election district, last November?"

"Yes, sir."

The mundane quality of Crowley's questions, while standard for establishing a basis for questions that reveal key points, added further to the drea-

riness of the courtroom atmosphere. Yet, it is upon such drudgery that the great dramas of life are built.

"And candidates voted for both of those officers by those who saw fit to vote for them?"

"Yes, sir."

"What day was the election?"

"Fifth day of November."

Crowley than said, "We offer the poll list and the registration of voters in evidence." The poll list was marked Exhibit A and the registration list was marked Exhibit B.

Sylvester Lewis Testifies

Crowley next called Sylvester Lewis, who on the days Anthony registered and voted had been a poll watcher for the Democratic Party.

Crowley asked him, "Where did you live in November, eighteen seventy-two?"

Lewis said, "In the city of Rochester."

"Do you know the defendants, Jones, Marsh and Hall?"

"I do." Poll watchers, then and now, are usually from the neighborhood where the polling precinct is located, allowing them to have familiarity with who votes.

"Do you know whether or not they acted as a board of registry for the registration of voters in the First Election District, Eighth Ward, city of Rochester, preceding the last general election?"

"I know they acted at the November election."

"Did they act as a board of registry preceding the election?"

"Yes, sir."

"Was you present on any day when they were registering voters?"

"I was present on Friday, mostly, and on Saturday."

"Were all three of these defendants there?"

"They were there most of the time."

"Receiving the names of persons who claimed to be entitled to vote?" Crowley asked.

"Yes, sir," Lewis said.

"And taking a registration list?"

"Yes, sir."

"Did you see Miss Anthony and other ladies there upon that day?"

"I saw Miss Anthony there on the first day and other ladies."

"Did you see there, upon that day, the following named persons." Crowley then read from a piece of paper: "Susan B. Anthony, Sarah Truesdell, Mary Pulver, Mary Anthony, Ellen S. Baker, Margaret Leyden, Ann S. Mosher, Nancy M. Chapman, Lottie B. Anthony, Susan M. Hough, Hannah Chatfield, Mary S. Hibbard, Rhoda DeGarmo, Jane Cogswell." Crowley named all of the women originally charged with registering to vote, although only Anthony was eventually brought to trial.

Lewis said, "I saw a number of them; I didn't see the whole of them."

"Do you know by sight any of those persons whose names I have read?"

"I know a number of them."

"Did you see a number of them there?"

"I did."

"Did you see any of them register on that day?"

"I did."

"Have you a list of those that you saw register?"

"I have." Lewis then took a piece of paper from one of his pockets.

"Please state to the jury those that you saw register on that day."

"I can hardly recollect which day they registered."

"Either of the days preceding the election when this board was in session."

Lewis read the names he remembered. "Rhoda DeGarmo, Mary Anthony, Sarah C. Truesdell, Susan M. Hough, Mrs. M.E. Pulver."

Van Voorhis interrupted with a question: "What paper are you reading from?"

"From a memorandum I made at the time." But he quickly amended what he said. "No, it is a paper that was given on the last day of registry."

"A paper that you made yourself?"

"The names that I took," said Lewis.

"On the last day of registry?" Van Voorhis asked. He was clearly trying to cast doubt on Lewis's memory.

"Yes, sir."

Crowley returned to his questioning of Lewis. "State them," he said.

Lewis replied, "The names of the parties that I found on the poll list as having registered. I didn't see them all register myself, but I did a good portion of them."

"I am asking you," Crowley said with a slight loss of patience, "to state who you saw register. I don't ask you who were registered before your attention was called to the list."

Lewis, not happy with Crowley's tone, said, "Well, I saw Rhoda DeGarmo

register, Miss Mary Anthony, Sarah C. Truesdell, Susan M. Hough. I think I saw Nancy M. Chatfield register. Mrs. Margaret Leyden, Mrs. M.E. Pulver. Those I recollect. I was better acquainted with those than with the others."

"At the time you saw these ladies register, were the three inspectors, Hall, Jones, and Marsh, present?"

"Some of the time I saw all three, I think, there. At other times I saw but two of them, sometimes Hall and Jones, sometimes Marsh and Jones, sometimes Hall and Marsh. I think they took turns when they went to dinner."

"On the day of election were you at the polls?"

"I was."

"Did you see any of these women vote on the day of election?"

"I did."

"Were these defendants present when their votes were received?"

"They were."

"And did they receive their votes?"

"They did."

With that question and Lewis's answer, Crowley had finally established that a crime had been committed. Next he wanted to establish that Anthony had committed it. "Who did you see vote or offer their votes upon the day of election?"

Lewis looked at a list of names that he held. "Susan B. Anthony, Mrs. McLean, Rhoda DeGarmo, Mary Anthony, Ellen S. Baker, Sarah C. Truesdell, Mrs. Hough, Mrs. Mosher, Mrs. Leyden, Mrs. Pulver. I recollect seeing those ladies. In fact, I think I saw the whole of them vote with the exception of two, but I will not be positive on that point."

"But you saw those whose names you have given?"

"Yes, sir."

"Do you know how many tickets they voted or offered to the inspectors?"

"I think they voted four tickets."

"Do you know how these tickets were endorsed or what they were called?"

"I was not near enough to see the endorsement. I noticed which boxes they went into."

"Upon the day of election were the defendants Jones, Marsh, and Hall acting as inspectors of election?"

"Yes, sir."

"Receiving votes?"

"Yes, sir."

"And were they2 acting as inspectors of election when these ladies voted?"

"Yes, sir."

"About what time in the day or what time in the morning was it that these ladies voted?"

"I think there had been but a very few votes received in the morning when a number of them voted."

"Well, was it about five o'clock in the morning, very early?"

"No, sir, not so early as that," Lewis said. "The probability is that there was not over twenty or twenty-five votes received before they presented theirs."

The excessive detail about the actual casting of Anthony's vote raised the specter of annoyance. Judge Hunt, Crowley, and Van Voorhis consulted briefly and agreed that "the women named in the indictment were women on the 5th day of November, 1872."[3]

Van Voorhis Cross-Examines Lewis

Then Van Voorhis questioned Lewis. "Which of those persons did you see register?" he asked.

"Mrs. Hough, Mrs. Pulver, Mrs. Truesdell, Mrs. Leyden."

"Do you swear you saw Mrs. Leyden register?"

"I think I did."

"Take a second thought and see if you are willing to say you saw her register. Please look off that paper. Do you recollect seeing those persons register, or do you suppose they did, because you find it on a paper there?" Again, Van Voorhis was attempting to create doubt about the accuracy of Lewis's memory.

"No, sir; I recollect seeing pretty much all of them on my list with the exception of one or two. I won't be fully positive I saw Mrs. Leyden register. I saw her vote." Lewis gave an answer any prosecutor would be happy with. If he claimed his memory was perfect, he would chip away at his own credibility.

"Did you go to Mrs. Leyden's house and advise her to go and register?"

"I don't think I did."

The information being elicited by Van Voorhis's questions were not important to any charges against the inspectors, but if the defense attorney could make it appear the witness was not reliable, the case against his clients would be weakened.

Judge Hunt was impatient. He said, "That is not important."

Van Voorhis did not acknowledge what Hunt said, but continued with his questions. "Do you recollect seeing any others register except those you have now mentioned?"

"I think I saw Mary Anthony," Lewis said.

"Any other?"

"Mrs. Chapman."

"Can you recollect this without looking at that paper?"

"Well, the object in looking at that paper is to try to refresh my memory on which day they registered." Crowley must have been pleased. He had an excellent witness.

"Does that paper contain dates?"

"No, sir, it contains the names of all those who registered."

"You copied that paper from the registry, didn't you?" Van Voorhis asked in a tone that suggested he was accusing Lewis of something.

Lewis ignored the implication and said, "They were copied by Hall at the time of the election and handed to me."

"What was your business at the registry at that time?"

"I had a poll list. I was checking parties that I supposed had a legal right to vote." Lewis did not say so, but he was a poll watcher for the Democratic Party and, as such, would be most interested in maximizing votes by Democrats and minimizing votes by Republicans. Anthony made no secret of the fact that she voted a straight Republican ticket.

"What sort of a poll list?" Van Voorhis asked.

Crowley objected, saying the point was immaterial. He worried that mentioning Lewis's clearly partisan objective in being at the polling place would taint his answer with a political tone.

But Judge Hunt, surprisingly, sided with the defense attorney when he said, "It is only competent as a test of his knowledge."

Lewis answered, "I had canvassed the ward and taken a list of all the voters in the first district, all those that I supposed would be entitled to vote."

Van Voorhis then asked, "You had canvassed the ward in the employment of somebody?" He wanted Lewis to say he was an employee of the Democratic Party.

But Crowley objected again, again saying the point was immaterial.

Hunt this time, not bothered by any inconsistency in his rulings, sustained the objection.[4]

Van Voorhis, unable to get Lewis to say he was working for the Democratic Party, switched direction. He asked, "How many of these people did you see vote?"

"I think I saw the whole of them vote, with the exception of Mrs. Hough and Mrs. Cogswell."

"Who took Miss Anthony's vote?"

"Mr. Jones."

"Were both the other inspectors present when he took it?"

"I believe they were," Lewis said.

"Did Jones take all of the votes of those persons whose names you have on your list?"

"I don't think he did."

"Who took any others that you saw?"

"I saw Mr. Hall take some of the ballots."

"How many?"

"I couldn't tell how many."

"Did you see him take more than one?"

"I don't know as I did."

"Do you know whose it was?"

"If I recollect right, it was Mrs. DeGarmo's."

"At that time was Jones there?"

"No. I believe Jones had stepped out."

"Hall received the vote on account of Jones being absent?" Van Voorhis asked.

"I believe so."

"Jones's position was at the window receiving votes?"

"Yes, sir."

"Who put them in the boxes?"

"Jones and Hall."

"You were not near enough to see what these ballots were?"

"No, sir."

This might seem like an important point for the defense, since the inspectors were charged with allowing the women to vote for members of the U.S. House of Representatives, not for any state officers, but it could have little impact since Anthony and other women said they had voted for the members of Congress.

"How many ballot boxes were there?"

"Six, if I recollect right."

"And six tickets voted at that poll?"

"Six tickets altogether. There was the constitutional amendment voted at that election."

"Did you observe which boxes the tickets of these persons were put into?"

"I did."

"Which were they?"

"I think that they were ballots that these ladies voted."[5]

"I don't want what you think. I want what you know."

"Well, they went into those boxes, member of Congress, member at large."

"Were there two boxes for congressmen?"

"I think there was," Lewis said. "I am not quite positive. I rather think I am mistaken about that."

"Well, give us what you know about the boxes?"

"The most that I know about is that the remark was made by the inspector that they voted the four tickets."

"You heard the remark made that they voted four tickets? Who made that remark?"

"Mr. Jones or Mr. Hall. When they passed their ballots they would say, 'They vote all four tickets. No constitutional amendment voted.'"

"That was the practice of the inspector, no matter who voted?" Van Voorhis asked.

"Yes, sir."

"Then you didn't see the tickets as they went into the boxes?"

"No, sir."

Van Voorhis was winning a minor point. If Lewis could not swear definitively that the inspectors placed ballots in boxes intended to hold votes for U.S. Congressmen, he was not a reliable witness to the breaking of a federal law.

"You can't swear which boxes they went into?" Van Voorhis asked rhetorically.

"I understood from the inspectors that they voted all the tickets with the exception of the constitutional amendment." Lewis in effect admitted his testimony was based on hearsay evidence.

And Van Voorhis wanted to emphasize that point, so he next said, "I don't ask for any conversation. I ask for what you know by what you saw."

"Well, I wasn't near enough to read the tickets."

"Did you hear either of the inspectors say anything about it?"

"I did."

"Which one?"

"I heard the inspector that would be at the window where the ballots would be received."

"Name him."

"I heard Mr. Jones say that they voted the four tickets."

"Was that all he said?"

"Well," Lewis said, "he would declare it in this way: sometimes he would

say, 'They vote all the tickets with the exception of the amendment.' That is the way he generally declared it."

"I want to get at what he said when these votes were taken."

"He didn't at all times declare the ticket voted."

"Are you willing to testify that you recollect distinctly anything that was said by either of the inspectors when these ladies voted?"

"Most decidedly. I heard Jones say that they voted the congressional ticket. I heard him say that they voted all the tickets."

"At the time they voted?"

"The question would be asked what tickets they voted," Lewis said, "and he would say, 'All the tickets with the exception of the amendment.'"

"Did he mention the congressional ticket?"

"I think he did."

"Do you recollect that he did?"

"My impression is that he said so. I can't say positively."

That Van Voorhis's questions and Lewis's answers were highly repetitive was obvious to everyone in the courtroom. "Did you say anything there about getting twenty women to vote?"

Crowley objected, saying the point was immaterial.

Van Voorhis turned to Judge Hunt and said, "I propose to show that this witness said to parties there that he would go and get twenty Irish women to vote to offset these votes."

Crowley repeated his objection, saying again the point was immaterial.

Judge Hunt agreed with Crowley, and Van Voorhis was done questioning Lewis.

City Clerk Recalled

Crowley then recalled City Clerk William Morrison. Morrison was holding a book, and Crowley said, "Please point out the following names if you find them in the registration list: Susan B. Anthony?"

Morrison said, "I find it."

"Sarah Truesdell?"

"Sarah C. Truesdell."

"Mary Pulver?"

"M.P. Pulver."

Crowley was reading the list of the women who had been charged with illegally registering to vote. "Mary Anthony?"

"I find it."

"Ellen S. Baker?"

"Yes, sir, I have it."

"Margaret Leyden?"

"Margaret L. Leyden."

"Ann S. Mosher?"

"Hannah L. Mosher."

"Nancy M. Chapman?"

"Nancy M. Chapman."

"Lottie B. Anthony?"

"Lottie B. Anthony."

"Susan M. Hough?"

"Susan M. Hough."

"Hannah Chatfield?"

"Hannah Chatfield."

"Mary S. Hibbard?"

"Mary S. Hibbard."

"Rhoda DeGarmo?"

"I don't find any such name. I find Robert DeGarmo and Elias DeGarmo."

"Jane Cogswell?"

"Jane Cogswell."

Although the named women had all been charged with registering illegally to vote, only one had been brought to trial. Yet, the three inspectors were charged with allowing all of them to register.

"Now turn to the names of voters contained in the list copied upon election day. Do you find the name of Susan B. Anthony upon that list?"

"I do."

"Sarah Truesdell?

"Yes, sir."

"Mary Pulver?"

"Yes, sir."

The routine of the calling of names of both the charged and uncharged was being repeated for those who actually voted.

"Mary Anthony?"

"Yes, sir."

"Mary S. Baker?"

"Yes, sir."

"Margaret Leyden?"

"Yes, sir."

"Ann S. Mosher?" Crowley asked.

"Hannah L. Mosher," Morrison said.

"Nancy Chapman?"

"Yes, sir."

"Lottie B. Anthony?"

"Yes, sir."

"Susan M. Hough?"

"Yes, sir."

"Hannah Chatfield?"

"Yes, sir."

"Mary S. Hibbard?"

"Yes, sir."

"Rhoda DeGarmo?"

"I find Mrs. Rosa DeGarmo."

"Jane Cogswell?"

"Yes, sir."

Evidently, by Crowley's courtroom logic, registering illegally to vote and illegally voting were not serious enough crimes to bring someone to trial unless she was nationally prominent, but allowing the prominent and non-prominent persons to register and vote was an offense worthy of punishment.

"Upon the list copied by the inspectors upon the day of election is there any heading purporting to show what tickets these people voted?"

"Yes, sir.

"Please state from the heading what tickets it purports to show they voted."

Morrison said, "The first column is electoral; the second, state; the third, Congress; the fourth, assembly[6]; the fifth, constitutional amendment."

"Please look and see which of those tickets the list purports to show that they voted."

Van Voorhis objected, saying any markings on the registration book not made by Morrison were not evidence that a person voted for members of the U.S. Congress.

Judge Hunt asked, "What is the statement there?"

Morrison said, "After the name of Miss Susan B. Anthony in the column of electors there is a small, straight mark."

Van Voorhis said, "I object to that as not evidence of what these votes were."

Hunt dismissed his objection, saying, "I think it is competent."

Crowley then said, "State, Mr. Morrison."

Morrison said, "Opposite each of the names that I have read there are

checks showing that they voted electoral, state, congressional and assembly tickets, four tickets."

"There are a large number of the inspectors' books of the last election filed with you as city clerk are there not?"

"Yes, sir."

"Do you know what the custom or habit is of copying these books when people vote?"

Van Voorhis objected, but before he could explain his objection, Crowley reworded the question.

"What custom the inspectors have of indicating what tickets a person votes when he offers his vote."

Van Voorhis objected again and Crowley withdrew the question.

City Clerk Cross-Examined

Then Van Voorhis stood to question Morrison. "All you know about these tickets or that book is what appears on the face of it, is it not?"

"Yes, sir; that is all."

"You don't know who made those straight marks."

"I don't," Morrison admitted.

"Or why they were made, so far as you have any knowledge?"

"No, sir."

Van Voorhis pointed to a page in the book. "Do you know what those letters are?"

Morrison said, "Preliminary oath and general oath, I should say."

"You would say that to each of these persons the preliminary oath was administered and also the general oath?"

"Yes, sir. It so shows here."

Van Voorhis was done questioning Morrison.

Margaret Leyden Testifies

Now Crowley called Margaret Leyden to testify. She was one of the women who had registered and voted. Crowley's first question to her was, "Did you reside in the city of Rochester in the month of November, eighteen seventy-two?"

"Yes, sir," Leyden said.

"Did you reside in the Eighth Ward?"

"I did."

"In the First Election District of that ward?"

"I did."

"Was your name registered before the election which took place on the fifth of November, eighteen seventy-two?"

"It was."

"By whom?"

"I think Mr. Jones. In fact, all three of the inspectors were there."

Unlike the questioning of Morrison, which focused on minutiae, Crowley had finally elicited from a witness a statement that clearly indicated that the three accused men were present when a law was violated.

"Did you, upon the fifth day of November, vote?"

"I did."

"Who received your vote?"

"Mr. Jones."

"Were the other inspectors there at the time?"

"Yes, sir."

"Did you vote for a candidate for Congress?" This was an important question because if she voted only for candidates for state office she would not have been violating a federal law.

"I did," Leyden said.

Crowley was done questioning Leyden, and he was pleased with himself.

Defense Questions Margaret Leyden

Van Voorhis was in a difficult position. There was no way to make Leyden's testimony seem unimportant. He asked, "Was Mr. Lewis there when you registered?"

"Mr. Lewis was not there," Leyden said.

"Do you recollect who took your vote?"

"I think Mr. Jones took it." She quickly added, "I know he did."

"Was your ballot folded up?" Van Voorhis's question was clearly an act of desperation. He would try to show that no one could know how she voted, for if her ballot was folded, no one could read it. But it was a meaningless point since she had already testified that she had voted and had voted for a candidate for Congress.

"It was," she said.

"Could any person read it or see what you voted or who you voted for?"

"No one but my husband."

"He saw it before you voted?"

"Yes, sir."

"Was your husband present when you voted?"

Crowley objected, saying the point was immaterial.

But Hunt said nothing, so Leyden answered. "He was."

Van Voorhis continued. "No one had seen your ballot except your husband before you handed it in?"

"No, sir."

"And when you handed it in it was folded so that no one could see it?"

"It was."

Judge Hunt, realizing he had not responded to Crowley's objection, finally spoke up. He asked, "What is the object of this?"

Van Voorhis said, "The district attorney inquired if she voted a certain ticket and assumes to charge these inspectors with knowing what she voted. It is to show that, the ticket being folded, the inspector could not see what was in it."

Hunt did not immediately respond, so Van Voorhis asked Leyden, "In voting, did you believe that you had a right to vote and vote in good faith?" He was adopting the same unsuccessful logic Selden had used in Susan B. Anthony's trial.

Crowley immediately objected, saying the point was immaterial, and Hunt immediately agreed. There was nothing left for Van Voorhis to question Leyden about, so he sat down.

Crowley Continues to Question Leyden

Crowley stood and asked the witness, "You have heard me name the different persons, have you not, when I asked Mr. Morrison questions?"

"Yes, sir."

"Were these people, or any of them, present, and were they registered at the same time you were?"

"Some of them were present."

"Who?"

"Mrs. Lottie B. Anthony. There was one lady that registered who didn't vote. I think Mrs. Anthony was the only lady that was present that voted. I can't recollect any more names."

"Who of these ladies were present when you voted and voted with you, if any?"

"Miss Susan B. Anthony, Mrs. Pulver, Mrs. Mosher, Mrs. Lottie B. Anthony, Miss Mary Anthony, Miss Baker, Mrs. Chapman."

"Did they all vote on that occasion?"

"They did."

That ended Crowley's questioning of Leyden, leaving Van Voorhis with no good questions to ask, nothing that would produce an answer helpful to his clients' case, so he asked a meaningless question instead. "Mrs. Lottie B. Anthony," he said, "is the wife of Alderman Anthony?"

"Yes, sir," Leyden said.

Beverley Jones Called

Both attorneys were done questioning Leyden, and Van Voorhis tried to salvage his case by calling one of his clients, Beverley Jones. He started with routine questions. "Mr. Jones," Van Voorhis asked, "where do you reside?"

"Eighth Ward, city of Rochester."

"What is your age?"

"Twenty-five last spring."

"Are you one of the defendants in this indictment?"

"Yes, sir."

"Were you inspector of election in the Eighth Ward?"

"Yes, sir."

"Which district?"

"First District."

"Were you elected or appointed?"

"Elected."

"By the people of the ward?"

"Yes, sir."

Then Van Voorhis finally reached a line of questioning that could potentially help his clients. He asked, "Were you present at the board of registry when Miss Anthony and others appeared there and demanded to be registered?"

"I was."

"Won't you state what occurred there?"

Jones said, "Miss Anthony and two other ladies came into the room. Miss Anthony asked if this was the place where they registered the names of voters. I told her it was. She said she would like to have her name registered. I told her I didn't think we could register her name. It was contrary to the constitution of the state of New York. She said she didn't claim any rights under the constitution of the state of New York. She claimed her rights under the Constitution of the United States, under an amendment to the constitution. She

asked me if I was conversant with the Fourteenth Amendment. I told her I had read it and heard of it several times."

"Before you go further, state who was present at that time."

"William B. Hall and myself were the only inspectors. Mr. Marsh was not there. Daniel J. Warner, the United States supervisor, Silas J. Wagner, another United States supervisor, and a United States marshal."

"State which one of these was Republican and which one Democratic."

"Silas J. Wagner, Republican. Daniel J. Warner, Democratic."

"Now go on."

"She read the Fourteenth Amendment to the Constitution of the United States. While she was reading the amendment and discussing different points, Mr. Daniel J. Warner said...."

Crowley interrupted Jones's answer: "I submit to the court that it is entirely immaterial what either Warner or Wagner said."

Judge Hunt said, "I don't see that that is competent in any view of the case." Hunt then turned to the witness and asked him, "Was your objection to registering Miss Anthony on the ground that she was a woman?"

Jones said, "I said it was contrary to the constitution of the State of New York, and I didn't think that we could register her."

Hunt asked, "On what ground was that?"

"Well, on the ground that she was a woman."

There was a moment of silence, so Van Voorhis said, "You may proceed and state what occurred there."

Jones started by saying, "Mr. Warner said ... ," but again Crowley objected.

Judge Hunt didn't wait for Crowley's explanation of his objection. He said, "I don't think that is competent, what Warner said."

Van Voorhis told the judge, "The district attorney has gone into what occurred at that time, and I ask to be permitted to show *all* that occurred at the time of the registry. This offense was committed there. It is a part of the *Res Gesta*.[7] All that occurred at the moment Miss Anthony presented herself and had her name put upon the registry."

Hunt, however, was insistent, saying, "I don't think that is competent."

"I ask to show," Van Voorhis said, "what occurred at the time of registry."

Hunt became adamant. He said, "I don't think it is competent to state what Warner or Wagner advised."

Van Voorhis pushed his point. He said, "So that the question may appear squarely in the case I offer to show what was said and done at the time Miss Anthony and the other ladies registered, by them, the inspectors, and the federal supervisors, Warner and Wagner, in their presence, in regard to that subject."

Hunt was losing his patience. He said, "I exclude it."

Van Voorhis next sought a clarification, asking, "Does that exclude all conversations that occurred there with any persons?"

Hunt provided the clarification. "It excludes anything of that character on the subject of advising them. Your case is just as good without it as with it."

Van Voorhis, however, continued along his argumentative path. "I didn't offer it in view of the advice but to show precisely what the operation of the minds of these inspectors was at that time, and what the facts are."

Hunt returned to his adamant tone. "It is not competent."

Van Voorhis finally understood that he had lost the point. More important than the point, he clearly now had a hostile judge running the courtroom. He returned to questioning Jones. "Were you present on the day of election?"

"Yes, sir," Jones said.

"Did you receive the votes of these persons?"

"I did."

"How many ballot boxes were there there?"

"Six."

"What position did you occupy during the day?"

"Chairman of the board."

"Did you stand at the window and receive the votes?"

"Most of the time I did."

"Were those ballots which you received from them folded?"

"They were."

"Did you or any of the inspectors see or know the contents of any of the ballots?"

Crowley again interrupted, saying, "If your honor please, I submit it is entirely immaterial whether these inspectors saw the names upon the ballots."

Hunt's impatience with Van Voorhis became quickly evident. He said, "I have excluded that already. It is not competent. It is proved that they put in votes, and it is proved by one of the ladies that she did vote for a candidate for Congress."

Van Voorhis would not be so easily deterred in his line of questioning. He told Hunt, "I propose to show by the witness that he didn't know the contents of any ballot and didn't see it."

Hunt's impatience would not wane. He said, "That will be assumed. He could not do it with any propriety."

Van Voorhis decided not to push the point, not to further alienate Judge Hunt. He asked Jones, "Did either one of the inspectors object to receiving the votes of the women at the polls?"

"Yes, sir."

"Which one?"

"William B. Hall."

"Did he take any part in receiving votes and, if so, state what part?"

"I believe that he took the ballot of one lady and placed it in the box. I stepped out, I believe, for a few moments."

Hall was the one inspector who objected to allowing women to register and vote, but taking that one ballot made him, from Crowley's view, as guilty as the other two.

"Did it to accommodate you while you stepped out?"

"Yes, sir.

"On the day of registry did the inspectors as a board decide unanimously to register these votes, all three of you consenting?"

"We did."

"When you came to receive the votes, Hall dissented?"

"He did, sir."

"But the other two were a majority, and he was overruled. Was this the way it was, or wasn't there anything in form said about it?"

"He was overruled. I felt it my duty to take the ballots."

"In receiving those ballots did you act honestly in accordance with your sense of duty and in accordance with your best judgment?"

"I did."

Crowley wanted a point Jones made to be emphasized, so he interrupted Van Voorhis by asking the witness a question. "All three of the inspectors," Crowley asked, "agreed in receiving these names for registration, did they not?"

"Yes, sir."

The point was to emphasize Hall's legal culpability.

Van Voorhis couldn't do anything about Crowley's interruption. It was concluded before Van Voorhis could react. So he returned to questioning Jones. He said, "I meant to have asked you in reference to the challenges, state whether or not challenges were entered against these voters prior to the day of election."

"There was," Jones said.

"On their presenting their votes, what was done?" Van Voorhis asked. This question would give Jones an opportunity to explain, in effect, why charging him with a crime was clearly unfair.

Jones said, "I told Miss Anthony when she offered her vote that she was challenged. She would have to swear her ballot in if she insisted upon voting.

She said she insisted upon voting, and I presented her the Bible and administered to her the preliminary oath, which she took. I turned to the gentleman that challenged her and asked him if he still insisted upon her taking the general oath."

"Were questions asked her?"

"There were, after taking the preliminary oath."

"In accordance with the instruction?"

"Yes, sir."

Jones paused, so Van Voorhis said, "Go on."

"I turned to the gentleman that challenged her," Jones said, "and asked him if he still insisted on his challenge. He said he did. I told her she would have to take the general oath. I administered the general oath, and she took it."

"Was that done in each case of the women who voted?"

"It was."

Crowley again interrupted Van Voorhis, rather than wait for his turn to cross-examine the witness. He said to Jones, "As I understand you, all three of the inspectors agreed in permitting these people to be registered."

"They didn't at first."

"Well," Crowley said, "they did before they were registered, did they not?"

"They did before their names were put upon the book," Jones said.

Crowley continued. "And when they voted, yourself and Mr. Marsh were in favor of receiving the votes and Hall was opposed to receiving the votes?"

"Yes, sir."

Van Voorhis finally insisted with his tone on returning to questioning his witness. He asked, "Did you suppose at that time that the law required you to take their votes?"

Crowley objected and Hunt quickly sustained the objection.

Crowley then again interrupted Van Voorhis. He asked Jones, "Did you have two meetings for the purpose of registration prior to election?"

"Yes, sir," said Jones.

"Upon the days fixed by the laws of the state of New York?" Crowley asked.

"Yes, sir."

"You made a list or registry, did you not, upon those days?"

"We did."

"Upon the day of election you had a list of voters?"

"Yes, sir."

"Those produced here today are the lists kept upon that occasion, are they not?"

Jones looked at exhibits A and B, and then answered. "Those are the books."

Judge Hunt then asked, "Did these ladies vote the congressional ticket, all of them?"

Jones was Van Voorhis's witness, but he clearly lost control of the process, and now Crowley and Hunt were taking over questioning, interfering with a defense attorney who had clearly become, at least temporarily, inept.

Jones answered the judge's question. "I couldn't swear to that."

Hunt instructed Jones. "Look at the book as to that."

"It does not tell for certain. The clerks may have made a mistake in making these marks. They do very often."

"Did you make any of the entries in that book?" Hunt asked.

"No, sir. A clerk appointed by me did it."

Then Crowley again asked questions, leaving Van Voorhis a mere spectator to his witness's testimony. Crowley asked, "When you counted up your votes at night, when the polls closed, did you compare your votes with the list?"

"Yes, sir."

"Did you find it correct?"

"We found it fell short of the poll list several ballots. I can't tell how many."

"Do you know whether it fell short on members of Congress?"

"Yes, sir, it did," Jones said.

Crowley asked, "Did you make a certificate and return of that fact?"

"Yes, sir. The certificate was filed in the clerk's office."

That was the final question and answer for Jones.

Edwin Marsh Called

Van Voorhis next called another of his clients, Edwin T. Marsh. His first question was, "Were you one of the inspectors of the Fifth Ward?"

Marsh said, "I was."

"How was you appointed?"

"I was appointed by the Common Council just before the first meeting of the board."

"What is your age?"

"I am thirty-three."

"Did you hear the statement of Mr. Jones?"

"I did."

"To save time I will ask you whether that was substantially correct as you understand it?"

"Yes, sir."

"Now I will ask you the question if in registering and receiving these votes you believed that the law required you to do it and you acted conscientiously and honestly?"

Crowley, unsurprisingly, objected.

Judge Hunt said, "Put the question as you did to the other witness, whether in receiving these votes he acted honestly and according to the best of his judgment."

Van Voorhis said, "Answer that question, please?"

"I most assuredly did."

That was the end of Van Voorhis's questions for Marsh. Crowley said he did not wish to cross-examine the witness.

A Surprise Witness

Van Voorhis next called a witness that surprised some people in the courtroom. William C. Storrs, some thought, seemed more like he should have been a witness for the prosecution. Van Voorhis asked him, "Where do you reside?"

"City of Rochester," Storrs said.

"What office do you hold?"

"United States commissioner."

"How long have you held that office?"

"Fifteen years."

"Do you know these defendants, Jones and Marsh?"

"I do, sir."

"Was any application made to you by any person at any time for a warrant against them for this offence?"

Before Storrs could answer, Crowley objected, and before Judge Hunt could rule on the objection, Van Voorhis said, "If the counsel objects I will not insist upon the evidence."

Van Voorhis had no other questions, and Crowley declined to cross-examine Storrs, leaving many spectators in the courtroom wondering what was going on. Van Voorhis wanted to demonstrate that the charges against his clients were politically motivated, but he knew Hunt would not allow questioning along that line. The question before the court was not why the defendants were charged but whether they had in fact violated a federal law. Van

Voorhis's handling of Storrs contributed to an impression that his defense of his clients was inept.

But Van Voorhis had another witness to call, one that would excite the interest of everyone in the courtroom, and create an immediate atmosphere of drama. He called Susan B. Anthony.

Susan B. Anthony Testifies

Anthony, as always, immediately became the leading actor on stage. Before being sworn in she said, "I would like to know if the testimony of a person who has been convicted of a crime can be taken." This was a bold reminder to everyone in the courtroom, especially the 12 men on the jury, that this trial was really about her, not the three accused men.

Judge Hunt, as always having difficulty hiding his impatience with Anthony, said, "They call you as a witness, madam." The fact that she had not been permitted to testify at her own trial went unmentioned.

Van Voorhis, now that Anthony was center stage, opened his questioning. "Miss Anthony, I want you to state what occurred at the board of registry when your name was registered."

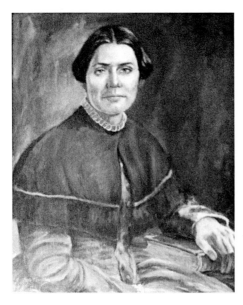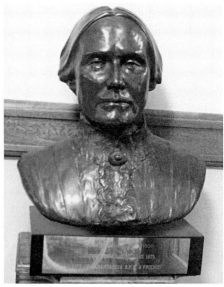

Susan B. Anthony portrait (left) and Susan B. Anthony bust (right). Today the very courtroom (slightly relocated) where Susan B. Anthony was tried as a criminal in 1872 contains these works as tributes to her (photograph by the author).

"That would be very tedious for it was full an hour."

Van Voorhis said, "State generally what was done, or what occupied that hour's time."

Crowley objected. The question was overly broad. So Van Voorhis narrowed it. "Well," he said, "was the question of your right to be registered a subject of discussion there?"

"It was," Anthony said.

"By and between whom?"

"Between the supervisors, the inspectors, and myself."

"State, if you please, what occurred when you presented yourself at the polls on election day."

"Mr. Hall decidedly objected...."

Crowley stood. He had not wanted Anthony to testify at her own trial and he was not happy that she was testifying now. "I submit to the court," he said, "that unless the counsel expects to change the version given by the other witnesses it is not necessary to take up time." Anthony was the best performer on the stage, the star of the show, and he did not want to be upstaged.

Judge Hunt shared his emotion. He said, "As a matter of discretion, I don't see how it will be of any benefit. It was fully related by the others and doubtless correctly."

"It is not disputed," Crowley said.

Anthony, however, knew better than either Crowley or Hunt how to stay at center stage. She said, "I would like to say, if I might be allowed by the court, that the general impression that I swore I was a male citizen is an erroneous one."

Van Voorhis continued with his questioning. "You took the two oaths there, did you?"

"Yes, sir."

Hunt could not resist the temptation to interrupt. He asked Anthony, "You presented yourself as a female claiming that you had a right to vote?"

"I presented myself not as a female at all, sir. I presented myself as a citizen of the United States. I was called to the United States ballot box by the Fourteenth Amendment, not as a female, but as a citizen, and I went there." She had created for herself an opportunity to say things she was forbidden to say in her own trial by Hunt's refusal to then allow her to testify. If she couldn't star in her own show, she would star in someone else's. Hunt, having looked bad in the skit, did not respond.

Van Voorhis said to Hunt, "We have a number of witnesses to prove what occurred at the time of registry, and what advice was given by these federal

supervisors, but under your honor's ruling it is not necessary for us to call them. Inasmuch as Mr. Hall is absent, I ask permission to put in his evidence as he gave it before the commissioners."

Crowley said, "I have not read it, your honor, but I am willing they should use so much of it as is competent under your honor's ruling."

Hunt asked, "Will it change the case at all, Mr. Van Voorhis?"

Van Voorhis said, "It only varies it a little as to Hall. He stated that he depended in consenting to the registry upon the advice of Mr. Warner, who was his friend, and upon whom he looked as a political father." Daniel Warner was at the time of the election the federal supervisor of elections.

Hunt said, "I think you have all the question that any evidence could give you in the case. These men have sworn that they acted honestly and in accordance with their best judgment. Now, if that is a defense, you have it, and it will not make it any stronger to multiply evidence."

Van Voorhis wanted clarification on one point, so he said to Judge Hunt, "I suppose it will be conceded that Hall stands in the same position as to his motives." His comment amounted to a question directed at the federal district attorney, Crowley.

Crowley said, "Yes; we have no evidence to offer upon that question at all."

That meant that the testimony of Susan B. Anthony was complete. Van Voorhis had accomplished nothing useful for his clients in calling her to the stand, but he had given her an opportunity she wanted to again be the star of the performance.

The Defense's Closing Argument

Next Van Voorhis presented his closing argument. "May it please the Court," he said, opening a lengthy statement, "I submit that there is no ground whatever to charge these defendants with any criminal offense."

One, because the women who voted were legal voters. Two, because they were challenged and took the oaths which the statute requires of electors, and the inspectors had no right, after such oath, to reject their votes....[8]

The defendants performed their duty strictly and fully according to the statute. The persons offering to vote were challenged. The defendants administered the preliminary oath to them. All the questions required by the statute were answered fully and truly. The challenge was still insisted on. The general oath was administered by the defendants to them. They took that oath, and every word contained in it was true in their case. The inspectors had no alternative. They could not reject the votes....[9] No United States statute prescribes or

attempts to prescribe their duties. They cannot legally be convicted and should be discharged.

"Three," Van Voorhis said, continuing his list of reasons why he believed his clients were not guilty of the charges against them,

> because no malice is shown. Whether the women were entitled to have their names registered and to vote or not the defendants believed they had such right and acted in good faith according to their best judgment in allowing the registry of their names, and in receiving their votes, and whether they decided right or wrong in point of law, they are not guilty of any criminal offense....[10]
>
> The inspectors were *compelled to decide the question,* and to decide it instantly, with no chance for examination or even consultation, and if they decided in good faith, according to the best of their ability, they are excused, whether they decided correctly or not in point of law. This is too well settled to admit of dispute, settled by authority as well as by the plainest principles of justice and common sense.
>
> The law never yet placed a public officer in a position where he would be compelled to decide a doubtful legal question, and to act upon his decision, *subject to the penalty of fine* or imprisonment if he chanced to err in his decision.
>
> All that is ever required of an officer, so placed, whether a judicial or ministerial officer, *so far as is necessary to escape any imputations of crime,* is good faith. Ministerial officers may be required in some cases to act at their peril as to *civil* responsibilities, but as to *criminal responsibilities* never. Inspectors of elections, however, *acting in good faith,* incur neither civil nor criminal responsibilities....[11]
>
> The defendants acted honestly and according to their best judgment. This is conceded. The most that can be said against them is that they have erred in judgment. They are not lawyers, nor skilled in the law. They had presented to them a legal question which, to say the least, has puzzled some of the ablest legal minds of the nation. The penalty is the same, on whichever side they err. If they can be convicted of crime, a test must be imposed upon them, which no judge in the land could stand. The defendants should be discharged by this court.

Finally, his long-winded argument completed, Van Voorhis sat down.

Judge Hunt for the Prosecution

Crowley then stood up to present his closing argument. But Judge Hunt said, "I don't think it is necessary for you to spend time in argument, Mr. Crowley." Hunt then delivered what amounted to a closing argument for the prosecution.

> I think upon the last authority cited by the counsel, there is no defense in this case. It is entirely clear that where there is a distinct judicial act, the party performing the judicial act is not responsible, civilly or criminally, unless corrup-

tion is proven, and in many cases not when corruption is proven. But where the act is not judicial in its character, where there is no discretion, then there is no legal protection.... Now, this is the point in the case, in my view of it: If there was any case in which a female was entitled to vote, then it would be a subject of examination. If a female over the age of twenty-one was entitled to vote, then it would be within the judicial authority of the inspectors to examine and determine whether in the given case the female came within that provision. If a married woman was entitled to vote, or if a married woman was not entitled to vote, and a single woman was entitled to vote, I think the inspectors would have a right in a case before them to judge upon the evidence whether the person before them was married or single. If they decided erroneously their judicial character would protect them. But under the law of this state, as it stands, under no circumstances is a woman entitled to vote. When Miss Anthony, Mrs. Leyden and the other ladies came there and presented themselves for registry, and presented themselves to offer their votes, when it appeared that they were women, that they were of the female sex, the power and authority of the inspectors was at an end. When they act upon a subject upon which they have no discretion, I think there is no judicial authority.

Spectators in the courtroom now understood that Judge Hunt was moments away from instructing the jury to deliver a directed verdict of guilty, just as he had done in Anthony's trial. Hunt continued.

There is a large range of discretion in regard to the votes offered by the male sex. If a man offers his vote there is a question whether he is a minor, whether he is twenty-one years of age. The subject is within their jurisdiction. If they decide correctly, it is well; if they decide erroneously, they act judicially, and are not liable. If the question is whether the person presenting his vote is a foreigner or naturalized, or whether he has been a resident of the state or district for a sufficient length of time, the subject is all within their jurisdiction, and they have a right to decide, and are protected if they decide wrong.

But upon the view which has been taken of this question of the right of females to vote, by the United States Court at Washington, and by the adjudication which was made this morning, upon this subject there is no discretion, and therefore I must hold that it affords no protection.

In that view of the case, is there anything to go to the jury?

Van Voorhis, desperately trying to avoid another directed verdict, one that would clearly go against his clients, said, "Yes, your Honor."

"What?" Hunt said, with some annoyance.

"The jury must pass upon the whole case, and particularly as to whether any ballots were received for representative in Congress, or candidates for representative in Congress, and whether the defendants acted willfully and maliciously."

Hunt, as always unsuccessfully trying to hide his annoyance, said, "It is too plain to argue that."

"There is nothing but circumstantial evidence."

"Your own witness testified to it," Hunt said with a tone of finality.

Van Voorhis was feeling desperate. "But 'knowingly,' your honor, implies knowing that it is a vote for representative in Congress."

"That comes within the decision of the question of law. I don't see that there is anything to go to the jury."

"I cannot take your honor's view of the case, but of course must submit to it. We ask to go to the jury upon this whole case and claim that in this case, as in all criminal cases, the right of trial by jury is made inviolate by the Constitution, that the court has no power to take it from the jury."

"I am going to submit it to the jury." Then he turned to the jury, and said, "Gentlemen of the jury, this case is now before you upon the evidence as it stands, and I shall leave the case with you to decide...."

Van Voorhis interrupted him. "I claim the right to address the jury."

Hunt's tone became dismissive.

> I don't think there is anything upon which you can legitimately address the jury. [He again turned to the dozen men in the jury box.] Gentlemen, the defendants are charged with knowingly, willfully, and wrongfully receiving the votes of the ladies whose names are mentioned in November last in the city of Rochester. They are charged in the same indictment with willfully and improperly registering those ladies. I decided in the case this morning, which many of you heard, probably, that under the law as it stands the ladies who offered their votes had no right to vote whatever. I repeat that decision, and I charge you that they had no right to offer their votes. They having no right to offer their votes, the inspectors of election ought not to receive them. The additional question exists in this case whether the fact that they acted as inspectors will relieve them from the charge in this case. You have heard the views which I have given upon that. I think they are administrative officers. I charge you that they are administrative and ministerial officers in this respect, that they are not judicial officers whose action protects them, and that therefore they are liable in this case. But, instead of doing as I did in the case this morning, directing a verdict, I submit the case to you with these instructions, and you can decide it here, or you may go out.

Van Voorhis next made a request he knew the judge would not agree to. "I ask your honor to instruct the jury that if they find these inspectors acted honestly, in accordance with their best judgment, they should be acquitted...."

Hunt impatiently spoke over Van Voorhis. "I have expressly ruled to the contrary of that, gentlemen, that that makes no difference."

"... and that in this country, under the laws of this country" Van Voorhis continued.

Hunt's patience broke. "That is enough," he snapped. "You need not argue it, Mr. Van Voorhis."

"Then I ask your honor to charge the jury that they must find the fact that these inspectors received the votes of these persons knowingly, and that such votes were votes for some person for member of Congress, there being in the case no evidence that any man was voted for, for member of Congress, and there being no evidence except that secret ballots were received; that the jury have a right to find for the defendants, if they choose."

Hunt struggled to regain his composure. "I charge the jury that there is sufficient evidence to sustain the indictment upon this point."

"I ask your honor also to charge the jury that there is sufficient evidence to sustain a verdict of not guilty."

"I cannot charge that."

"Then why should it go to the jury?"

Hunt snapped, "As a matter of form."

"If the jury should find a verdict of not guilty, could your honor set it aside?" This was a clever remark by Van Voorhis, a message to the jury that its 12 members could engage in jury nullification, if only the jury understood his suggestion.

Hunt missed Van Voorhis's cleverness and merely said, "I will debate that with you when the occasion arises." Then he turned to the jury. "Gentlemen, you may deliberate here or retire, as you choose." Offering to allow them to deliberate in the jury box was like telling them there was nothing to deliberate.

The jury decided to move to the jury room, a small but good sign for the defense. It meant that at least some of the jury members were not willing to so quickly give in to the judge's desire for a guilty verdict.

Hunt's decision to send what amounted to a directed verdict to the jury "as a matter of form" was a clear indication he recognized that his decision in the Anthony case to not allow the jury to deliberate stood on thin and highly shaky constitutional stilts.

Hunt recessed the trial until 7 p.m. giving everyone time for dinner.

The Jury Returns, Twice

At 7 p.m. the court reconvened. The court clerk, following Judge Hunt's instructions, called the jury into the courtroom. The clerk then asked the jury members if they had reached a verdict. The jury foreman said they had not.

That meant, perhaps, that at least one member of the jury possessed the courage, for now, to stand up to Judge Hunt's judicial heavy-handedness.

Hunt, his voice calm and polite, said, "Is there anything upon which I can give you any advice, gentlemen, or any information?"

One juror said, "We stand eleven for conviction, and one opposed."

Hunt said, "If that gentleman desires to ask any questions in respect to the questions of law or the facts in the case, I will give him any information he desires."

No one on the jury spoke or made any movement indicating he wanted to speak.

Hunt added, "It is quite proper, if any gentleman has any doubt about anything, either as to the law or the facts, that he should state it to the court. Counsel are both present, and I can give such information as is correct."

One juror, evidently the lone holdout, said, "I don't wish to ask any questions."

Hunt said, "Then you may retire again, gentlemen. The court will adjourn until tomorrow morning."

The jurors went back into the jury room. The lawyers and clerk and Judge Hunt were collecting papers, chatting and preparing to leave the courthouse. Only about 10 minutes passed, however, when the jury returned to the courtroom, to the jury box.

The court clerk called the names of each of the jurors to ascertain they were all present. Then he asked, "Gentlemen, have you agreed upon your verdict?"

The foreman stood and said, "We have."

The clerk asked, "How say you? Do you find the prisoners at the bar guilty of the offense whereof they stand indicted or not guilty?"

The foreman said, "Guilty."

The clerk, following an old court tradition, then said, "Hearken to your verdict as it stands recorded by the court. You say you find the prisoners at the bar guilty of the offense whereof they stand indicted, and so say you all."

Van Voorhis stood and said, "I ask that the jury be polled."

Judge Hunt nodded and the clerk asked each juror individually, "Is this your verdict?" Twelve answers came in succession. All affirmative.

Courage is often temporary.

The Inspectors Are Sentenced

The next morning, June 19, Van Voorhis made an oral argument for a new trial. His argument consisted of points already made during the trial and

already rejected by the court. But he made them anyway. The chief part of his motion was that Hunt's directed verdict violated his client's constitutional right to a jury trial. And the case against William Hall, Van Voorhis said, should never have been tried because Hall was not present in the courtroom.

Hunt, without comment, denied the motion. Then Hunt asked the two defendants who were present, Jones and Marsh, if they wished to say anything before they were sentenced. Both said they wanted to speak.

Beverley Jones spoke first. He was confrontational. He said,

> Your honor has pronounced me guilty of crime. The jury had but little to do with it. In the performance of my duties as an inspector of election, which position I have held for the last four years, I acted conscientiously, faithfully, and according to the best of my judgment and ability. I did not believe that I had a right to reject the ballot of a citizen who offered to vote and who took the preliminary and general oaths, and answered all questions prescribed by law. The instructions furnished me by the state authorities declared that I had no such right. As far as the registry of the names is concerned, they would never have been placed upon the registry if it had not been for Daniel Warner, the Democratic federal supervisor of elections, appointed by this court, who not only advised the registry, but addressed us, saying, "Young men, do you know the penalty of the law if you refuse to register these names?" And after discharging my duties faithfully and honestly and to the best of my ability, if it is to vindicate the law that I am to be imprisoned, I willingly submit to the penalty.

Beverley Jones displayed more courage than 11 members of the jury and sustained it longer than the twelfth.

Marsh was not confrontational. Until the end of his statement. Marsh said,

> In October last, just previous to the time fixed for the sitting of the board of registrars in the First District of the Eighth Ward of Rochester, a vacancy occurred. I was solicited to act, and consenting, was duly appointed by the Common Council. I had never given the matter a thought until called to the position and as a consequence knew nothing of the law. On the morning of the first day of the last session of the board, Miss Anthony and other women presented themselves and claimed the right to be registered. So far as I knew, the question of woman suffrage had never come up in that shape before. We were in a position where we could take no middle course. Decide which way we might, we were liable to prosecution. We devoted all the time to acquiring information on the subject that our duties as registrars would allow. We were expected, it seems, to make an infallible decision, inside of two days, of a question in regard to which some of the best minds of the country are divided. The influences by which we were surrounded were nearly all in unison with the course we took. I believed then and believe now that we acted *lawfully*. I faithfully discharged the duties of my office according to the best of my ability in strict compliance with the oath administered to me. I consider the argument of our counsel unan-

swered and unanswerable. *The verdict is not the verdict of the jury. I am* NOT GUILTY *of the charge.*

Hunt did not respond to the comments of either Jones or Marsh. He said all three defendants were to pay fines of $25 each plus the costs of prosecution.

7

The Wages of Crime

By February 26, 1874, when Anthony returned to Rochester after a lecture tour, she was surprised to find that the inspectors had been arrested and jailed for refusing to pay their $25 fines. The order to jail the men came from Crowley.[1]

There was a heavy snowstorm, but Anthony walked through it to visit Selden in his downtown office, and together they agreed she should seek to use her influence in Washington to get the men freed, but that the men should not pay the fine. They believed President Grant could be persuaded to pardon the inspectors.

Anthony contacted friends in Washington to see what could be done. Her friend Benjamin Butler, the Republican congressman from Massachusetts, who supported her efforts to increase women's rights, sent her a message:

"My Dear Miss Anthony:

"In regard to the Inspectors of Election, I would not, if I were they, pay, but allow any process to be served; and I have no doubt the President will remit the fine if they are pressed too far.

"I am yours truly,

"Benjamin F. Butler"

Anthony visited the prisoners in the Rochester city jail and urged them not to pay their fines. Paying the fines would be an admission they had done something wrong. If they did get a presidential pardon, they would be exonerated. Of course, Crowley had not arrested Anthony. She was not the one in jail. Anthony wrote in her diary, "I could not bear to come away and leave them one night in that dolorous place."

She also visited several Rochester newspaper offices and urged her women suffragists friends to help. She successfully rallied much of the city to the defense of the men.

On February 26, the Rochester *Evening Express* published an unsigned editorial under the heading "Tyranny in Rochester." It said, in part,

> The arrest and imprisonment in our city jail of the Election Inspectors who received the votes of Susan B. Anthony and other ladies, at the polls of the Eighth Ward, some months ago, is a petty but malicious act of tyranny, of which the officers who are responsible for it will yet be ashamed. It should be known to the public that these young men received Miss Anthony's vote by the advice of the best legal talent that could be procured. The ladies themselves took oath that they were citizens of the United States and entitled to vote.... The Court, however, fined these inspectors $25 and costs, for an offense which at the worst is merely technical, and now, nearly nine months after conviction, in default of payment, they are seized and shut up in jail, away from their families and their business, and subjected to all the inconvenience to say nothing of the odium of such an incarceration. This is an outrage which ought not to be tolerated in this country, and we shall be disappointed if public sentiment does not yet rebuke, in thunder-tones, the authorities who have perpetrated it. Miss Anthony is willing to fight her own battles and take the consequences, but she naturally feels indignant that others should suffer in this matter through no fault of their own.

That final sentence clearly reflects a conversation Anthony had with an editor.

The morning *Democrat and Chronicle* ran an editorial under the headline "An Outrage." It said, in part,

> We regard this action on the part of District Attorney Crowley as an outrage, in that these young men, who, at the worst, are but accessories in the violation of law, are made to feel its terrors, while the chief criminal is allowed to defy the law with impunity. No effort has been made to satisfy the judgment of the court against Miss Anthony. She contemns the law which adjudged her guilty, and its duly appointed administrators are either too timid or too negligent of duty to endeavor to enforce it.... It is doubtful whether they had the right to refuse those votes. In any event their offense is venial as compared with hers. It does not look well for the District Attorney thus to proceed against the lesser offenders, while the chief offender snaps her fingers at the law, and dares its ministers to make her a martyr.... We write in no spirit of vindictiveness, nor even in one of antagonism toward Miss Anthony; but in the name of justice we are called upon to protest against the unseemly proceeding which persecutes those excellent young men and hesitates to attack this woman, who stands as a representative of what she regards a great reform, and in its advocacy shrinks not from any of the terrors the law may have in store for her. Mr. District Attorney, it is your duty to arrest Miss Anthony; to cross swords with an antagonist worthy of your steel. Your present action looks ignoble, and is unworthy of you or of the office you fill.

The end of this editorial, also, reflects Anthony's influence with the editor. She was daring Crowley, through the newspaper, to come after her, implying that he lacked the courage.

Every day of their incarceration, women in Rochester visited the election officials, brought them food to eat, urged them to not pay the fines, promised their support. Breakfast, lunch, dinner. Over the days, hundreds of Rochester women visited. To feed them. To support them. To thank them.

Anthony had a breakfast with them on March 2, and reiterated her belief that the president would help. Among her many suffragist friends around the country, one was in a particularly useful position. Ellen Clark Sargent was a leader of California's women's rights movement. She also happened to be married to a U.S. senator, Aaron Augustus Sargent. Senator Sargent did pretty much whatever the Southern Pacific Railroad wanted him to, and he sponsored legislation that effectively ended Chinese immigration into the United States for decades. But he listened to his wife.

Four years later, Senator Sargent would write a proposed amendment to the U.S. Constitution that would be defeated. But it was introduced year after year after year, long after Sargent left the Senate. For 40 consecutive years it was introduced. When it finally did pass and became part of the Constitution in 1920, it would be widely known as the Susan B. Anthony amendment. It forbade states from denying the right to vote to any citizen on the basis of sex.

The first introduction of that bill would be in 1878. In 1874 Senator Sargent responded to his wife's influence by sending a written request to the White House. The president responded immediately. At noon on March 2, the same day Anthony had breakfast with the jailed inspectors, a telegram was sent from Washington, D.C.:

"March 2, 1874—12 noon.

"To Miss Susan B. Anthony:—I laid the case of the Inspectors before the President to-day. He kindly orders their pardon. Papers are being prepared.

"A.A. Sargent."

That same day, the Associated Press wired a story to its member newspapers: "At the written request of Senator Sargent, the President to-day directed the Attorney-General [George Henry Williams] to prepare the necessary papers to remit the fine and imprisonment of Hall, Marsh, and others, the Rochester Election Inspectors, who were tried and convicted in June, 1873, of registering Susan B. Anthony and other women, and receiving their votes."

More than a week passed before the pardon papers arrived in Rochester, and the inspectors were free men again. Susan B. Anthony had orchestrated a victory outside of the courtroom over Richard Crowley.

"Small-brained" Judge

Susan B. Anthony had no respect for Crowley, but for Judge Ward Hunt she had a deep disdain she made no attempt to hide. About a decade after the trial, writing in the third volume of the six volume *History of Woman Suffrage,* she offered an unsoftened view of the trial judge: "On the bench sat Judge Hunt, a small-brained, pale-faced, prim-looking man, enveloped in a faultless suit of black broadcloth, and a snowy white neck-tie. This was the first criminal case he had been called on to try since his appointment, and with remarkable forethought, he had penned his decision before hearing it."[2]

Writing in her journal shortly after the trial ended,[3] she called the outcome of her trial "the greatest judicial outrage history ever recorded! No law, logic or demand of justice could change Judge Hunt's will. We were convicted before we had a hearing and the trial was a mere farce." The hyperbole and historical misreading, from a woman who knew much better, reflects the anger Hunt's actions injected into her.

Her attorney, Selden, a little while later, wrote her a letter with a more balanced view: "I regard the ruling of the judge, and also his refusal to submit the case to the jury, as utterly indefensible."

Ida Harper's biography of Anthony would later claim, "Scarcely a newspaper in the country sustained Judge Hunt's action." That comes very close to being accurate.

The *Canandaigua Times,* published in the town where the trial was held, wrote:

> The decisions of Judge Hunt in the Anthony case have been widely criticised, and it seems to us not without reason. Even among those who accept the conclusion that women have not a legal right to vote and who do not hesitate to express the opinion that Miss Anthony deserved a greater punishment than she received, we find many seriously questioning the propriety of a proceeding whereby the proper functions of the jury are dispensed with, and the Court arrogates to itself the right to determine as to the guilt or innocence of the accused party. If this may be done in one instance, why may it not in all? And if our courts may thus arbitrarily direct what verdicts shall be rendered, what becomes of the right to trial "by an impartial jury," which the Constitution guarantees to all persons alike, whether male or female? These are questions of grave importance, to which the American people now have their attention forcibly directed through the extraordinary action of a judge of the Supreme Court. It is for them to say whether the right of trial by jury shall exist only in form, or be perpetuated according to the letter and spirit of the Constitution.

Her hometown *Rochester Democrat and Chronicle* said: "In the action of Judge Hunt there was a grand, over-reaching assumption of authority, unsup-

ported by any point in the case itself, but adopted as an established legal principle. If there is such a principle, Judge Hunt did his duty beyond question, and he is scarcely lower than the angels so far as personal power goes."

Even Hunt's hometown paper found fault with him. *The Observer,* in Utica, New York, where he was born and where he was once mayor, said,

> We have sought the advice of the best legal and judicial minds in our State in regard to the ruling of Justice Ward Hunt in the case of Susan B. Anthony. While the written opinion of the judge is very generally commended, his action in ordering a verdict of guilty to be entered, without giving the jury an opportunity of saying whether it was their verdict or not, is almost universally condemned. Such a case never before occurred in the history of our courts, and the hope is very general that it never will again. Between the indictment and the judgment stands the jury, and there is no way known to the law by which the jury's power in criminal cases can be abrogated. The judge may charge the jury that the defense is invalid; that it is their clear duty to find the prisoner guilty. But beyond this he can not properly go. He has no right to order the clerk to enter a verdict which is not the verdict of the jury. In doing this thing Justice Hunt outraged the rights of Susan B. Anthony. It would probably puzzle him to tell why he submitted the case of the inspectors to the jury after taking the case of Miss Anthony out of their hands. It would also puzzle his newspaper champions.

The Sun, in New York City, among the most respected newspapers in the country, said Hunt "must be impeached and removed. Such punishment for the commission of a crime like his against civil liberty is a necessity. The American people will not tolerate a judge like this on the bench of their highest court. To do it would be to submit their necks to as detestable a tyranny as ever existed on the face of the earth. They will not sit quietly by to see their liberties, red and radiant with the blood of a million of their sons, silently melted away in the judicial crucible of a stolid and tyrannical judge of their Federal Court."

The *Chicago Legal News,* the largest circulation legal newspaper in the country, opined, as would be expected by a publication edited by a leading woman's suffragist, against Hunt. Myra Bradwell, the editor, had been unsuccessful in her attempt to become the first female attorney in Illinois because that state's Supreme Court said state law barred women from entering into legal contracts on their own, and the U.S. Supreme Court upheld the decision.

Bradwell wrote, "Judge Ward Hunt, of the Federal Bench, violated the Constitution of the United States more in convicting Miss Anthony of illegal voting, than she did in voting; for he had sworn to support it, and she had not."

Only a very small number of publications defended Hunt, among them *The Albany Law Journal,* published in New York's capital city, which sarcastically suggested that "if Miss Anthony does not like our laws she'd better emigrate!"

The More Important Legal Case

Susan B. Anthony's legal plans went awry early. Her expectation was that she would not be permitted to register, would sue, and her case would work its way up to the U.S. Supreme Court, and that court would decide if, as she insisted, she and all women who were American citizens had a right to vote under the 14th Amendment to the U.S. Constitution. But she was, to her surprise, allowed to register, allowed to vote, arrested, tried, found guilty, and made into a national iconic hero.

The case she wanted to be hers was *Minor V. Happersett.*[4] Virginia L. Minor tried to register in St. Louis, was turned away, sued, claiming the 14th Amendment gave her the right to vote, and her case, not Anthony's, went to the Supreme Court.

Anthony's case attracted more attention, is far better remembered today, and provided an important emotional spur that propelled the women's suffragist movement forward. But Minor's case, in purely legal terms, was more important.

On October 15, 1872, she went to 2004 Market St. in St. Louis, the polling place for the city's 13th Election District, to register. She was old enough, lived within the district, met all the requirements of a voter, except one. She was not a male. The registrar at the polling place, Reese Happersett, told her that under Section 18 of Article II of the Missouri constitution she was not permitted to vote. The state constitution limited the voting franchise to males. Her attorneys—John M. Krum, John B. Henderson, and Francis Minor—filed suit claiming her right to vote was protected under several provisions of the U.S. Constitution, but the main right claimed was based on the 14th Amendment. Francis Minor, one of her attorneys, was her husband and was the man who wrote the letter to *The Revolution* that convinced Anthony she could successfully sue once she had been denied the right to register.

Under Missouri law, Virginia Minor, since she was married, could not sue anyone on her own behalf, so her husband filed suit for both of them in a circuit court. His co-attorneys, Krum and Henderson, were prominent St. Louis lawyers. Krum helped to establish the public school system in the city and Henderson was appointed a U.S. senator during the Civil War when the

incumbent, Trusten Polk, was expelled from the Senate because he supported the Confederacy. (Missouri was one of four slave states, along with Kentucky, Maryland, and Delaware, that remained in the Union.) Henderson was a co-author of the 13th Amendment, the one that bans slavery. His political career ended when he voted to acquit President Andrew Johnson, who had been impeached by Republicans in Congress. Their client, Virginia Minor, was the most prominent advocate of women's suffrage in Missouri.

As expected the Minors lost in the circuit court and again, on appeal, in the state Supreme Court. And, as expected, the U.S. Supreme Court agreed to hear their appeal.

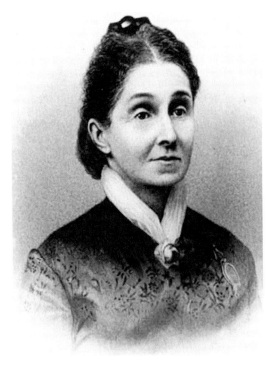

Virginia Minor. Susan B. Anthony's case, based on her belief that the 14th Amendment to the U.S. Constitution gave her a right to vote, never reached the U.S. Supreme Court. But the case of Virginia Minor did. Minor lost; a unanimous court ruled that the 14th Amendment did not give women the right to vote, a clear indication that Anthony, if her case had reached the high court, also would have lost (*History of Woman Suffrage*, Vol. 2).

The plaintiff's attorneys presented their oral arguments to the Supreme Court on February 9, 1875. The defense did not send an attorney, instead submitting a demurrer, or a short written statement, saying, in effect, we agree with the lower courts. The court issued its ruling seven weeks later, on March 29, 1875.

The ruling could not have been worse for the women's suffragist movement. The court's opinion, written by Chief Justice Morrison Waite, was unanimous.[5] Waite's opinion effectively rejected all the ancillary arguments—including claims that denying women the vote subjected them to slavery and therefore violated the 13th Amendment and violated their free speech rights under the First Amendment—by saying the issue before them was whether or not the 14th Amendment entitled women to vote.

The fact that the 14th Amendment confirmed that

women, like men, are citizens did not in itself confer upon them the right to vote, according to Waite's reasoning. He wrote, "In respect to suffrage in the several States it cannot for a moment be doubted that if it had been intended to make all citizens of the United States voters, the framers of the Constitution would not have left it to implication. So important a change in the condition of citizenship as it actually existed, if intended, would have been expressly declared."

The 132 words in his next to final paragraph, out of nearly 4,900 in the full opinion, suggest Waite, and perhaps others on the court, had some sympathy for a woman's right to vote. But that was not the issue they were ruling on. That next to last paragraph says,

> We have given this case the careful consideration its importance demands. If the law is wrong, it ought to be changed; but the power for that is not with us. The arguments addressed to us bearing upon such a view of the subject may perhaps be sufficient to induce those having the power, to make the alteration, but they ought not to be permitted to influence our judgment in determining the present rights of the parties now litigating before us. No argument as to woman's need of suffrage can be considered. We can only act upon her rights as they exist. It is not for us to look at the hardship of withholding. Our duty is at an end if we find it is within the power of a State to withhold.

But it's the final paragraph that sealed the fate of the plan to win women the right to vote by claiming the denial was a violation of the 14th Amendment. It said, "Being unanimously of the opinion that the Constitution of the United States does not confer the right of suffrage upon any one, and that the constitutions and laws of the several States which commit that important trust to men alone are not necessarily void, we AFFIRM THE JUDGMENT."

The other seven justices who concurred with Waite? Nathan Clifford (the only Democrat on the court), Noah H. Swayne (the first Republican ever appointed to the court), Samuel F. Miller, David Davis, Stephen J. Field, William Strong, Joseph P. Bradley, and...

Ward Hunt.

New Plan Needed

The New Departure was a failure. The plan proposed by Virginia and Francis Minor to win the right to vote for women by challenging the exclusion of women from polling places by claiming the 14th Amendment guaranteed female suffrage had been tested and lost. Lost irrevocably.

A new plan was now needed, and only three alternatives were available. One, hope that a future Supreme Court, with different members, would

overturn the ruling in the Minor case. The principle of *stare decisis,* a Latin term meaning "to stand by prior decisions," would make it difficult for any future court to overturn such a decisive ruling. Of course, the high court has done that since, very notably in *Brown v. Topeka,* which overturned the reasoning in *Plessy.* Plessy established the principle of "separate but equal," *Brown* rejected it as unconstitutional. More important than the legal principle was the political practicality that the ruling in the Minor case had been 9–0, which meant that overturning the ruling would mean five new members, at a minimum, would have to be appointed to the court. And if even one of those agreed with the Minor ruling, the wait would be even longer. No, waiting and hoping for a new court majority was both wishful and impractical.

A second alternative was to try to persuade each state legislature to change its laws. Of course, the movement had been attempting to do that for decades with little success. And, ironically and sadly, the success of the black suffragist movement, Anthony, Stanton, and other female suffragists realized, made this path all the more difficult to walk down. Anthony's open conflict with Frederick Douglass in Steinway Hall in 1869 told them that. The hostility of some blacks in Kansas to women's efforts to win the vote told them that. Two movements that spiritually and politically should have been united often found themselves arguing and confrontational.

The third alternative was to seek an amendment to the national Constitution. This had in the past seemed the least likely of the choices because it could be such a complicated process. But now it seemed the most feasible.

Appeal to Congress

Henry Selden, Anthony's attorney, suggested she appeal her conviction to Congress.[6] Selden's research found a case involving Matthew Lyon,[7] who was imprisoned and sentenced to pay a $1,000 fine for criticizing President John Adams, in violation of the Alien and Sedition Acts. Congress, after Thomas Jefferson defeated Adams and took over the presidency, remitted the fine to Lyon's heirs as an expression of its dissatisfaction with the acts. With a Jeffersonian majority in Congress the acts were repealed.

Van Voorhis like Selden was outraged at Hunt's imposed verdict and said, "Trial by jury was completely annihilated in this case, and there is no remedy except to appeal to the justice of Congress to remit the fine and declare that trial by jury does and shall exist in this country."

Her appeal, probably written by Selden, said,

Your petitioner respectfully submits that, in these proceedings, she has been denied the rights guaranteed by the Constitution to all persons accused of crime, the right of trial by jury and the right to have the assistance of counsel for their defense. It is a mockery to call hers a trial by jury; and, unless the assistance of counsel may be limited to the argument of legal questions, without the privilege of saying a word to the jury upon the question of the guilt or innocence in fact of a party charged, or the privilege of ascertaining from the jury whether they do or do not agree to the verdict pronounced by the Court in their name, she has been denied the assistance of counsel for her defense.

Of the decision of the judge upon the question of the right of your petitioner to vote, she makes no complaint. It was a question properly belonging to the Court to decide, was fully and fairly submitted to the judge, and of his decision, whether right or wrong, your petitioner is well aware she can not here complain. But in regard to her conviction of crime, which she insists, for the reasons above given, was in violation of the principles of the common law, of common morality, of the statute under which she was charged, and of the Constitution—a crime of which she was as innocent as the judge by whom she was convicted—she respectfully asks, inasmuch as the law has provided no means of reviewing the decisions of the judge, or of correcting his errors, that the fine imposed upon your petitioner be remitted, as an expression of the sense of this high tribunal that her conviction was unjust.

Friends in high places tried to be helpful. Aaron Augustus Sargent, the U.S. senator from California who had asked President Grant to pardon the three election inspectors, introduced the petition in the Senate, and William Loughridge, a Republican from Iowa, introduced it in the House. Both bodies referred it to their judiciary committees. Crowley, the district attorney who had brought the charges against Anthony, was upset. He sent a letter to the House Judiciary Committee urging them "not to degrade a just judge and applaud a criminal." He added, in an incredibly audacious statement, "Miss Anthony's trial was fair and constitutional and by an impartial jury." How he saw what happened in Canandaigua as a trial by jury, even coming from someone who agreed with the judge's action, is difficult to comprehend.

The House committee, chaired by Lyman Tremain,[8] a Republican from Albany, New York, said, "Congress can not be converted into a national court of review for any and all criminal convictions where it shall be alleged the judge has committed an error." The report also said, somewhat incorrectly, "Since the discussion of this question has arisen in the committee, the President has pardoned Miss Anthony for the offense of which she was convicted and this seems to furnish a conclusive reason why no further action should be taken by the judiciary committee." Tremain and others on the committee probably misunderstood the fact that Grant's pardon applied only to the three

inspectors. Anthony, in fact, never requested a pardon for herself. She was asking only that Congress pay her $100 fine. She, no doubt, could have afforded to pay or, even if not, found others willing to, but she believed that if Congress paid it she would receive some measure of vindication. Of course, public opinion already provided that vindication, and history would continue to do so.

Benjamin Butler, an old friend and supporter of women's suffrage, was a member of the committee and submitted a minority report, saying, "Because the fine has been imposed by a court of the United States for an offense triable by jury, without the same being submitted to the jury, and because the court assumed to itself the right to enter a verdict without submitting the case to the jury, and in order that the judgment of the House of Representatives, if it concur with the judgment of the committee, may, in the most signal and impressive form, mark its determination to sustain in its integrity the common law right of trial by jury, your committee recommend that the prayer of the petitioner be granted."

The Senate committee's reply came from its chairman, George F. Edmunds, a Republican from Vermont, who wrote, "That they are not satisfied that the ruling of the judge was precisely as represented in the petition, and that if it were so, the Senate could not legally take any action in the premises, and they move that the committee be discharged from the further consideration of the petition, and that the bill be postponed indefinitely."

Senator Matthew Hale Carpenter, a Republican from Wisconsin, wrote a minority report in support of the petition. He said,

> Unfortunately the United States has no "well-ordered system of jurisprudence." A citizen may be tried, condemned and put to death by the erroneous judgment of a single inferior judge, and no court can grant him relief or a new trial. If a citizen have a cause involving the title to his farm, if it exceed $2,000 in value, he may bring his cause to the Supreme Court; but if it involve his liberty or his life, he can not. While we permit this blemish to exist on our judicial system, it behooves us to watch carefully the judgments inferior courts may render; and it is doubly important that we should see to it that twelve jurors shall concur with the judge before a citizen shall be hanged, incarcerated or otherwise punished.
>
> I concur with the majority of the committee that Congress can not grant the precise relief prayed for in the memorial; but I deem it to be the duty of Congress to declare its disapproval of the doctrine asserted and the course pursued in the trial of Miss Anthony; and all the more for the reason that no judicial court has jurisdiction to review the proceedings therein.
>
> I need not disclaim all purpose to question the motives of the learned judge before whom this trial was conducted. The best of judges may commit the gravest of errors amid the hurry and confusion of a *nisi prius*[9] term; and the

wrong Miss Anthony has suffered ought to be charged to the vicious system which denies to those convicted of offenses against the laws of the United States a hearing before the court of last resort—a defect it is equally within the power and the duty of Congress speedily to remedy.

The overarching problem for Anthony was that while many members of Congress may have agreed with her that Hunt violated her constitutional rights by not allowing the jury to select its own verdict, and while others may have been at least sympathetic to her position, clearly most were unwilling to invite innumerable petitioners to appeal their convictions to Congress, and granting her request certainly would have been such an invitation.

In the end, neither house of Congress agreed to remit her fine.

Her Private Life

After the trial, Susan B. Anthony's personal life continued as it had been before the trial. She never married and never had children. She is the only source for any information about romance in her life.

In the late 1840s, when she was in her mid and late twenties, she taught school in Canajoharie, New York, about 170 miles due east of Rochester, and decades later she would tell her first biographer, Ida Harper Husted, of several men she knew there. One was "a real soft-headed old bachelor." Another was a "noble-hearted fellow." A third sent her "a piece of poetry on Love" and another poem called "Ridin' on a Rail" and "numerous little stories and things equally as bad." She wrote in her diary about the man who sent the poems and stories, "What he means I can not tell, but silence will be the best rebuke." In another diary entry she wrote of dreaming of "being married, queerly enough, too, for it seemed as if I had married a Presbyterian priest, whom I never before had seen."[10]

Once while teaching in Canajoharie, she went with some friends on a carriage ride to Saratoga Springs, about 50 miles to the northeast. Saratoga Springs has several mineral springs and has long attracted tourists. Anthony very much looked forward to the trip because she knew a young man she liked would be going along, but when it came time to leave, she learned the young man had invited another young woman to accompany him, and Anthony ended up sitting in the buggy next to another man she was not interested in. That man asked her to stop teaching and to marry him. She declined both requests.[11]

And in 1845, she would tell Harper decades later, a man whose wife had died proposed marriage, pointing out that he had a good farm, a large house,

and sixty cows. And, he said, she reminded him of his late wife. Anthony turned down that proposal, also.[12]

In writing home to her parents she made reference to a Mr. Loaux ("Well, I passed the fiery ordeal ... no doubt he thought I was handsome"), a Mr. Stafford, a Mr. Wells, and a Dan S., but provided little information about them other than the partial names.[13]

How important a role these men played in her life might be surmised from a comment she made to Ida Husted Harper, who, while writing Anthony's biography decades later, asked her why her diaries did not mention more "beaux." Anthony said, "There were plenty of them, but I never could bring myself to put anything about them on paper."[14]

In the mid–1850s, after she had given up teaching and was working full time on behalf of abolition of slavery and gaining greater rights for women, traveling from New York town to New York town, giving speech after speech, writing newspaper and magazine articles endlessly, never being at home, always exhausted, seldom resting, she met a man who might have interested her, but ... Ida Harper tells the story:

> Her mission accomplished, Miss Anthony plunged again into the ice and snow of northern New York. At Albany a wealthy and cultured Quaker gentleman had been an attentive and interested listener, and when she took the stage a few days later at Lake George, she found not only that he was to be her fellow-passenger, but that he had a thick plank heated, which he asked permission to place under her feet. Whenever the stage stopped he had it re-heated, and in many ways added to the comfort of her journey. At the close of the next meeting to her surprise she found his fine sleigh waiting filled with robes and drawn by two spirited gray horses, and he himself drove her to his own beautiful home presided over by a sister, where she spent Sunday. In this same luxurious conveyance she was taken to several towns and, during one of these trips, was urged in the most earnest manner to give up the hard life she was leading and accept the ease and protection he could offer. But her heart made no response to this appeal while it did urge her strongly to continue in her chosen work.[15]

Many biographers of Anthony have interpreted the Harper paragraph as Anthony saying the man proposed marriage to her, but a careful reading certainly allows for other interpretations. The man may simply have been inquiring whether she was interested in settling down.

Regardless of whether Anthony had several proposals of marriage or merely interpreted conversations with men that way when something else was intended, or nothing at all was intended, the fact remains that she never married. She was never engaged. She never had children. And there's not the least bit of evidence that she ever had an affair. Or that she ever wanted to marry.

Or have children. It's possible that if she had married and had raised children she might not have been able to participate as vigorously as she did in the suffragist and women's rights movement. But many married women who were her contemporaries, notably her friend Elizabeth Cady Stanton, married and raised children and worked as hard and as long as she did for the same causes.

But if she had married, if she had raised children, if her personal life had indeed interfered with her work in the cause, would women in America have never won the right to vote?

A leader does not create the cause; the cause creates the leader.

A Short History

Although democracy is commonly said to have been invented in ancient Athens, many historians think it probably predates anything we might call ancient civilization and might go back to tribal cultures. Even today, when a tribal culture's population is small enough, decisions tend to be made by a form of group consensus which may or may not involve some form of voting but certainly involves a sense of majority rule. Only when tribes became larger and more complicated did forms of government that did not involve consensus emerge. Whether women participated in consensus building in European, Asian, or African prehistoric cultures cannot be determined, but there is evidence that in some Native American cultures, particularly among the Iroquois of upstate New York, women did have a say. They often participated in group discussions that led to group consensus.

When democracy became formalized, as in the late 6th Century BC Athens, women were not included. Voting was restricted to adult free white men. Democracy as a widespread form of government has a short history. Most nations throughout world history have been governed by one form or another of monarchy.

Sweden did have a democracy in much of the 18th Century, and in 1718 some Swedish women, particularly those who paid taxes, were granted the right to vote in both local and national elections. Forty years later their right to vote in local elections was retracted, and 13 years after that it was taken away from them in national elections. Corsica gave women the right to vote in 1755, but when France annexed the island country in 1769, it was taken away. The history of women voting in Europe followed that pattern for centuries. A country would give some women a limited right to vote and then take it away.

In the British colonies in North America, the pattern was the same. In

1756 the town of Uxbridge, Massachusetts, about 80 miles southwest of Boston, allowed one woman, Lydia Chapin Taft, to vote in a town meeting. Her husband, Josiah, the richest man in town, had died, and the town was voting on whether to appropriate funds for local soldiers being sent to fight in the French and Indian War. She voted in favor of spending the money. But she's known to have voted only twice more in town meetings, in 1758 and 1765. No other woman is known to have voted in colonial town meetings.

In 1776, New Jersey said women who owned property could vote. In 1807 the state said no, they can't vote. As in Europe, in the early history of the United States the vote was given to some women in some states, never to all, and then taken away.

Not until 1893 did any country give women the right to a vote on a par with men's right to vote. That country, New Zealand, never took that right away. In the United States the first place to give women the right to vote without later rescinding it was the Territory of Wyoming. In 1869. Part of the reason was to attract more women to live in the territory. The following year Utah Territory also gave women the right to vote, but Congress took it away seven years later. The congressional action was based on a belief that in a territory where polygamy was widely practiced a woman could not cast a truly free vote. The Edmunds-Tucker Act which revoked votes for women in Utah contained numerous provisions designed to weaken the control of the territorial government by the Mormon church. When Wyoming was admitted to the Union in 1890, women in the new state became the first in the United States to legally vote in national elections. Utah was admitted to the union in 1896 with a state constitution that both banned polygamy and granted women the right to vote in all elections.

But in the late 19th and early 20th centuries, country after country in Europe, and state after state in the U.S., granted women the right to vote. The women's suffragist movement was worldwide. And in the U.S, it was strongest in the West.

Susan B. Anthony did not create that movement, but she helped propel it.

After Susan B. Anthony

Susan B. Anthony died on March 13, 1908. She was 86 years old. Death came at her home on Madison Street in Rochester. Heart failure and pneumonia.

After her trial she continued a vigorous schedule of talks and conventions and writings for a quarter of a century, but in 1900 she pretty much retired,

greatly limiting her public appearances and the number of articles she wrote. She was 78 years old and she was tired, worn down from a life of hard work designed to reform the world. To end slavery. Against alcohol. For equal pay and legal rights for women. And, more and more as she got older and older, to win the right to vote for women.

Late in her life she came to realize she would not live long enough to see a women's suffragist amendment added to the U.S. Constitution. A few years before she died, her first biographer, Ida Husted Harper, asked her if she really expected women to win the vote, and she replied, "It will come, but I shall not see it.... It is inevitable. We can no more deny forever the right of self-government to one-half our people than we could keep the Negro forever in bondage. It will not be wrought by the same disrupting forces that freed the slave, but come it will, and I believe within a generation." Later, in a different setting, when asked a similar question, she noted all the young and energetic and motivated women who had become part of the suffragist movement, and she spoke the most famous words she ever spoke: "Failure is impossible." It was more a tribute to those young women than a sense of inevitability.

And, of course, she was right. It did come. Nearly a century and a half after the founding of what is often called the greatest democracy in the history of world, the one-half of the population that had not been permitted a say in who would govern them was finally granted what they were entitled to all those years.

On August 26, 1920, Secretary of State Bainbridge Colby certified that enough states had ratified the 19th Amendment, making it officially part of the Constitution of the United States of America.

It contains only two sentences: "The right of citizens of the United States to vote shall not be denied or abridged by the United States or by any State on account of sex. Congress shall have power to enforce this article by appropriate legislation."

It is often referred to as the Susan B. Anthony Amendment.

One Final Legal Case

Too bad the story doesn't end there. Unfortunately, there always seems to be a spoiler. A naysayer. In this case his name was Oscar Leser. When Cecilia Streett Waters and Mary D. Randolph registered to vote in Baltimore, Maryland, on October 12, 1920, he sued to have their names removed from the list of eligible voters.[16] He argued that the 19th Amendment did not apply in Maryland because the state's constitution limited voting to adult males and Maryland had not voted to ratify the amendment; that some states did not

allow their legislatures to ratify the amendment, and that two states—Tennessee and West Virginia—did not properly follow their own rules when they ratified the amendment.

Associate Justice Louis Brandeis, writing for a unanimous court, ruled that it didn't matter what the Maryland constitution said because the national Constitution superseded it; that it didn't matter if some states' constitutions prohibited their legislatures from ratifying the amendment because in the case of ratification those legislatures were acting under the authority of the nation's Constitution, not those of the states, and that it didn't matter if Tennessee and West Virginia followed proper procedures, because since the amendment had been certified as official by the Secretary of State, two other states, Connecticut and Vermont, had also ratified it. On that third point, the court also ruled that once the states submitted their ratifications to the Secretary of State it was too late to rescind them.

So, despite Oscar Leser's efforts, Cecilia Streett Waters and Mary D. Randolph were legally allowed to vote in the state of Maryland.

Final Words for a Friend

By February 1895, time had dulled the edges of the sharp exchange on the floor of Steinway Hall in New York City in 1869 between Susan B. Anthony and Frederick Douglass. That exchange had embittered Anthony, had led her to forsake hope of winning the vote for women at the same time it was won for blacks. And that in turn led to her decision to register and then to vote, hoping she would create a legal case that would go to the U.S. Supreme Court. During the quarter century that passed since then, Anthony and Douglass had often met again and were always civil and frequently spoke of each other as friends. But Anthony just the previous month asked Douglass to not attend a women's suffragist meeting in Atlanta, worrying the presence of a black man might offend white Southern women. And a decade earlier, when their mutual friend Elizabeth Cady Stanton wanted to send a public letter of congratulations to a newspaper on the occasion of Douglass' second marriage—this one to a white woman—Anthony bullied her out of it, saying it could interfere with their fight for female suffrage.

But when the two aging warriors—she was 75, he 78—met in Washington, D.C., on February 20, 1895, there was cordiality, even warmth, in their conversation. The occasion was the annual meeting of the Women's National Council at Metzerott Hall. When Douglass entered the hall, the council president, May Wright Sewall, noticed him and quickly appointed a committee

of two to escort him to the front of the room. It was technically a closed business session, with only about 50 men and women, but of course Frederick Douglass would be permitted to sit in. One member of the committee was the Rev. May Wright Sewall herself. The other was Susan B. Anthony. The audience, realizing who their special guest was, applauded long and warmly. Douglass was invited to sit in the front and did, and thanked the audience with a nod. Anthony sat nearby, and she leaned over and told him he "must attend" the upcoming 80th birthday party for their mutual friend Elizabeth Cady Stanton on November 12. He smiled and said, "I shall be there and I shall be ready with my words."[17] Throughout the meeting Douglass often rubbed his left hand with his right.

Douglass had planned to leave the meeting before noon, but late in the morning a discussion focused on the possibility of dividing the council into

This statue of Susan B. Anthony and Frederick Douglass in Susan B. Anthony Park in Rochester, New York, created by Pepsy Kettavong, is mildly controversial because it reflects a scene, the two of them sitting down for tea, that almost certainly never occurred. It symbolically represents their friendship but omits any reference to their strained relationship beginning in 1869 (photograph by the author).

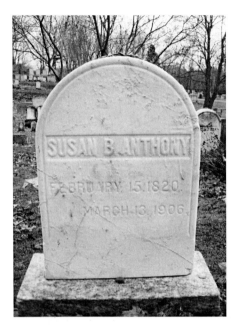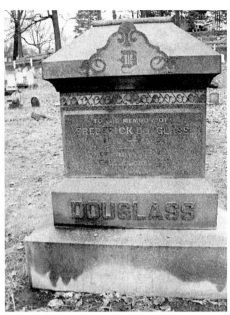

Susan B. Anthony and Frederick Douglass, long-time friends and sometimes adversaries, are now buried not far from each other in Mount Hope Cemetery in Rochester (photographs by the author).

two bodies, an upper house and a lower one, and he became so interested in that proposal that he returned for the afternoon session and stayed until 5 p.m. But he couldn't attend the evening session. He had a speech to give elsewhere in the city.

He now lived in Washington's Anacostia neighborhood, and he left the meeting a little after 5 p.m. He and his wife, Helen, dined together and at about 6, while the two stood in a hallway of their home, he started to tell her about the proposal to split the council into two parts, the proposition that so interested him, and he became, as he often did, animated, and when he fell to his knees, his hands raised in the air, she believed it was part of his explanation. But it wasn't. It was a massive heart attack. She knelt and lifted his head, then ran out the front door and screamed for help. Some men came inside, and one ran to get a doctor. Dr. J. Stewart Harrison arrived in a few minutes, and as he started to insert a needle with some medication into a vein on Douglass' arm, the doctor realized that his patient was dead.[18]

Just about that time, a carriage arrived at the front of the house as planned to take Douglass to the nearby Hillside African Church, where he was scheduled to deliver a lecture.

Word was sent to Metzerott Hall. When someone approached Anthony, as she was standing outside the main room waiting for the evening session to begin, and was quietly told the news, people standing nearby could see a change in her expression. She almost always maintained a stoical appearance. Stable. Unshakable. But this time her facial muscles moved. Quivered. Some unidentifiable sound came from her lips. News of what happened spread just as people were entering the main hall to await the start of the evening session. Anthony said she must go to Cedar Hill, the Douglass home, but others persuaded her, no, the roads are not good, it is too late in the night, you must wait, tomorrow, tomorrow you can go. So, she waited.

A few days later, Anthony would tell a reporter for *The New York Times* of a long ago incident:

> During the early days of the anti-slavery agitation Miss Anthony and her venerable associate, Elizabeth Cady Stanton, appeared at an anti-slavery meeting in which Frederick Douglass was taking a prominent part. Women were not welcome as public speakers in those days, and Mr. Douglass had agreed to read an address prepared by Mrs. Stanton. His rendition of her written remarks did not suit that lady, and, stepping forward, she took the paper from his hands with the remark, "Here, Frederick, let me read it." And she did so, thus marking the initiative in the appearance of women as actors in public gatherings.

On the 25th, the funeral was held at the Metropolitan African American Episcopal Church, the largest black church in Washington. Numerous dignitaries spoke. Among them, at the request of Mrs. Douglass, was Susan B. Anthony. She told the thousands in attendance about her last conversation with Douglass, about his promise to attend Elizabeth Cady Stanton's 80th birthday. And she read a letter from Stanton, who was unable to attend because of health problems caused by age and obesity. Stanton wrote of her long friendship with Douglass and at the grief she felt in hearing of his death. Then Anthony said something else. Stanton, Anthony said, "was beloved by Frederick Douglass more than any other woman in the ranks of the suffragists."

That is what Anthony told a newspaper reporter and the crowd at the funeral. About Douglass and Stanton. Not about Douglass and Anthony.

After the funeral, the body of Frederick Douglass was put on a train and returned to Rochester, New York, where he had resided for a quarter of a century, longer than he had lived anywhere else. He was interred in the city's Mount Hope Cemetery.

When Susan B. Anthony died 11 years later, her remains, too, were interred in Mount Hope Cemetery, three-tenths of a mile directly north of the grave of Frederick Douglass.

Appendix A: Indictment in the Case of *United States vs. Susan B. Anthony*

INDICTMENT
AGAINST SUSAN B. ANTHONY.
DISTRICT COURT OF THE UNITED STATES OF AMERICA,
IN AND FOR THE
NORTHERN DISTRICT OF NEW YORK.

At a stated session of the District Court of the United States of America, held in and for Northern District of New York, at the City Hall, in the city of Albany, in the said Northern District of New York, on the third Tuesday of January, in the year of our Lord one thousand eight hundred and seventy-three, before the Honorable Nathan K. Hall, Judge of the said Court, assigned to keep the peace of the said United States of America, in and for the said District, and also to hear and determine divers Felonies, Misdemeanors and other offenses against the said United States of America, in the said District committed,

Brace Millerd,
James D. Wasson,
Peter H. Bradt,
James McGinty,
Henry A. Davis,
Loring W. Osborn,
Thomas Whitbeck,
John Mullen,
Samuel G. Harris,
Ralph Davis,
Matthew Fanning,
Abram Kimmey,
Derrick B. Van Schoonhoven,
Wilhelmus Van Natten,
James Kenney,
Adam Winne,

James Goold,
Samuel S. Fowler,
Peter D. R. Johnson,
Patrick Carroll,

good and lawful men of the said District, then and there sworn and charged to inquire for the said United States of America, and for the body of said District, do, upon their oaths, present, that Susan B. Anthony now or late of Rochester, in the county of Monroe, with force and arms, etc., to-wit: at and in the First Election District of the Eighth Ward of the city of Rochester, in the county of Monroe, in said Northern District of New York, and within the jurisdiction of this Court, heretofore, to-wit: on the fifth day of November, in the year of our Lord one thousand eight hundred and seventy-two, at an election duly held at and in the First Election District of the said Eighth Ward of the city of Rochester, in said county, and in said Northern District of New York, which said election was for Representatives in the Congress of the United States, to-wit: a Representative in the Congress of the United States for the State of New York at large, and a Representative in the Congress of the United States for the Twenty-ninth Congressional District of the State of New York, said First Election District of said Eighth Ward of said city of Rochester, being then and there a part of said Twenty-ninth Congressional District of the State of New York, did knowingly, wrongfully and unlawfully vote for a Representative in the Congress of the United States for the State of New York at large, and for a Representative in the Congress of the United States for said Twenty-ninth Congressional District, without having a lawful right to vote in said election district (the said Susan B. Anthony being then and there a person of the female sex,) as she, the said Susan B. Anthony then and there well knew, contrary to the form of the statute of the United States of America in such case made and provided, and against the peace of the United States of America and their dignity.

Second Count—And the jurors aforesaid their oaths aforesaid do further present that said Susan B. Anthony, now or late of Rochester, in the county of Monroe, with force and arms, etc., to-wit: at and in the First Election District of the Eighth Ward of the city of Rochester, in the county of Monroe, in said Northern District of New York, and within the jurisdiction of this Court, heretofore, to-wit: on the fifth day of November, in the year of our Lord one thousand eight hundred and seventy-two, at an election duly held at and in the First Election District of the said Eighth Ward, of said city of Rochester, in said county, and in said Northern District of New York, which said election was for Representatives in the Congress of the United States, to-wit: a Representative in the Congress of the United States for the State of New York at large, and a Representative in the Congress of the United States for the Twenty-ninth Congressional District of the State of New York, said First Election District of said Eighth Ward, of said city of Rochester, being then and there a part of said Twenty-ninth Congressional District of the State of New York, did knowingly, wrongfully and unlawfully vote for a candidate for Representative in the Congress of the United States for the State of New York at large, and for a candidate for Representative in the Congress of the United States for said Twenty-ninth Congressional District, without having a lawful right to vote in said First Election District (the said Susan B. Anthony being then and there a person of the female sex,) as she, the said Susan B. Anthony then and there well knew, contrary to the form of the state of the United States of America in such case made and provided, and against the peace of the United States of America and their dignity.

RICHARD CROWLEY,
Attorney of the United States,
For the Northern District of New York.
(Endorsed.) Jan. 24, 1873.
Pleads not guilty.
RICHARD CROWLEY,
U.S. Attorney.

Appendix B: Supreme Court Ruling in Minor Case

WAITE, C.J., Opinion of the Court

The CHIEF JUSTICE delivered the opinion of the court.

The question is presented in this case, whether, since the adoption of the Fourteenth Amendment, a woman, who is a citizen of the United States and of the State of Missouri, is a voter in that State, notwithstanding the provision of the constitution and laws of the State, which confine the right of suffrage to men alone. We might, perhaps, decide the case upon other grounds, but this question is fairly made. From the opinion we find that it was the only one decided in the court below, and it is the only one which has been argued here. The case was undoubtedly brought to this court for the sole purpose of having that question decided by us, and in view of the evident propriety there is of having it settled, so far as it can be by such a decision, we have concluded to waive all other considerations and proceed at once to its determination.

It is contended that the provisions of the constitution and laws of the State of Missouri which confine the right of suffrage and registration therefor to men, are in violation of the Constitution of the United States, and therefore void. The argument is, that as a woman, born or naturalized in the United States and subject to the jurisdiction thereof, is a citizen of the United States and of the State in which she resides, she has the right of suffrage as one of the privileges and immunities of her citizenship, which the State cannot by its laws or constitution abridge.

There is no doubt that women may be citizens. They are persons, and by the Fourteenth Amendment "all persons born or naturalized in the United States and subject to the jurisdiction thereof" are expressly declared to be "citizens of the United States and of the State wherein they reside." But, in our opinion, it did not need this amendment to give them that position. Before its adoption the Constitution of the United States did not in terms prescribe who should be citizens of the United States or of the several States, yet there were necessarily such citizens without such provision. There cannot be a nation without a people. The very idea of a political community, such as a nation is, implies an association of persons for the promotion of their general welfare. Each one of the persons associated becomes a member of the nation formed by the association. He owes it allegiance and is entitled to its protection. Allegiance and protection are, in

this connection, reciprocal obligations. The one is a compensation for the other; allegiance for protection and protection for allegiance.

For convenience it has been found necessary to give a name to this membership. The object is to designate by a title the person and the relation he bears to the nation. For this purpose the words "subject," "inhabitant," and "citizen" have been used, and the choice between them is sometimes made to depend upon the form of the government. Citizen is now more commonly employed, however, and as it has been considered better suited to the description of one living under a republican government, it was adopted by nearly all of the States upon their separation from Great Britain, and was afterwards adopted in the Articles of Confederation and in the Constitution of the United States. When used in this sense it is understood as conveying the idea of membership of a nation, and nothing more.

To determine, then, who were citizens of the United States before the adoption of the amendment, it is necessary to ascertain what persons originally associated themselves together to form the nation, and what were afterwards admitted to membership.

Looking at the Constitution itself we find that it was ordained and established by "the people of the United States," and then going further back, we find that these were the people of the several States that had before dissolved the political bands which connected them with Great Britain, and assumed a separate and equal station among the powers of the earth, and that had by Articles of Confederation and Perpetual Union, in which they took the name of "the United States of America," entered into a firm league of friendship with each other for their common defence, the security of their liberties and their mutual and general welfare, binding themselves to assist each other against all force offered to or attack made upon them, or any of them, on account of religion, sovereignty, trade, or any other pretence whatever.

Whoever, then, was one of the people of either of these States when the Constitution of the United States was adopted, became ipso facto a citizen—a member of the nation created by its adoption. He was one of the persons associating together to form the nation, and was, consequently, one of its original citizens. As to this there has never been a doubt. Disputes have arisen as to whether or not certain persons or certain classes of persons were part of the people at the time, but never as to their citizenship if they were.

Additions might always be made to the citizenship of the United States in two ways: first, by birth, and second, by naturalization. This is apparent from the Constitution itself, for it provides that "no person except a natural-born citizen, or a citizen of the United States at the time of the adoption of the Constitution, shall be eligible to the office of President," and that Congress shall have power "to establish a uniform rule of naturalization." Thus new citizens may be born or they may be created by naturalization.

The Constitution does not, in words, say who shall be natural-born citizens. Resort must be had elsewhere to ascertain that. At common-law, with the nomenclature of which the framers of the Constitution were familiar, it was never doubted that all children born in a country of parents who were its citizens became themselves, upon their birth, citizens also. These were natives, or natural-born citizens, as distinguished from aliens or foreigners. Some authorities go further and include as citizens children born within the jurisdiction without reference to the citizenship of their parents. As to this class there have been doubts, but never as to the first. For the purposes of this case it is

not necessary to solve these doubts. It is sufficient for everything we have now to consider that all children born of citizen parents within the jurisdiction are themselves citizens. The words "all children" are certainly as comprehensive, when used in this connection, as "all persons," and if females are included in the last they must be in the first. That they are included in the last is not denied. In fact the whole argument of the plaintiffs proceeds upon that idea.

Under the power to adopt a uniform system of naturalization Congress, as early as 1790, provided "that any alien, being a free white person," might be admitted as a citizen of the United States, and that the children of such persons so naturalized, dwelling within the United States, being under twenty-one years of age at the time of such naturalization, should also be considered citizens of the United States, and that the children of citizens of the United States that might be born beyond the sea, or out of the limits of the United States, should be considered as natural-born citizens. These provisions thus enacted have, in substance, been retained in all the naturalization laws adopted since. In 1855, however, the last provision was somewhat extended, and all persons theretofore born or thereafter to be born out of the limits of the jurisdiction of the United States, whose fathers were, or should be at the time of their birth, citizens of the United States, were declared to be citizens also.

As early as 1804 it was enacted by Congress that when any alien who had declared his intention to become a citizen in the manner provided by law died before he was actually naturalized, his widow and children should be considered as citizens of the United States, and entitled to all rights and privileges as such upon taking the necessary oath; and in 1855 it was further provided that any woman who might lawfully be naturalized under the existing laws, married, or who should be married to a citizen of the United States, should be deemed and taken to be a citizen.

From this it is apparent that from the commencement of the legislation upon this subject alien women and alien minors could be made citizens by naturalization, and we think it will not be contended that this would have been done if it had not been supposed that native women and native minors were already citizens by birth.

But if more is necessary to show that women have always been considered as citizens the same as men, abundant proof is to be found in the legislative and judicial history of the country. Thus, by the Constitution, the judicial power of the United States is made to extend to controversies between citizens of different States. Under this it has been uniformly held that the citizenship necessary to give the courts of the United States jurisdiction of a cause must be affirmatively shown on the record. Its existence as a fact may be put in issue and tried. If found not to exist the case must be dismissed. Notwithstanding this the records of the courts are full of cases in which the jurisdiction depends upon the citizenship of women, and not one can be found, we think, in which objection was made on that account. Certainly none can be found in which it has been held that women could not sue or be sued in the courts of the United States. Again, at the time of the adoption of the Constitution, in many of the States (and in some probably now) aliens could not inherit or transmit inheritance. There are a multitude of cases to be found in which the question has been presented whether a woman was or was not an alien, and as such capable or incapable of inheritance, but in no one has it been insisted that she was not a citizen because she was a woman. On the contrary, her right to citizenship has been in all cases assumed. The only question has been whether, in the particular case under consideration, she had availed herself of the right.

In the legislative department of the government similar proof will be found. Thus, in the pre-emption laws, a widow, "being a citizen of the United States," is allowed to make settlement on the public lands and purchase upon the terms specified, and women, "being citizens of the United States," are permitted to avail themselves of the benefit of the homestead law.

Other proof of like character might be found, but certainly more cannot be necessary to establish the fact that sex has never been made one of the elements of citizenship in the United States. In this respect men have never had an advantage over women. The same laws precisely apply to both. The Fourteenth Amendment did not affect the citizenship of women any more than it did of men. In this particular, therefore, the rights of Mrs. Minor do not depend upon the amendment. She has always been a citizen from her birth, and entitled to all the privileges and immunities of citizenship. The amendment prohibited the State, of which she is a citizen, from abridging any of her privileges and immunities as a citizen of the United States; but it did not confer citizenship on her. That she had before its adoption.

If the right of suffrage is one of the necessary privileges of a citizen of the United States, then the constitution and laws of Missouri confining it to men are in violation of the Constitution of the United States, as amended, and consequently void. The direct question is, therefore, presented whether all citizens are necessarily voters.

The Constitution does not define the privileges and immunities of citizens. For that definition we must look elsewhere. In this case we need not determine what they are, but only whether suffrage is necessarily one of them.

It certainly is nowhere made so in express terms. The United States has no voters in the States of its own creation. The elective officers of the United States are all elected directly or indirectly by State voters. The members of the House of Representatives are to be chosen by the people of the States, and the electors in each State must have the qualifications requisite for electors of the most numerous branch of the State legislature. Senators are to be chosen by the legislatures of the States, and necessarily the members of the legislature required to make the choice are elected by the voters of the State. Each State must appoint in such manner, as the legislature thereof may direct, the electors to elect the President and Vice-President. The times, places, and manner of holding elections for Senators and Representatives are to be prescribed in each State by the legislature thereof; but Congress may at any time, by law, make or alter such regulations, except as to the place of choosing Senators. It is not necessary to inquire whether this power of supervision thus given to Congress is sufficient to authorize any interference with the State laws prescribing the qualifications of voters, for no such interference has ever been attempted. The power of the State in this particular is certainly supreme until Congress acts.

The amendment did not add to the privileges and immunities of a citizen. It simply furnished an additional guaranty for the protection of such as he already had. No new voters were necessarily made by it. Indirectly it may have had that effect, because it may have increased the number of citizens entitled to suffrage under the constitution and laws of the States, but it operates for this purpose, if at all, through the States and the State laws, and not directly upon the citizen.

It is clear, therefore, we think, that the Constitution has not added the right of suffrage to the privileges and immunities of citizenship as they existed at the time it was adopted. This makes it proper to inquire whether suffrage was coextensive with the cit-

izenship of the States at the time of its adoption. If it was, then it may with force be argued that suffrage was one of the rights which belonged to citizenship, and in the enjoyment of which every citizen must be protected. But if it was not, the contrary may with propriety be assumed.

When the Federal Constitution was adopted, all the States, with the exception of Rhode Island and Connecticut, had constitutions of their own. These two continued to act under their charters from the Crown. Upon an examination of those constitutions we find that in no State were all citizens permitted to vote. Each State determined for itself who should have that power. Thus, in New Hampshire, "every male inhabitant of each town and parish with town privileges, and places unincorporated in the State, of twenty-one years of age and upwards, excepting paupers and persons excused from paying taxes at their own request," were its voters; in Massachusetts "every male inhabitant of twenty-one years of age and upwards, having a freehold estate within the commonwealth of the annual income of three pounds, or any estate of the value of sixty pounds"; in Rhode Island "such as are admitted free of the company and society" of the colony; in Connecticut such persons as had "maturity in years, quiet and peaceable behavior, a civil conversation, and forty shillings freehold or forty pounds personal estate," if so certified by the selectmen; in New York "every male inhabitant of full age who shall have personally resided within one of the counties of the State for six months immediately preceding the day of election ... if during the time aforesaid he shall have been a freeholder, possessing a freehold of the value of twenty pounds within the county, or have rented a tenement therein of the yearly value of forty shillings, and been rated and actually paid taxes to the State"; in New Jersey "all inhabitants ... of full age who are worth fifty pounds, proclamation-money, clear estate in the same, and have resided in the county in which they claim a vote for twelve months immediately preceding the election"; in Pennsylvania "every freeman of the age of twenty-one years, having resided in the State two years next before the election, and within that time paid a State or county tax which shall have been assessed at least six months before the election"; in Delaware and Virginia "as exercised by law at present"; in Maryland "all freemen above twenty-one years of age having a freehold of fifty acres of land in the county in which they offer to vote and residing therein, and all freemen having property in the State above the value of thirty pounds current money, and having resided in the county in which they offer to vote one whole year next preceding the election"; in North Carolina, for senators, "all freemen of the age of twenty-one years who have been inhabitants of any one county within the State twelve months immediately preceding the day of election, and possessed of a freehold within the same county of fifty acres of land for six months next before and at the day of election," and for members of the house of commons "all freemen of the age of twenty-one years who have been inhabitants in any one county within the State twelve months immediately preceding the day of any election, and shall have paid public taxes"; in South Carolina "every free white man of the age of twenty-one years, being a citizen of the State and having resided therein two years previous to the day of election, and who hath a freehold of fifty acres of land, or a town lot of which he hath been legally seized and possessed at least six months before such election, or (not having such freehold or town lot), hath been a resident within the election district in which he offers to give his vote six months before said election, and hath paid a tax the preceding year of three shillings sterling towards the support of the government"; and in Georgia such "citizens and inhabitants of the State as shall have attained to the age of twenty-one years, and shall

have paid tax for the year next preceding the election, and shall have resided six months within the county."

In this condition of the law in respect to suffrage in the several States it cannot for a moment be doubted that if it had been intended to make all citizens of the United States voters, the framers of the Constitution would not have left it to implication. So important a change in the condition of citizenship as it actually existed, if intended, would have been expressly declared.

But if further proof is necessary to show that no such change was intended, it can easily be found both in and out of the Constitution. By Article 4, section 2, it is provided that "the citizens of each State shall be entitled to all the privileges and immunities of citizens in the several States." If suffrage is necessarily a part of citizenship, then the citizens of each State must be entitled to vote in the several States precisely as their citizens are. This is more than asserting that they may change their residence and become citizens of the State and thus be voters. It goes to the extent of insisting that while retaining their original citizenship they may vote in any State. This, we think, has never been claimed. And again, by the very terms of the amendment we have been considering (the Fourteenth), "Representatives shall be apportioned among the several States according to their respective numbers, counting the whole number of persons in each State, excluding Indians not taxed. But when the right to vote at any election for the choice of electors for President and Vice-President of the United States, representatives in Congress, the executive and judicial officers of a State, or the members of the legislature thereof, is denied to any of the male inhabitants of such State, being twenty-one years of age and citizens of the United States, or in any way abridged, except for participation in the rebellion, or other crimes, the basis of representation therein shall be reduced in the proportion which the number of such male citizens shall bear to the whole number of male citizens twenty-one years of age in such State." Why this, if it was not in the power of the legislature to deny the right of suffrage to some male inhabitants? And if suffrage was necessarily one of the absolute rights of citizenship, why confine the operation of the limitation to male inhabitants? Women and children are, as we have seen, "persons." They are counted in the enumeration upon which the apportionment is to be made, but if they were necessarily voters because of their citizenship unless clearly excluded, why inflict the penalty for the exclusion of males alone? Clearly, no such form of words would have been selected to express the idea here indicated if suffrage was the absolute right of all citizens.

And still again, after the adoption of the Fourteenth Amendment, it was deemed necessary to adopt a fifteenth, as follows: "The right of citizens of the United States to vote shall not be denied or abridged by the United States, or by any State, on account of race, color, or previous condition of servitude." The Fourteenth Amendment had already provided that no State should make or enforce any law which should abridge the privileges or immunities of citizens of the United States. If suffrage was one of these privileges or immunities, why amend the Constitution to prevent its being denied on account of race, &c.? Nothing is more evident than that the greater must include the less, and if all were already protected why go through with the form of amending the Constitution to protect a part?

It is true that the United States guarantees to every State a republican form of government. It is also true that no State can pass a bill of attainder, and that no person can be deprived of life, liberty, or property without due process of law. All these several pro-

visions of the Constitution must be construed in connection with the other parts of the instrument, and in the light of the surrounding circumstances.

The guaranty is of a republican form of government. No particular government is designated as republican, neither is the exact form to be guaranteed, in any manner especially designated. Here, as in other parts of the instrument, we are compelled to resort elsewhere to ascertain what was intended.

The guaranty necessarily implies a duty on the part of the States themselves to provide such a government. All the States had governments when the Constitution was adopted. In all the people participated to some extent, through their representatives elected in the manner specially provided. These governments the Constitution did not change. They were accepted precisely as they were, and it is, therefore, to be presumed that they were such as it was the duty of the States to provide. Thus we have unmistakable evidence of what was republican in form, within the meaning of that term as employed in the Constitution.

As has been seen, all the citizens of the States were not invested with the right of suffrage. In all, save perhaps New Jersey, this right was only bestowed upon men and not upon all of them. Under these circumstances it is certainly now too late to contend that a government is not republican, within the meaning of this guaranty in the Constitution, because women are not made voters.

The same may be said of the other provisions just quoted. Women were excluded from suffrage in nearly all the States by the express provision of their constitutions and laws. If that had been equivalent to a bill of attainder, certainly its abrogation would not have been left to implication. Nothing less than express language would have been employed to effect so radical a change. So also of the amendment which declares that no person shall be deprived of life, liberty, or property without due process of law, adopted as it was as early as 1791. If suffrage was intended to be included within its obligations, language better adapted to express that intent would most certainly have been employed. The right of suffrage, when granted, will be protected. He who has it can only be deprived of it by due process of law, but in order to claim protection he must first show that he has the right.

But we have already sufficiently considered the proof found upon the inside of the Constitution. That upon the outside is equally effective.

The Constitution was submitted to the States for adoption in 1787, and was ratified by nine States in 1788, and finally by the thirteen original States in 1790. Vermont was the first new State admitted to the Union, and it came in under a constitution which conferred the right of suffrage only upon men of the full age of twenty-one years, having resided in the State for the space of one whole year next before the election, and who were of quiet and peaceable behavior. This was in 1791. The next year, 1792, Kentucky followed with a constitution confining the right of suffrage to free male citizens of the age of twenty-one years who had resided in the State two years or in the county in which they offered to vote one year next before the election. Then followed Tennessee, in 1796, with voters of freemen of the age of twenty-one years and upwards, possessing a freehold in the county wherein they may vote, and being inhabitants of the State or freemen being inhabitants of any one county in the State six months immediately preceding the day of election. But we need not particularize further. No new State has ever been admitted to the Union which has conferred the right of suffrage upon women, and this has never been considered a valid objection to her admission. On the contrary, as is claimed in the

argument, the right of suffrage was withdrawn from women as early as 1807 in the State of New Jersey, without any attempt to obtain the interference of the United States to prevent it. Since then the governments of the insurgent States have been reorganized under a requirement that before their representatives could be admitted to seats in Congress they must have adopted new constitutions, republican in form. In no one of these constitutions was suffrage conferred upon women, and yet the States have all been restored to their original position as States in the Union.

Besides this, citizenship has not in all cases been made a condition precedent to the enjoyment of the right of suffrage. Thus, in Missouri, persons of foreign birth, who have declared their intention to become citizens of the United States, may under certain circumstances vote. The same provision is to be found in the constitutions of Alabama, Arkansas, Florida, Georgia, Indiana, Kansas, Minnesota, and Texas.

Certainly, if the courts can consider any question settled, this is one. For nearly ninety years the people have acted upon the idea that the Constitution, when it conferred citizenship, did not necessarily confer the right of suffrage. If uniform practice long continued can settle the construction of so important an instrument as the Constitution of the United States confessedly is, most certainly it has been done here. Our province is to decide what the law is, not to declare what it should be.

We have given this case the careful consideration its importance demands. If the law is wrong, it ought to be changed; but the power for that is not with us. The arguments addressed to us bearing upon such a view of the subject may perhaps be sufficient to induce those having the power, to make the alteration, but they ought not to be permitted to influence our judgment in determining the present rights of the parties now litigating before us. No argument as to woman's need of suffrage can be considered. We can only act upon her rights as they exist. It is not for us to look at the hardship of withholding. Our duty is at an end if we find it is within the power of a State to withhold.

Being unanimously of the opinion that the Constitution of the United States does not confer the right of suffrage upon any one, and that the constitutions and laws of the several States which commit that important trust to men alone are not necessarily void, we AFFIRM THE JUDGMENT.

Chapter Notes

Chapter 1

1. Steinway and Sons website, webpage on history, http://www.steinwayshowrooms.com/about-us/steinway-history.

2. Unless otherwise indicated, details of the meeting come from *History of Woman Suffrage*, pp. 379–404.

3. For biographical information on Frothingham, see Caruthers, *Octavius Brooks Frothingham*.

4. For biographical information on Stephen Symonds Foster, see "The Late Stephen S. Foster," *Worcester Spy*.

5. For a history of the passage of the 15th Amendment see Gillette, *The Right to Vote*.

6. For biographical information on George Francis Train see Thornton, *The Nine Lives of Citizen Train*.

7. Most biographies of Susan B. Anthony devote much attention to Train's involvement in the women's rights movement, as do most histories of the movement. For a particularly succinct and thoughtful account of Train's involvement with Susan B. Anthony see Chapter 19, "George Francis Train and The Revolution," in Gurko, *The Ladies of Seneca Falls*.

8. Train's quotes come from Ward, *Not For Ourselves Alone*, p. 108.

9. The three-way exchange among Foster, Anthony, and Stanton was reported in "Men's Rights," *New York Daily Tribune*, May 14, 1869, p. 4.

10. For biographical information on Mary Livermore see Livermore, *The Story of My Life*, and Venet, *A Strong-Minded Woman*.

11. For biographical information on Henry Blackwell see Hays, *Those Extraordinary Blackwells*.

12. There are many biographies of Frederick Douglass, although most of them do not devote much attention to his conflict with leaders of the women's rights movement. However, see, McFeely, *Frederick Douglass*, and Quarles, *Frederick Douglass*.

13. The laughter no doubt resulted from the widespread knowledge that many black women gave birth to children fathered by white masters, and by rumors then common and now largely substantiated, that Jefferson in particular had fathered six children with his slave Sally Hemings, who herself was the daughter of a black slave woman and a white slave owner.

14. Douglass was alluding to the 11 states that joined the Confederacy and the four others (Delaware, Kentucky, Maryland, and Missouri) that did not but where slavery was legal before the Civil War.

15. Douglass's question and Anthony's reply are contained in Harper's biography of Anthony but not in *History of Woman Suffrage*.

16. Sarah Norton's exact words were not recorded in *History of Woman Suffrage* or anywhere else. The quote used here is derived from the summation of her remarks as recorded in *History of Woman Suffrage*.

17. In his *Autobiography*, Twain writes of Olive Logan, "She was merely a name and some rich and costly clothes and neither of these properties had any lasting quality, though for a while they were able to command a fee of $100 a night." See Twain's *Autobiography*, as edited by Charles Neider, Washington Square Press, New York, 1961, p. 179.

18. For biographical information on Ernestine Rose see Komerten, *The American Life of Ernestine L. Rose*.

19. The quote used here is derived from the summation of her remarks as recorded in *History of Woman Suffrage*.

20. Quote adapted from a summation in *History of Woman Suffrage*.

21. *History of Woman Suffrage* refers only to a Senator Wilson and does not further identify him, but Henry Wilson was an ardent abolitionist and supporter of women's rights, and it seems likely he is the person being referenced.

22. Quote adapted from a summation in *History of Woman Suffrage*.

23. Ibid.

24. Ibid.

25. Ibid.

26. Harper's remarks adapted from a summation in *History of Women Suffrage*.

27. Quote adapted from a summation in *History of Women Suffrage*.

28. Ibid.

29. Ibid.

30. Most of the details of the Brooklyn meeting come from "Men's Rights," *New York Daily Tribune*, May 14, 1869, p. 4. *History of Woman Suffrage* reported that "most" of the delegates to the New York convention attended the Brooklyn convention, but that seems unlikely since the *New York Daily Tribune* reported about 200 people at the Brooklyn convention, and *History of Woman Suffrage* earlier reported that 2,000 attended the New York meeting.

31. Only the *Brooklyn Daily Eagle* (May 15, 1869, p. 2) reported that Frederick Douglass spoke at the Brooklyn meeting, although it provided no details of the contents of his remarks.

Chapter 2

1. The letter and the events surrounding the letter come from Anthony, et al., *History of Woman Suffrage*, pp. 407–418.

2. Caleb Cushing was attorney general during the administration of President Franklin Pierce.

3. William Wirt was attorney general during the administrations of both James Monroe and John Quincy Adams.

4. This is a misspelling by Minor. Hugh Swinton Legare was attorney general for 21 months during the administration of President John Tyler. Minor also implies that Legare was attorney general of South Carolina when he made his ruling concerning free blacks. In fact, he was attorney general of South Carolina from 1830 to 1831 and U.S. attorney general from September 1841 to June 1843.

5. William L. Marcy was secretary of state during the administration of President Franklin Pierce.

6. Edward Bates was attorney general for most of Abraham Lincoln's first term as president.

7. For *Plessy*, see Lofgren, *The Plessy Case*.

8. For *Brown v. Topeka*, see Patterson, *Brown v. Board of Education*.

9. For *Scopes* see Johnson, *The Scopes "Monkey Trial."*

10. Dayton's population in 1920 was 1,701, and in and 1930 it was 2,006, according to the U.S. Census.

11. For Lucy Stone see, Kerr, *Lucy Stone*.

12. One notable difference between Anthony's NWSA and Stone's AWSA at the time is that Stone's organization permitted men to be full-fledged members and Anthony's did not.

13. See Sherr, *Failure is Impossible*, p. 31.

14. See "Frederick Douglass" at the Winning the Vote website at http://winningthevote.org/FDouglass.html.

15. Sherr, *Failure is Impossible*, pp. 75–76.

16. Ibid., p. 76. Anthony spelled the key word "terific" in her diary.

17. Stanton, *Eighty Years and More*, p. 164.

18. Ida Harper, p. 187.

19. The quote is from a letter Anthony wrote to Stanton's cousin. See Sherr, p. 175.

20. See, for example, Ward, pp. 82–83.

21. These comments appear in letters Anthony wrote to Brown, the first female ordained minister in the United States, on April 22 and May 2, 1858. See Sherr, p. 4. Brown was ordained in the Congregational church but later became a Unitarian. She was from Henrietta, a suburb of Rochester, and she and Anthony visited frequently.

22. The quote is from a letter Anthony wrote to Stanton on June 5, 1856. See Sherr, p. 7. Lucy, of course, refers to Lucy Stone and Nette to Antoinette Brown Blackwell.

23. See Ward, p. 85.

24. See any of numerous letters reprinted, in whole or part, in Sherr, Ward, Harper, and elsewhere. She also, Gurko, p. 277.

25. Ward, p. 134.

26. Ibid., p. 139.

27. Ibid., p. 188.

28. See, for example, Katherine Anthony, *Susan B. Anthony*; Banner, *Elizabeth Cady Stanton*; Barry, *Susan B. Anthony*; Clarke, *Bloomers and Ballots*; Colman, *Elizabeth Cady Stanton and Susan B. Anthony*; Cullen-DuPont, *Elizabeth Cady Stanton*; Griffith, *In Her Own Right*; Ida Harper, *The Life and Work of Susan B. Anthony*; Judith Harper, *Susan B. Anthony*; Lutz, *Created Equal*; Sherr, *Failure is Impossible*; Sigerman, *Elizabeth Cady Stanton*; Stanton, *Eighty Years*; Stanton and Blatch, *Elizabeth Cady Stanton*; and Ward, *Not for Ourselves Alone*. Also, *Not for Ourselves Alone*, film directed by Ken Burns.

29. Harper, p. 136.

30. Banner, p. 116.

31. Ibid.

32. For Woodhull, see Gabriel, *Notorious Victoria*.

33. Banner, pp. 129–130.

34. Ibid., p. 140.

35. Stanton and Blatch, Vol. 2, p. 172.

36. Banner, p. 171.

37. All of the quotes in this paragraph can be found in Harper, Vol. 1, p. 388.

38. Stanton, *Eighty Years*, p. 393.

39. Gordon, Vol. 2, p. 449.

40. Harper, Vol. 1, p. 416.

41. Ibid., p. 420.

42. Ibid.

43. For Shadd Cary, see Rhodes, *Shadd*.

44. For Sojourner Truth see Truth, *Narrative*, and Mabee and Newhouse, *Sojourner Truth*.

45. See Colman, pp. 150–151.

Chapter 3

1. The editorial comment appeared in the *Rochester Democrat and Chronicle*, Nov. 11, 1872, p. 4, under the headline "Register To-Day."

2. See Harper, *The Life and Work of Susan B. Anthony*, Vol. 1. Harper, and thus Anthony, discuss the actual casting of the vote on pp. 423–429. The details of her actual registration are taken from these pages.

3. *Rochester Democrat and Chronicle*, Saturday, November 12, 1872, p. 4.

4. Ibid.

5. Ibid. Tuesday, November 5, 1872, p. 4.

6. Ibid. Thursday, November 7, 1872, p. 4.

7. Hull, *The Woman Who Dared*, p. 65, speculates E.L.G. refers to Elizabeth Gay, a Rochester resident and advocate of women's rights, but her book does not provide any sources to support this guess. (The book contains no endnotes or footnotes, and instead says the sources are on file in the Rutgers University School of Law in Camden, New Jersey. A request to the law school that the sources be sent was answered with an unsigned e-mail saying they are available in Camden. The author herself did not respond to several requests.)

8. *Rochester Democrat and Chronicle*, Friday, November 9, 1872, p. 4. Hull (p. 66) assumes the writer of this letter was a man, but her book does not offer any proof of that (see note 7, this chapter).

9. Petroleum V. Nasby was the pen name of David Ross Locke. Among Nasby's many fans were Abraham Lincoln and Mark Twain. Nasby's "letters" were still appearing in Northern newspapers in the 1870s and his style was widely imitated.

10. The building where Susan B. Anthony voted no longer exists. On that site is a newer building that houses, among other businesses, the 1872 Café, named in honor of her act.

11. Hewitt, *Women's Activism and Social Change*, p. 211, *Democrat and Chronicle*, Nov. 1, 1872, and Harper, *Life and Work*, pp. 423–429.

12. Ida Harper, p. 426. Other details of the day the women voted and the events in the days following also come from Ida Harper, pp. 426–428, and from Anthony, et al., *History of Woman Suffrage*, pp. 627–630. Details of the description of the furnishings in Anthony's parlor at the time are from a photograph on file at the Library of Congress.

13. Ida Harper, p. 429. The version of the arrest warrant in Harper's biography of Anthony leaves a dash where the name of Sylvester Lewis should be. Lewis, a Democratic Party poll watcher, openly said he was the person who filed the complaint.

14. Details of the first day of the hearing are from the *Rochester Democrat and Chronicle*, Saturday, Nov. 30, 1872, p. 4. Details of the hearing held on subsequent days come from subsequent editions of the same newspaper.

15. "W.B. Jones" clearly refers to Beverly Waugh Jones. It's not clear if Marsh or the reporter, whose name is not listed in the newspaper, reversed the order of the initials.

16. At this point and some others, the *Democrat and Chronicle* reporter does not put the words in quotation marks, suggesting he is approximating the wording.

17. The newspaper report at this point says "tives," not "motives," but that is clearly a mistake.

18. There has been no book-length biography of Selden written. The information in this section comes from an article on him in the *Biographical Record of the City of Rochester*, with bits of additional information coming from newspaper articles cited in this book as the sources of the Anthony hearing and trial.

19. Butler had been a Democrat, switched to the Republican Party when Lincoln was elected, served as a general in the Union Army during the Civil War, and generally, after the war, supported increased rights for both women and blacks.

20. Much of what appears a bit awkward in the testimony may be the result of an abbreviation of what Jones said by the newspaper reporter, although it may also be the way Jones spoke, or a combination of both.

21. The newspaper account does not indicate which defense counsel, Van Voorhis or Selden, asked the question. Most likely it was Van Voorhis, since most of the questioning for the defense came from him, although by this point Selden had reentered the courtroom.

22. The *Democrat and Chronicle* identifies Warner as one of the "inspectors," but that is incorrect.

23. For a brief biography of Van Voorhis, see the Federal Judiciary Center website.

24. As noted above, in Note 11 in this chapter, the details of this part of the hearing come from the *Rochester Democrat and Chronicle*. However, the *Rochester Daily Union and Advertiser* published a lengthy report on this part of the hearing (Saturday, Nov. 30, 1872, p. 2), and its version differs slightly from the one in the *Democrat and Chronicle*. For example, where the *Democrat and Chronicle* has Van Voorhis asking, "Are you the defendant in this case?" and Anthony answering, "I am," the *Union and Advertiser* omits the question and gives the answer as "I am the person spoken of in the complaint, the defendant." However, despite occasional differences in wording between the two newspapers, there is no difference in meanings of either questions or answers.

25. For a brief biography of John E. Pound see the Federal Judiciary Center website.

26. Mr. Garragus' first name is not provided in the newspaper account. The only information offered about him is contained in this brief testimony. Hull (p. 79) says his name is Mr. Garrigan, but her book does not cite a source (see Note 7 above, this chapter).

27. See *Rochester Democrat and Chronicle*, Wednesday, December 18, 1872, p. 4.

28. *Rochester Democrat and Chronicle*, Dec. 27, 1872, p. 4. This article is the source for the information on the day's events.

29. For information on Keeney see Ida Harper, *Susan B. Anthony*, pp. 426–427, Keeney, "Last Will and Testament," and Peck, *History of the Police Department of Rochester, N.Y.*

30. The details of the Albany hearing come from Ida Harper, pp. 432–433.

31. The indictment appears in full in Appendix A.

32. All four of the editorial commentaries appear in Ida Harper, p. 429.

Chapter 4

1. For a history of nullification in the United States and elsewhere see Conrad, *Jury Nullification*.

2. Quotes from Anthony's speech from Harper, *The Life and Work of Susan B. Anthony*, Vol. 2, pp. 977–992.

3. Noah Webster published the most famous American dictionary of the 19th Century. Worcester was his chief rival in what was sometimes referred to as the "dictionary wars." *Bou-*

vier's Law Dictionary was the leading legal dictionary of the day.

4. These were, of course, among the richest Americans of the day. Cornelius Vanderbilt, who made his fortune in shipping and railroads, is often ranked, when adjustments for inflation are made, as the richest man in American history. Alexander Turney Stewart developed the world's largest dry goods business and built in New York City what at the time was the world's largest store. He is listed, again with adjustments for inflation, among the 20 richest Americans ever. The Conkling family was prominent in New York and national politics. Her reference to the Fentons is a bit unclear, although several Fentons at the time were prominent in politics and other areas. The reference, most likely, was to Reuben Fenton, who at the time of her speech was a Republican U.S. senator from New York.

5. Details of court proceedings in May 1872 come from various Rochester, New York, newspapers.

6. This quote is adapted from several newspaper reports that report her saying, in the third person, that she had "done only what she had a perfect right to do."

7. For biographical information on Matilda Joslyn Gave see Brammer, *Excluded From Suffrage History*, and Goodier, "Gage, Matilda (Electa) Joslyn."

8. Quotes from Gage's speech are from *Daily Democrat and Chronicle Book Print, An Account of the Proceedings on the Trial of Susan B. Anthony*.

9. The quote was made by Stephen Hopkins, a signer of the Declaration of Independence from Rhode Island. There were many ministers in the Hopkins's family, but he was not one.

10. This was not technically accurate. The judge who would sit in the trial of Susan B. Anthony was Ward Hunt, who indeed had just been appointed to the United States Supreme Court, and at the time—the late 19th Century—Supreme Court justices rode circuit and presided over trials. Hunt would sit as a judge who happened to be a Supreme Court justice, and not as a member of the high court.

11. Ricker is discussed in Anthony, et al., *History of Woman Suffrage*, pp. 586–587.

12. Ibid., pp. 587–599.

13. Ibid., p. 600.

14. Ibid., pp. 600–601.

15. Ibid.

16. Ibid., pp. 626–627.

17. Ida Harper, p. 433.

18. Ibid., pp. 433–434.

19. Ibid., p. 434.

20. Ibid.

21. Sometimes this woman's name is spelled

Hibbard and sometimes her middle initial is listed as L.

22. Ida Harper, p. 434.

Chapter 5

1. The physical description of the Ontario County Courthouse comes from Ontario County, *Ontario County Court House*. The courthouse still exists, on Main Street, Canandaigua, but it has been expanded. The courtroom in which Anthony was tried no longer exists, but a new courtroom several feet to the north of it does exist and retains much the original's appearance.

2. Part of the 1988 cult horror film classic *Lady in White* was filmed in the Searl-designed Wayne County Courthouse in Lyons.

3. See Pierce, "Lady 'Justice,'" and Merrill, *The Lakes Country*, pp. 49–50.

4. All quotes from the trial come from transcript as published in a pamphlet paid for by Susan B. Anthony shortly after the trial was completed. See *Daily Democrat and Chronicle* in the bibliography.

5. While sitting on a Supreme Court case, Ward Hunt would be referred to as "justice," but while sitting in a circuit court case protocol called for him to be referred to as "judge."

6. For a brief biography of Richard Crowley see the Biographical Directory of Members of Congress website.

7. The transcript at this point misspells the name as Voorhees. Misspellings in the transcript have generally been corrected since what is being recorded here is not what the transcript says but rather what was said, according to the transcript, in the courtroom.

8. Judge Hunt's quote here is adapted from the summation of his comments that appear in the transcript.

9. *Bouvier's Law Dictionary*, first published in 1839, was written by John Bouvier (1787–1851), a Philadelphia attorney.

10. Richard Grant White (1822–1885) was best known as America's first important Shakespearean scholar. Selden was quoting his 1870 book *Words and Their Uses*.

11. *Corfield v. Coryell* upheld a New Jersey law forbidding non-residents from gathering oysters and clams. Bushrod Washington was the nephew of George Washington. He inherited Mount Vernon upon his uncle's death. He was appointed to the Supreme Court by John Adams.

12. Hale was an English barrister, lawyer, and judge who lived from 1609 to 1676.

13. The U.S. Supreme Court had ruled only two months before the Anthony trial that the 14th Amendment to the U.S. Constitution protected only those rights enjoyed by a citizen of the United States, not the rights enjoyed by a citizen of an individual state. The Slaughter House cases involved a Louisiana law that allowed the city of New Orleans to control the butchering business in the city. The law was designed to regulate how butchers disposed of their waste so it wouldn't endanger the city's water supply. The butchers argued, unsuccessfully, that it infringed on their rights to conduct a legal business.

14. The cases he mentioned were "*Corfield agt. Coryell*, 4 Wash.; C. C. R., 371. *Ward agt. Maryland*; 12 Wall., 430. *Paul agt. Virginia*, 8 Wall., 140." *Ward v. Maryland* was an 1869 case in which the Supreme Court ruled a citizen of any state has the right to enter and leave another state. *Paul v. Virginia*, also an 1869 case, held that a corporation is not a citizen. All three cases involved Supreme Court interpretations of the 14th Amendment.

15. The transcript uses the word "and" here, not "as," but "and" clearly does not make sense in this context and was probably a stenographic error.

16. The reference is to Samuel Freeman Miller, who was appointed to the Supreme Court in 1862 by President Lincoln and who served until his death in 1890.

17. The trial transcripts reads "*Corfield agt. Coryell* (Supra.)." See Note 11 above for an explanation of the case.

18. The case of *Bradwell v. Illinois* had been argued before the U.S. Supreme Court on January 18, 1873. The court issued its ruling on April 16, 1873, just two months prior to the trial of Susan B. Anthony.

19. Joseph P. Bradley was appointed to the Supreme Court by President Grant and served from 1870 to 1892.

20. Stephen J. Field was appointed to the Supreme Court by President Lincoln and served from 1863 to 1897.

21. Judge Hunt was incorrect on this point, because a third justice, Noah H. Swayne concurred, as did Field, in the opinion written by Bradley, which said, in part, "The natural and proper timidity and delicacy which belongs to the female sex evidently unfits it for many of the occupations of civil life.... The paramount destiny and mission of women are to fulfill the noble and benign offices of wife and mother. This is the law of the Creator." The rest of the majority in the 8–1 ruling did not emphasize sex but rather based their ruling on the right of states to regulate voting. Only Chief Justice Salmon P. Chase dissented.

22. The cases cited by Hunt were "*Hamilton against The People*, 57th of Barbour, p. 625; *State against Boyet*, 10th of Iredell, p. 336; *State against*

Hart, 6th Jones, 389; *McGuire against State*, 7 Humphrey, 54; 15th of Iowa reports, 404."

23. Most likely the "professional friend" was John Van Voorhis.

24. The transcript has the clerk speaking these words, but that clearly is incorrect, since only the judge would have the authority to discharge the jury. Also, later in the transcript, Selden quotes the judge as having said, "That cannot be allowed. Gentlemen of the jury, you are discharged."

25. For biographical information on Ward Hunt see *Encyclopedia of Contemporary Biography*, Fitch, *New York Times* "Obituary," and Roper.

26. The transcript does not contain any suggestion by Judge Hunt that Selden first discuss the questions of law. Probably, therefore, the suggestion was made during a sidebar. That is, a conversation between attorneys and the judge out of hearing of the jury or anyone else in the courtroom. Sidebars are not typically recorded in transcripts, one of many reasons transcripts, being incomplete, are not fully reliable sources of what happens in a courtroom.

27. Neither the transcript nor any other source indicates who the friend was, but most likely it was John Van Voorhis.

28. *State v. Shule* was a North Carolina case in 1849 in which, after the jury had deliberated but before it could report its verdict to the court, the prosecuting attorney instructed the clerk to enter a verdict of guilty. That verdict was overturned on appeal to the North Carolina Supreme Court, which ordered a new trial.

29. The wording in the transcript is: "I refer to the case of the *State vs. Shule* (10 Iredell, 153) the substance of which is stated in 2 Graham Waterman on New Trials, page 363. Before stating that case I quote from the text of G. W."

30. A writ for summoning a new jury.

31. The transcript reads, "Cancemi 18 N.Y., 128."

32. At this point the transcript reads "(*The People vs. Perkins*, 1 Wend. 91, *Jackson vs. Hawks*, 2 Wend. 619. *Fox vs. Smith*, 3 Cowen, 23.)" Since the transcripts lists the three cases in parenthesis, it's likely Selden presented them in writing to the court stenographer.

33. Selden is here quoting from Hunt's instructions to the jury. He makes some slight but insignificant changes in the wording.

34. See Pierce, "Lady 'Justice,'" and Merrill, *The Lakes Country*, pp. 49–50.

Chapter 6

1. At this point the transcript says "(12 Metcalf, 387, *Commonwealth v. Peters*)." The

parenthesis are in the transcript, indicating that Van Voorhis gave this information to the court stenographer at some time other than when he was speaking.

2. The transcript does not contain the word "they," which seems likely to have been a stenographic error.

3. The wording in this quote comes directly from the transcript, which does not attribute it to any specific person.

4. The transcript does not specifically say Judge Hunt sustained the objection, or that he commented on it at all, but since Lewis does not answer the question and Van Voorhis's follow up questions move on to another point, Hunt must have agreed with Crowley.

5. The transcript reads, "I think that the ballots that these ladies voted," but that seems to be an error.

6. The state legislature in New York is referred to as the Assembly. Thus, votes in the election were being cast for members of the state legislature, as well as members of the U.S. Congress.

7. *Res Gesta*, usually spelled *res gestae*, refers to the "start-to-end" period of a felony, and in the U.S. can refer to an exception to hearsay rules if a statement is part of the crime or made spontaneously.

8. Van Voorhis at this point quotes more than 500 words from the New York state law defining the duties of inspectors of election.

9. Van Voorhis at this point quoted from "*The People vs. Pease*, 27 N.Y. 45," a case decided by the New York Court of Appeals, the highest court in the state, in which the court ruled that inspectors of election had very limited authority to refuse to allow someone to vote. He devoted nearly 700 words to his quotes and explanations.

10. Van Voorhis at this point again quoted from the relevant state statue.

11. Van Voorhis at this point cited more than a dozen cases in New York and other states and in Britain in which public officials were found not guilty of any crime when they made mistakes in judgment in carrying out their duties. He used about 2,500 words to cite and explain the cases.

Chapter 7

1. Details of the arrest of the inspectors and subsequent developments come from Anthony, et al., *History of Woman Suffrage*, pp. 714–716, and Ida Harper, *Anthony*, pp. 452–453.

2. From Anthony, et al., *History of Woman Suffrage*, Vol. 2, p. 647.

3. The quotes from Anthony's journal entry, Selden's letter, and the newspaper and law

journal excerpts can all be found in Ida Harper, *Anthony*, pp. 441–444.

4. Details of *Minor v. Happersett* can be found in Anthony, et al., *History of Woman Suffrage*, Vol. 2, pp. 715–755.

5. The Supreme Court's ruling in *Minor v. Happersett* is contained in its entirety in Appendix B.

6. Except where otherwise indicated, information in this section comes from Ida Harper, *Anthony*, pp. 449–465.

7. For Matthew Lyon see Austin, *Matthew Lyon*.

8. Ida Harper spells his name "Tremaine."

9. *Nisi prius* is Latin for "unless first" and refers to a court of original jurisdiction.

10. These quotes are from Ida Harper, *Anthony*, Vol. 1, p. 28.

11. Ibid., pp. 43–44.

12. Ibid.

13. Barry, pp. 42–43.

14. Ira Harper, *Anthony*, Vol. 1, p. 38.

15. Ibid., p. 126.

16. For *Leser v. Garnett* see "The Validity of the Nineteenth Amendment," *Yale Law Journal*.

17. *New York Times*, "Tribute of Two Races."

18. Details of the death of Frederick Douglass and his last time spent with Susan B. Anthony come from three contemporaneous *New York Times* articles, "Death of Fred Douglas," "The Slave Who Ran Away," and "Tribute of Two Races," and from Ida Harper, *Susan B. Anthony*, pp. 812–814.

Bibliography

Aldrich, Lewis Cass. *History of Ontario County, New York*. Syracuse, N.Y.: D. Mason, 1893.

"The Anniversaries: Thirty-seventh Annual Meeting of the American Anti-Slavery Society," *Brooklyn Daily Eagle*, May 12, 1869, p. 3.

Anthony, Katharine. *Susan B. Anthony: Her Personal History and Her Era*. Garden City, NY: Doubleday, 1954.

Anthony, Susan B., et al., eds. *History of Woman Suffrage*. New York: Arno Press, New York Times, 1969. This six volume history, containing in total over 6,000 pages, was published between 1881 and 1922. Much of it, particularly the last two volumes, consists of accumulated documentation rather than new writing. Editors in addition to Anthony included Elizabeth Cady Stanton, Matilda Joslyn Gage, and Ida Husted Harper. All six volumes are available online at the Project Gutenberg website at http://www.gutenberg.org/catalog/.

Austin, Aleine. *Matthew Lyon: "New Man" of the Democratic Revolution, 1749–1822*. University Park: Pennsylvania State University Press, 1981.

Banner, Lois W. *Elizabeth Cady Stanton: A Radical for Women's Rights*. Boston: Little, Brown, 1980.

Barker, Gordon S. *The Imperfect Revolution: Anthony Burns and the Landscape of Race in Antebellum America*. Kent, Ohio: Kent State University Press, 2010.

Barry, Kathleen. *Susan B. Anthony: A Biography of a Singular Feminist*. New York University Press, 1988.

Biographical Record of the City of Rochester and Monroe County, "Susan B. Anthony" and "Henry Rogers Selden," New York and Chicago: S.J. Clarke, 1902. No authors for the articles or editor for the volume are listed.

Brammer, Leila R. *Excluded From Suffrage History: Matilda Joslyn Gage, Nineteenth Century American Feminist*. Westport, CT: Greenwood Press, 2000.

Burns, Anthony, and William I. Bowditch. *The Rendition of Anthony Burns*. Boston: Robert F. Wallcut, 1854.

Canandaigua, As It Is Today, 1910, Ontario County Times, Canandaigua, New York, 1910. No author or editor listed.

Caruthers, J. Wade. *Octavius Brooks Frothingham: Gentle Radical*. Tuscaloosa: University of Alabama Press, 1977.

Chidsey, Donald Barr. *The Gentleman from New York: A Life of Roscoe Conkling*. New Haven, CT: Yale University Press, 1935.

Clark, Louis M. *A Book of Facts About the City of Canandaigua, Ontario County, New York, 1789–1991*. Canandaigua, New York: Ontario County Historical Society, 1991.

_____. *A Village Becomes a City: Canandaigua Architecture, 1850–1920*, Canandaigua, New York: Ontario County Historical Society, 2007.

Clarke, Mary Stetson. *Bloomers and Ballots: Elizabeth Cady Stanton and Women's Rights*. New York: Viking, 1971.

Colman, Penny. *Elizabeth Cady Stanton and Susan B. Anthony: A Friendship That Changed the World*. New York: Henry Holt, 2011.

Conover, George S., ed. *History of Ontario County, New York.* Syracuse, NY: D. Mason, 1893.

Conrad, Clay S. *Jury Nullification: The Evolution of a Doctrine.* Durham, NC: Carolina Academic Press, 1988.

Corbett, Theodore. *A Home in the Battenkill Valley: The Early Years of Susan B. Anthony.* Greenwich, NY: NorthStar Historical Project, 2007.

Cullen-DuPont, Kathryn. *Elizabeth Cady Stanton and Women's Liberty.* New York: Facts On File, 1992.

Daily Democrat and Chronicle Book Print, An Account of the Proceedings on the Trial of Susan B. Anthony, on the Charge of Illegal Voting, at the Presidential Election in Nov., 1872, and on the Trial of Beverly W. Jones, Edwin T. Marsh and William B. Hall, the Inspectors of Election by Which Her Vote Was Received. Rochester, New York, 1874. This book is available online at http://www.gutenberg.org/files/1828 1/18281-h/18281-h.htm.

"Elizabeth Cady Stanton Dies at Her Home." *New York Times,* Oct. 27, 1902.

Ellis, David M., James A. Frost, Harold C. Syrett, and Harry J. Carman. *A Short History of New York State.* Ithaca, NY: Cornell University Press, 1957.

"Equal Rights: Anniversary of the American Equal Rights Association, Spirited Debate on Questions of Reform, Manhood Suffrage, National Suicide—Females Enfranchisement Our Only Safety, Full Recognition of the Labor Movement." *New York Times,* May 13, 1869.

"Ex-Judge Ward Hunt," obituary. *New York Times,* March 25, 1886.

Fitch, Charles Elliott. "Hunt, Ward." *Encyclopedia of Biography of New York,* Vol. 3. New York: American Historical Society, 1916.

Free, Laura, E. "Anthony, Susan B(rownell)." *The Encyclopedia of New York State.* Syracuse, NY: Syracuse University Press, 2005.

_____. "Stanton, Elizabeth Cady." *The Encyclopedia of New York State.* Syracuse, NY: Syracuse University Press, 2005.

Gabriel, Mary. *Notorious Victoria: The Life of Victoria Woodhull, Uncensored.* Chapel Hill, NC: Algonquin, 1998.

"George Francis Train" (editorial comment). *New York Times,* Jan. 21, 1904.

Gillette, William. *The Right to Vote: Politics and the Passage of the Fifteenth Amendment.* Baltimore: Johns Hopkins Press, 1965.

Goodier, Susan. "Gage, Matilda (Electa) Joslyn." *The Encyclopedia of New York State.* Syracuse, NY: Syracuse University Press, 2005.

Gordon, Ann D., ed. *The Selected Papers of Elizabeth Cady Stanton and Susan B. Anthony,* 5 vols. New Brunswick, NJ: Rutgers University Press, 1997–2013.

Griffith, Elisabeth. *In Her Own Right: The Life of Elizabeth Cady Stanton.* New York: Oxford University Press, 1984.

Gurko, Miriam. *The Ladies of Seneca Falls: The Birth of the Woman's Rights Movement,* New York: Macmillan, 1974.

Harper, Ida Husted, and Carrie Chapman Catt. *The Life and Work of Susan B. Anthony, Including Public Addresses, Her Own Letters and Many from Her Contemporaries During Fifty Years.* Indianapolis and Kansas City: Bowen-Merrill, 1989–1908.

Harper, Judith E. *Susan B. Anthony: A Biographical Companion.* Santa Barbara, CA: ABC-CLIO, 1998.

Hays, Elinor Rice. *Those Extraordinary Blackwells: The Story of a Journey to a Better World.* New York: Harcourt, Brace and World, 1967.

Hewitt, Nancy C. *Women's Activism and Social Change, Rochester, New York, 1822–1872.* Ithaca, NY: Cornell University Press, 1984.

Hotra, Lynda McCurdy. *Canandaigua, 1850–1930: A Photographic History of the Village and the Lake.* Canandaigua, NY: Ontario County Historical Society, 1982.

Hull, N.E.H. *The Woman Who Dared to Vote.* Lawrence: University of Kansas Press, 2012.

Johnson, Anne Janette. *The Scopes "Monkey Trial."* Detroit: Omnigraphics, 2007.

Jordan, David. *Roscoe Conkling of New York: A Voice in the Senate.* Ithaca, NY: Cornell University Press, 1971.

Keeney, Elisa J. "Last Will and Testament." http://files.usgwarchives.net/ny/monroe/wills/v19/keeney-elisha.txt.

Kerr, Andrea Moore. *Lucy Stone: Speaking Out for Equality.* New Brunswick, NJ: Rutgers University Press, 1992.

Klees, Emerson. *The Women's Rights Movement and the Finger Lakes Region.* Rochester, New York: Friends of the Finger Lakes, 1998.

Knoblauch, Valerie, comp. *Ontario County, Pictorial Reflections in the Finger Lakes Region.* Canandaigua, NY: Ontario County Four Seasons Development Corporation, 1989.

Kolmerten, Carol A. *The American Life of Ernestine L. Rose.* Syracuse, NY: Syracuse University Press, 1999.

"The Late Stephen S. Foster, Sketch of the Veteran Anti-Slavery Worker and Temperance Orator." *Worcester* (Mass.) *Spy,* September 8, 1881. Republished in *The New York Times,* September 13, 1881.

Livermore, Mary Ashton Rice. *The Story of My Life, or, The Sunshine and Shadow of Seventy Years.* Hartford, CT: A.D. Worthington, 1897.

Lofgren, Charles A. *The Plessy Case: A Legal-Historical Interpretation.* New York: Oxford University Press, 1987.

Lutz, Alma. *Created Equal: A Biography of Elizabeth Cady Stanton, 1815–1902.* New York: John Day, 1940.

_____. *Susan B. Anthony.* Boston: Beacon Press, 1959.

_____. "Susan B. Anthony and John Brown." *Rochester History.* Rochester Public Library, July 1953.

Mabee, Carleton, and Susan Mabee Newhouse. *Sojourner Truth: Slave, Prophet, Legend.* New York University Press, 1993.

McFeely, William S. *Frederick Douglass.* New York: Norton, 1991.

McIntosh, W.H. *History of Ontario Co., New York, With Illustrations, Descriptive of Its Scenery, Palatial Residences, Public Buildings, Fine Blocks, and Important Manufactories.* Philadelphia: Everts, Ensign and Everts, 1876.

McKelvey, Blake. "Susan B. Anthony." *Rochester History.* Rochester Public Library, April 1945.

_____. "Susan B. Anthony's Hometown Trials." *Rochester History.* Rochester Public Library, July 1982.

McMillen, Sally G. *Seneca Falls and the Origins of the Women's Rights Movement.* New York: Oxford University Press, 2005.

Merrill, Arch. *The Lakes Country.* Rochester, NY: Louis Heindi and Son, 1944.

"Miss Susan B. Anthony Died This Morning," obituary. *New York Times,* March 13, 1906.

Naparsteck, Martin. *"Rochester Democrat and Chronicle." The Encyclopedia of New York State.* Syracuse, NY: Syracuse University Press, 2005.

"Men's Rights." *New York Daily Tribune,* May 14, 1869, p. 4.

Ontario County Court House: Its History and Restoration. Canandaigua, NY, 1988.

Ontario County Pictorial History. Daily/Sunday Messenger, Canandaigua, NY, 1998. No author or editor listed.

Patterson, James T. *Brown v. Board of Education: A Civil Rights Milestone and Its Troubled Legacy.* New York: Oxford University Press, 2001.

Peck, William F. *History of the Police Department of Rochester, N.Y., With a Record of the Principal Crimes Committed, A Description of the Public Buildings Connected with the Administration of Justice, and Lists of the Officers and Members of the Force from the Beginning and of Officials Connected with the Department.* Rochester Police Benevolent Association, 1903.

Pierce, Preston E. "Lady 'Justice,' A Verdict and a Legend," Department of Records, Archives and Information Management Services, Ontario County, Canandaigua, New York, 2012.

_____. *Seat of Justice: Witness to History; A History of the Ontario County Court House.* Office of the County Historian, Canandaigua, NY, 1989.

Quartes, Benjamin. *Frederick Douglass.* Englewood Cliffs, NJ: Prentice-Hall, 1991.

Rhodes, Jane. *Mary Ann Shadd Cary, The Black Press and Protest in the Nineteenth Century.* Bloomington: Indiana University Press, 1998.

Ridarsky, Christine L., and Mary M. Huth, eds. *Susan B. Anthony and the Struggle for Equal Rights.* Rochester, NY: University of Rochester Press, 2012.

Rochester Daily Union and Advertiser.

Rochester Democrat and Chronicle, numerous editions in 1860s and 1870s. This daily newspaper, which still exists, has over the years been published under many similar names, sometimes using the name of the city as part of the title, sometimes not; sometimes using the word "and" and sometimes using "&"; and sometimes using "Daily" as part of the name. When cited in the text or endnotes, the form used is the one current with the citation.

Roper, Donald M., "Hunt, Ward." *The Encyclopedia of New York State.* Syracuse, NY: Syracuse University Press, 2005.

Rosenberg-Naparsteck, Ruth. "Failure is Impossible: The Legacy of Susan B. Anthony." *Rochester History,* Rochester Public Library, Fall 1995.

_____. "Rochester." *The Encyclopedia of New York State.* Syracuse, NY: Syracuse University Press, 2005.

_____. *Rochester, A Pictorial History.* Norfolk/Virginia Beach: Donning, 1989.

Sherr, Lynn. *Failure is Impossible: Susan B. Anthony in Her Own Words.* New York: Times, 1995.

Sigerman, Harriet. *Elizabeth Cady Stanton: The Right is Ours.* New York: Oxford University Press, 2001.

Stalcup, Brenda, ed. *Susan B. Anthony.* San Diego: Greenhaven Press, 2002.

Stanton, Elizabeth Cady. *Eighty Years and More: Reminiscences, 1815–1897.* New York: European, 1898.

Stanton, Theodore, and Harriot Stanton Blatch, eds. *Elizabeth Cady Stanton: As Revealed in Her Letters, Diary, and Reminiscences.* New York: Harper & Brothers, 1922.

"Stephen Hopkins." *Harper's Encyclopedia of United States History from 458 A.D. to 1905,* Vol. 4, New York: Philadelphia Press, 1905, pp. 415–424.

Sterngass, Jon. "Conkling, Roscoe." *The Encyclopedia of New York State.* Syracuse, NY: Syracuse University Press, 2005.

Swartout, Barbara C. *Building Canandaigua: A Collection.* Canandaigua, NY: Ontario County Historical Society, 1997.

Thornton, Willis. *The Nine Lives of Citizen Train.* New York: Greenberg, 1948.

"Train to Lie in State, 'Sage of Madison Square' Died Poor, It is Said, Some of His Eccentricities and Sensational Achievements in This Country and in Europe Recalled." *New York Times,* Jan. 20, 1904.

"Tribute from Miss Anthony." *New York Times,* Oct. 27, 1902 (Susan B. Anthony's comments on learning of the death of Elizabeth Cady Stanton).

Truth, Sojourner, and Imani Perry. *Narrative of Sojourner Truth, with "Book of Life" and "A Memorial Chapter,"* New York: Barnes and Noble Classics, 2006. First published in 1850.

Venet, Wendy Hammand. *A Strong-minded Woman: The Life of Mary Livermore.* Amherst: University of Massachusetts Press, 2006.

Ward, Geoffrey C. *Not for Ourselves Alone: The Story of Elizabeth Cady Stanton and Susan B. Anthony, An Illustrated History.* New York: Knopf, 1999.

"Ward Hunt." *Encyclopedia of Contemporary Biography of New York,* Vol. 1. New York: Atlantic Publishing and Engraving, 1878. No author for the article or editor for the volume are listed.

"Woman Suffrage, Mass Meeting at the Academy of Music in Brooklyn—Speeches by Mrs. E. Cady Stanton, Mrs. Livermore, Miss Peckham, the Rev. Mr. Chadwick, Lucretia Mott, Henry Ward Beecher and Others." *New York Daily Tribune,* May 16, 1869, p. 3.

"The Women in Council, Meeting of the Equal Rights Association This Morning, Speeches of Mrs. Stanton, Mrs. Stone, Mrs. Livermore and Others, The Lords of Creation Ungallantly Snubbed, They Want to Join in the Pow Wow, but Won't be Allowed, A Foretaste of Feminine Rule in the Future." *Brooklyn Daily Eagle,* May 14, 1869, p. 3. This article contains a tagline attributing it to H.W. Slocum.

"Women's Rights, The Proceedings Yesterday, A Conservative Woman Makes a Speech, A Policeman Tries to Shut Her Up but Fails, The Evening Session." *Brooklyn Daily Eagle,* May 15, 1869, p. 3.

Filmography

Not for Ourselves Alone: The Story of Elizabeth Cady Stanton and Susan B. Anthony. Directed by Ken Burns, written by Geoffrey C. Ward, produced by Paul Barnes and Ken Burns, narrated by Sally Kellerman, 1999.

Websites

Biographical Directory of the United States Congress, 1774–Present. http://bioguide .congress.gov/biosearch/biosearch.asp.
National Women's Hall of Fame. http://w ww.greatwomen.org/.
Project Gutenberg. http://www.gutenberg. org/catalog/.
Steinway and Sons website, history webpage. http://www.steinwayshowrooms.c om/about-us/steinway-history.

Susan B. Anthony: Celebrating "A Heroic Life." Department of Rare Books and Special Collections, Rush Rhees Library, University of Rochester. http://www.lib. rochester.edu/index.cfm?page=4119.
Susan B. Anthony Collection at Rochester Public Library, Local History Division. http://www.libraryweb.org/rochimag/ SBA/intro.htm.
Susan B. Anthony Museum and House. http://susanbanthonyhouse.org/index. php.
The Trial of Susan B. Anthony. Federal Judicial Center, History of the Federal Judiciary, http://www.fjc.gov/history/ho me.nsf/page/tu_anthony_doc_16.html.
Trial of Susan B. Anthony. University of Missouri at Kansas City. http://law2. umkc.edu/faculty/projects/ftrials/ anthony/sbahome.html.
Winning the Vote. http://winningthevote.

Index

Numbers in **_bold italics_** indicate pages with photographs.

Abolitionist Movement 6, 9, 14, 16, 17, 18, 28, 44, 65, 194, 216*ch*1*n*21
Adams, John 100, 190, 221*n*11
Akron, Ohio 49
Albany, New York 43, 76–80, 82–83, 98, 147, 187, 191, 194, 203, 218*n*30
Albany City Hall 80, 83, 203
Albany Law Journal 187
amendments to U.S. Constitution: fifth 92, 149, 161; sixth 3, 129, 133–137, 139, 141, 177–178, 180, 185–186, 191; thirteenth 6, 9, 11, 12, 125–6, 149–150, 187–188; fourteenth 2, 6, 12–13, 32, 37–38, 50, 52–54, 62, 66, 75, 81, 83, 85, 92–94, 104–105, 111, 115, 123, 125–128, 130, 141, 149–150, 163, 173, 187–189, 209, 211, 218*n*13, 218*n*14; fifteenth 6, 12–15, 18–20, 22–23, 27–28, 30, 85, 93, 125, 127, 133, 149–150, 211, 219–220*n*22; nineteenth 1, 197; *see also* Constitution, United States
American Civil Liberties Union 39
American Equal Rights Association 9, 14, 28, 30
American Woman Suffrage Association 40, 44
Anacostia 200
Anthony, Lottie B. 55, 153, 160–161, 164–165
Anthony, Mary S. 44, 55, 61, 153–154, 156, 159–160, 164
Anthony, Susan B. *172*; arrested 2, 3, 5, 7, 60–61, 76, 78–81, 84–85, 101, 134, 143, 187, 217*n*11; bullies Stanton 42–48; fined 3, 145, 192; friendship with Frederick Douglass 5, 9, 31, 44, *199*; and jury nullification 4, 86–106, 178; motivation for

crime 9–30; personality 1, 6, 41–42, 44, 49, 78, 131; physical appearance 45; planning the crime 51–50; publishes trial transcripts 5, 219*n*4; trial of 107–146; votes in 1872 2, 5–7, 51–85; votes in 1873 105–106
Arcade Building 61–63, 76
Around the World in Eighty Days 13
Articles of Confederation 89, 207
Ashfield, Massachusetts 94
Athens, Greece 195
Atlanta, Georgia 44, 198
Atwater, Moses 108
Australia 15

Baker, Ellen S. 55, 153–154, 160, 164
Baltimore, Maryland 70, 197
Baltimore Sun 39
Bancroft, George 100
Batchelder, L.S. 25
Bates, Edward 34, 93, 216*n*6
Battle Creek, Michigan 49
Baum, L. Frank 99
Baumfree, Elizabeth *see* Truth, Sojourner
Beecher, Henry Ward 30
Blackstone, William 122
Blackwell, Antoinette Brown 23, 26, 43, 216*ch*2*n*22
Blackwell, Henry 18, 23–24, 28–29
Blake, Lillie Devereaux 99
Boston, Massachusetts 20, 27, 87, 196
Bouvier's Law Dictionary 93, 123, 218*n*3, 219*n*9
Bradley, Joseph P. 128, 189, 219*n*19, 219*n*21
Bradwell, Myra 128, 186, 219*n*18
Brandeis, Louis 198
Brewer, David Josiah 37

Brockport, New York 88
Brooklyn Academy of Music 30
Brooklyn Chapter, American Equal Rights Association 30
Brooklyn Daily Eagle 30, 216*ch*1*n*31
Brown, Albert 104
Brown, Antoinette *see* Blackwell, Antoinette Brown
Brown, B. Gratz 89
Brown, Henry Billings 37
Brown, Oliver L. 38
Brown University 72
Brown v. Topeka 13, 37–38, 40, 190
Bryan, William Jennings 39
Burleigh, C.C. 28
Burned Over District 99
Burnham, Carrie S. 104
Burns, Anthony 87
Butler, Benjamin 66, 182, 192, 217*n*19
Butler Act 39

California 41, 47–48, 91, 104, 184, 191
Canada 49, 62, 87, 144
Canadice, New York 100
Canajoharie, New York 193
Canandaigua, New York 5, 7, 88, 97–98, 100, 102, 106–109, 146, 148, 191, 219*n*1
Canandaigua Times 185
Cancemi case 139, 141, 220*n*31
Carpenter, Matthew Hale 192
Carroll, Anna Ella 98
Cary, Mary Ann Shadd 49
Cedar Hill 201
Chapman, Nancy M. 55, 153, 156, 160–161, 164
Chatfield, Hannah (also called Nancy) 55, 153, 154, 160–161
Chicago, Illinois 65
Chicago Legal News 186
Chinese 14, 122, 184
Chisholm v. Georgia 122
Church of England 86
Churchville, New York 88
Civil War 6, 9, 11–13, 15, 47, 49, 54, 65, 67, 86, 89, 98, 187, 215*n*14, 217*n*19
Claflin, Tennessee 46
Clarke, Freeman 56
Clarkson, New York 65
Cleveland, Ohio 41
Clifford, Nathan 189
Cogswell, Jane 153, 156, 160–161
Colby, Bainbridge 197
Colby, Clara 42

Comité des Citoyens (Committee of Citizens) 36
Confederate soldiers 29
Confederate States 13, 15, 54, 83, 188, 215*n*14
Congress, United States 2, 10, 13–14, 31, 33, 35, 56, 60–61, 65, 68, 70, 76, 83, 95, 110–114, 116–117, 120, 123, 125, 127, 129, 133–134, 141–142, 148, 151, 157–159, 161–163, 167, 170, 176–178, 188, 190–193, 196–197, 204, 207–209, 211, 213, 217*n*12, 222*n*6
Conkling, Roscoe 94, 132, 218*n*10
Connecticut 198, 210
Constitution, Missouri 187, 206, 209, 213
Constitution, New York 66, 82, 90, 114–115, 125–126, 128, 141, 157–158, 161, 165–166
Constitution, United States 1–3, 6, 9–10, 12–13, 23, 28–29, 31–37, 39, 46, 50, 52, 54, 58, 66, 75–76, 80–81, 83–86, 88–95, 96, 103–104, 109, 11, 115, 117, 121–123, 125–127, 129–131, 133, 137–138, 142, 145, 147–149, 165–166, 184, 187, 188, 189–191, 197–198, 206–213, 219*n*13; *see also* amendments to the U.S. Constitution
Cooper Institute 28
Corfield v. Coryell 123, 127, 219*n*11
Cornell, Ezra 21
Cornell University 21
Corsica 195
Court of Appeals, New York 62, 64–65, 132, 139, 220*n*9
Couzins, Phoebe 23, 30
Covington, Louisiana 36
Cox, Samuel Sullivan 55
Cromwell agt. Nevada 126
Crowley, Richard 2, 70, 72, 77–78, 83, 97–98, 102–103, 105, 109–121, 131, 142, 147–148, 150–156, 159, 160–171, 173–175, 182–185, 191, 205, 220*n*4
Culver, Mary 55
Curtis, Mary 58

Darrow, Clarence 39
Davis, David 189
Davis, Mary F. 26
Davis, Paulina Wright 26
Dayton, Tennessee 39, 216*n*10
Declaration of Independence 89, 103, 122, 218*n*9
DeGarmo, Rhoda 55, 57, 60, 153–154, 157, 160–161
Delaware 38, 188, 210, 215*n*14
Democracy in America 109

Democrat and Chronicle 3, 75–76, 183, 185, 217*n*1, 217*n*8, 217*n*16, 218*n*22, 218*n*24
Democratic Party 14, 16, 39, 51, 55–57, 59, 63, 65, 68, 69, 71–72, 84, 132, 152, 156, 157, 166, 180, 217*n*13
Detroit, Michigan 49, 103
Dix, John Adams 56
Dolley, Dr. Sarah Adamson 55
Douglass, Frederick 5, 9, 18, *19*, 20–23, 27–28, 30, 40, 70, 107, 190, 198, 199; death 200–201; friendship with Anthony 5, 9, 31, 44; marriage to a white woman 41–42, 198; nominated for vice president 46
Douglass, Helen 41–42, 200
Dover, New Hampshire 103
Dred Scott Case 13, 37, 84, 93
Dutton, Mrs. Dr. 53

Earlville, Illinois 94
East Louisiana Railroad 36
Edmunds, George F. 192
Edmunds-Tucker Act 196
educated suffrage 12, 14, 22
Enforcement Act of 1870 83, 133
England 15, 18, 42, 86, 101=102, 144
Equal Rights Party 46
Evening Express 85, 183

Falconer, William 79
Farmington, New York 88
Ferguson, John Howard 36–37
Field, Stephen J. 128, 189, 219*n*20, 219*n*21
Fillmore, Millard 82, 111
Fish, Mary 55
Fogg, Phileas 15
Fort Wayne, Indiana 105
Foster, Stephen S. 9, 11–12, 14, 17–18, 24
France 101, 195
Franklin, Benjamin 100
French and Indian War 196
Frothinghm, Octavius Brook 9–11, 18
Fugitive Slave Act 86–87

Gage, Matilda Joslyn 7, 98, *99*, 100–103
Gardiner, Addison 65
Gardner, Nanette 49, 103
Garfield, James A. 47
Garner, William 132–133
Garragus, Mr. 73, 218*n*26
Geneva, New York 88, 100
Georgia 12, 14, 87, 94, 122, 210, 213
Georgia v. Brailsford 87
Gilman, James A. 68
Godwin, William 122

Grant, Ulysses S. 2–3, 14, 22, 48, 55, *56*, 71, 94, 97–98, 116, 132, 182, 191, 219*n*19
Graves, Ezra 56
Greeley, Horace 55, *57*, 71, 73
Griffing, Josephine S. 35
Grimke, Angelina 49
Grimke, Sarah 49
Guardian Mutual Life Insurance Company
Guiteau, Charles J. 47

habeas corpus 80–81, 84, 92, 126
Hale, Matthew 124, 219*n*12
Hall, Nathan K. 77–78, 80–83, 96–98, 203
Hall, William B. 52, 63, 66, 112, 147, 151–152, 154, 156–158, 166, 168–169, 173–174, 180, 184
Hallowell, Mary 57
Hamlin, Hannibal 65
Hancock, John 100
Hancock, Winfield S. 47
Hannaford, Phebe 10, 24–25, 30
Happersett, Reese 104, 187
Harlan, John Marshall 37
Harper, Frances 27–28
Harper, Ida Husted 5, 45, 52–53, 59–60, 105–106, 117, 185, 193–194, 197
Harrison, J. Stewart 200
Haven, Gilbert 23–24, 26, 30
Hebard (or Hebbard), Mrs. Charles 53, 105
Hebard, Mary L. (also listed as Mary S.) 55, 105
Henderson, John B. 187–188
Henry, William 87
Hillside African Church 200
Hilton, New York 88
History of Woman Suffrage 5, 30, 117, 185
Hoffman, John 15
Honeoye Falls, New York 88
Hooker, Isabella Beecher 35
Hough, Susan M. 55, 153–156, 160–161
Howe, Julia Ward 20
Hunt, Ward 3, 7, 97, 103, 109–11, 114–115, 117–121, 123–131, *132*, 133–136, 138, 141–146, 148, 150, 155–156, 159, 161, 164, 166–167, 169–181, 185–187, 189–190, 193, 218*n*10, 219*n*5, 219*n*21, 220*n*26, 220*n*33
Huntington, Sarah M.T. 104

Illinois 94, 104, 128, 186
immunities *see* privileges and immunities clause
Iowa 14, 191
Iroquois 109, 195

Jay, John 87, **88**
Jefferson, Thomas 19, 100, 190, 215*n*13
Jerry Rescue 87
Jim Crow laws 37
Johnson, Andrew 188
Jones, Beverly W. 52, 57, 63, 65–67, 69, 111–
 116, 147, 151–152, 154, 157–159, 163, 165–
 171, 180–181, 217*n*15, 217*n*20
jury nullification 86–88, 92, 98–99, 100,
 103, 178

Kansas 15–16, 22, 37–38, 40, 52, 190, 213
Keeney, Elijah J. 61, 76, 78–80
Keeney, Mary Ann 79
Kelley, Abbey 11
Kelly, Hugh 79
Kentucky 132, 188, 212, 215*n*14
Kettavong, Pepsy 58, 199
Kirk, Eleanor 26
Krum, John M. 187

Lake George, New York 194
Leser, Oscar 197–198
Lewis, Sylvester 59–60, 63, 65–66, 68–69,
 71–73, 152–159, 163, 217*n*13, 220*n*4
Leyden, Margaret
Lincoln, Abraham 14, 65, 70, 93, 122,
 216*n*6, 217*n*9, 217*n*19, 219*n*16
Lincoln Hall 35, 79
Livermore, Mary 17, 24–25, 28–29
Loaux, Mr. 194
Lockport, New York 72, 116
Logan, Olive 23, 30, 215*n*17
Loughridge, William 191
Louisiana 36, 38, 219*n*13
Lyme, Connecticut 65
Lyon, Matthew 190
Lyons, New York 109, 219*n*2

Macaulay, Thomas Babbington 100
Madison, James 89
Mann, Mrs. 58
Marcellus, New York 82
Marion, Indiana 105
Marsh, Edwin F. 52, 57, 63–64, 112, 147,
 151–152, 154, 166, 169–171, 180–181,
 217*n*15
Martin, Luther 89
Martindale, John H. 67
Maryland 42, 188, 197–198, 210, 215*n*14
Massachusetts 10, 18, 22, 25–26, 34, 66, 86,
 91, 94, 182, 196, 210
Matilda effect 99
McKinley, William 39

McLean, Guelma Anthony 55, 96, 154
Mellis, David Mr. 16
Mencken, H.L. 39
Metropolitan African American Episcopal
 Church 201
Metzerott Hall 198, 201
Miller, Samuel Freeman 126, 189, 219*n*16
Minor, Francis 2, 6, 31–32, 34–35, 104, 187,
 189
Minor, Virginia 2, 33–35, 38, 104, 187, **188**
Minor v. Happersett 104, 187, 196, 206–213
Mississippi 14
Missouri 33–5, 38, 87, 89, 187–188, 206,
 209, 213, 215*n*14
Missouri State Association of the National
 Woman Suffrage Association 33
Monroe County, New York 7, 86, 88, 96,
 98–99, 101, 204
Moore, Edward M. 45
Morrison, William F. 150–151, 159, 161–164
Mosher, Hannah Anthony (Ann S.) 35, 154,
 153, 160–161, 164
Mosier, Mrs. Hanna L. 53
Mott, Lucretia 26, 35
Mount Hope Cemetery 200, **200**

Naples, New York 100
Nasby, Petroleum V. 54, 219*n*9
National Union Party 70
National Woman Suffrage Association 33,
 35, 40–41, 46, 216*n*12
National Women's Rights Association 79
Nebraska 14
Nevada 14
new departure 34–35, 40, 189
New Hyde Park, New York 49
New Jersey 22, 47, 49, 196, 210, 212–213,
 217*n*7, 219*n*11
New Orleans 19, 36, 219*n*13
New York City 6, 9, 14–15, 19, 26, 31, 40,
 45–46, 109, 186, 198, 216*ch*1*n*30, 218*n*4
New York Commercial Advertiser 84
New York Daily Tribune 30
New York State 2, 9, 15, 26, 32, 46, 49, 52,
 55, 56, 62, 64–65, 82–83, 85, 90, 102, 110,
 113–115, 118, 127, 132, 148–149, 165–166,
 169, 194, 204, 210, 218*n*4, 220*n*6, 220*n*8,
 220*n*11
New York Sun 85, 186
New York Times 201
New York Working Women's Association
 26
New York World 16
New Zealand 196

Norton, Sarah 21, 26, 215*n*16
Norwalk, Connecticut 104

The Observer 186
Ohio 41–42, 46–47, 50, 75, 85, 104
Onondaga County, New York 98
Ontario County, New York 7, 88, 91, 98–
 100, 102, 104, 107, *108*, 109, 219*n*1
Otis, James 100

Pennsylvania 89, 104, 210
Phelps, New York 88, 100
Philadelphia 104, 219*n*9
Pickering, Timothy 109
Pierce, Franklin 87, 216*ch*2*n*5
Pillsbury, Parker 16
Pitts, Helen *see* Douglass, Helen
Pittsford, New York 88
Plesey, Homer 36–37
Plessy v. Ferguson 36–38, 40, 190
Polk, John 100
Polk, Trusten 188
Post, Amy 53, 55, 57
Pound, John B. 62–64, 66–67, 69, 71–76, 97,
 118–119
privileges and immunities clause 12, 32, 93,
 123, 126, 206, 209, 211
Providence, Rhode Island 72
Pulver, Mary 55, 105, 153–155, 159–160, 164

Quakers 60, 86–87, 194

Randolph, Mary D. 197–198
Republican Party 2, 14–16, 47–48, 51–52,
 55–57, 59, 63, 65–67, 70, 84, 89–90, 116,
 132, 156, 166, 182, 188–189, 191–192,
 217*n*19, 218*n*4
The Revolution 12, 15–19, 31, 34, 45, 104,
 145, 187
Ricker, Marilia M. 103
Robinson, John C. 56
Rochester, New York 2, 5, 9, 43, 47, 52–53,
 55–57, 59–62, 65, 67–70, 72–73, 75–82,
 85, 87–88, 96, 99, 101–102, 105, 107, 110–
 113, 116, 118–119, 134, 147, 150–151, 152,
 162, 165, 171, 177, 180, 182–184, 193, 196,
 199–201, 204, 216*ch*2*n*21, 217*n*7
Rochester City Hall 75–76
Rochester Evening Express 52, 55, 85, 183
Rose, Ernestine 25–26, 29
Russia 101

S., Dan 194
St. Louis, Missouri 2, 6, 16, 31–33, 104, 187

St. Louis Suffrage Association 16
San Francisco, California 41
Santa Cruz, California 91, 104
Saratoga Springs, New York 193
Sargent, Aaron Augustus 184, 191
Sargent, Helen Clark 184
Schenectady, New York 132
Scopes, John 39–40
Scopes Monkey Trail 38–40
Searl, Henry 107, 109, 219*n*2
Selden, George 65
Selden, Henry R. 54, 57, 62–65, 67, 70–71,
 73–77, 80–82, 84, 110–115, 117–125, 127,
 129–144, 148–149, 164, 182, 185, 191,
 217*n*21, 220*n*24, 220*n*26, 220*n*32, 220*n*33
Selden, Samuel 57, 65
Seneca, New York 100
Seneca Falls, New York 9, 26, 43
Seneca Indians 70
Separate Car Act 36
Sewall, Mary Wright 198–199
Slaughter House Cases 126, 219*n*13
slavery 6, 13–14, 16, 19, 22, 26–27, 31, 42,
 78, 86–87, 93–94, 101–102, 144, 188,
 197, 215*n*13; *see also* Fugitive Slave Act;
 slaves
slaves 6, 9–12, 17–18, 20, 49, 62, 65, 70, 87,
 95, 99, 125, 188, 194, 197, 201, 215*n*14; see
 also Fugitive Slave Act; slavery
Smith, Mrs. L.C. 55
the South 14–15, 22, 26–27, 29, 37, 44, 87,
 94, 107
South America 15, 78
South Carolina 13, 33, 38, 94, 210, 216*n*4
Southern Pacific Railroad 184
Spencer, Sara Andrews 103
Spencerport, New York 88
Stafford, Mr. 194
Stanton, Elizabeth Cady 2, 6, 9, 12, 14–22,
 26–27, 29–30, 34, 40, *42*, 48, 55, 57–58,
 79–80, 94, 99, 190, 195, 198, 201; bullied
 by Anthony 42–48; obesity 41, 45, 48;
 votes 47; as writer 16, 35, 43, 48, 198
Stanton, Harriot 43
State v. Shule 137–138, 220*n*28
Stebbins, Catharine 58
Steinway Hall 9–10, 14, 17, 21, 28, 30, 48,
 109, 190, 198
Stevens, Thaddeus 89
Stone, Lucy 9–10, 21–22, 25–26, 28–30,
 40–41, 43, 216*ch*2*n*22
Storrs, William C. 60–64, 66–69, 72–76,
 79, 81, 105, 118, 171–172
Strong, William 190

Stroud, Reuben W. 56
Stuart, Gilbert 88
Sumner, Charles 90
Supreme Court of Louisiana 36
Supreme Court of Missouri 188
Supreme Court of South Carolina 220*n*28
Supreme Court of Tennessee 40
Supreme Court of the District of Columbia 104
Supreme Court of the United States 3, 6–7, 13, 34, 36–39, 50, 74, 77, 80–82, 84, 87–88, 97, 102, 104–105, 122–123, 126, 128, 132, 142, 185–189, 192, 199, 206–213, 218*n*10, 219*n*5, 219*n*11, 219*n*13, 219*n*14, 219*n*16, 219*n*18, 219*n*19, 219*n*20
Swayne, Noah H. 189, 219*n*21
Sweden 101, 195
Syracuse, New York 87, 98

Taft, Josiah 196
Taft, Lydia Chapin 196
Taft, William Howard 39
Taney, Roger 93
Taylor, Zachary 82
Tenafly, New Jersey 47
Tennessee 38–39, 98, 198, 212
Texas 14, 213
Tocqueville, Alexis de 109
Toledo Blade 85
Train, George Francis 12, 15–17
Tremain, Lyman 55, 191
trial transcript 5, 117, 219*n*4, 220*n*24, 220*n*26, 220*n*27, 220*n*29
Truesdale, Sarah 55
Truth, Sojourner 49

Union and Advertiser 53, 218*n*24
Union College 132
Union Pacific Railroad 15
Unitarian Church 10, 58, 216*ch*2*n*21
United States v. Reese 132
Upton, Harriet Taylor 42, 46
Utah 196
Utica, New York 132, 186
Uxbridge, Massachusetts 196

Valkenburg, Ellen van 91–92, 104
Van Voorhis, John 63–64, 66–67, 69–76, 80–82, 110, 119, 129, 133, 148–150, 153, 155–159, 161–180, 190, 217*n*21, 218*n*24,
220*n*23, 220*n*27, 220*ch*6*n*1, 220*n*4, 220*n*8, 220*n*9, 220*n*10, 220*n*11
Vermont 192, 198, 212
Verne, Jules 15
Victor, New York 88, 100
Vineland, New Jersey 49
Virginia 2, 6, 14, 33, 38, 87, 210
Viroqua, Wisconsin 91

Wagner (Wagoner?), Silas J. 59, 64, 166
Waite, Catharine V. 104
Waite, Morrison 188–189, 206–213
Wall, Sarah E. 91
Warner, Daniel J. 59, 64, 66, 69, 166, 174, 180, 218*n*22
Warren, Mercy Otis 100
Washington, Bushrod 123, 219*n*11
Washington, George 1, 3, 19, 100, 109, 219*n*11
Washington, D.C. 35, 38, 41–42, 48–49, 57, 79, 126, 176, 182, 184, 199–201
Waters, Cecilia Street 197–198
Webster, New York 88
Webster, Sara E. 104
Weeden, Mrs. J.S. 91
Wells, Mr. 194
West End News Depot 51–53, 55, 105
West Virginia 198
White, Richard Grant 123, 219*n*10
Williams, George Henry 184
Williams, Mary Hamilton 105
Willis, Mrs. 57
Wilson, Henry 25, 216*n*21
Wilson, Woodrow 39
Woman's Rights Association 10, 79
Woman's Suffrage Association 29, 40
Woman's Suffrage Convention 31
Women, Church, and State 99
Women's National Council 199
Women's Taxpayers Association of Monroe County 96
Woodhull, Victoria 46
Woodhull and Claflin's Weekly 46
Worcester, Massachusetts 91
Wright, Martha 45
Wyoming 196

Yosemite Valley 48

Zenger, Peter 86